"There is no life, anywhere, more worthy of a memoir than Sebastian Horsley's. And fortunately for us, he's as witty and talented in recording it as he is in living it. *Dandy in the Underworld* is my new personal bible for unorthodox sparkly living—complete with crucifixion and loads of fornicating."

—Josh Kilmer-Purcell, author of the *New York Times* bestseller
I Am Not Myself These Days

"The work of a lifetime. . . . Adorable, lovely, and sad. . . . A triumph."

—Gavin Rossdale

"I couldn't stop reading it. Freakish Genius!"

—Belle de Jour

"Beautiful writing, great reading, genius!"

—Sharleen Spiteri

"*Dandy in the Underworld* shits all over William Burroughs's first two books and makes Will Self look like a ponce."

—Shane McGowan

"I find myself experiencing greater ambivalence toward Horsley than I can ever remember feeling about anyone else. He is simultaneously enthralling, charming, and fantastically annoying."

—Will Self

"Unlike most modern tales of dope and degradation, in *Dandy in the Underworld* the writing is exquisite, hysterically funny, and unapologetic. Highly recommended."

—Legs McNeil, author of *Please Kill Me*
and co-founder of *Punk* magazine

"*Dandy in the Underworld* is a masterpiece of filth."

—Bryan Ferry

"Dear Sebastian, I regret to inform you that you have written a truly great book. It's so funny it left me feeling depressed about myself. There is nothing worse than a poseur with talent. May I suggest that you do the smart thing and fuck-off and die?"

—Cosmo Landesman

"The second greatest story ever told. I felt like I'd been beaten up when I finally put it down. I really think it's up there with Klaus Kinski's autobiography, *Uncut*. Or *A Drink with Shane McGowan*."

—Ian Johnston, author of *Bad Seed:
The Biography of Nick Cave*

"Delicious, vicious, fanatical fun."

—Heather McElhatton, author of the national bestseller
Pretty Little Mistakes

"Sebastian is an atheist, but the first I've ever met whose spiritual tradition doesn't just come from a lack of imagination. His attempts to become other than he is are epic."

—Nick Cave

"*Dandy in the Underworld* is immortality for a while (a dashing immorality)."

—Sarah Lucas, artist and film director

CONSCIENTIOUS OBJECTIONS TO
Dandy in the Underworld

"Sebastian Horsley, a man who has absolutely nothing to declare but his own lack of talent. He is a prat . . . a wanker. This book should be avoided by anyone of a nervous disposition or by anyone who has a fondness for the female sex. The question that may enter the inquiring mind is what exactly is the point of Sebastian Horsley? Do him a favor and bin it."

—*The Evening Standard* (London)

"An emotionally infantile spoiled brat, a vapid poser, he has less talent than a used condom."
—*QX* magazine

"His autobiographical theme of narcissistic bravado has already been successfully played by Beaton, Dalí, and other modernists; his wit, and some of his style, is also borrowed—from Oscar Wilde and Quentin Crisp. . . . Horsley adopts an artistic sensibility and has himself crucified in the Philippines. That's been done, too, and better."
—*The Times* (London)

"An insufferable cretin."
—*The Leeds Guide*

"An attention-seeking tosser. . . . This book is forced and embarrassing. He is a show-off who can't do anything. He has a wild artistic temperament but no talent."
—*The Telegraph* (London)

"Horsley is the grubby, moderately brighter equivalent of the model/actor. His heroes—Brummell, Byron, and his namesake Sebastian Flyte—wouldn't have liked Horsley. The chip on his shoulder squeals from every page. Spare yourselves this trivial autobiography and wait for him to appear on *Celebrity Big Brother*."
—*The Literary Review*

"Sebastian Horsley is a pervert who stands for everything that is wrong with British society today."
—Jeremy Vine

"Why don't you just put it in the fucking bin!"
—John Lydon

DANDY IN THE UNDERWORLD

Sebastian Horsley

DANDY IN THE UNDERWORLD

An Unauthorised Autobiography

HARPER ● PERENNIAL

NEW YORK ● LONDON ● TORONTO ● SYDNEY ● NEW DELHI ● AUCKLAND

HARPER ● PERENNIAL

I have changed the names of some individuals, and modified identifying features, including physical descriptions and occupations, of other individuals in order to preserve their anonymity. In some cases, composite characters have been created or timelines have been compressed, in order to further preserve privacy and to maintain narrative flow. The goal in all cases was to protect people's privacy without damaging the integrity of the story.

First published in Great Britain in 2007 by Hodder & Stoughton, a division of Hodder Headline.

P.S.™ is a trademark of HarperCollins Publishers.

FIRST U.S. EDITION

Library of Congress Cataloging-in-Publication Data is available upon request.

ISBN 978-0-06-146125-5

08 09 10 11 12 RRD 10 9 8 7 6 5 4 3 2 1

This book is dedicated to the brilliant and beautiful Rachels who are a never-ending source of inspiration and delight and who wrote most of this book – including this dedication.

Not that it matters, but what follows is true.*

* Though I have, reluctantly, changed a few names.

1

Birth was almost the death of me

When Mother found out she was pregnant with me she took an overdose. Father gave her the pills. She needed a drama from time to time to remind her that she was still alive. The overdose didn't work. Had she known I would turn out like this she would have taken cyanide.

Still, even with a fine career as a failed abortion behind me, I couldn't wait to be born. Mother might just as well have tried to stop a meteorite. Hurtling towards the earth, in 1962 I exploded on Hull. I was so appalled I couldn't talk for two years.

Mother had been drunk throughout the entire pregnancy. It was me who was well mannered. I gave her no labour pains. I have never kicked a woman in my life – not even my own mother.

On the way to the hospital it had been decided that I would be called Hugo Horsley. During my birth she changed her mind, I was registered as Marcus. This would have been nice because, having danced myself out the womb, I could have been named after my first hero, Marc Bolan. It was not to be. By the time Mother got home she realised she had made a mistake. She took a deep breath and called me Sebastian. My name was changed officially by deed poll – but only when Mother got round to it. In 1967.

For this I am grateful. The most beautiful word in the English language is 'Sebastian'. Sebastian Flyte, Sebastian Dangerfield, Sebastian Venable; the title is divine – all gleaming with vermilion.

Even to the militant lowbrow that was Father. After my final naming, Father said to Mother, 'I hope that name doesn't give him any ideas.'

I have to say, it did rather. Years later when I was crucified and was asked repeatedly why I had done it I replied 'Because I am called Sebastian.' In the hooligan world of art this was understood. Sebastian as an icon is attractive – even if only to faggots. Mr Wilde took Sebastian as his Christian name for his alias when on the run in France. He also wrote 'the grave of Keats' for me:

> The youngest of the martyrs here is lain,
> Fair as Sebastian, and as early slain.

A good idea attempted is better than a bad idea perfected. There was no question that Mother and Father's marriage was the latter. It had begun with a drama which would have turned Miss Scarlet O' Hara herself crimson.

Mother had been wandering the world to no effect. Born in Wales – a country where Sunday starts early and lasts several years – she had had good reasons to flee. Her own mother had been someone who had nothing and wanted to share it with the world – so she had joined the Communist party, and entombed her daughter in a Catholic convent.

She had to be subsidised at *Le Bon Sauveur*, Holyhead, by the nuns who had a whip round to buy her clothing. This was Catholicism smartly sold, for Mother loved all the frocks and clothes. But she was determined to remain unsaved. A skinny, plain little girl with mousey hair and chilblains, she seemed shy as an antelope but her timidity masked a leonine spirit.

Ordered to do needlework she flushed her sampler down the lavatory. Confronted in class she threw ink over a Nun's habit. One day she went on hunger strike. A nun sat across the table from her in the dining room commanding her to swallow. Mother folded her arms as tight as a straightjacket. Afternoon turned into dusk. The semolina cooled but her lips remained frozen.

The sky turned dark. Suddenly she stood bolt upright and threw the pudding on to the floor. She marched round to the nun and fixed her with her stare. 'Now *you* lick it up,' she said.

It is impossible to receive grace in a state of rebellion. Hopeless at games and all subjects except for English Literature, Mother was about as useful as a nun's tit.

At fourteen, Mother was moved to an elementary school. She was a solitary teenager with no friends and was nicknamed 'gormless' by her enemies. Her only recourse was to begin a journey to the interior. With no television in the house and a radio which could only be turned on when her mother was out (she hated any sign of the outside world) she saw and heard nothing; she had to use her imagination.

She wasn't really grand enough to be a secretary but at seventeen she went to typing school in Llandudno, and from there to Edinburgh to become a shorthand typist for the Inland Revenue where she was paid £4.10 a week. She worked like a poor woman but walked like a queen. Give her the luxuries of life and she dispensed with the necessities. Food and shelter were optional, hats and furs obligatory. Mother understood instinctively that style has little to do with wealth; it is a way of being yourself in a hostile or indifferent world. To be 'well dressed' is not to have expensive clothes or the 'right' clothes. You can wear rags, so long as they suit you. Style is not elegance but consistency.

On a whim Mother left for New York and became a personal assistant to a Wall Street banker. The idea of Mother on Wall Street seems bizarre to me – but not to her. She was a bohemian – without prejudices and without roots.

She sat at her desk each morning reading Keats. Only urgent business would rouse her. One day she heard that a rival firm was going to do a promotion across the street. Two thousand balloons would be dropped from the top windows that evening. One of them would have a plane ticket attached. Mother put on her best hat to go out.

Where others swaggered down Wall Street in pursuit of money,

Mother (who knew that shrewdness was the enemy of romance) skipped through the street in pursuit of her dreams. The red, white and blue balloons floated around her like soap bubbles. Crowds reached for the sky, but she jumped up and caught a balloon. And tied to it was the air ticket. Its destination – New Orleans.

When she arrived there she knew no one and had nowhere to live, not that this would inhibit her. She always seemed to land on her feet – or someone else's. Meandering down to the French Quarter she spotted an art gallery, with its wares displayed on the street. She decided that she would stay and threw the return ticket away.

Art doesn't pay but the hours are good. In the beginning, Mother worked full days. Her boss had her deal with the painters coming in, which she enjoyed. Artists are easy to get on with – if you're fond of children. After a month she had eased off slightly. She got her office hours down to twelve to one – with an hour off for lunch.

Even in frivolity, she was disciplined. She gave her life over entirely to her own interests. She understood that all art constantly aspires towards the condition of music, towards that condition where our innermost point stands outside us. So she spent her days enjoying the soaring kindness of classical and ignoring the measured malice of Jazz. She loved one with the same fervour as she loathed the other. 'Well, Jazz has a bad name because it's crap and boring you know,' she would say years later. 'It is the most *terrible* revenge of the blacks on whites.'

Back in her rooms she read Shakespeare and Baudelaire. But her study programme also – inevitably – involved self-destruction. After all, it *is* the quickest way to gain control over your own destiny. She had discovered alcohol on the boat over to New York and would now stay up all night in saloons drinking bourbon and flirting with the men at the bar.

She met Janet who was to become a lifelong friend. On Sundays they would waltz – arm in arm – into a lesbian bar which had

a free buffet. Both wore short cropped hair and boyish clothes but it was always Mother who got hit on. 'Are you gay?' a taxi driver once asked her. She shrugged, 'Well sir, some days I am. Some days I'm not.'

Late one night Mother was walking through New Orleans. A white van pulled up. Two young men jumped out and dragged her into the back. 'If you scream we'll strangle you,' one said. He tore down her knickers and then climbed on top of her. Then the second man took his turn. 'They were just kids,' Mother said later. 'They couldn't get it up. They were trying to play snooker with a rope.'

Mother's boss had been Billie Holiday's last lover, apparently. 'I knew I was off heroin when I stopped watching TV,' Miss Holiday famously said. He invited Mother to his apartment for dinner. The difference between rape and seduction is salesmanship. When Mother got there there was no supper. Instead he stood up, whipped out his cock and informed her, 'What you need young lady is a good fuck.' Mother bolted. The glass door slammed behind her. He ran straight through it and collapsed amid his shattered ego.

After Mother was fired, she was destitute. She survived on bananas that she ate in the supermarket. She was an instrument of fate.

One afternoon whilst sitting on the grass in Jackson Square Park she noticed a pointlessly tall man, with an irregular lope. He stood out. Everyone else wore sneakers or flip-flops, or went barefoot. Surely she heard the unmistakable clip of English brogue on English rogue? A bet was made with Janet, who was lounging beside her, that he was English. She won her bet. And two days later she married him.

Father had just hitch-hiked into town from Canada, where he had spent the last nine months doing odd jobs and seeing the country before returning home to settle down into the family business in Yorkshire. 'I have a dairy,' he told Mother. 'Oh sure — a shack on the Moors with one cow,' Janet said. Mother couldn't

care less. But when she went over she sent a telegram from a mansion in Yorkshire. All she said was: 'There's more than one cow.'

They spent their two day courtship in the way stations for the whisky wounded. Nothing ever closes in the French Quarter. It was sitting in Poppa Joe's that Father asked Mother to marry him. She got up, went to the jukebox, selected Sarah Vaughn's 'I'm glad there is you', and knocked back another drink. Then they tottered off East. Those days in America the man had to have a blood test for VD before the certificate could be signed. Father was terrified of needles. They found the one state where it was not mandatory.

The Justice of the Peace at Gulf Port, Mississippi raised a quizzical eyebrow when Mother walked in. 'Er, hello again,' he said.

Two weeks before Mother had been to the same place to marry an ex-con called Jack Stone. She had known him two days. Enough to warn him, 'If I say yes to anything when I am drunk don't believe me.'

Mother was like a bobbing ship which never moved but by the wind of men's breath. With no oars of her own to steer and no personal ballast or rudder, she was blown to and fro, nowhere at home and everywhere at sea. When Mother and Mr Stone had got to the registry office the justice had asked her for proof of identity. Anything would do. Even a letter with an address on it. Mother had nothing.

Now, turning up again with Father, Mother had a letter but no ring. They had to borrow Janet's. On the drive back to New Orleans, they came across a funfair and their first wedding present was a ride on the carousel. Father sent an economic telegram to his family. 'MARRIED ENGLISH TODAY STOP LETTER FOLLOWING.'

It was Hitler's birthday. 20 April 1958. They sold their story to the *New Orleans Item*. Under the heading 'British Couple Meet Here, Wed', they stare out from their photo with eyes unaware

of all the hurt that will come. Mother rests gently on Father's shoulder, a beautiful and inextricable combination of glamour and suffering. Father looks down, hidden in a forest of hair like a shy deer. He cradles awkwardly in his arms – as if foreseeing his children – a Neapolitan mandolin.

'I just guess we're not very English,' Father said in the interview with a nod toward his bride of three days. The paper tells the story of their 'whirlwind courtship' saying 'while it wasn't as poignant as that of Elizabeth Barrett and Robert Browning, at least it shows that some Englishmen have more romance than caution in their souls.' Due to sail from New York on the Queen Mary 'there is a small cloud hanging over them. They have no money.' Father said: 'We may have to hitch-hike.'

Finally the reporter asked them, 'Are you temperamentally suited to each other?' Mother knew a good headline when she uttered one. 'I've no idea,' she said, 'I've only known him a week. I don't know who he is.'

For a long time I was troubled by three faint memories. In one we are at Castle House, a large folly in Brough. I must have been two or three. The fridge is full of eggs. I put my hands on the eggs and move them about but I don't lift any of them up. They are cold and symmetrical and there are a lot of them. Slowly I close my hand around one and drop it semi-accidentally on the kitchen floor. The plop and the mess it makes are so delicious that I take another egg in my hand and repeat the experience. By the time Mother finds me an hour later the kitchen has been completely redecorated in eggshell white. The beam of sheer delight and satisfaction on my face made it impossible for her to admonish me. Knowing her she went even further and allowed me to feel that this was a taste we shared. As far as I was concerned I was Mother's favourite. She hadn't yet told me that I had been conceived through a broken condom and had survived an attempted abortion – although, clearly unable to keep this bit of gossip

to herself, she had told my traumatised older sister that it was her she had tried to terminate.

In the second memory I am sitting in my high chair slobbering food. My arm is hanging down the side and my hand is by a cupboard – the door of which is open. Ash, my sister, suddenly slams the door shut cutting off the tip of the little finger on my right hand. Blood squirts everywhere. The nanny screams, like the nanny in *Battleship Potemkin*. The gardener, who as usual is in the kitchen rather than the garden, picks up the severed digit, pops it in an envelope, and rushes me and the bit of me to hospital. It is too late for the doctors to reunite us. They threw the wrong bit of me into the bin.

I was too well-mannered as a baby to cry – though in extenuating circumstances, such as these, I may have uttered a small yelp. So, as tears are the most potent weapons in a baby's inexhaustibly malevolent arsenal, I was forced to arm myself elsewhere.

My revenge was exquisitely wrought. I waited – a few years – until Ash was bouncing bare-legged on the bed from her knees to her feet. I daintily spun a piece of broken glass on to the mattress which then harmlessly imbedded itself in her knee. My siblings were always too vulgar for me.

My last memory from this time involved learning to run before I could walk. As I stumbled down a long corridor I fell on to a milk bottle. The glass shattered against my hand. So much blood! So much blood outside that should be on the inside!

To this day my hands have not fully healed. Untouchable nerve ends tingle and jingle. Scars sing but I like them. Memories are only memories, but you can trust a scar.

In 1966 we moved from Castle House to High Hall where I remained until I was eleven and it is here that my sharper recollections begin. Before everything is hazy – memories seem like a mirage – but at the mere sound of the name of High Hall all the sights and the sounds and the smells of my childhood come back in a vivid rush.

High Hall was on the top of a hill so that God could see everything that went on. Below was the little village of Etton with its one street, one pub and one shop. The graveyard was part of the village where the dead rested, and Etton was the part of the churchyard where the living rested. All is full of silence. My memory always looks out towards the empty fields and gloomy yew trees standing along the blue-grey paths that zigzagged the landscape. The sun shines, the earth is unpopulated and to my waking eye all is frozen as if forever in a state of pause and expectancy.

Originally a small eighteenth-century manor house High Hall had now been transformed into a mansion large enough to accommodate an entire Catholic family. A soaring, rambling building of red brick with stone dressings and sharp gables, it had three floors with endless bedrooms and bathrooms and attics and corridors along which to race and fall. And in the middle of it all was the vast balconied entrance hall, so high that it felt as if trees as tall as sequoias could have bloomed there. Outside were lawns and paddocks, tennis courts, out-houses and stables. It was an entire universe for a child. I remember it all so well. High Hall may have forgotten me but I have not forgotten her.

In sleep, when all the gunk of memory flies like rubbish from a dustbin upset in a high wind, I return again and again to this house. It is the setting for my most persistent adult dream where I am swooping through the gardens and trees. The fields are tinged with red, the rivers yellow, and the trees painted blue. The lanes are paved with opals and the air sparkles like diamonds. There are camellias as big as cabbages and sunflowers as tall as telegraph poles. I alone hold the key to this paradise.

In my thirties, when I was ill in bed from drugs, I revisited High Hall with the sentimental oversensitivity of heroin sickness. Even the mildest withdrawal causes acute nostalgia. For me, I always return to the magic of childhood. Each morning, I woke up a little sick. I lay there looking at shadows on the white plaster ceiling. I felt the awful ache of longing for High

Hall and was torn, remembering the golden nights falling on to the sunset lawn.

In the early days of Mother and Father's marriage they were happy, but I have no memory of this. The astonishing glass shade that – Mr Forster tells us – falls and interposes between married couples and the world had most definitely fallen. They barely left the house. They sat and they drank. Occasionally, they stood up and walked – to the Light Dragoon pub in the village.

They seemed to believe that Romantic love excluded procreation. When we have a child we are creating our greatest rival, a person we are going to love more than each other. They weren't having any of this. They paid hardly any attention to us whatsoever. They didn't even ignore us.

At the age of five I went to Cherry Burton primary school, two miles from Etton. I remember my first day well because I shat myself – in class. My upper half was dripping with tears and my lower half was dripping with excrement. But what really upset me was that the teacher put me in a pair of bright yellow shorts with big white polka dots which I had to walk home in. I had my standards. They may have been low, but I had them.

It was at primary school that the dreadful realisation started to dawn on me that I wasn't particularly clever. It is true that I neither distinguished nor disgraced myself at the school, but I was slow – almost stationary.

You are better off with half a brain so you can't grasp the extent of your own shortcomings. But I knew only too well. It was compounded by Ash's brilliance. She dazzled in mathematics, languages and sciences – all of the things which I simply couldn't, and still can't, understand. (In real life, I assure you, there is no such thing as algebra. I have never had to whip out a book of logarithms to work out what to pay my dealer.) The headmaster actually called Mother and Father to the school to tell them that he thought Ash was touched with genius.

While *she* was solving the problems of the universe in six different languages. I was having problems tying my shoelaces.

I pretended to love slip-ons rather than admit my shameful secret. Father taught Sister to read and write at the age of three, but he gave up on me. So – eventually – did she. Once, trying to school me in something and not having the desired effect, Ash got more and more bossy until in the end I punched her in the face.

It was hopeless. I couldn't read, write, catch or spell. Father never tired of reminding me, 'Well, I tried to teach Sebastian but he was too stupid to get it.' I longed for dyslexia or some such alibi. Any attempts to dignify my idiocy were inevitably shot down by Father. 'Dyslexia is the term posh people use to describe their children's stupidity,' he would drawl.

I can't believe that Mother, who had never had more than a seaside romance with responsibility, could have possibly noticed, but she invited my primary school teacher, Mr Piles, round to discuss my progress – or lack of it. It was 4 p.m. and Mother offered him tea. 'I'll have a whisky,' he said. After a brief discussion about me they both got pleasantly tipsy. But as the afternoon progressed into evening, my teacher became belligerent and his working-class roots started to grow until he was out of his family tree. Mother, who detested the working classes, tried to change the subject. How cross drunks get if you try to do this to them. To try and snatch a subject from a drunk is like trying to snatch a bone from a mad Alsatian.

Mr Piles stood up, and – pointing to the massive garden – screamed, 'See those fucking sweet peas out there – that's money. That's fucking money! It's because of those fucking peas and people like you that people like me never get anywhere. Why do I have to teach your fucking children anyway? *Fuck you.*'

There is a thin line between a dignified alcoholic and an obnoxious drunk. Mr Piles staggered into the courtyard and then into his car. Mother tried to stop him by jumping on to its running board. They tore through the gates of High Hall and then screeched into the road throwing Mother into a ditch. Teacher, car and career then went careering off in a headlong

downhill rush, through Etton, into a wall and then – another ditch.

At High Hall we spent most of our time in isolation. This didn't worry me particularly. As a natural loner I grasped early the irrelevance of family life. The outside world and the part which I might play in it seemed unreal and perilous. Already I had begun the retreat into the strong, sad kingdom of self.

Although I did have my grand passions, my love affairs, my distractions. I fell in love with the sunflower. I would plant them every year, a monstrous regiment ranked against the wall of the barn. I did not care for the marigold, the dahlia or the rose. It was only the sunflower that I identified with. I had an instinct for its sudden, fantastic radiance and its equally sudden collapse. Maybe, even then, I sensed in it an emblem of our own lives.

My other hobby at this stage of my life was arson. Arson is a bit like a drug – you need bigger and bigger hits to achieve the same effect. I started small. Models which I had spent weeks painstakingly assembling, assiduously painting, would then be proudly lined up on the old stone mounting block in the yard, doused with petrol and torched. But that didn't keep me happy for long.

First I selected my target: a large haystack about a quarter of a mile from the house. Then, waiting until dusk, I took out the matches. The dry stalks immediately caught. I remember the thrill of the smoke, the fear that caught in my throat as the flames suddenly leapt up. I remember the excitement as I cycled as fast as I could back to the house and ran up to the attic. From there I watched the fire which blazed like a vast gold idol in the night.

Later, I watched the lights of the fire engines arriving, blinking in and out of focus like fireflies as they zigzagged along the country lanes. I drank in the sight. It was my first taste of that intoxicating cocktail of fear and power.

Next: High Hall. It was an accident of course – though it began in Ash's pram which, left in the boiler room, I had doused

in methylated spirits and then torched. I sat in the middle of the floor giggling. Mother rushed in with a blanket over her head and put the fire out. The sight of Mother behaving responsibly was an absurd an image as Count Dracula going for an early morning run.

Another of my pastimes at this tender age was acting as an electrical conductor. There were live fences in the paddocks surrounding our home – to keep the horses in and the Horsleys out. I would lure a friend over and then, clutching the wire, would let the currents pass through me and – as I grabbed their hand – into them. It was worth it to see their faces jerk. Their bodies jumped like puppets on strings.

However, I did manage to learn how to read and write in Father's library. I had discovered Tintin – which was for children who found Asterix too intellectual. I'd been rather bored by *The Hardy Boys Go Eat Their Lunch*. To me Tintin was truer than if he had really existed and I worshipped him.

Mother and Father were too intelligent to have been tempted to fool either themselves or others by appearing bohemian. Mother was a poet. A *real* poet. She did nothing. Not even write poems. Father had had vague romantic dreams of writing like Hemingway but instead he started to sell pork pies.

But many people are born a poet and die a businessman. His library reflected his lost hopes – in his study was his harem: Kafka, Fitzgerald, Baudelaire and Ginsberg. My favourite was William Burroughs.

I opened *Naked Lunch*. Page 99. And read:

> 'Darling, I want to rim you,' she whispers.
> 'No. Not now.'
> 'Please, I want to.'
> 'Well, all right. I'll go wash my ass.'
> 'No, I'll wash it.'
> 'Aw shucks now, it ain't dirty.'
> 'Yes it is. Come on now, Johnny boy.'

I knew I was approaching the spot where the treasure lay buried.

Mother read Wilde to us. It was often the same story. 'The Happy Prince.' She was always unable to finish reading because her face was wet with tears. Years later when I tried to read the same tale to a lover, I too couldn't finish it. Perhaps the deepest parts of our hearts are inherited.

It wasn't just the literature of Wilde that Mother seemed to have picked up like a silk glove, tried it on, and found a perfect fit. His style had permeated her life. And she passed his theatricality down the parade to me. I can remember her dressing once with great care in front of the mirror before going out, demanding that one of her children accompany her. 'Which child?' the nanny asked. 'I don't care,' Mother snapped. 'Whichever one goes with red velvet.' (Naturally it was me.) Her twin obsessions, death and clothes, merged in an unholy matrimony. She would talk incessantly about wearing glamorous underwear so as to be prepared for the cataclysmic car accident which she, and we, spent half our lives waiting for.

If charisma is being able to persuade without the use of logic then Mother had charisma. She led me into a life-long exotic swoon from which I have never really recovered. When I think of her swirling in her hats and furs like a vamp of the silent screen, what gaudy ghosts I see in the rear-view mirror of my own life.

But at the time all I felt was embarrassment. It was sports day at primary school and as usual I had lost everything it was possible to lose. I waited to tell Mother that her fine young son hadn't gone far. Mother, naturally, was late.

The Jaguar crunched down the drive and the door slowly opened. What came out the back seemed to have more legs than a bucket of chicken, all wearing fishnet stockings. Mother followed, adorned with jewels, a black feather boa and flamingo-pink gloves. She looked like a drag queen's Christmas tree. Her dress was split to the frontiers of decency and was so tight you could see what she was thinking. And when she let go of her

hat brim, she seemed to have on her head a great flapping bird that was finding it difficult to roost on a moving perch. Tipsily she tottered over. 'Lost again sweetie?' she asked.

How Mother ever got a driving licence was the eighth wonder of the world. On the occasions we missed the school bus she would be at the wheel of her open top Triumph dressed in her negligee and slippers, her long hair blowing wildly in the wind. She would babble and curse away to herself like a bag lady. We never knew what these conversations were about except that they were stuffed with expletives. She was the most even tempered person I ever knew. She was always mad.

Life is only theatre – and Mother understood that it was mostly cheap melodrama at that. She was a performance in search of an audience.

Father had given up his search for everything – except the bottle of spirits. He was present – but completely inaccessible. And this suited me. Father and son are natural enemies, and it is in the interests of both of them to keep it that way.

The worst misfortune that can happen to an ordinary man is to have an extraordinary father. And Father was extraordinary – but not in the way he wanted to be. He made it appear when he had attained the object of his work – the making of a fortune – that it was not the object of his work. He had followed his father into the family company and turned the dairy into Northern Dairies and Northern Dairies into Northern Foods. From the head quarters in Hull he eventually built up a two billion pound business. And yet, offered the CBE for services to industry, he turned it down.

To refuse awards is another way of accepting them with more noise than is normal. But he turned his down quietly – much to the horror of his parents. They adored titles and heredities in their hearts and yet ridiculed them with their mouths, particularly Grandfather, who in vanity's parade not only marched at the head but carried the biggest, brightest banner.

But Father had the truly talented inability to appreciate his

rare gifts. As a businessman he was forever apologising for his occupation. It was as if he didn't want to become a man of success; he wanted to become a man of value. And value to him lay in a profession like creative writing, investigative journalism or radical politics.

Motherhood, as all stylists know, is the most starless role a woman can play. Mother understood this and wasn't going to let a minor detail – like three children – get in the way of her performance. Father, on the other hand, was an enemy of style. People who are not vain about their clothes are often vain about not being vain about their clothes. He had been neglecting his appearance for so long it had gone away. Yet he showed a strange, unholy symmetry with Mother. It may take years for someone to realise that they are ill-suited for the roles they have been offered but Father knew immediately that, in playing himself, he had been completely miscast. He was not the sort of man who could be counted upon either as a lover, a husband, a father or even a vaguely civil companion. And in this, at least, he was completely professional.

I have no real memories of him at all, except that he gave me swimming lessons. Each Sunday he would drive us in his Jaguar – I used to travel in the boot – to Pocklington Baths. I recall that I had a few problems with buoyancy but that Father seemed content with my performance.

But apart from that he did nothing. He didn't even take me aside and leave me there. It's ironic even now that I am referring to him as 'Father' because in the ten years that I knew him he refused to answer me if I called him by this name – or worse 'Dad' or 'Daddy'. I was only allowed to call him 'Nick'.

Perhaps it was because of his bodily condition. Father's physical self stood in the way of his intellectual and spiritual self. He was a spastic. Along with a business, he had inherited a paraplegic condition from my grandparents. It was genetic – an extremely rare degenerative disorder of the spinal cord which can only be manifested when two people, carrying the same

genetic mutation, have children. The chances of two people who carry it meeting and then breeding are almost infinitesimally small. But that was the sort of luck that ran in my family.

As children we were spectators at the slow drama of his disintegration. It started with the strange walk Mother had noticed when she met him in New Orleans: a dragging, shuffled gait. By the time we were growing up shoes were becoming uncomfortable. We would hear his walk, a sliding of slippers across the parquet hall, the coins in his pocket jingle-jangling. It steadily got worse. First sticks, then crutches and finally he was confined to a wheelchair. The only place he could move freely was in water. Then it was I who watched him swim.

Before the doctors knew what his condition was they tried to operate on him by breaking all his toes one by one and then drilling wire through to straighten them. I remember going to visit him in hospital. Father lay in the dark room, heavily sedated, his lower legs swathed in thick bandages. The cloying smell of hospitals and their sickness and their heat, hung in the air. I can remember my confusion. Why had they had hurt him? Why had they broken my father's feet? When he came home it was almost unbearably painful and yet compelling to see this quietly dominant figure who had ruled my life by default for so long limping about the house. To this day my heart cracks when I see a cripple. I have to wince and turn away. It always lights a powder trail that leads straight back to Father.

After sunflowers I developed an infatuation with the great white shark. I spent days in my room studying and drawing it and collecting books and magazines with features starring my new friend. Brother was preoccupied with dinosaurs which seemed pointless to me because they didn't exist. The true mystery of the world for me was already the visible, not the invisible. The shark was a living dinosaur – 400 million years old – and it ate people.

My career as a vandal was flourishing. I laid waste to the green fields of Etton like a locust. The greenhouses were my speciality. I would lock other children in them and then pelt all

I could find down on them. Bricks, slates, pebbles, toy cars, tin cans, action men and dolls – all arched through the air and, like Nijinsky, paused for one precious moment before crashing down through the roof. With my cousins on a bridge over the motorway in Brough I dropped stones on to the passing cars. Then we would scramble under the flyover and hide in the channel between the overpass and the embankment. Here we sat happily rolling logs down on to the highway.

When I was nine I managed to get my hands on a 1.77 air rifle. The roof of High Hall was accessible through a small trap-door in the attic. In the basting summer heat, I used to lie on one of the many parapets that ran round the top of the house and take aim at the trees and the cars and the cows. In the country, where everything is well behaved – even the flowers and the trees – someone has to set a standard of bad behaviour.

After a while I grew bored so I started taking potshots at members of my own family while they played croquet. I'm sure I would have remembered if I had hit any of them but in love it is always the gesture that is important. In this my aim was true.

It was only a matter of time before I graduated to murder. I woke up one morning and the sun was shining. I felt like killing something. Anything. I set off down the lane at the front of High Hall and crept up on a robin perched on a farm gate. I stopped to study the little bird. It seemed so pleased with its own prettiness. It chirped up at the blue sky as if the whole world had been created for its own happiness. I raised my gun. I remember the satisfying crack as the slug smashed the brittle crust of its thorax. The bird dropped dead on to the ground.

I felt like I'd just shot Father Christmas. I rushed over to the broken creature, bent down on my knees and burst into tears. I carried it to the back of the garden where I made a little grave and laid it down in the earth, cold and alone.

No wonder people are so horrible given that they start life as children. The idea that children are innocent is a myth. I

don't ever remember being virginal or particularly surprised or shocked by anything at all. What was so awful about me was my sheer selfishness, my naked Darwinian lust for supremacy. As an adult at least I learnt how to disguise it.

The idea that Mother and Father would divide their love amongst three was appalling. I simply cannot live within my income of praise. From the very start I wanted to be the bride at every wedding, the corpse at every funeral and the baby at every christening.

I was particularly horrible to my brother. It started early. When Ash, coming back from the hospital, told me 'It's a boy,' my face fell to the floor. 'Stillborn' was kinda what I was hoping for. Jake was a potential threat to my individuality. From that moment on, my relationship with him was always fraught – any excuse I got to slap, stab, or shoot him, I took it. I remember pushing his pram down the sloping lawn and then letting it go to career into a ditch and turn over. 'Jake's dead I think,' I informed my mother. When he was older I used more subtle tactics. I remember kicking him in the stomach and watching him crumple like a deflating airbag. Once he was ostentatiously tapping his foot to Marc Bolan. I stood up and stamped on it. 'Find your own music,' I said. Later he stole my clothes and possessions, trying to inhabit me. He failed. Nobody can be exactly like me. Even I have trouble doing it.

Mother had an appetite for sadness that no amount of mis-fortune could satisfy. One day we got a black and white television. It was a lighted rectangle packed with celebrities and other un-natural disasters which Mother took great delight in revealing to us. Her favourite subject was death. And movie stars. But it was *how* movie stars died that really excited her.

She stood behind us, drink in hand as we sat mesmerised by the flickering images.

'Ohhh that's Jayne Mansfield isn't it? Isn't she ugly? Do you know how she died children? *Decapitated* with her *children* in

the back of the car. Can you imagine? Oh and isn't that George Sanders? He was a pig! Do you know what happened to him? He committed suicide leaving a note saying: "God I'm so *bored*."' And so it went on. 'Kay Kendall? Cancer. *Horribly*.' 'Linda Darnell? Burned to death after falling asleep with a cigarette! Can you imagine? God I'd hate to burn to death. You look so *awful* afterwards.'

Mother's childhood had been an apprenticeship in human despair. Her father, 'Jack the Bolter', was a pulp writer of lurid fiction who never worked and disappeared soon after Mother's birth. She never saw him again. She remembers only his big blue eyes. His words were cheap and invariably stolen. He would send her stories to the convent which she later found out he had plagiarised. There is no record of his books. However, we should not be judged by what comes out of our mouths but what comes out of our hearts. Nothing, it seemed, in the bolter's case. He was a chronic womaniser and knew little of that melancholy sexual perversion known as fidelity. Mother's mother was wife no. 4.

Ada – who we called Gogo – was an awesome study in self-destruction. A drunken spirit whose divine essence was lunacy. As a child I was aware of the unpredictability that is the pulse of madness. Mother too had grown up with it. She'd lived in a little flat in which the curtains were kept permanently drawn. Her character, like a photograph, developed in darkness. No one ever came to visit the house and no one ever knew what time of day it was. 'It was like living on an island,' Mother told me. Gogo favoured her son over her daughter. She would wake at four in the afternoon and prepare breakfast, giving him a brown egg which for some reason she considered superior to Mother's white. And she would often disappear and leave both of them in the house for days on end. Gogo always ended up in the same place. Drunk.

Father understood Gogo. He understood the democracy of drink. No drunk, after all, can look down on another. Being

inebriated was like a Christian act of communion. Anyone could come in and share. Besides, he hated to feel alone in his vice. When Gogo came to High Hall he always put a bottle of her favourite Dubonnet by her bedside.

As an adult I was touched by Gogo's failure, but as a child I was scared of her. The careless way in which she bore the burden of life left a fear in us all that she might lose or cast it away at any moment. Always falling over and having accidents, the worst of which – a car crash – left her with severe head injuries and paralysis down her right side. She had no feelings in her arm or hand. When she came to High Hall she would demonstrate this by putting this numb appendage in the fire and leaving it there. We would crowd round her and cheer her on: 'Put it in further Gogo! To the left a bit – there – over that flame!' We waited for her to scream and jump back in agony or for the skin on her hand to burn, crack or melt. It never did.

On another occasion she fell over and gouged her eye. I remember it being the middle of the longest night. I heard her wailing first, then the noise of her stumbling and scratching around in the blackness like a wounded bear. She staggered out of her room, the blood pouring from her face. She had fallen on the bed-end, apparently, and the knob had sunk into her eye socket.

Screaming, I turned and fled. She tottered after me, arms outstretched, like some grotesque old ghoul. In my mind she was chasing me. In her mind she was trying to comfort me.

From that day on the spare room in which she had slept became malevolent. I couldn't go in there anymore but I would peep round the door and see the dried darkness of the blood-stain on the carpet.

I can safely say that I had the worst luck since this cosmic dust ball of a planet opened for business. I was born into a family of socialists. Socialism means – to me – a wider distribution of smoked salmon, caviar and champagne. But it didn't to them.

It meant organising, controlling and marshalling people – and particularly their own kin.

The good news was that the spacious philanthropy and socialism which Father exhaled upon the world stopped quite sharply at the door of his own home. High Hall was riddled with standards of living. Every luxury was lavished on me – atheism, alcoholism and insanity. There were compensations. Money, chiefly, and lots of it. It cascaded from the sky like confetti. It dawned on me fairly early on that I was a *parvenu*. Oh well. Nouveau Riche is better than No Riche. But at the time it set us apart. The Jaguars, High Hall, the London flat. When we went up there, Harrods doubled up as our corner shop. We would run and scream, grabbing toys and walloping each other. We never bothered to ask the price of what we wanted – it would have been unseemly for children of our position.

As with the Christian religion, the worst advertisement for socialism is its adherents. Grandfather had founded the family business, Northern Diaries, which became the main supplier of food products to Marks & Spencer. He believed that just because a business was large, efficient and profitable did not mean that it had to take advantage of the public. But the problem that he faced was that the urge to save humanity is almost always a false front for the urge to rule. There are two types of tyrants. Those who think they are God and those who are certain of it. Grandfather was certain of it.

Those who claim to care about the human race are utterly indifferent to the sufferings of individuals. Grandfather was essentially a man of peace – except in his domestic affairs. And here this particular dove of peace shat on everybody. No one loves the man whom he fears. Father hated him right up to the end. He didn't even bother to attend his funeral.

My family may have been opposed to capitalism but not to capital. However strict their social conscience, they lived in houses as big as they could pay for. And their ethics did not prevent them from selling these houses for twice their value if

a buyer was a naïve negotiator. *Caveat emptor* was their family motto.

Talbot Lodge, Hessle was where my grandparents on Father's side lived and as children we spent a lot of time here among the weeping willows that lined the swimming pool – especially when Mother and Father's marriage began to disintegrate. The house and its decoration were horrible – you wouldn't have imagined it possible to spend £100,000 in Woolworth's.

Grandmother played golf which is the nearest thing to being dead on this planet. She was an complete enigma. If you scratched her surface you would only find more surface. Only once did her Formica veneer crack: when Father deposed Grandfather. He had been getting old and was losing his judgement, starting to fund bad business projects and donate to dodgy causes. Father, as deputy chairman of the company, led a boardroom coup and got him fired. Grandmother threw a drink over him. Other than that she was a silent mystery to everyone and died at eighty-two of embroidery.

Her one great quality was loyalty. She was Eva Braun to Grandfather's Adolf. You could imagine him shovelling the Jews into the big ovens while she stood by her little one saying 'Darling, would you like one potato or two?' She didn't have a bad word to say about anybody – even Adolf Hitler: he was the best in his field.

At Talbot Lodge Grandfather held court. The rich, the famous and the desperate all turned up. The house set the scene for the first business meeting between Gordon White and James Hanson. It was where the legendary foreign correspondent James Cameron used to talk about the horrors of nuclear warfare after he had watched the 1946 explosion at Bikini Atoll, his opinions reinforced in Hiroshima where he saw the after-effects that radioactivity had on survivors of the 'Little Boy' atomic bomb. Left wing show-business figures like Susannah York, Sybil Thorndyke and Paul Robeson rubbed shoulders with political figures like Michael Foot and Bruce Kent – the head of the

Campaign for Nuclear Disarmament. Philip Larkin came to High Hall and Fay Godwin was a regular visitor. One evening she took photographs of me posing with a guitar like Marc Bolan. Almost everyone wants to be famous, or if not famous to have some tenuous connection to celebrity. The Horsley family were no exception. They could not endure the economic equality they espoused nor could they leave the underdog alone.

People should only take offence at people who are genuinely offensive – like terrorists or pregnant women. Talbot Lodge had even dodgier visitors. A paedophile friend of Grandfather's, his face riddled with cancer, once took quite a shine to Brother. Brother, as a child, had one of those faces of marvellous beauty which stopped strangers in the streets, so a paedophile invited into the family circle could hardly have been expected to be indifferent. I detested his ingratiating manner, his obsequious compliments – but solely because they weren't directed at me.

Grandfather would bring all kinds of deadbeats back to the house where he would try to rehabilitate them. Of course, they were his equals in every sense except that of being equal to him. He loved the poor, the downtrodden and the queer. But his favourite were the blacks, whom he loved unashamedly – he certainly wouldn't have had his servants any other colour.

There is a certain spiritual calm that comes from having money in the bank. Grandfather visited Myra Hindley and the notorious Glaswegian gangster and murderer Jimmy Boyle in the Barlinnie Special Unit. When the Great Train Robbers were in Hull he went to see them regularly – which in its day was shocking. How morality has changed. Who today, except possibly the Postmaster General, would refuse to shake hands with one of the Great Train Robbers? Grandfather, on the other hand, looking at the guard bleeding to death on the hijacked train would say, 'We must find the man who did this. He needs help!' He was like the Liberals who have invented whole college majors – psychology, sociology, women's studies – to prove that nothing is anybody's fault.

Mother and Father couldn't help adopting some of these dreary causes. They used to go out on peace demonstrations. I can't remember now whose side they were on. One of their great stories was that Ash had been conceived on the Aldermaston peace march. While all the other demonstrators slept out in the open, Mother and Father went to the Hotel Majestic-Fantastic.

It was to my great delight that I found I had been conceived in New York: artificial, machine made, and against nature. I was a natural born American! I had been promised the end of the world as a boy and I was very disappointed that I wasn't getting it.

2

The dandy is divine

True longing must always be directed to something unattainable. Marc Bolan was achingly so. I knew him as others know God. He was all-pervading but remote: I created him, but his fate was not my fate and he remained intractable, unlikely to respond to my prayers. I yearned for him to save me from the maelstrom of High Hall, from a place where, until I discovered Marc, uproar was the only music. Like all true stars, the more the surrounding night darkened the more brightly his image glowed in the firmament of my dreams.

When I turned my eyes towards him, my pulse quickened; the shadows on the walls of High Hall grew sharper; the background music swelled. By these signs I was made aware that I was in love. Here was a man whose diamond hands were stacked with roses – the precious roses of personality.

It was time to become Marc Bolan. I spent my days studying his face, his make-up, his clothes, his voice. I made magical charms, I cast spells, I uttered petitions of prayer that would bring him closer to me. My bedroom was littered with offerings: guitars created out of cardboard boxes with wool for strings, microphones made out of bamboo sticks with tennis balls for heads, and amplifiers from old tea chests covered with tin foil.

I stole into Mother's dressing room and, draping myself in her black feather boa, slid on her pink silk gloves. I sat at her

dressing table and painted myself with her brightest red lipstick. I can still remember the sticky aroma and the strange waxy texture on my lips. But I was dazzled by the gash across my face. Copying Mother, I rubbed my lips together, pursing and pouting in the mirror. The transformation was intoxicating.

I would stage concerts where I mimed along to Marc's gorgeously nonsensical and deliciously fey lyrics. My favourite was the nothing risque, nothing gained 'Raw Ramp':

> Ohh woman, I love your chests.
> Ohh baby I'm crazy about your
> breasts.'

I had never been happier. I could keep these performances up for whole afternoons.

One day Father walked in on me while I was in full flight and I crumpled in on myself wincing with embarrassment. I fell on the floor so hard that the record jumped and scratched. I can still see him staring at me in disbelief.

I couldn't stop myself. Through Father I had learnt that men were of the air. They had the adventurous spirit of ruthlessness and distance. Through Mother I had learnt that it was women who were the repository of the passions. My emotions were always in motion – I was starting to feel more and more of an honorary woman as a result. I also noted the difference between Mother and Father's style. Diamonds seemed to be a girl's best friend, but a man's best friend was a dog. No wonder I had decided to switch allegiances.

In order to complete my metamorphosis I searched myself for vestiges of masculinity as though for lice. I did not worry about my character but about my hair and clothes. I burnt my Action Men – or at least those few that had heroically got through all the earlier adventures with the chemistry set – and started to accumulate the props and accoutrements of the fairer sex.

First, I bought women's magazines. *Jackie* became my bible.

Dolls and their garments followed. It took months but finally I had grown my hair as long as I could and tried with a yearning heart – and a few cunning simpers – to pass myself off as a girl. Ash was imperiously instructed that, as of now, her brother was officially 'dead'. She must, henceforth, refer to me (if at all) as her sister. Proof that my mission had finally been triumphantly accomplished came when a shopkeeper, having served Ash, turned towards me. 'And what does the little girl want?'

To most children there is a difference in degree between their imaginary and their real lives – the one being more fluid, freer and more beautiful than the other. To me fantasy and reality were not merely different; they were opposed. In the one I was Marc or some other exotic, disdainful woman; and in the other I was just a boy.

What I adored about Marc was that he allowed me to start being the person whom I was beginning to suspect that I was. He was the first icon to turn androgyny into a saleable commodity. Even during his days as an elfin folk singer, he was haunted by an angelic, hermaphroditic mood. A special aura radiates from people who have succeeded in synthesising their professional and personal lives. Marc was someone who could not have been invented – not even if the whole world had sat up all night. My real education was about to begin. At 8.30 in the evening, on 22 December 1972 at the Edmonton Sundown in London, I finally saw him.

I had arrived with my little friend Steve who I had met in Sicily. He loved Marc. I loved Marc. This is the stuff of friendship when you're young.

Steve had fractured his leg in a skiing accident. We had been driven to the concert hall in a black limousine as long and swift-flowing as the Thames. Its windows were blackened and everything inside was expensively upholstered, including the chauffeur. As the car purred through the crowds that were milling at the entrance, girls started hurling themselves upon it like suffragettes. 'MARC! MARC! MARC!'

It was a catastrophic case of mistaken non-entity. When two spotty brats – one of whom was in plaster – hobbled out of the limousine the screams died on their foaming lips. I, who have always had such a strong sense of the disappointingness of existence, hung my head in shame. I was sorry that I was nobody. Steve tried to stand tall on his dignity. He failed. It is difficult to look significant on crutches.

Inside the concert hall the lights dimmed and Marc walked on to the stage. He was wraith thin and tiny, with huge lamp-lit eyes and black corkscrew hair that seemed not so much to grow as to cascade round his ethereally pale face. His gold lamé jumpsuit and pink lamé tailcoat were set off by the tiny women's shoes in which he skipped out from the wings. He prowled round the stage: arrogant, magnificent; he strutted and preened every movement radioactive and glowing with his utter self belief. 'I stared at the make-up on his face, his long black hair, his animal grace.' David Bowie had got it completely right. I fell at his feet.

Music is sublime. No other art form can match it. No other art form can offer so reliable an antidote to everyday life – as long as you are prepared to surrender yourself completely to its passions. This music was my own. I was only ten. But already I recognised it as every young man will recognise the thing that he is destined to love the most.

Returning home I decided that I too was going to become a famous pop star and rule the world. Mother bought me a cheap electric guitar and Ash a piano. A teacher came twice a week to bridge the awful chasm between her and Beethoven and me and Marc.

I liked to try and play but not so anyone would like to hear. I only knew two tunes. One of them was 'Get it on' and the other wasn't. I had read in *Jackie* that Marc Bolan was a three-chord fraud but I didn't care – to me he was the most beautiful fraud in the world. He would provide me with wit just as Tintin had provided me with wisdom.

Marc was super-plastic profound. A curious hybrid of dandy

and poseur, street urchin and visionary. The mass of contradictions could be held together only by the unifying power of art. The only real philosophy he had was that a human being was an art form in itself. He was entirely his own creation: a creature lovingly constructed from the materials of his imagination. He was important for being trivial yet deep, poppy yet interesting – all the things I came to love in one person.

Marc Bolan explained me to myself. Like the pop stars I too would try to empty myself of the dreariness of mere character and make myself available, without reservation, not to individuals but to the world at large. I was to find out that this way of life was a martyrdom of sorts.

There are few people who are unashamed of their love affairs when the infatuation is over. I was never ashamed of Marc. As I grew up I was able see him more as a person and I realised it was better that he lived only in my heart, where nothing could stain our love. He had served his purpose. I had kept for myself a little back shop which was all my own, quite unadulterated, in which I tried to establish my true freedom and the place of my schemes and dreams. Here I made my little offerings to him in the shape of album sleeves and drawings, pillow cases and posters. Marc had been my first muse.

While I was making pictures Mother was still making scenes. She was not alone. Scenes were to my family what glass beads were to African traders. There is a photo I have of them all taken around this time. Mother is on the floor face down in a pool of her own vomit. On the sofa sits Gogo, her wig awry, her lipstick skid-marked across her face. Next to her sits Father, his drink in one hand and his cock in the other. Home sweet home was obviously written by a bachelor.

For me, this picture marks the moment when sanity finally walked out on us. Mother's love affair with Father was shattering and, of course, in the most dramatic and spectacular fashion. If two people love each other there can be no happy end to it. The reality was probably that the relationship had

simply exhausted all its possibilities and one of them should have whipped out a scarf (preferably silk) and flapped goodbye. But human beings are rarely able to arrive at such a philosophical point without destroying everything around them first. Mother and Father were losers: two stowaways on the kamikaze plane of life. In the beginning their love had been like a fairy tale suspended in the perpetual fantasy of youth. Now had come a darker day.

Father was not going to help the situation. He had pickled his monstrous ego in depravity. He had never operated an open-house policy. But now it was open-bed. Lovers called in from the cold – in their dozens. Sex sat enthroned; her drawbridge pulled up to keep intellect at bay. Father was more interested in penetrating orifices than penetrating insights. Often we came home to find him in the company of a woman – there were many, none of whom bore any resemblance to Mother. Often we sat in some stranger's sitting room, playing with some stranger's kids, while father disappeared upstairs with the stranger in question for an hour or two.

One evening he fucked Mother's best friend, Janet, while they were swimming in the Mediterranean. I watched them sucking and fumbling at each other like a brace of mating sea slugs. Another time he tried to seduce Mother's sister-in-law (conveniently for him, she was ill, and so bed-bound upstairs). But there were too many to recall them all. Drinking when he wasn't thirsty and screwing regardless of season – that was all there was to distinguish Father from other mammals.

Occasionally, one member of the family would try to rein one of the others in. Mother's behaviour was always the most admirable. She would lock Sister in a room all day; she would almost set the house on fire; she burnt all Father's possessions in a jealous rage and then skipped round the bonfire wild as a banshee; she was arrested for shoplifting from Father's own shops; she ran over a policeman, and she wrote off three of Father's Jaguars by driving drunk to the off-licence. Finally,

in exasperation, he confiscated the car keys, hoping to kill two birds with one stone, only to find her driving to the liquor store on a motorised lawn-mower.

Style is when they're running you out of town and you make it look as if you're leading the parade. Mother wasn't leading any more. One New Year's Eve she drove Father's Jaguar off the road and into a ditch where she spent the evening upside down. At five o'clock in the morning she was discovered, semi-conscious and covered in so much blood the police officer could barely find her face. She was sent back to hospital — yet again. When she came home I went to see her and was haunted by the deep gash in her forehead and the awful pallor of her skin. She looked like a graveyard mist. Loneliness moaned around the room. I felt the treacherous entanglement of pity and love.

If you don't know where you're going, any road will take you there. There was nothing that could be done. There are people who have an appetite for grief; pleasure is not strong enough, and they crave pain. The best way to keep Mother at home at this point was to keep the gin in good supply, the coal on the fires and let the air out of the tyres. When she finally recovered her only solution for avoiding accidents was to stay in bed all day. Even then, there was always the chance that she would fall out.

Being around Mother and Father was like watching a natural disaster. As the plot sickened it turned into an irresistible blend of violence and black humour. One evening, Mother smashed a bottle over Father's head. The most effective cure for her depression would have been to hit her — instead Father put his arm through the bedroom window. Another afternoon, Mother threw a typewriter through one of the upstairs windows. I was in the garden when it landed and burst apart like a bomb. Then it was Father's turn to drive his Jaguar into the ditch. Ash and I visited the crash site and looked mournfully at the bright new wood of the barrier that had been rebuilt. Once we were in the car when he drove it insensibly into a wall. We sat in the back

screaming as he chugged and stuttered home up the hill to High Hall. Later, we found him unconscious behind a chair in his bedroom – naked except for a blue towelling dressing gown which had fallen open like the petals of a dead flower.

Was their violence an aperitif to sex? Ash and I sat on the landing dangling our legs through the banisters listening to the screams and the tinkling of breaking glass. We could hear Mother's pitiful wail echoing round the cavernous hall and it carried with it all that was most awful about our lives. Like a bereaved widow at a wake, it was the sound of someone crying alone in an empty church.

'Well, if the worst comes to the worst they will get divorced,' I said to Ash. We didn't realise just how much of their connection with reality had been with the necrotic aspect of its other side, its darkness. 'Cheer up Bash, things could be worse,' said Ash, holding my hand. So I cheered up, and sure enough, things got worse.

In walked Stepfather.

He lived in the village of Etton with his wife and five children. He had returned from India where he was a teacher of small children – to modern minds a dead giveaway if ever there was one. In India he had been so occupied in trying to educate others that he had never had any time to educate himself. To make up for this he tried to give himself a character by adopting familiar disguises – a beard and, later, robes.

He had returned from India because he had a dickey heart and needed a pacemaker. It was this fake heart that he threw at Mother. His wife had met Mother in the village and encouraged her to visit him while he was recuperating. And that was that. He crashed into our lives and installed himself, like a cuckoo in our nest.

What I disliked most about him was his piercing earnestness. The one serious conviction a man should have is that nothing should be taken too seriously – least of all spirituality, the biggest pose of them all. He had the romantic notion that middle-class

Europeans like to go for: that the Indian with the painted spot on his forehead and the guru-like beard has more insight than a stockbroker. The other is always more holy than the known.

He would sit on the edge of my bed and say things like, 'The way to discover one's original being is through self knowledge, Sebastian. You have to peel your being the way one peels an onion. Go on peeling . . . You will find layers within layers and finally, when all the layers are discarded, you will find in your hands pure nothingness, emptiness . . . emptiness is your essential core. And what is emptiness? Emptiness is love, Sebastian. Pure love.'

He discoursed like an angel (though a slightly long-winded one) but he lived like an animal. For a start, his volcanic temper didn't quite fit with the holy old Ghandi-man of the mountains.

Once, I was happily cycling around Etton on my Chopper on the eye-out for something to destroy when suddenly a car came screeching around the corner. Out of it burst Stepfather. His face was so red that the blood had flooded every visible vessel in his skin. Even his eyes had turned pink. He had a spanner in his hand. He marched towards me and just when I thought he was going to hit me with it he bent down, took off the front wheel of my bicycle, put it under his arm and stormed back into the car. As he tore off into the night he screamed out through the open window, 'That'll fucking teach you for being late for supper!'

It was always uncanny being with Stepfather – like being shut up with an apparently lucid person whom, you gradually realise, is in fact seriously deranged. His real nature was hidden. He thought he was just fine, but that's the truest sign of insanity. Insane people are always sure they're just fine. It's only the sane people who are willing to admit they're crazy. I was (naturally, on a one-wheeled bicycle) a little later even than usual for supper.

Once he went to see Grandfather and asked him 'Do you ever feel like God?'

'No,' lied Grandfather.

'I do,' replied Stepfather.

34

His unpredictability unnerved me but I still hoped he was a wise man and would refer to him as 'The Wizard'. Even though I knew his magic potions – especially his one for insomnia – were fake. As the family was coming apart I had problems sleeping and would ask Stepfather to sit on the end of my bed and hold my hand until I fell asleep. I was afraid then to surrender to even temporary oblivion. I would slowly counterfeit sleep, relaxing my eyes and deepening my breathing until I would hear him creeping off into the night. To this day, I am reluctant to forgo a single ounce of attention.

Although I resented Stepfather's presence it was through him that I was to learn, inadvertently, one of the great lessons of life. Father drunk was a better man than Stepfather sober. It is better to be hated for what you are than loved for what you are not.

Father and Stepfather were both womanisers but Father was honest about his condition. Most of the time he could not establish a connection in his mind between the absurd trivialities which filled his day – like running a multinational two billion pound business – and the serious business of drinking and screwing. His infidelities were numerous but we always knew about them and even saw them. Stepfather, on the other hand, believed that hypocrisy was the lubricant of society, the Vaseline of social intercourse, and he was going to take it to the bedroom for some intercourse of his own. It was this that made him tawdry. To dress up sexuality as spirituality, to talk about Kundalini when all you want to do is cunnilingus, is not, as far as I am concerned, a stylish pursuit.

In the early days, although everyone knew, Mother and Stepfather's affair had been semi-clandestine. Father would come back to the house through the front door and Stepfather would bolt out of the back door. He would scuttle off to his little bungalow and his little woman in the village. You certainly wouldn't covet his house or his wife. But Father did. He went down there and screwed her.

Not for revenge – he didn't believe in revenge. He believed in

nothing: only his laziness kept him from being an nihilist. 'Easter is cancelled this year,' he deadpanned every year. 'They've found the body.' Other holidays received the same treatment: 'Xmas? Sounds like a bloody skin disease.' In a way it was a pity Father wasn't religious as the most remarkable achievement of the Christian faith was that it could take drunks, cripples, slaves, imbeciles, adulterers, the simple and the mighty, and reward them with eternal life. He certainly had the qualifications to get the gig.

He didn't care about anything. Stepfather was quick to work this out. Now, when Father returned home he would find him cooking in the kitchen. He was always in the house. It was like a bad French film: Louis sleeps with Claudette because Bernadette slept with Cristophe – and in the end they all go off to a restaurant. This was the man Mother had fallen in love with and was to throw the world away for. She was to lose her family, her wealth, High Hall and what remained of her mental health. Of the three it was her who first cracked.

Actually, her descent into the holy state of lunacy was innate. It hadn't much to do with her situation. It was hereditary. Nine months in Gogo's womb and anyone would have been born a bit loopy. She had just happened to remain so. All her life, though she had been strolling past Bedlam, she hadn't actually lived there yet. Now she did. What was High Hall but a comfortably padded lunatic asylum?

Mother felt the loyalty we all feel to unhappiness; the sense that this is where we really belong. As far as she was concerned, when Mr Freud had described suicide as a great passion – like being in love – he had been right. Suicide (thinly disguised as martyrdom) was the rock on which she had tried to build her whole life. When her life had fallen down, when every standard she had tried to exist by no longer made any sense, this rock was all that had remained: the high floodmark of a life that was one long history of failures. In this last and final failure she clung to a final chance for self assertion, for the

freedom (however minimal) to die in her own way and at her own time.

She took another overdose. This time she was alone. But Stepfather – ever useless – came home unexpectedly and found her unconscious on the bed. She was rushed to hospital. Here she had her stomach pumped and Stepfather was told by a nurse who was empathetic to everything except pain, 'Well, she will probably live but she could be brain damaged'.

Mother came round unscathed – or at least the brain damage was indiscernable. 'When you are in between the devil and the deep blue sea the deep blue sea can seem very inviting,' she chirped to Father.

To this day she still talks about committing suicide. She assumes it is normal to pass an hour each day in contemplation of the relative merit of carbon-monoxide poisoning over the high jump. 'All that matters is a sense of style in dying – one *must* go out glamorously,' she says proudly. But after four unsuccessful attempts, I can proudly assure you that Mother is a failed suicide. On the evolutionary scale you can hardly get lower than this.

Where Mother had once been fire she was now ashes. She had no feeling of being anywhere, or of being anyone. She shuffled around lonely as a cloud – but without the poet to keep her company. The situation was not without humour. Good old-fashioned Mother. Always in the kitchen – with her head in the oven. If she was not more careful, one of these days she was going to hurt herself. She didn't seem to care. Death was the only thing which interested her. As a rule she lived on booze and pills and never got out of bed except for funerals.

I developed a suicide game all of my own. Watch with Mother. There were three attic windows on one side of the house. Six feet under them were balconies. Each time a new friend came to the house I took them through the same ritual. Leaving them at the door I opened the window. In suitably elegiac pose I then jumped out, screaming. I will always remember their faces as they peered down longingly at me lying there, regally spread-eagled on the

balcony. Mother was right. There is a great deal to be said for being dead.

My parents' world had a fashionably permissive exterior and an emotionally destructive heart. Father could not or would not go through the pain barrier of living with himself without the anaesthetic of alcohol. Every night at 6 p.m. sharp we heard the Jaguar crunching on the gravel and him hobbling in and pouring himself a drink. A double ice-cold gin and catatonic, the glass fogged with condensation, straight up and then straight down and the warm flood of painkiller hitting his stomach and then his brain and an hour of sweetly melancholic euphoria. Then wine with dinner finished off with brandy and lastly, Irish coffee with all the four essential food groups for Father: alcohol, caffeine, sugar and fat.

Or Sunday lunch: in the dining room at High Hall we sat at a table as long as life itself and chewed roast beef while Mother and Father got pleasantly smashed watching the sun crash. I come from a family where gravy is considered an alcoholic beverage.

I would come down in the mornings after one of their end-of-the-world parties and find Mother and Father broken by booze. They lay among their bottles like convicts among their chains, gamblers among their games. Half-burnt cigarettes floated in their half-drunk glasses. Later Gogo would collect the empty bottles and wheel them in a pram down the hill into Etton, distributing them on the doorsteps of different cottages. 'Well, we *can't* have the dustbin man knowing our business can we?' she said.

Every night High Hall was hit by a tidal wave of alcohol. The consequences were devastating. Father, because he was a drunk and a cripple, was always falling over. Mother, because she was a drunk, a manic depressive – and lazy – never got out of bed, and Stepfather with his faulty pacemaker which kept conking out, spent his life holding on to the floor. Indeed, everyone in my life who should have been vertical was horizontal.

The chaos had to burn itself out. Eventually, it was Father who made the decision. Navigating Mother's moods was like navigating Niagara Falls in a canoe. She at least had the rudder of self-medication but she made and remade her mind more often than her bed, which wouldn't have been hard given that she barely left it.

In the end Father left High Hall, attaching a note to Stepfather's bicycle. It read: 'I think you will be better off with Michael. Perhaps he loves you more than I do.'

When a man steals your wife, there is no better revenge than to let him keep her. There was no discussion with Mother and no discussion with the children. He simply hobbled out of our lives. I barely saw him again.

It was 1973 and I was eleven. It was time for the children to leave home. This was England. The dogs were kept at home and the children sent off to high-class kennels to be trained. Ash and I were sent to separate schools in separate parts of the country. From home to disowned.

In many ways my childhood was a ruin but a ruin among whose debris I could discover myself. It was theatrical, almost operatic. And this had brought a different set of problems. We had been feral children with no reward and no punishment and as everyone who has dealt with young children knows, infants cry as often from bewilderment at too wide a choice as they do from frustration. Choice is a form of imprisonment rather than a kind of freedom. In raising a child in High Hall, my parents had about as much chance of success as growing orchids in the Moroccan desert.

As a child my insides were full of nightmares, of impossible battles, terrifying anxieties of blood, pain, aloneness, darkness and destruction mixed with limitless desires, sensations of unspeakable beauty, majesty, awe and mystery. Sometimes my adolescence was spent in quiet but dark revolt. And yet, these were also the happiest days of my life.

What made them so great was Mother. When I think that life

is just the misery left between abortion and euthanasia it is always to her that I turn. If glamour is where all is present but not all is given then Mother had glamour. She taught me the only thing worth knowing: where there is conflict between illusion and reality, reality should be requested to give in gracefully.

Of course, Mother's charm went with a sympathy for ruin but what made her so marvellous was that she could take her desolation with gusto. Even more importantly – with style. Rimbaud called his mother 'the Mouth of Darkness' as I could mine. I remember her once telling Ash and me, 'Well, Madame Verlaine had the right idea! She preferred the company of *her* two children – both *stillborn*: sitting in her bedroom, curled up in pickling jars. Well, there we are children – whenever a child can be seen but not heard, it's a shame really that they're dead.'

Years later, she came to visit me in a drugs clinic. I was lying in bed withdrawing savagely from crack and heroin. I was looking and feeling fit only for the undertaker. Out of the corner of my eye I saw a blazing Technicolor explosion which I took to be a fruit cart. It was Mother. She waltzed in clad toe to crown in velvet and silk and perched on the end of the bed.

'Have I failed you as a mother, Sylvester?'

'It's *Sebastian*, Mother.'

3

Reaching the limits of genius attainable by people who can't do anything

My new school was a kind of expensive borstal. It had a reputation for being progressive but unacademic. In other words, it was perfect for rich losers.

I was sent there after failing the entrance examination to Bedales which was the school I had wanted to go to. I had trailed around awful schools with names like Frensham Heights and Dartington Hall with a heavy heart resigned to being excommunicated, but Bedales had lifted my spirits somewhat. Everyone seemed beautiful and golden and treasured.

On the weekend that I went there to sit my examinations the skies were clear as crystal and the valleys rang with laughter. I ran and swam with the other children and I yearned to become part of their family, to become their slave. As a child I was appallingly free and craved structure. Bedales represented to me the love of discipline and the discipline of love. But perhaps my yearning is due to rejection. Appeal is always inversely proportional to attainability.

My new home was a mixed boarding school and a potpourri of races, creeds and colours. It was as if the skies had opened and the whole world had emptied down into the grounds of the school. What glued the warp and weave of this hive swarming with Wops, Nips, Coons, Dagos, Spics, Chinks, Pakis and Honkies was the honey of money. The place dripped with it. The school wasn't renowned for producing winners or people stiff with achievement.

But it didn't need to. The advantage of a classical education is that it teaches you to despise the wealth which it prevents you from achieving. But the advantage of a dummy's education is that it enables you to love the wealth that you have not had to go to the trouble of earning. Most of my fellow pupils came from the champagne and cocaine belts of the world. They were rich beyond the dreams of avarice. With some exceptions.

It was school policy to take in children that nobody else wanted. Borstal Boys and Trailer-Trash Girls were given subsidised places. This made for a rather unnerving mix. There were all kinds of stories circulating about someone we named 'The Gunslinger' on account of his waddle walk who was rumoured to have blown up a local police station. Another convict had apparently been expelled for putting cyanide into the school milk. Both of these legends were lionised in our hearts as the hotshots of our wild west.

On my first day I arrived wearing my little brown corduroy shorts, with a few toys and a tuck box covered with pictures of Marc. I had driven up with Mother, Stepfather and his two daughters who were at the school. The Range Rover curled around the gloomy country lanes of Rochester. I was nervous, but still basking in the confidence bestowed on me by my surrounding family.

But by the evening I was alone. After supper, nervous and unsure, I tiptoed back to my dorm where the little bed I had been allocated waited, its striped mauve cover turned back, its pillows puffed. On the crisp white sheets lay a murdered teddy. My six-foot snake had been throttled and dangled, limp from the ceiling, and my little dog had been decapitated. Its body lay under the bed, spilling stuffing and sawdust. The little grey head with the ears that I had cuddled and sucked and stroked for so many years had been flung down beside it. The brutality left me stunned. It was a warning. Children at play are not playing at all.

I became preoccupied with survival: learning the rules, lying

low under fire and laying the blame on others. But inwardly I was inconsolable. I no longer cared about the problems at High Hall. I was homesick for my sick home.

During one of my routine fits of weeping I spoke to Mother and begged her to take me away. 'You'll get used to it, darling,' she said. 'Now, if you don't stop crying I shall reverse the charges.' *Dalton Holme 251.* I can still see the little phone box, its panelling covered in numbers, the desperate codes of lonely children scribbled and re-scribbled into the wood.

Eventually, however, I became resigned to my fate and took a timorous look around. The whole school was in an even greater ferment of emotion than High Hall had ever been. Because it was a mixed boarding school the affairs and crushes and sexual encounters of the pupils – in all their gruesome exotic detail – were one of our abiding preoccupations. It was *the* currency and when I realised this, I longed to be the subject of a school-shaking romance.

Up until this time, however, as far as rewarding physical experiences had gone, the principal beneficiary of my sexual attentions had been myself. I had discovered masturbation when I was eleven and to this day it is the only fact of life I have ever fully understood.

After I first came, I was amazed that I hadn't died, gone mad or contracted some incurable disease. The only thing that worried me about the experience was that I hadn't produced any spunk. This convinced me that I was even more of a misfit freak than even I had suspected.

And then I saw her. A man always remembers his first love with special tenderness, but after that he begins to bunch them together. What all men want to discover is a virgin who is a whore and, though I didn't yet know it, I by felicitous accident had just stumbled across this rare creature.

There were two acclaimed beauties of the school – and Ragi was one of them. As she walked across the Rose Yard I knew I had to have her. She was Indian. An essential ingredient of beauty

43

is romantic melancholy and she had it: large eyes with hair blacker than the raven wings of midnight. I directed my peerless sashay towards her.

'You walk like Marc Bolan,' she said. Full marks. She looked at me and when she raised her eyelids she seemed to raise her shirt with them and expose everything. I fell in love with extraordinary ease. I was going to flow into her like a river and drown.

All the girls slept in the main school. But the boys were distributed among satellite houses that were scattered within a two-mile radius of this honey pot. What Romeo could resist?

One night, filling my bed with cunningly blanketed pillows, I climbed out of the window, shimmied down the fire escape, crossed the thickly mudded fields and crept, in pitch darkness, along the corridors and up the stairs that led to the girls dormitory. I let myself in – into my girl's room, into her bed, and finally into her. I know now that Romeo might as well have married the girl next door. Ragi and I could have met over a fag behind some dreary bike shed almost any afternoon. But what I did, I did not for love alone, but in order to defy the authorities with all the world on my side. I was not caught. But I was quick to mine this little seam of romance and by suppertime the next day the whole school knew every detail of this escapade. It had become a great quarry.

I had got my retaliation in first. All the boys at the school – including the teddy decapitators – had wanted Ragi. It was perfect. What is revenge but love with its trousers down?

I worked hard at lessons or at least hard enough to glimmer faintly in a couple of subjects. They weren't even going to attempt to educate me beyond my intelligence. I was good at English where I settled into a vague, literary, omni-tolerant indolence. But in other areas they pretty much gave up on me and let me do whatever I wanted. Their effort to enlighten me in physics and mathematics, for example, produced no effect whatsoever. I never knew what they were talking about; nor whether what they were talking about was true.

I suspected it wasn't. I was already a young-fashioned solipsist. Ptolemy, we were told, thought the sun went round the earth. Copernicus thought the earth went round the sun. Horsley thought the sun, the earth – the whole solar system – went round himself. I had no interest in the physics of the subject. I was just interested in the fact itself.

'Why do we need to know that water boils at 100°C when we can just turn on a kettle?' I once asked the physics teacher. He never answered. Maybe there are too many possibilities in physics. But the problem with mathematics was that there was only one correct answer. How could I convince my teachers that my *answers* were meant ironically? I'd try desperately to pass tests by memory alone. I used to stumble into the examination room, pale lips mumbling equations and formulas, and come out again thoroughly confused, knowing nothing.

I implored the masters to let me give up these dreary subjects and join the girls in Home Economics, and to my delight – and their despair – they agreed. We discussed how to stuff a mushroom, how to tie a pinnie, how to apply blusher, how to make sure the white sauce didn't turn lumpy. I have to say I was never particularly talented at cooking. The first dish I attempted was so disgusting it was impossible to tell where the plate ended and the boeuf bourguignon began. But at least I was content – the Mary Quantum Theory was, to me, understandable physics.

I was around women. This, it seemed to me, was what real education was about. All the rest of it confused me. Once, in a geography lesson, I learnt all the names of all the currents of the entire Pacific Ocean. Where, I thought to myself, am I going to use this information? I daydreamed – which for an incorrigible fantasist is to the mind what exercise is to the body. I longed to be taught how to sing and dance because these seemed like activities I could take into the outside world with me and wear like a crown. People who have learned to sing will always have richer, rounder voices. People who have learnt to dance will always have bigger, bolder movements. My little victory in joining

the women to cook was my first real step towards the definition of myself in my own and others eyes. Art is I; science is we. I was becoming the Romantic – the one who discovers himself as centre.

Part of this involved secrecy. One tenth of my personality broke the surface and nine tenths lay, like an iceberg waiting quietly and ominously below. Any one of my scams would have got me expelled. But as a person trying to become whole they were more than childish pranks. I needed them. Denied expression, the spirit would wither and die.

I cheated in my exams. I stole from the teachers – once breaking in to my housemaster's wine cellar before deciding to make my own alcohol. The first problem was finding a venue in which I wouldn't be discovered. After a brief reconnaissance, I concluded that the geography block roof was the ideal site for a shebeen. I had never been any good at geography. My only sense of direction was downwards.

It was a disaster. After lugging great bins up into the loft and spending weeks trying to perfect the concoction, the potion that eventually emerged was a foul smelling brew that re-emerged virtually unchanged an hour later. If we had poured the stuff down the toilet we would have cut out the middle man. But this would have missed the point. I could now sit in geography class and turn my eyes heavenwards.

From an early age I was already sluicing down the liquor with the abandon of one truly spooked by my own existence. I was thirteen when I first got drunk. It was a summer Sunday and I went down to the games fields with my friends Bird and Will and three large bottles of Pommagne. The light and the grass and the water seemed to stretch for all eternity and I remember that sudden click in my head as, after the second glass, my mind shifted into a new gear, soaring off into a space that was filled with happiness and gratitude and warmth. All appeared new and strange in this land, inexpressibly rare and confoundingly beautiful. The fields, bursting with the harvest, seemed immortal,

everlasting; and the haze of the sun was as precious as gold as we ran and leapt, our hearts mad with ecstasy.

I had found the door to artificial paradise.

I never took anything stronger than dope before I was thirteen. I managed to steal some marijuana from one of the other corrupt boys at the school and locked myself in the lavatory shaking with fear and excitement. I puffed away. Waiting for the effects I thought the whole school would now know that I was an addict – surely it would show on my face like a brand. Instead, it seemed to have no outward effect at all. I sat in class staring at the wall. Since most people couldn't tell the difference between natural and chemically induced stupidity I passed myself off as a dull but happy fellow. I didn't care. From now on any drug, even the weakest, was better than real life.

At the end of the first term I returned to Yorkshire filled with misgiving. Mother had swapped High Hall for a little house in Beverley, a market town near Hull. She had lost thousands and thousands of pounds on the deal to some kind friends who, after Father had walked out, had generously offered to exchange their pokey little town residence for her oh-so-awkward mansion. No one can treat you badly without your consent. But Mother had been completely incapable. She had simply handed her heritage over to these smiling thieves.

But things were not as bad as they seemed. They were worse. High Hall was gone. Father was gone. And Mother was gone. Standing there was Stepfather.

He was dressed toe to crown in orange. His trousers were orange. His shirt was orange. His socks were orange. His shoes were orange. Over the top of this assemblage was a robe – orange. His hair was down to his shoulders and his long white beard straggly and unkempt. What was left of his face was no more than a clearing in the jungle. Stepfather had joined the Bhagwan Shree Rajneesh, the sect of the orange people.

In his hand he had a pendulum which he was swinging from side to side over a copy of the Guardian. The headline read '250

47

Dead in Air Crash'. Stooped over, like Professor Calculus from Tintin, he narrowed his eyes, cleared his throat and intoned, 'Doomed. The pendulum says they were all doomed.'

The orange people were led by the Bhagwan – the anti-materialistic leader who owned ninety-nine Rolls Royces. To Stepfather, the Golden Guru had all the answers to the problems of modern life, particularly those which afflict Westerners – such as acute gullibility.

Mother was nowhere to be seen. 'Where is she?' I asked Stepfather. 'She's been committed,' he replied. 'We are allowed to visit this afternoon.'

'You won't find your mother much changed,' he announced, as the car turned into the drive of the mental asylum. The building was austere, stripped of character. We entered a room whose floor was so polished that even the sane could hardly stay upright. We were careful to look out the window because we had been told that among the laurel bushes lurked men who were in the habit of exposing themselves to visitors. A nurse led us to Mother's bedside.

She was so drugged up she could barely lift her eyelids. She had been having a form of sleep therapy which involved inordinate amounts of Valium. If dreaming permits each and every one of us to be quietly and safely insane every night of our lives she was living in a kind of dreadful nightmare without any respite. The nurse tried to shake her awake and then went off to fetch some food.

Mother couldn't hold the fork. Stepfather tried to help her. 'Oh no,' said the nurse taking the fork out of his hand and putting it back in Mother's, 'she must learn to do it herself.' Mother rocked the bed table with her knees. As the smash of the plate echoed round the room Mother mumbled, 'This place is an absolute madhouse.'

It was a horrible scene. I was uncomfortable with her weakness – but then people always despise the victims of misfortune. And yet it wasn't just that. The feelings of passive suffering which

48

I had inherited through Mother had cursed me with the gift of deep compassion for others. I have always found this repulsive. The problem with compassion is that it is not photogenic.

Whatever, the wind of the wing of madness has passed over my family. Gogo was clinically insane. After this, Mother was in and out of the nuthouse. She would oscillate wildly depending on the treatment she was receiving. After electric-shock treatment she would feel 'rather sparky, actually' and have a zing to her step; after Mandrax she would be depressed and wander around the house like a tortoise on a lettuce hunt. I often wonder how it is that I, who have always had the mind and the nerves and the history – everything necessary, really, to go mad – have never actually done so. Instead, I spend my life poised between Savile Row and Death Row, trying to find a balance between vanity and insanity, wandering aimlessly like the dispossessed king that I am.

Mother was eventually thrown out of the loony bin for depressing the other patients. She came home to depress her family, instead. While she was messing up I spent my days at the top of the house dressing up. Steve was still my partner in crime and in the holidays he would come over and we would hole up together.

Our new passion was Hammer horror films. How we longed to be in them! I almost was. Setting up camp in Mother's new house, I had replaced the Marc Bolan posters that had wall-papered my quarters at High Hall with ghastly scenes of torture and mutilation carefully selected from the most monstrous, most gruesome, most camp slasher pictures. The womenfolk in my family were too scared to even enter. But I loved film. Film seemed to be so like life – but with all the ghastly tedious bits cut out.

One afternoon, at the age of thirteen, I managed to wangle my way into my first X-rated film by dressing up as a man with a hat and long trenchcoat. The film: *One Flew Over the Cuckoo's Nest*.

The American bands KISS and the New York Dolls took up the rest of our time. Good taste is better than bad taste, but bad taste is better than no taste. I had no choice – it was a terrible era. The audible wallpaper of Yes, ELP and Rick Wakeman dominated. With Marc, music knew its place. Now it had fallen in with a bad crowd and lost its sense of common decency. The function of music is to release us from the boredom of existence. I wanted art that reflected my life, and my life was theatre.

I remember going to see KISS on 15 May 1976 at the Hammersmith Odeon. It was the first time they had played in England. I wore black lipstick and Mother's platform boots. Then I bunked off school and went to welcome the band. The only way to atone for being a little overdressed is by being always absolutely undereducated.

It is so moving to see someone doing *exactly* what they should be doing. Paul Stanley, with his heart-shaped face and eyes like teardrop diamonds served the teenaged world up their dreams with a masterful grace. 'There was a time where an audience thought that they were lucky to be at a concert and they were lucky that you would play for them. We are lucky that you are here. And we have to work hard to make sure you stay,' he said from the stage.

With KISS and the Dolls I had found simultaneously the most real and artificial bands in the world. I was happy. I've always liked trash. And un-hip trash too. I know you're supposed to like all those blacks singing the blues or those blues singing the blacks but I'm afraid I don't. Bands like the Rolling Stones are the worst – the whites singing the blacks. Nice middle-class boys pretending to be negroes is just *so* silly. I like Marc Bolan and KISS and the Sex Pistols and Guns 'n' Roses. The whites singing the whites.

All the games I played with Steve were really one game. We dressed up in Mother's clothes, clapped on as much make-up as the forces of gravity would allow and staggered into the

streets of Beverley. Hours had been spent painting each other's eyeshadow, lipstick and rouge. Then we stood outside photographing each other and the faces of astonished bystanders.

Homosexual tendencies are in some degree common to all creative personalities. It later turned out that my little friend was in fact homosexual and could have influenced me. I wasn't a faggot but I was willing to learn.

Being an instinctive pessimist, however, I confidently expected all human affairs to go seriously wrong at some point. I wasn't disappointed. Stepfather decided that our relationship was 'unhealthy' and 'antisocial'. Remarks were made about our sexuality. Steve was banished for ever from the home. All this did was inflame our love: there is always a charm about the forbidden that makes it unspeakably desirable. I spent my days in a silent rage throwing darts dipped in red paint at photographs of Stepfather. As all teenagers know, impotent hatred is the most horrible of all emotions; one should hate nobody whom one cannot destroy.

Maybe it was wrong to discriminate based on this incident when there were so many other reasons to dislike him. One day, however, Stepfather did something that was utterly unforgivable: he saved my life.

Summer had set in with its usual severity and I was busy sitting around watching the hours pass when I was asked to cut the lawn. Like many people who have nothing to do, I was resentful of any claims on my time – especially when it came to the garden. Nothing would induce me to till or even scratch the soil – apart from a promise of money.

Even trying to start the lawnmower took more time and energy than if I'd cut the entire lawn with my teeth. But eventually I managed to drag the damn thing out of slumber. It waltzed off – with me in tow – up and down the lawn. Look at me, I thought. Gardening. No hope for the future.

After about ten minutes I had had enough of topiary and was just about ready to throw in the trowel when I cut through

the cable of the electric lawnmower. 'Shit!' I cut the engine and set about trying to repair the lead. Nicking the plastic covering of the severed wires, I put them in my mouth and stripped it back. Then, rejoining the two ends, I got some scissors to trim the untidy bits off.

I screamed. At first I thought someone had kicked me in the back. I lurched forward, my body jerking in spasms, my mind an explosion of glittering, fizzing and popping stars. I didn't see my life flash in front of me – perhaps because I hadn't actually done anything. But I was flung, convulsing on to the ground, unable to let go of the scissors which had hooked me up with the mains current. My screams were heard from the house – they were probably heard from heaven. Mother walked into the garden and just joined in – bawling and caterwauling – but Stepfather knew right away what to do. He ran to the mains and turned the power off. He had been due to go out but had cancelled at the last minute.

I lay there stunned. The stench of burning flesh filled my nostrils. The hot metal of the scissors had burnt me to the bone. I hadn't died for long, but it was enough for me. I had been to the other side. And if this was dying, I didn't think much of it. For the amount of publicity it's got it was a bit of an anticlimax.

At the hospital the doctor told me that only a strong heart had saved me. And if the wires had joined in my mouth? Then the final curtain would have closed. I still wonder if anyone would have clapped.

When I returned to school I was plunged into another drama. In the holidays my love affair with Ragi had blossomed. I had written her pornographic letters which her parents had intercepted and taken to the headmaster. My expulsion was demanded. I was thrilled – this would heighten my princely stature and confirm gallantry, but instead we were split up and now spent all our lessons apart. At least I was getting attention.

Everything about my first love was dramatic and painful. Ragi plunged me into the cold, toxic bath of jealousy from which I

have never really recovered. A faithful woman is someone who is responsible – she doesn't want two men to suffer at the same time. Ragi would have found two men suffering irresponsible when she could have had four. I can still remember their names – Boris. Flynn. Andrew. And I can still remember the gut-twisting agony of watching her walking hand in hand with Flynn down to the games field, or peering through the sixth-form study window as she bobbed up and down affectionately on Andrew's knee. Outside was unforgiving, wintry and dark – but inside his blond hair glowed warm in the orange light as they snuggled and giggled. Love may be blind, but jealousy sees too much.

'You're the one I really love Sebastian,' she said as I caressed her with all the warmth and hurt of my desires. We were lying at the back of the gym wrapped around each other and I imagined the other boys touching her dark skin and felt my body wincing and aching with pain. Except that they weren't boys to me – they were men. Boris was sixteen when Ragi had lost her virginity to him. We fumbled around in foreplay and for years I sniffed and scrabbled around for the leftovers thrown down from the big boys' table. But in the end we were all the same. Ragi played with us like flies in a bottle pulling our wings off one by one. '*He loves me, He loves me not. He loves me, he loves me not.*'

I was faithful to her. Ash had now moved from her school to mine and would scoop me up in her arms as I wailed at the latest betrayal. If all life ends in weeping, then all love begins in it. At least mine did. When you are older, being hurt gives you a pleasant mournful glow and I often luxuriate in feeling wounded. But as a boy I did not. Mr Auden tells us that the affairs of the heart are as crooked as a corkscrew. Maybe he would agree that my first romantic experience would have bent a straight? Jealousy is usually a symptom of neurotic insecurity. In my case perhaps my neurotic insecurity was inspired by this dreadful jealousy?

Two months was the longest stretch I did of not talking to

Ragi. Standing in the food queue laughing ostentatiously as I monitored her obsessively out of the corner of my eye. Running around the physics room with other girls jumping and playing as I saw her approaching in the distance. The days stretched out eternally. In suffering, time is made visible.

I had so much time on my hands and so little to fill it. By now I had been relieved of all sporting duty on the grounds that I wasn't 'suited'. This was a victory – I detested sport with the same passion that I loved music. As a young man preparing my lifestyle I avoided playing even the mildest games because they did not constitute part of that style. For one thing, I knew I would not win; and for another, I knew that competition of any kind encourages a man to make comparisons between himself and other people, which is a completely misguided activity. In sport, I had only the rugged will to lose.

In football I won one game in a row. My theory is that if you buy an ice-cream cone and make it hit your mouth, you can play football or tennis. If you stick it on your forehead, your chances are less. I was worse at cricket. I've never been able to catch and I couldn't hit a cow's backside with a banjo, let alone the ball. I was put on the boundary and encouraged to look upon the game for what it was – organised daydreaming.

But it was rugby that I reserved the bulk of my loathing for. The idea of the game was to run head first into the other players. The ball seemed incidental. If, however, you happened to get this ball everyone would hit you. For me, therefore, the object of the match was that, the moment the whistle left the referee's frostbitten lips, I should get as far away from it as possible. On those bitter afternoons, I would fling myself upon the field and run madly off in all directions.

It was not only in sport that I failed to excel. Academically I was more than brilliant – I was mediocre. The problems I was having at this time were exacerbated by the first signs of a nervous disorder that only later I would identify as obsessive-compulsive disorder.

I was always worried as a child and if worry is interest paid on trouble before it falls due then I developed rituals to repay the debt once and for all. It began with touching, counting, feeling underneath surfaces – always multiples of six and thirty-six times. (When I found out about lucky numbers, Mother was thirty-six.) Leaving rooms became problematic for me and reading and writing, never easy, were now hindered by endless compulsive rituals. All my work had to be underlined twice in red ink and I would remember a passage, line or word in a book and spend days trying to find it, not resting until I had. I would ask myself a question. 'Will Ragi leave me?' or 'Will I pass this exam?' and then open a book at random. Seeing an 'E' first meant YES, an 'O' – NO. Seeing 'ON' was NO reversed and so YES. And so on. And on. This ritual could be repeated anything from six to thirty-six times. It was exhausting. There was now a 'right' way to do everything and if it was done 'wrong' something would go awry.

I once heard a story of a train passenger who spent an entire journey from London to Bristol tearing his newspaper into small pieces which he would then throw out of the window. 'Why do you keep doing that?' asked a bemused fellow passenger. 'Because it keeps the tigers away,' came the reply. 'But there *are* no tigers.' 'Wonderfully effective, isn't it.' That's OCD.

And I had it. Walking down the street I would be touching railings compulsively. If I threw something away in the bin I would then have to empty the entire contents on to the floor to retrieve it. That problem was solved by disposing of anything vaguely risky in the lavatory, though another problem of course ensued as the pipes choked up with file paper, paint chippings, cigarette ends and even – eventually – my wedding ring.

Driving my moped I was constantly having to turn back to find the doorstep I had seen with the can on it, or the magazine page that had looked like it had been dropped in the wrong place, or the gate that had to be opened or shut, or the stones that it seemed to me were in dire need of rearrangement. When

a concrete floor was laid in the basement I had to absent myself. The thought of all that crucial stuff irretrievably buried was too much to bear.

Tidiness had always been my vice and it meant I would never really be chic. Only a fool would make the bed every morning. I couldn't help it. A complete meltdown would follow if the kettle was not facing due east. For me controlling interior space and keeping order in an inherently chaotic existence were intimately connected. As I got older, my craving for classification seen in the uniformity of my clothes, the obsessive need for perfection in my work, and the symmetry in my art was a means of staving off the chaos I saw at the centre of my being.

My way of dealing with it was infantile. OCD is petitions of prayer where you try to manipulate the result. And prayers are to men as dolls are to children. They are not without use and comfort, but they should not be taken too seriously.

Dismissed from sports I was put second in command of the chemistry lab and given keys to the building. The building was set in a deep recess with the main door on lower ground and the back of the lab facing higher ground. On summer days I used to lock the door and stand on a stool where I could peer and leer through the back windows masturbating furiously to girls' ankles. The measure of a perversion is its need to be repeated and its inability to be satisfied. I could keep this up for most of my waking hours – and often on into my dreams.

I also developed a further interest in cooking. I had invented some new recipes that I wanted to try out. Once I whipped a large plasticiney lump of potassium and waited until the school swimming pool was full of people before lobbing it in. The effects were spectacular. It cruised wildly round the surface spitting sparkles and fizzing while frightened swimmers thrashed about as frantically as if they had just seen a shark.

That was so effective that – inspired by Tintin – I decided to branch out. I nicked a bottle of chloroform. My victim was small and American, and that seemed to be enough. As we

chugged along happily on a school trip to the sewage works, I drenched a sock in the pungent liquid and clamped it over his mouth. I was hoping he would swoon like some comic-book baddy. But he didn't. He just coughed and carried on talking as Americans always do. I sniffed straight from the bottle to find out what was wrong. And, when my victim finally turned round it was me who had passed out. That didn't happen in Tintin.

At the end of 1976 my school was finally saved from my ennui by the greatest meteorite ever to be hurled at the earth. They were called the Sex Pistols and they were the most profound philosophers since Kierkegaard.

I was immediately spellbound. There had been Marc of course. But ultimately, glam rock was too quaint to be truly subversive. To my shame I barely noticed Marc's greatest career move the next year – his death. In many ways the Sex Pistols weren't saying anything new – punk was glam with the lining ripped and turned inside out. Johnny Rotten was Rimbaud reborn in Finsbury Park. He had all the unmistakable signs – the charismatic aura, the dandy's narcissism, the canny look of the holy tramp. Bin liners, safety pins, berets, he even had the Gorgon's glare – the metaphor for the hypnotic power of vision, genius or madness. 'I shall return, with limbs of steel, a dark skin and a furious eye,' spat Rimbaud. And Rotten was flawless as those blazingly beautiful *poètes maudits*, those decadents who, through a slow and rational disordering of the senses, aimed to lose sight of themselves and see the world with real eyes, to seek transcendence in degradation. The vagabondage, the flashes of temperament, the surreal lyrics, the hostility, *the look*.

It was astonishing that someone this young possessed so much intelligence and vision. He was the only one of the Sex Pistols with moral conviction. The rest of the band were pretty ordinary although Sid was not as stupid as he made out – he went to the university of life and graduated with extinction. But to me punk was only ever about one man – and that man

was Rotten. Not that you could know him. Elusive, ironic, sarcastic, he was a serial enigma. A cool narcissist, detached, self-contained and disdaining displays of emotion. But beneath the chameleon posturing was a ferocious heart . . . and an extraordinary poet:

> Where there's no future, how can there be sin?
> We're the flowers in the dustbin

This was irresistible to me. Sitting at my desk in the evenings at school the Pistols sounded like an accusation: why are you doing that work when you could be as free as we are? I was too young to realise that freedom is an internal achievement rather than an external adjustment. I started on my appearance. I began to use my clothes politically. They were my finest way of mocking power and authority. I cut all my hair off and dyed it black. I bought PVC trousers, a straightjacket and electric-blue brothel creepers. Making painted shirts and trousers jingling with zips, razor blades and safety-pins took up most of my spare time – the rest was taken up in swanking about in them.

The Sex Pistols were an inspiration to find yourself, not clone yourself. And yet teenagers must dress alike to assert their individuality. I obeyed the strict code of the elite punk club. But it simplified my existence. As soon as I put my punk uniform on, the rest of my life hardened around me like a shell. From that moment on, my friends were anyone who could tolerate punk, my enemies anyone who could not.

I was bullied and beaten up at school by the older boys, in Derby by Teddy boys and in Yorkshire by the showjumper Harvey Smith. It was at the time when he was in the headlines for doing a V sign and being friends with Princess Anne. His party was stiff with showjumping Lester bigots. 'I don't want any of you violent and crude punk rockers at my fucking house,' he spat before slapping me across the face.

Maybe it was the suede shoes. In those days, at best, a sure sign of sexual ambivalence. Whatever, it was worth it. The sense

of belonging to a tribe at that time when so few others did was exhilarating as well as dangerous and to see someone else in the street with drainpipes on was enough to constitute membership.

Sniffing Glue, the punk fanzine, told us 'Here's three chords. Now form a band.' The fact I couldn't play was a mere detail. One good thing about being young is that you are not experienced enough to know you can't possibly do the thing you are doing. Will was the singer, Ged was on bass, Giant on drums and I was on guitar. We called ourselves the Fauves after the French 'Wild Beast' painters. We were only fourteen, granted, but rock music is not one of those professions like literature or philosophy where age brings wisdom. Of course, we needed something extra special for stardom. They call it talent. It was said at the time that the Sex Pistols couldn't play. Believe me, they could.

What we did have was a rehearsal room called 'The Hole' underneath the gymnasium and some equipment which we had 'assembled'. While at home I had stolen money from Mother and Stepfather's guests. One by one I would go through their coats while they sat for dinner taking a pound here, five pounds there until I had sixty pounds and could buy a big Trucker amplifier.

I saw out my days at school in The Hole writing awful ear-flaying songs. One was called 'School days', and another 'Sewn up/Shown up':

> Sewn up or shown up – you ain't got no choice.
> Sewn up or shown up – in daddy's Rolls Royce

As the final weeks of my school career approached we huddled together in the spirit of rebellion and decided to go off and see the Clash in Derby without permission. For this Will and I were kept back at the end of term to do hard labour which involved driving a roller across the cricket pitch and was only hard in a straightjacket. When it came to being picked up, Father, as ever, didn't show. In the five years that I had been at boarding school,

I'd had absolutely no contact with him. Not a letter, not a birthday card, not a visit. All my requests to see him had been ignored. My letters might as well have been posted into a black hole. Father had remarried and his philosophy was: a child in need is a child to be avoided. But he had the last laugh. He had sent a car to take us home. Will and I stood at the top of the drive imprisoned in our punk uniforms – Doc Marten high-leggies, mohair jumpers, dyed hair – waiting for our carriage. We saw a large car flashing and glittering through the trees which we couldn't recognise. Suddenly, when we did, we shrank like snails whose horns have just been poked into their punk shells. It was a Rolls Royce.

When I got back to Beverley I found that Mother had moved again and this time we were living temporarily above a children's book shop called 'The Owl and the Beaver'. She and Stepfather had gone into business. The idea of these two purveying books seems preposterous but then the difference between reality and fiction is that fiction has to make sense. Having found that their own children had gone completely feral, they turned to selling fluffy bunny fantasies to other people's kids. I suppose it was their attempt to educate a new generation – and it certainly worked for us. We pinched books by the dozen and flogged them down the street. But I do remember loving *Watership Down*. It was pretty well written for a rabbit.

While I was living here, Gogo won her great gamble with the future. She died. She had taken an overdose of booze and pills and was found a week later alone in her little dark flat in Liverpool. The image of her unaccompanied, undiscovered haunted me. I tried to think that her suicide was the most completely meaningful act she ever committed – an act of courage and of affirmation. The difficulty with this is that Gogo's own final solution could hardly be seen as stylish.

I was troubled. In my heart I knew that I was on the same ride. It had begun with Mother and my birth and I was now hurtling un-piloted through my own life. It felt too late to ask

where I was going. I had no idea where I had come from. And I had no idea where I was. But I'd seen that suicide was a temple to my family's faith and that, if extravagance worshipped at its shrine, nihilism was the priest at the altar.

Mother coped with it in the two ways she coped with everything – drinking and moving. Motion itself seemed to have become a way of life for her. Misery and anxiety spread through her body when she sat down with no activity to distract her. The names of her homes reflected her passions. With a few stops in between we had moved from High Hall to The Bar House – just in case we hadn't got the message.

Our new home was called this because it had, attached to the main house, a twelfth-century bar over the road through which the cars passed. Apparently a hiding place for Charles I when on the run, this dungeon now became my new lair. I amused myself here by emptying my bladder out of the old arch windows, splattering on the ant-like minions below. On the Queen's Silver Jubilee she herself was due to pass under my bedroom as part of the celebrations. I hung a ripped and safety-pinned Union Jack advertising the Sex Pistols' 'God Save the Queen' single out of the window, unzipped my flies and got ready. Sadly, within minutes the police put a stop to my little revolt.

I was miserable. Punk was beginning to disintegrate. The Sex Pistols had proved that they were a true kamikaze band: they had self-destructed when their mission was accomplished. Their anti-establishment stance was so successful that they never achieved actual success. The bitterest pill I had to take was on Christmas Day 1977. I had a ticket to see what later turned out to be their last concert ever in Britain. It was at a club called Ivanhoe's in Huddersfield. I couldn't go because there was no public transport – or private. Stepfather refused to drive me. As you grow older, you'll find the only things you regret are the things you didn't do. Well I didn't see the Sex Pistols. I shall regret it to my dying day – if ever I live that long.

I left school only to go to another one in Pocklington to do

my A-levels. Here I took English, Art and General Studies. I passed all of them except General Studies where I got Unclassified. Effortlessly achieved. But what I enjoyed most about the exams was the sex I had in them. I used to sit down at my desk and when the examiner said, 'You may turn the paper over now and start', I still sat at my desk, doing nothing. I looked at the clock ticking by and thought to myself, 'So little time, so little to do.' For some reason this shook up an exhilarating cocktail of sheer fear and excitement which immediately made me ejaculate.

Sex was not just one of my A-level subjects. I had discovered voyeurism and was spending my life at keyholes. Seen through a keyhole, almost anything has an air of sordid mystery. In order to get to my bedroom, I had to pass through Sister's room. This presented a splendid opportunity. I drilled a hole through the door, made a putty plug and covered it with a picture (of myself). In the evenings, I would draw the cork, take out the door knob (and my own) and masturbate furiously to the sight of Sister's friends – including Stepsister and even Sister herself when there was no one else around.

One evening in the middle of the night I crept down and started to peel off the covers from Stepsister with one hand while sexually harassing myself with the other. There were two good reasons why I liked her. The answer was in the plural and they bounced. I leered over her fondling myself like a baboon. The blue-veined custard chucker was just about to chuck when suddenly, she opened her eyes. She glared at me like Medusa. Certainly, it was a tricky situation. I legged it. Fortunately in the morning she thought I had been sleep walking and was blowing on her.

Voyeurism is a healthy, non-participatory sexual activity. The world should look at the world. It is a sad human being that has nothing to hide from the public. And besides, what is privacy for if not for invading? *NO, I CANNOT AND WILL NOT DRAG AROUND THIS SHITTY GUILT-FEELING LIKE A*

DISGUSTING CROSS! I APOLOGISE FOR NOTHING! All right, maybe I was a pervert – but then so was Byron.

It was only part of a much wider Romantic culture of excess that I was growing up with. And romance was clearly in the air – or at least in Sister's bed, where Stepfather had taken to leaving *billets doux* professing undying love. 'I don't know what the difference is between love and being in love,' gushed one. Ash said nothing for years. But secretly she was bewildered and didn't know what had hit her. Mother did however.

Stepfather was putting his spirituality into action by trying to seduce Sister and belting Mother. She had a black eye one morning when we came down to breakfast. She sat huddled into her dressing gown with her wild hair falling about her bruised face. Ash slunk off to school. I left appalled. Spiritual combat is as brutal as the battle of men so I guess he had his work cut out with these two frail women.

Mother sat, pathetically at first, snivelling and confused. But eventually she plucked up courage to take her revenge – for a second time, by lighting a bonfire. All his orange clothes went up in orange flames. Going though the charred embers on my return from school I found that some of my wardrobe had also gone up in the blaze.

At Pocklington I joined my second band who were even worse than the first, although I had more hope for them. I had promised with the Fauves that I'd take myself out of the second division. I had – into the third division. Our problem was that we were too nice and the disease of niceness cripples more lives than alcoholism or cancer. The rebel is the man who says NO and nice people are simply afraid to say it. It wasn't our fault. Punk had encouraged everybody in the country to form a bloody band and looking at our group, the Void, clearly this had been a mistake. When I joined them they already had songs in their repertoire that went by such silly titles as 'High on a Numbie' and 'Sending My Girl to Holloway'. That which is not worth saying is usually sung. But imagine the sound of

five middle-class boys getting together. Then imagine the sound of a door slamming.

Our problems deserved understanding and sympathy – but not a paying audience. More often than not, we never got one. It took a lot of imagination for us to be musicians – like imagining there was an audience out front. There was a punk song at the time called 'One Chord Wonders' by The Adverts which went:

> I wonder what we'll do when things go wrong,
> When we're halfway through our favourite song,
> We look up and the audience has gone.

They were lucky to get anyone to turn up to leave. When we supported them in Doncaster we were received with thunderous silence.

There were a few benefits. After opening for some of the lousy groups of the era like Adam and the Ants we got to play with some of the great bands of the day. In 1979 we were on the bill for the Leeds Futurama festival. I was so nervous that I got drunk before we went on. I remember standing in the glaring lights in front of seven thousand people trying to work out what song we were in let alone what key. By any standards our performance was rubbish. The review in *Sounds* said: 'The Void are not even crap. They looked and sounded like five public-school boys which is what I am told they are.'

Joy Division were on after us. At that time the only debate as to what was the bleakest record of all time was whether it was Joy Division's first LP or their second. Naturally, I was a fan. The song began and I watched backstage as Ian Curtis danced like a epileptic puppet with demons tugging at his strings. He suddenly jerked sideways, transforming into a twitching mass of flesh and bone. Staring maniacally ahead, his arms flailing, his legs jerking, he looked like someone possessed. The guitars slowly faded away leaving the lonely drummer to finish the song on his own.

The headlining act that evening was Johnny Rotten's new band – Public Image Ltd. He walked onto the stage in a three-piece fleck suit carrying an old white carrier bag full of lyrics. It was so rare to see Lydon on a stage in those days. No one had been able to see the Sex Pistols and PIL refused to tour. The thousands in the hall had waited years to see this mesmerising man. He performed the entire concert with his back to the audience.

Before the show I found myself in the large dressing room with him but could only stare. Here was the man I had worshipped from afar sitting in front of me. He looked like a risen spirit, with his deathly pallor and wild hair. He was surrounded by an entourage which should have made me suspicious. A good part of the fame of most celebrated men is due to the short-sightedness of their admirers. It doesn't take a giant to throw a giant shadow on the wall. Outlined in fame's illusive light: tiny man. Big light. Giant shadow. But he wasn't a tiny man. He had brought new meanings into the world once with the Sex Pistols and now again with PIL. And he had natural charisma – a thing that makes you interested in hearing what comes out of someone's mouth. You either have it or you don't.

The Void stumbled on for a few years. But the writing was on the wall. The problem was – we were all illiterate. It took a record to put us out of our misery. Released by the man who had organised the Leeds Festival, it was a compilation album of public school bands entitled: *Music for the Upper Classes to do Something to*. Within weeks the record was deleted by popular demand.

We played mainly in and around Hull which was basically a cemetery with traffic lights. It is a nowhere of a place that has never really recovered from the war. One half of it appears to be burnt down, and the other not to be built up. The docks were a special zone where no single nationality was dominant and where civilisation had begun to dissolve into the sea. Even the

name 'Hull' is ghastly – the weariness of it, its connotations of emptiness, dullness and destitution.

It is not necessary to have relatives in Hull to be unhappy. I was amazed that I had even survived here to the age of seventeen. Still – I was making a pretty good attempt to change things. I had bought myself a Honda SS50 moped and was proving to be a kamikaze of the road. In the year that I had the bike I hit two cars, two ditches and one sheep.

I knew what was wrong. I was looking in both directions as I went through red lights but I wasn't getting anywhere. I may have been promised the world – but I had ended up with Hull. If I couldn't repair my brakes, I must make my horn louder.

But how? The problem was that underneath my shallow show-off exterior lay an enormous lack of character. I couldn't really do anything. I had a vague idea that somehow I wanted to be on the stage. I'd tried music and proven that I was woefully inadequate. I had tried acting at school (a quick look in the mirror was my only love scene) and again I was no good.

What was I to do? I could have gone abroad as a lot of my friends did at that time but that never appealed to me. The cool dudes who ran away, who were never going home were actually failures who couldn't hack it. They went to escape reality, not to find it. There was university but I didn't want to imprison my gifts, such as they were, in such a conventional manner. I had been groomed for Oxford and had considered taking the entrance examination but had decided against it at the last moment. I feared three years at Oxford would spoil me, sap my naivety and energy and turn me into a muddled hybrid with a lot to emulate and nothing to say.

In the end I settled for compromise. I'd secured a place at Edinburgh University to read English the following year conditional on my retaking French O level. I found a polytechnic which would let me take it but my decision to go to Edinburgh was also coloured by the fact that my friend Steve was there. I went to college not running eagerly towards life but creeping backwards,

trying to avoid reality. I knew that, while I sat dreaming through the lectures, at least I was putting off for another year my terrible confrontation with the outer world.

And I'd had enough confrontation with the inner world. All out of doors may be Bedlam, provided that there is no disturbance within. This was not the case. Unfortunately I could no longer blame Mother and Father. As I reached my late teens life had opened me up to a sense of isolation far more painful than the mere loneliness of the rejected child. I didn't know who I was, why I was born, what I was doing on the planet, what I was supposed to do, what I could expect. All I could see was the all-encompassing vacancy. Futility was all that I had so far found.

My family hardly helped. If I'd had any fantasies of home life then I had been rudely awakened. If someone were to set up a production in which Bette Davis was directed by Roman Polanski, it could not express to the full the pent-up violence and depravity of a single day in the life of my family. It was a foul octopus from whose tentacles I would never quite escape.

Stepfather had left. He finally decided to go and live at the Rajneesh community in Oregon. The English didn't understand him, he complained. And he might have been right. One day when he went into a cornershop to buy the paper, the lady leaned over the counter to inspect the necklace that he always wore. It was made of beads and had a pendant with a photo of his guru smiling beatifically out of his shaggy beard. 'Ah how sweet,' cooed the shop lady as she leaned closer. 'Is that your spaniel?'

Stepfather had every characteristic of a dog – except loyalty. He walked out and went to where orange people from all over the universe converged to hear His Holiness. Each day the Bhagwan would select one of his ninety-nine Rolls Royces and drive slowly through the fawning crowds – waving royally and parting the orange sea.

They came seeking freedom from their shackles. But the

rehabilitation he proposed was hardly orthodox. Bhagwan's idea of group therapy was an orgy. Every evening the camp was wet with lust. A shocking wilderness of human flesh. People sucking, fucking and licking to the point of cardiac arrest. Stepfather was in his element. At home his efforts at seduction had been returned unopened. But here his two passions – the flesh and the spirit had merged in holy harmony. He had finally found what he had been looking for all his life: the meaningful one-night stand.

Sex has nothing to do with morals. It is a compulsion like murder. As the camp grew it became increasingly paranoid. Armed guards – the 'Peace Force' – patrolled the grounds. Outsiders were banned from entering the compound. The surrounding community of Oregon became the enemy. Then the final act. A cult becomes a religion when it progresses from killing its members to killing non-members. The local water supply was poisoned by the Rajneesh. This did not unduly disturb Stepfather. When he occasionally returned home and was confronted with the bald facts of his new family he would simply retort, 'That's your problem.' Stepfather had gone to find himself. I can only imagine that when he did he was very disappointed.

Meanwhile, Mother's depressions drove us towards ever more barren regions of dread. Father had by now got remarried to Stepmother 1 – the Indian stepdaughter of the style-less lefty journalist James Cameron. Comparing her to Mother was like comparing Glade air freshener to Chanel No. 5. And yet she did eventually follow her to the mental asylum which was sweet of her and proved that a woman's place is in a home. But she did it with none of Mother's panache. Where Mother had chosen to drink herself out of the world, Stepmother had chosen to eat herself into it. There is nothing remotely heroic about an eating problem. Worse than this she had no style. In India the elephants wear better emeralds.

If one is not going to take the necessary precautions to

avoid having parents, one must undertake to bring them up. Unfortunately I was not free or old enough to rebuke them or even stand up to them. I decided it was time to curtail my family's opportunities to make me dislike them. I left home.

4

I don't know where I'm going but I'm on my way

I spent my eighteenth birthday in Paris in a brothel smoking opium. I had had to go. My greatest fear had been that in Hull I might live and die and never matter. So I showed my appreciation of my native town in the most stylish way: by getting out of it as quick as possible.

I had crossed the channel with a group of friends and a guitar thinking that we could busk for a living. My guitar was stolen on the first day so that was the end of that. I hadn't had a great time. There had been some incidental pleasures, of course, including the pleasure of leaving places you never wanted to arrive in again. But it was the memory of the drug which stayed with me. The feeling of calm, of quick-wittedness, and the deep, deep sleep that followed. It was the eloquence of the drug – the euphoria I got from it was subtle and enchanting. I was intrigued by a new realm – and it was a glimpse of this kingdom which would later bring me back again and again to the drug. As I took more the effects changed but they were no less pleasurable. I remember crawling on my hands and knees on the cold stone floor of the whorehouse giggling away to myself, happily.

I was far too shy and naive to employ a prostitute to celebrate my coming of age. It would be years before I could muster up the courage to overcome my disdain for *all* flesh – let alone bought flesh. I was divided between a puritan obsession with dirty sex and my own Romantic nature. Later, to overcome this

conflict I buried myself in it. But at this time I was crippled by gaucheness and could only stare.

At the brothel in Pigalle I had fantasised about buying all of them and making them my slaves. With their cheap corsets and lacquered bodies I could tell that these people had never known a world in which they had had the upper hand. Even better – perhaps I could become their slave. Either way I had a vision of buying myself into happiness.

On my birthday I had the means. Father gave me money – that most impersonal instrument of intimacy. Except that it wasn't cash as such, but shares in his business – Northern Dairies. Not that I cared. One of the few things worth having is money which you have not had the trouble of earning. Doesn't really matter what form it takes. I guess I could have tried to go further and joined the family firm. Most of my cousins entered the world of business, the logical destiny of bores. But it wasn't me. What a life. Sitting around waiting for a funeral.

Did Father know how to give his son the hardship that would make him rich? He didn't think about things like that. He had other motives. After the divorce, Mother had been advised by her lawyers to go for half his wealth. He bullied her out of it. The lawyers were completely thrown. Normally you can be certain that if you are reading something that you can't under-stand, it was written by lawyers. But their parting letter read: 'Mrs Horsley, you are making a mistake which you will regret for the rest of your life.'

My parents had settled on a third which was fixed and not to rise with his income. As the kids came of age – eighteen – he made each of us take over his maintenance payments. I would get letters from Stepfather reminding me that his alimony was due.

Father had negotiated this because he was mean. When he walked out of High Hall the first thing he had done was to close their joint account. When Mother objected he wrote and told her to 'stop whining.' The closest thing to his heart was his wallet. He only related to women sexually. Mother tells a story

that when Stepmother 1 left him she went to see him. He sat sobbing like an abandoned child. On the way home from dinner he asked her to fuck him. When she politely refused his offer, he flung open the car door and threw her out on the verge. It was 2 a.m. Mother was drunk and five miles from home.

I made the payments for a few years but eventually I confronted him. He shrank like a tortoise into his large city collar and cuffs. I was accused of being 'greedy'. A family is a group of individuals united by blood and divided by money. I resorted to lawyers. Contrary to what Father thought, the fight had little to do with gluttony and much to do with mutiny. A lifetime of neglect had left me seething with a lust for revenge. If you are disowned it is impossible to get through existence without accumulating a vast stockpile of vendettas.

Father had been a ghost – something dead which seems living. Now at last, with a tangible target, I could begin the exorcism. I wasn't going to miss my cue. Forgiveness would have been too extravagant – retaliation, on the other hand, was a luxury I could now afford.

Why would you join the army when all the instincts it speaks of are already encompassed within the parameters of any decent family? I relished this conflict. I did not feign to be above the battle. I wanted to feel it, to smell the sulphur, to taste the blood. When the lawyers suggested that there was a possibility that Father had broken the law, I remember skipping down the street punching the air in defiance. I had a vision of finally facing him in the dock dressed all in black like an avenging angel. Witness after witness would be called to state that, as a Father, he had been little better than a corpse. As far as I was concerned he may have been deceased as a parent, but he was in need of further persecution. One stab in the heart was not enough. This was overkill.

I imagined the judge summing up. 'The court was not previously aware of Mr Horsley's sins. In view of these, we see fit to hang draw and quarter him and place his dismembered limbs upon the spikes of Hull bridge.'

I was disappointed when nothing illegal (only negligence) was uncovered. I had forfeited an act of patricide. But I was allowed to stop the payments.

But on balance I was happy. War is salutary. It increases the solidarity of nations and reaffirms boundaries – *and* I had a private income: the young artist's best friend. It was an enormous sum of money. I simply couldn't count the amount! The shares were worth £150,000 on paper. How did that make me feel? Richer. I knew that money couldn't buy me happiness, but it wasn't happiness I wanted. It was money.

I set off for Edinburgh, a little uneasy about the future. Who wouldn't be? Sure, I didn't need to earn a living – but nor did I know who I was or what I wanted to do or why I wanted to do it or how I wouldn't do it. Without the courage of my confusions I was left with both feet planted firmly in the air.

I wasn't born in a slum, but I moved into one as soon as I could afford it. I moved in with my old friend Steve in a revolting little apartment. It was so small, that when I closed the door, the doorknob got into bed with me. The furniture consisted of two beds as narrow as coffins and a defeated old sofa. Whoever said that a man should swallow a toad every morning if he wishes to be sure of finding nothing still more disgusting before the day was over, obviously hadn't stayed in our flat. In the afternoons, when we awoke, we would find heavenly constellations mapped across our carpet. They glittered and gleamed. They were made from the mucus trail of slugs. I had to wear my boots in bed so that, dipping a dainty toe floor-ward upon rising, I would not squelch upon one of these improper creatures. But deep down, I didn't care. Squalor is my natural setting.

There were few men alive who would have had character enough to lead a life of such backbreaking indolence as we did. We started the day by going straight back to bed. But I was happy. Sleep to me has always been like death without the long term commitment. I was a rank amateur by Steve's standards. I used to come home from college to find him still asleep at

5 p.m., the whole flat drowned in darkness. Even the Indian folklore demon Kumbhakarna, who spent his life asleep, must have occasionally got up to go the lavatory. Steve retired at birth, but had fantasies of being a filmmaker.

His genius for inactivity was excused on the grounds of money. He didn't have any. What he really enjoyed was talking endlessly about the films he was never going to produce. He wanted to be Andy Warhol but rather than making a film called *Sleep* he just slept. For some peculiar reason he thought he was going to be 'discovered' – in bed. Of course everything was a conspiracy and ambition was a poor excuse for not having sense enough to be lazy. 'What's wrong with dropping out?' he used to snap. 'To me, this is the whole point: my right to withdraw from a society that offers no spiritual or creative sustenance, and to go back to bed. It's all right for you – you've got money.'

It is bad enough to suspect that you are loved for your wealth; to discover that you are despised for it is too much. As I watched him waddling back to bed I realised that I couldn't argue with this line of attack. Dreams are the only luxury of the poor.

Of course, I still had *my* aspirations and to some extent I still lived in the future – a habit which is the death of happiness. I wrote poems and song lyrics and looked forward to the day that they would be published or heard. I indulged in fantasies of living the public life of a famous writer, painter or pop star. I just wanted to be somebody – not necessarily myself. When I switched these dreams off and tried to come to terms with my true expectations I realised that I was probably never going to be recognised. As I sat on the bus traveling to Stevenson's Polytechnic to resit my French O level I understood that my ambitions slightly exceeded my talents. And so, of course I was miserable. The trouble was, I did nothing. And, inevitably, this led to nothing. I awoke one afternoon and found myself anonymous.

I watched the rain drizzling down on the city. It perfectly mirrored my internal landscape. You only know it is summer in Scotland because the rain gets warmer. Every day was one of

those grey days, the clammy skies clogged with the smell of hops. The rows of houses were stacked up the slopes like mildewed trunks abandoned in some damp attic. The people were stony faced as the façades that they walked through. The whole place was a permanent solar eclipse.

The college was even worse. Wester Hailes had been built in the seventies and was the dark underbelly of Edinburgh's gentile culture. It was full of the lost, the ruined and the shipwrecked from the chaos of the housing schemes. As I wandered around these foul buildings and tower blocks I became angry. I saw a home improvement shop on one of the estates. What do they sell? I asked myself. TNT?

Wester Hailes was where I first met Jimmy Boyle. Grandfather had introduced us. He had been involved in putting on exhibitions of his sculpture in Hull. Jimmy, when I met him, was on a Training For Freedom course, working two days a week at the local community centre and then returning to Saughton Prison at night. I had read his book *A Sense of Freedom*.

Born into the notorious Gorbals district of Glasgow, he had already been leading gangs in his teens: looting and shooting, running protection rackets and working with the Krays. During the Sixties he earned a reputation as Glasgow's most notorious hard man. His book was full of stories about attacking people with knives, guns, bottles and bricks and feeling much better after taking people's eyes out. Sometimes they are men, sometimes kids and other times just happen to be passing. On the cover was a black and white photograph of him. Boyle looked just like Fred West but he lacked his compassion.

He stood trial for murder twice in 1965; on the first occasion he was found not guilty and on the second the charges were dropped. In both trials witnesses houses were blown up by gelignite bombs. In 1967 his luck ran out – he was jailed for murder. He was found guilty of stabbing William 'Babs' Rooney to death and given a life sentence. He had missed the death sentence by a matter of months. What an ignominy it was for a great stylist

like Boyle to end up sewing mailbags with the petty crooks.

Time has not been kind to murderers. In Dick Turpin's day the crowning moment of a criminal's life was his public execution. Modern day murder had its dash wrested from it by the abolition of capital punishment. And now life imprisonment robs murder completely of its special quality. It is not a merciful sentence. Mr Boyle coped with this vacuum admirably. Style is knowing who you are, what you want to say and do, and not giving a damn. He realised that you only have power over people as long as you don't take everything away from them. If you take everything, they're free.

Boyle was an extremely violent prisoner. Two months into his life sentence he smashed the cheekbone of the governor of Barlinnie prison. He was found guilty of two more assaults on prison officers, and in 1973, he had an extra half dozen years added on for good measure after one particularly savage outbreak in which a man lost an eye. He was in combat with the world – but he didn't care about defeat and that made him dangerous. Little wonder he became known as 'Scotland's most violent man' – quite an achievement given the competition.

He invented the dirty protest: covering himself in his own faeces, the repulsiveness a weapon against his warders. He spent long months of his sentence in solitary confinement in a straight-jacket. Soon, no prison would take him. One governor in 1973 wrote: 'I am firmly of the opinion that this man is so dangerous that he should never, under any circumstances, be liberated from prison and further, despite the assaults and incidents in which he has been involved in the past, he is still, even at this moment, planning further assaults and further incidents. He is liable at any time, if given the slightest opportunity, to attack and kill anybody with whom he is liable to come in contact.'

But when he was finally transferred to the Special Unit at Barlinnie – the last resort of lost causes – he pulled off a coup that only the expert could attempt: he turned from criminal to artist. There was no essential incongruity. Both crime and art

take vision, imagination and courage. Murder is one of the fine arts, as Mr De Quincey once said.

Being an artist is the best and most individual lifestyle you can have in society without being a criminal. Boyle understood this. He started making sculptures and he wrote a book – a saga of human depravity that made lies sound truthful and murder respectable. This brought him the biggest gift of them all: fame.

It was easy to see why: there is more rejoicing among *Guardian* readers over the repentance of one sinner etc. He already had the attentions of those from his own background – every outlaw is dear to the hearts of the oppressed. But now he had a new audience: people like me, people who believed that society was unfair, that the downtrodden would be redeemed if offered the very opportunities that we all felt so guilty for having inherited and so shunned. We were enthralled by his fable.

Sitting opposite him at the community centre in Wester Hailes I was in awe. And he knew it. He is the only person I have ever known who can strut while still sitting.

I wondered at how little scar tissue he had. Where were the stigmata of the stabbings and shootings and beatings? I wanted to read his body like I had read his book. But now that I know him, I know too that I was looking in the wrong place. No doubt, when his enemies got through with him, he *was* all covered in blood – but it was their blood.

I sat there, like a rabbit, in the headlights of his steely blue stare. 'Whit aboot daein some graft aroond the c'mmunity centre here?' he asked. Eagerly I agreed. His life seemed so exciting – it wasn't hard compared to mine. I went home and sat on the pavement rereading his book. I felt like the ten-year-old child who had first glimpsed Marc. Crime, like music, fulfils every boy's fantasy of daring and danger. But for me it was more than this. I didn't just want a fantasy, I wanted a father.

Boyle was all I talked about. I dropped his name, like Hansel dropped pebbles, to find my way home. I would tell anybody listening – or not – what an amazing life he had had and how

he had changed and how I was going to work with him and what a great artist he was and how he helped people less fortunate than himself and how I was going to learn from him and teach society that people *could* change and what a great artist I was going to become and how we would save the world and . . .

The trouble was I could barely get out of bed. I kept in touch with Jimmy but I never went back to the community centre.

My life was utterly aimless. Here was I, so impressionable I had no identity and yet so self-obsessed I was sure I would one day be noticed. This self-obsession left me isolated. Of course I reasoned it was solitude, which, in setting me apart, proclaimed my distinction. But in truth I was lonely. A solipsist basically means someone with no friends.

I became a vegetarian – as you do in this situation – not because I loved animals or because I hated plants. But even as a vegetarian I was a failure. How could I sacrifice bacon? I embarked on secret fry ups as soon as Steve left the flat – which was unfortunately rather rarely, and once he came home earlier than expected and I had to hurl the evidence out of the window. The stench of hot flesh hung incriminatingly around the kitchen. It stickied the air. 'What's that smell?' Steve said as he shuffled off to bed.

After a year, I gave up. I had enlisted my conscience to play its noble bit part, but it was far too hammy. The rest of my body booed it off stage. I loved animals, I concluded. Especially in good gravy.

Life in our bunker was pretty miserable. Steve and I were like an old married couple. Naturally we believed that friendship should be limited to a very few – the fountain playing higher by the aperture being diminished. But we spent most of our time drinking beer and, in the absence of anything better to do, going on bizarre diets together. A brown rice fast, after a week, left us more flatulent than alive. Homoeopathics for pathetic homos.

Steve had, by then, come out of the closest. Stepfather had been right. Steve told me one evening in hushed tones and I had to stare dutifully at the floor for the requisite interval. Being gay

seemed so gravely important to our young, stupid minds. The air in the room was so thick with solemnity that he might as well have announced: 'I've just been given six months to live.'

I shouldn't have been surprised. Here, after all, was the man I had spent a decade with putting on lipstick and dressing in women's clothes. I may not have fancied Steve, but I hadn't chosen him by accident. He had been my first co-conspirator. He had ganged up with me against the world – and my family – and he had been banished from my house as a result.

I thought of my home – that claustrophobic enclave of mis-matches. Homosexuality was beginning to seem glamorous. Soon I was beginning to wonder if it was the way to enlightenment.

Luckily, our wishes and our destiny are almost always opposed. A week after Steve's declaration we went to the the Laughing Duck – a saloon with a Q certificate. No-one was allowed admittance unless accompanied by a queer. I entered a heaving, homogenous sea of crew-cuts, tractor boots, pre-ruined jeans, kitchen-tablecloth shirts and scrubby moustaches. And I was just wishing that everybody would climb straight back into the closet that they had come out of when I spotted a girl on the dance floor, dressed toe to crown in black. Her skirt would barely have served as a cummerbund and her thigh-high leather boots looked as tall as she was small. She had hair like a firework explosion in black and a face which indul-gence was already leading to decay. The Romantic melancholy of Marc's 'Ballrooms of Mars' surged through me:

> You dance
> With your lizard leather boots on
> And pull the strings
> That change the faces of men

It was love: love which prefers twilight to daylight. Normally its women who deteriorate during the night and leave half their complexions dying on the pillowcase. But I had so much make-up on I couldn't even find my face. When she looked at me first

thing in the afternoon she said, 'Dae yir eywis wear quite so much, ken?'

'Eh?' I answered, quoting her freely.

We got on. One should choose for a lover only a woman one would choose for a friend if she were a man. Mother had brought me up to hate the 'revolting working classes' with their mono-syllabic names – as if to have more syllables in one's name were a sign of superiority. Thankfully, my girl just scraped through this stringent social test. She was called Evlynn.

Born in Edinburgh, she was the youngest of the five daughters of a decorator and his wife who had somehow managed to rear them in a three-room basement flat that would have fitted into the pantry of High Hall.

Fortunately for me, who at six foot would not have even fitted in otherwise, all her sisters had married and moved on by the time I met her. Ev lived alone with her parents. Her father had had an aneurysm and now shuffled around the house like a clock-work toy whose spring has gone slack. He would open the door and stare at me blankly, trying to work out if I was the postman, his son or a burglar. 'Hello Cuthbert' he would eventually say – it sounded vaguely posh to him so it might have been right. The wheel was still going round but the gerbil had died.

The home was dominated by women – especially the mother whose physical frailty was superseded by her mental strength. Ev and her sisters had inherited this. It left the father isolated and before his brain finally short-circuited he had occasionally hit out at one of them in a drunken rage. Even the cat was a female though it refused to procreate. 'Five daughters and even the cat's a lesbian,' he had used to say.

All the sisters apart from Ev had bred by now. If you weren't pregnant in this part of town by thirteen, you stood out. But that was not the only reason she seemed different. 'Fantasy is all I got' Marc had sung and in the same way that Bolan had saved my life Bowie had saved Ev's. He too was a self-made man in love with his creator. He too had sacrificed himself on the

altar of artifice. Ev set about deforming her character in the same way.

At the end of each week the transformation would begin. It started with her clothes. She didn't need much money. She would trawl the thrift shops or sew her own. Her hair was a riot of colour – turning with the regularity of some eccentric traffic light from red to orange to green. Last came her face: white flesh and black lips. By the time she had finished with her make-up her face talked louder than the words that streamed out of it. For her, to dress was to put on her thoughts, her attitudes to life.

Real elegance is in the mind. Ev had left school at fifteen to train as a hairdresser. This attracted me at once. I have never really been comfortable around intellectuals. It seems to me that the intelligent are to the intelligentsia what a gentlemen is to the gents. Besides, she wanted to be an artist and while I did too, I was always getting ready to live, but never living. Ev just got on with it.

She could move easily from the highest to the lowest society and charm most of the people she met on the way. Intelligence is what enables you to get along without education; education is what enables you to get along without intelligence.

But best of all she was working class!

I was ashamed of everything that was real about me. Ashamed of myself, of my relations, my accent, my opinions, my experience, my name, my bank balance. How could such middle-class credentials lend me the authority to exist? I had swallowed the romantic notion whole: the drunk on the corner has more wisdom than the guy in the ivory tower. Criminals, vagrants, tramps, hairdressers and drunks (especially when drunk) were more authentic than any bourgeois hypocrites who lived a life crippled by A levels, incomes and loving families.

I wanted to be working class. The trouble was, apart from serving as a diligent caretaker of my own beauty, I didn't work. Any time that could be spared from the adornment of myself, was devoted to the neglect of my duties. But Ev, as a real live hair-

dresser, could show me the way to salvation. She dyed my locks bright orange and lacquered them as stiffly as an epileptic fit.

A pharaohic sun-god was the image I had in mind. It looked more like I lent a little too close to the gas flame. Never mind. I donned an apple-green suit (in hindsight it could have opened for Liberace in Vegas). And lo and behold – I became a peacock without a cause.

Or so I liked to think. Others were of another opinion. Going into a pub with Evlynn, I stayed at the table while she went to buy the drinks. 'Here's some nuts for the parrot,' the barman said.

Because I was living in Scotland my whole life at this point was an unsympathetic part played to a hostile audience. Fortunately, I was one of those happy characters that actually enjoyed hatred and felt glorified by contempt. As far as I was concerned the whole of Edinburgh was a stage, and as soon as I went out the door I was 'on'. The peacock was in a goldfish bowl and he loved it. The average man gets some girl to tell him, 'Oh Rupert darling, you're ripping', and as soon as the words have been uttered he can get on with his life but there are others like me for whom this is not enough. I thought to myself 'All right, Evlynn says it, but what about those other people out there?' My heart was a secret sanctuary into which only one person could enter (myself – the high priest). The problem was, there were also lots of little anterooms and chambers which craved a congregation. I may have had the soul of Narcissus but, in truth, my spirit was more Julie Andrews. I was needy – but constantly at war with the emotion because it compromised my autonomy. To love is to desire, which is to be dependent.

Intellectually, I considered myself homosexual – although Steve's antics were putting me off any physical consummation. As a typical faggot he was pathologically incapable of making love with his friends or making friends of his lovers. If I asked him what his latest boyfriend was like, I never got the answer, that he is wise, or kind, or brave. He would only say, 'It's enormous.'

In the winter, Steve, Evlynn and I moved into a new flat

together – which I bought. But it was too small, too close, too suffocating. Trapped like spiders in a bottle, we began to devour each other. Steve resented Evlynn and me – and rightly so: nothing is more revolting than the smug satisfaction of the new couple. Maybe it was to counteract this that one evening I took it upon myself to declare my love for Steve. I suppose I sensed him swimming away, and knew I could catch him with a very small hook. Evlynn, furious, plunged into the white-water ride of her rage. I had detonated a disaster. So, just to make sure total destruction was assured I lent some money to Steve.

Friendship is a sacred bond. Deep and sweet and loyal and enduring, it will last a lifetime – as long as neither party is asked to lend money . . . or live with the other . . . or have sex.

I dealt with the problem the way I dealt with everything at this point in my life. Silence. Withdrawal. Evasion. I remember Ev and Steve interrogating me for a whole night. They stood like prison guards over the sofa on which I sat dumbly, but my lips remained locked, my tongue was in chains. The unanswered questions crashed clumsily to the floor and broke open. I put my hands between my legs, hunched over and bowed my head to show that I respected the weightiness of the situation. It was hopeless. I couldn't bring myself to tell them the truth – that I was lying.

I retreated into the world of make believe through which I could sink without trace. I was going to try again to become a pop star! Yes, I was a terrible musician – but I had this irresistible urge to prove it. I had been rehearsing with Mr Paul Haig from the band Josef K, but when he realised that I hadn't a hope in hell of even becoming mediocre, he fired me. So, with a persistence beyond the call of talent I decided to make a record. The future was looking very dark indeed.

It cost me a considerable amount of money. As far as noise was concerned, it was like an unsavoury stench in the ear. I designed the sleeve – a self-portrait by a mentally ill friend whom I had visited in the nuthouse in Yorkshire. On the back

was my own self-portrait (surely you didn't imagine that I was going to omit it) – copied from Edvard Munch and with a hand that looked as if it had just gone through the mincer (which can't have surprised anyone who had heard me playing the guitar).

I sent it out to a host of record companies who returned it with the alacrity of Wimbledon champions. I might as well have sent a tube of toothpaste to Island Records and asked for a deal. So I embraced defeat my oldest friend and went on as though nothing unpleasant had happened. But inwardly, I was confused. I had made a record so bad that to this day I cannot understand why it was not successful.

What could I do? I had resat my French O level so that I could take up a place at Edinburgh University. But I was having trouble with gender. Obviously I could see that a plank of wood was feminine and that a peacock was masculine – but all the rest was bewildering to me. I failed the French.

And so, equipped with no qualifications for any profession, I resolved to try my fortunes as an artist. Everyone knows that the first requisite of this profession is to have no money, no talent and a total lack of responsibility. I failed in the first. But after that things looked up. I had no original thoughts. I had no ideas. I knew nothing about composition. And I couldn't take care of myself let alone anyone else. Maybe I *could* become an artist.

Mother was keen. I had showed early promise, she said. At three years old, I had painted my penis all the colours of the rainbow and run around a courtyard in Cassis gleefully showing it off. Clearly my character was deformed from a much earlier age than even I dared to hope.

I put myself under studio arrest. I closed my windows, latched my shutters, and tried to build magical realms in the night. The eternal conflict of the tortured Romantic and the soaring star could now be played out in all its high drama – in reality, I simply copied the paintings of the Fauves and Matthew Smith. Whatever

my sources, I didn't transcend them. At the end of six months' work my pictures looked like counterfeit bad paintings.

Undeterred, Evlynn and I applied to the art college of the day – Saint Martins – and to my amazement I got in. I was thrilled – the chance to study anything without paying fees, even if it is something that can never be the slightest use, cannot be allowed to pass by. Evlynn wasn't so unlucky – but she managed to get a job in a hairdressers so fashionable people thought it was stylish. We said goodbye to Steve. The next time I saw him more than two decades had passed and he was unrecognisable. Enormously fat, he had chins cascading all the way down to a stomach so substantial that there was enough to have made another person. His face was covered in fur and his body in tattoos. He was dripping with rings, daggers and amulets. Finishing it off was a Nazi helmet. He was a Hell's Angel.

It was not hard to see what had happened. You make a mark on your body when you feel you can't make a mark on your life. But his appearance served another purpose. People in bars are always claiming to be boxers, hoping thereby to ward off attack, like a blacksnake will vibrate its tail in dead leaves and try and impersonate a rattlesnake. Hover-flies imitate wasps. Homosexuals try to make themselves look like members of a chain gang. But I for one was not convinced. Steve was a Hell's Angel without a motorbike – and with a job.

Ev and I set off for London with a freedom that comes from lack of possessions. I knew that I would not necessarily find what I was looking for, but the journey itself had become the important thing. Life, for me, was a great big canvas, and I was going to throw all the paint on it I could.

5

I stand for nothing and fall for everything

It was 1982 and London was swinging. My London was swinging too – like a hanged man. Ev and I moved into a basement studio on Beaufort Street in Chelsea. It was so small it could barely even entertain an echo. But this suited me just fine. I have always held with Mr da Vinci's conviction that small rooms concentrate the mind. Intimate feelings come from intimate spaces. I like living in one room. Spare spaces, unattended and uncared for, become nasty and start bitching about you behind your back.

I set about getting rid of all the superfluous things – except Ev. I started to live then as I have always liked to lived since – as if life was going to turn on me and make a fool of me at any moment. So, I prepared for that moment. Material objects are just hostages to fortune. Your possessions possess you. I threw out all the furniture, all the kitchenware, all the awful pictures that they had strewn about the walls, the curtains, the rugs, the lava lamp, the rotting rubber bathmat, the sink plunger, the scouring pads and the salt cellars that they had nicked from the café round the corner in the first place. I stripped the place until it looked like a prison cell. When we can do with what we need rather than what we want we are at peace.

I was satisfied. This was going to be my colosseum, my grand arena, my inner sanctum. I had no need to go beyond it. The adventure, the great adventure for me at this point, was work. To see something unknown emerge out of the mists

of my imagination to sublimate upon the surface of the canvas seemed to my fired up emotions to be worth more than any mere gap trip to see Ghandi. I was in love with the Romantic. I too wanted to be the master of my own tiny (but unfathomably fascinating) universe. I wanted to be a paragon of authenticity – but measured in artifice. This was my destiny. I must cling to it by my teeth. Here, I would remain free in total isolation from the planet (Ev was a mere blip), alone with brush and lamp in the innermost cave of my acute self-consciousness. I would close off the outside world in order to open up the inner.

Trouble was, I was due at art college. From day one this was a problem. It was ironic that the Sex Pistols had played their first concert at Saint Martins College of Art in November 1975. As far as I was concerned they had shown that great art comes from the complete refusal of all authority. True artistic success arises from refusing to do what promoters want, by refusing to perform what the public wants . . . in fact, by refusing to do *anything* to order. And now here I was at the college in which the authorities had taken it upon themselves to pull the plug on them three numbers in.

My problem was that, although all my heroes were completely self-taught, I knew that going solo was difficult enough – even for the working-class rebel. For the person with no talent it would be positively hazardous. I went to college.

I had to compensate by becoming a complete twat. I was one of those middle-class malcontents who blame the professional classes for all my own shortcomings. Nothing worth knowing could be taught, I fumed. Students had a herd mentality – they had to have or they wouldn't be in college in the first place. Art-school kids were spoilt brats who had too much of everything. It was official: Saint Martins was the enemy. It was a place where pebbles were polished and diamonds were dimmed. I – the great nobody – would *not* be dimmed. I was an electric eel in a pond of goldfish.

The trouble was I had to pay for the privilege. Because of some technicality about being in Scotland rather than England when I applied for my place, I was refused a grant. (I don't blame them. I wouldn't have let the Scots in either.) I didn't have the pink document that I needed to show them to prove I had paid. So I set about making my first creative work – I forged a certificate complete with photograph and fake stamp.

Once I had been let back in, I set about plundering the place. In the six months that I was there I took a little art, a modest amount of architecture, a plentiful helping of easels, paints, brushes and pencils, a couple of skulls and a spare human arm.

Every day during lunch break I would march in equipped with black bin liners and after half an hour of pillaging I would leave. Only when I had stripped the place bare as a Polish shop shelf did I set off for new pastures. I hit Goldsmiths and Chelsea. I was, as far as I was concerned, the Robin Hood Punk of the art world. I stole from the poor to feed the rich – though of course my stupidity prevented me from seeing that being bohemian is rather conventional.

Meanwhile, back at the studio, I set about my grand work. First of all, inspired by (aka copying) Jimmy Boyle I attempted stone carving. It was not a success. When asked how Michelangelo created David he said, 'I just got a big block of marble and chipped away everything that wasn't David.' I tried to do the same. I just got a big block of David and chipped away everything that was marble. By the end there was nothing left at all.

So I wandered off into the streets of Chelsea longing to be someone else. Quentin Crisp lived opposite me and Johnny Rotten a couple of streets away. I would stand outside their flats breathing in the aura of fame. If I could only get to meet them, then I knew that, when the ark finally sailed, they might invite me on.

One day I found the door of Mr Rotten's house had been left ajar. I tiptoed closer. The door was covered in fans' graffiti. 'Answer the bell you cunt,' I read. 'I don't like hiding in this foliage and peat, it's wet and I'm losing my body heat.' Clearly

I was not the first. I pushed open the door and went in. As I crept around among the tattered furniture and Red Stripe beer cans, my heart thumping louder than the Jah Wobble bass beat, I scanned the room for something to steal, a sacred relic. Suddenly, I heard a noise upstairs. I panicked and ran ripping a poster off the wall as I fled. It was a Public Image bill for my favourite song 'Death Disco'.

I never spotted Quentin Crisp – fortunately for him. Perhaps he had already moved to America. 'They hate me in England, hate me. They stop you on the streets, they beat you, they spit at you,' he told me in New York when, several years later, I finally met him. We had supper together in his local diner. He arrived punctual to the second and called me 'Mr Sebastian'. I returned the compliment by putting on my pink gabardine and paying the bill.

I could have finished every one of his sentences for him – I had read all his books. But professional courtesy forbade me. Toward the end of the evening, even he noticed. 'If you've heard this before Mr Sebastian, don't stop me because I'd like to hear it again,' he said. I wish he wasn't dead. He could find lots of his lines in this book.

After dinner, we walked home arm in arm through the Lower East Side. Outside the corner shop where we stopped to buy a few bottles of Guinness, the neighbourhood's Hells Angels chapter had assembled. The ranks of chromed Harleys gleamed in the night. Mr Crisp bowed his head, 'to show that I respect their supremacy' he explained. But he didn't need to. In America, they love a loser turned winner as much as we love the opposite. These were heavenly angels. They wolf-whistled and broke into applause.

Meanwhile, back in London, I was back on the drugs. The opium in Paris had been the first bite of the fatal apple. Now all drugs had an enticing aura of illegality. But I hadn't enjoyed marijuana – no wonder, it was a bit cramped being an astronaut in my inner space. Nor did I like acid – also scarcely

surprising. It was difficult enough for me to cope with what I really saw and felt. So I set off for the suburbs of addiction. It was 1982 BC (Before Crack). I was twenty. But I was ready to start where others would stop.

Opium could be turned into morphine which was ten times stronger . . . and *then* turned into heroin which was even stronger than that. I *had* to get some. Little Ben, a junkie friend of mine who was to take a big bit part in my life, ran the errand. I remember the excitement, the trepidation and the craving. I was in the presence of the king of kings – the sceptre of Satan trailing an odour of brimstone brown.

I thought I was going to be hooked as soon as I snorted it. Instead, I was sick. I didn't yet know that disappointment will vanish when you find that the drugs come back up with the food. So I just lay on the bed cuddling Little Ben. I wasn't wildly impressed. There had I been expecting some sublime insight; instead I was happy just sitting and staring at my big toe.

I started taking speed regularly. Amphetamine sulphate was a poor Northerner's drug. That would suit what I wanted to be. Besides, what I loved was the wanking. They went together rather well. I would stay locked in the lavatory for whole days. I could – and would – masturbate until the cow (Ev) came home. She of course wasn't best pleased. Where marijuana (especially with poppers) gave me a hard on the size of a small mammal, on speed it was more like a salted slug.

One evening I was at the Warren Street squat – the hangout of Boy George and Marilyn. It was a two-star accommodation – and you could see both of them through the roof. I was with Ben Bream, son of the classical guitarist Julian, who I had known at school. We had been drinking all day and in an attempt to drop anchor in the sea of alcohol, moved on to drugs. After a joint, the coke came out. I took the biggest snort (the Devil always gets the best lines). And then followed it by a hit of heroin. But even then I didn't approve of ingesting things through my nose. It always seemed so undignified for a man of my

stature. But though Little Ben would leave needles around the flat, I was far too squeamish – and still slightly too respectable – to use them.

'Shall we go out and destroy ourselves?' I suggested brightly.

The words hung in the air – the way they do when you're stoned. I slipped the speed in my wallet and the hash in my pants (in those days, quaintly, I still wore them). We sloped off – me in a new suit cut as viciously as my hair; Ben, like some witch doctor draped all in black and jangling with beads, skulls and jewels. We had it all: natural style, unnatural drugs, super-natural tailors.

The West End on a Friday night is like an upturned dustbin. We rummaged our way through the mess of people. But it was when we were going through a real skip on Oxford Street that the police pounced.

Before we knew it, I was spreadeagled against a wall. The speed had been discovered and I had been arrested just as fast. Ben tried to swallow his heroin stash but the officer threw him to the ground, and lashed out with his truncheon again and again. I remember seeing Ben, curling into a foetal position, while his blood flecked the policeman's hands. How odd, I remember thinking, that this should happen on Oxford Street.

I was charged with possession and Ben with assault – even though it was he who had the broken nose. 'If you're not guilty, how come you're bleeding?' was their argument. Ben, handcuffed and spitting blood and curses, stood in front of the desk sergeant as he read him his rights. The red globules plopped on to the white charge sheet like sealing wax.

I, on the other hand, had perfected my social graces and made them indistinguishable from rudeness. My politeness became my shield – and my sword. I was not a member of what Graham Greene called 'the torturable classes'. Besides, a true dandy must not permit anyone to pierce his impeccably polished armour.

We were strip-searched. Truth may walk about naked but lies should be clothed. And I hadn't told them about the stash in

my underpants. I was in a tricky position. Should I confess? I lurched towards a decision. Slipping off my knickers, the quarter of hash gripped tightly inside the cloth, I offered them to the officer with an eager-to-please smile. Unsurprisingly, he didn't seem particularly to want to handle them himself. I clutched them in my hand as my buttocks were parted and, when it was all over, I put them back on.

The cell was about eight feet by twelve with no window, but a lavatory and a bed. I sat hunched on the latter, festering with rage. Its embers would still be glowing weeks and weeks later. Ben was a peaceful vegetarian who wouldn't have harmed a chicken – unless it was in self-defence. I was enraged – but not so much by their violence as by their facetiousness: by the insulting manner in which a group of professionals who at all costs should remain neutral, set out to provoke the anger which they could then enjoy punishing.

I was so full of fury that even though I needed it, I refused to use the lavatory in the cell. The police may grovel for their wages in the excrement of the world but they weren't having mine. My shit was worth their diamonds.

I slumped sulkily on the floor. Suddenly I remembered the dope. What a victory! They may have got the gram of amphetamine, but so what ? More hash, less speed. I took the quarter out and chewed it. After fifteen minutes I was stoned out of my mind and my bloodstream was chuckling with pleasure. I still needed to relieve myself. But I didn't want my effluence passing through their sewer pipe. Yeah right, I thought. Smash the cistern! Smash the cistern! We are born free but The Man pulls the chain! Smash the cistern! I fell on the floor giggling in the way that you do when you've just eaten a quarter of an ounce of marijuana locked in a police cell.

In the morning I was still giggling. I was sorry to be going. You get attached to things whether you like them or not. Sure, the service was poor, but the room had been cosy.

I wrote about my experience to Jimmy Boyle: page upon page

of fulminating drivel about The Man, about how the police weren't here to keep order but to promote disorder. If they didn't have crime, I ranted, they'd be on their knees begging for it. It was all that they had. I was thrilled. At last the system had served me an injustice – or, at least, if not an injustice a bit of indignity. What more could I want? Here was my evidence – and not only from the pages of the *Guardian*. It was first hand! It was authentic! I had been beaten up by the pigs at last! The only thing I overlooked was that they weren't actually wrong. Ben came out of the police cells and after a life of disorganised crime murdered someone and went back inside.

Jimmy Boyle – still doing his life sentence – replied to my letter. My social hymen had been broken, he told me. I would never be the same again. He warned me of the evils of drugs – which I ignored; and sent me a book – which I adored.

It was a philosophical commentary called *The Denial of Death*. Written by Ernest Becker, it had won the Pulitzer Prize in 1974. No book has had such a profound effect on me, before or since. Its basic premise – drawn from the books of many different thinkers – was that man is the only creature on the planet that must pass his entire existence cowering under the shadow of death. Mortality haunts even our most sun-lit hours. Our fear of death is the driving force behind everything that we do. Every ambition, every achievement, every distraction is simply a way of fending it off, of trying to deny our inevitable end.

Celebrity, narcissism, charisma, art, religion, neurosis – all our consoling props – are no more than cultural formulas, Becker argues, in which we hide from our fate. Any hope that the things which we do can be of lasting meaning is just a cover-up. Death lurks beneath.

Man is half symbolic, half animal, Becker says. His symbolic self can be a god-like creator. But his animal half is mere food for worms. So we construct a character in which to hide from mortality not realising that, instead of freeing us, this carapace becomes a prison. It has been built solely because we are trying

to deny our 'animal' halves. But if we admit to this instead, if we admit that we are just doomed and defecating creatures, we can begin to transcend our plight.

How do you do this? By realising that the entire history of human achievement is merely a measure of the distance that man has managed to place between himself and his shit.

I was so affected by the book that I felt I had to respond. I had to do something constructive. So I locked myself into my own flat, stripped myself naked and sat there listening to Beethoven's Ninth. After a few hours I defecated in a neat pile on the floor and scooped it up in my hands. Running it through my fingers, like a gardener assessing the friability of the soil, I examined it. It was slimy as wet clay.

It would do. I used my shit to swipe the word MAN on my chest, and then PIG on the walls. Then I covered the rest of my body in ordure until no flesh was visible. Beethoven swelled through the room. I sat there musing. Sex, I decided, returning to a favourite subject, was interesting. But not as important as excretion. People can go eighty years without a pump. But they die in weeks without a dump. My philosophical insight gave me a hard on. I had a wank to quieten the imperious urge. God knows what I looked like, plastered in excrement and knocking one off. But that's the great thing about masturbation – you don't have to dress up for it.

What now? I put a finger into my mouth and sucked it, while I gripped my flesh with my other hand, digging the nails in to stop myself retching. It had the sticky, dry consistency of Peanut Butter. I swallowed. *Fait accompli.*

Inwardly I took a bow. I had committed the ultimate transgression. I crowed like a cock on my dunghill.

For three days I stayed there, lying on the floor, eating and sleeping amid my own waste. 'The turd is the enemy of mankind', I scraped the words across the wall. When the whiff got a bit too much – it was high summer – I opened the patio door. I was also a little concerned about the neighbours. And slightly

worried that my landlords, Chelsea Estates would stage one of their impromptu checks. But I needn't have worried. Even the flies left me alone.

I consider my greatest asset to be my ability to humiliate myself. But still, this memory feels too painful to admit. I cannot, to this day, buy lavatory paper (my cleaner has to be sent out). I sympathise with the Chagga tribe for whom, apparently, the height of fashion is a tight-fitting anal plug. They proclaim their social superiority by pretending not to need to defecate.

I am utterly baffled at the sheer *non sense* of creation. I mean, why fashion the sublime miracle of my face, why conjure this radiant apparition out of nothing, out of the void, and make it shine like the noonday sun, why take such a miracle and put miracles again within it, why embed such deep beauties in eyes gorgeous as glass – and then combine it all with an anus that shits. How could you do this, Oh Lord? How could you do this to *me*?

Oh well – I guess it could be worse. On the highest throne in the world man sits on his arse. On a slightly lower throne, women have to squat. The most ethereal, the most beautiful, the most divine among us, hunker down like baboons to defecate every day. For the Byrons among us, this discovery is surely a fate far worse than death.

I set about making artworks. Of course, like any self respecting young artist, I was haunted by the prospect of death. You had to taste it with the lips of your living body I would proclaim. But the truth is, the only taste I had was derivative. I was a cemetery of dead ideas. I've yet to meet a young artist who didn't think his work was about death. Until you have promised that it is, I don't think they will hand over the paints in the shop.

Your death is always with you, no doubt. But I didn't understand that so I decided to run around looking for it.

First stop: Meditation. Well, it was better than sitting and doing nothing. And of course I was spiritual – I was so mindless I was almost Zen. But transcendental meditation? I took up

karate instead. But this was inconveniently energetic. It slopped the ice cubes out of my drink – and besides, it was hardly dangerous.

Finally I alighted on parachuting. This seemed as good a way as any to pointlessly risk a life. And I was ready to die for an idea, provided that idea was not quite clear to me. But first I had to be trained. In a little club in a motel on Tottenham Court Road, I spent several hours jumping off coffee tables. Apparently this would prepare me for freefall from 2000 feet.

I dressed in black for the big day – in combat fatigues and Doc Marten boots. I wanted to look like someone parachuted behind enemy lines. I wanted to look like an SAS operative. I have always longed for war, for the warm security of mindless obedience, for the lovely glory of socially encouraged destruction.

I went into the bathroom to prepare for my jump. First of all, I took some amphetamines. Then, I admired myself in the mirror.

'Fuck everyone! Give me your money!' I said.

As the plane took off, the drugs were coming on – and my death wish was going off. But it was too late. The plane was travelling at a hundred miles an hour and I was travelling at two hundred. So was my tongue. I gabbled frenetically. But I couldn't talk my way out of it. Suddenly it was my turn to jump.

I couldn't see anything but clouds. All two hours of my coffee table training – be calm, jump, spreadeagle, head back, pull the rip chord – went out the window as I went out the door. Screaming and hollering, arms and legs scrambling, yelling at the air, I plunged, somersaulting madly through empty space, fumbling desperately for a rip chord. Scientists tell us that the fastest animal on earth is a cow that has been dropped out of a helicopter. It travels at a top speed of 120 feet per second. I can confirm this. I was in vertical freefall. Oh fuck! I thought. What a way to go!

I was jerked back as the chute opened.

After the initial thrill of being saved had passed it wasn't half as exciting – I drifted like a dandelion seed down towards the earth. Risk is what separates the good part of life from the tedium.

As I hit the ground I felt my leg snap in two like a freshly cut sapling. I lay prostrate, listening to the ambulance wailing towards me through a speed haze. I put on my best impersonation of a wounded man. But inwardly I was smiling. At last, I thought, something has happened to me.

For an artist, dying while you are young can be quite useful in old age. So my little experiment had not been a wild success. It could have been worse though. My cousin who really was in the army did the same jump and broke his back. Still, I rather enjoyed being an invalid. It is a profession in which no one can criticise you for doing absolutely nothing. And it made me feel close to Father, who was a cripple and a drunk. I couldn't help feeling that he deserved worse.

By the time I got out of hospital and was limping home on crutches, Ev had visited the Pussy Room (home to Genesis P Orridge and Psychick TV) and had her nipple and her nose pierced. It appeared to be the uniform for a new job in a Soho strip club. I didn't approve. 'Gee, what could you do to make yourself even less desirable? Cut your head off?'

I didn't like those Psychick TV people. It wasn't just that 'Do what Crowley wilt is the whole of the law,' seemed to be their philosophy. Before my jump we had raided a church together and I had managed to make off with the most coveted piece of loot. Now they claimed that it was one of their spells that had crippled me. It was they who had punished me. Oh well, it was sweet of them to have remembered me in their prayers I suppose.

They seemed to remember Ev rather often too. One of them fancied her. He stole her clothes, snipped off some of his pubic hair and masturbated on to the mix. This sorcery apparently was a way to win her. It all seemed a little elaborate. 'Hello. Any chance of a fuck?' would have probably done the trick.

The trouble was, there was no chance that I would fuck her. As distance decreases, affection fades. Our sex life was over. It had addled in the nest.

Of course, one should be wary of anyone who promises that their love will last longer than a weekend. I wanted time alone. I was far too much of an aesthete to really enjoy sex. How can you make love with your excremental organs? It was so naughty of God to put the chocolate machine in the playground. Not that I considered myself a bad lover. What I lacked in size, I made up for in speed.

I announced that I wanted to give up sex because it was what animals did. Ev was appalled. When we met, I had been all but a virgin. She all but a nymphomaniac. She was still aching with lust – and this put me off even more. Sex hasn't been the same since women started to enjoy it.

Of course I didn't understand. Sex is just a sublimation of drug addiction.

Drug addicts try to find artificial relief. But they can never be completely successful. So, tortured by all-consuming anxiety, they are sadistic, mystical, vain – and/or homosexual.

I remember the first time I had *real* sex – I still have the receipt.

Ever since spending my eighteenth birthday in the brothel in Paris I had been attracted to whores but without really knowing why. Of course I was far too gauche to do anything about it except fall even more deeply in love with the very idea of them. I always fell in love with whatever seemed weak, ruined, saddened, orphaned, disintegrated. It probably reminded me of my family. And I was quick to recognise in these sexual rummagers some equivalent of the artist outlaw. Both were by nature dissident. They took no part in society's rituals, observed none of its canons or taboos. The artist, like the whore, I believed, should be fit for the highest and the lowest society – but never join either.

Of course, it was all very well for me to idealise the under-world, to dream of a street life that was noble and picturesque – I had never had to live there. And I was certainly not about to

let that detail stop me. I was, after all, a member of the British middle class.

Sex for the proletariat is, by the very nature of its backdrop, rendered so deliciously sordid that no artificial degradation is required. It is the well-born, in contrast, who must forever twist and turn between the stained sheets in search of the precious grit of depravity without which they are in danger of lapsing into elegance – or worse, spirituality.

But on the evening of my first paid encounter with a call-girl I was not quite so confidently philosophical. 'I am a human being,' I wrote in my journal. It was vaguely reassuring. Anyway, it gave me the courage to call the number at the back of the porn mag. 'There's a red light outside my basement door,' I told her. I probably wanted to make her feel at home.

She had barely teetered her way down the dank steps before a skinny brown hand came out of the camel hair coat asking me for the money up front. Then she undressed and sat down on the edge of the bed, her thin shoulders hunched, her hands slipped between her thighs, her bare feet pointing inwards. She looked as if she was posing for Edvard Munch's *Puberty*. Ugliness is in the eye of the beholder. I looked at her face, at the line of knobbles that ran down her narrow back, at her caved-in haunches. I thought about the grave she had dug between her legs.

I stripped. Then gathering the threads of my personality about me like a policeman escorting a nudist back to the station, I arrested all thought and all feeling – except lust. If the urge was not met immediately it might degenerate into something less valuable. Pity, for instance.

She looked alive. Her skin was semi-warm. Occasionally she blinked. But her arms were as rigid as a corpse and her stare utterly blank. And every thrust that I made only carried me further into the abandoned cave. I listened to the dull slap of flesh on flesh, the great gulps of emptiness that came between. And I felt nothing – except a sudden, overwhelming mind-battering boredom. I climbed off, stood up, got dressed, said

goodbye. It had cost me £10. I remember thinking that I could have strangled her for £50.

For weeks, I turned the experience over and over like a coin in my memory. Desire and disgust, desire and disgust. I had crossed my own inner boundary. I felt the hard lurch of the excitement, the hot flare of the thrill . . . and then the curdling reality. My skin crawled at the thought of her chill custard flesh, her teeth like dead bones, her tits like dog's ears. I let my guilt twist into a hard contempt – a contempt that covered my appalled sensitivities. I craved a retreat. Suddenly it was the human heart I wanted, it was warmth and vulnerability. It was real emotion. It was sex.

I was elated that at last I had paid for it. I couldn't see what was wrong. Of course men proudly proclaim that they have never had to pay for it. They would never do that! But what are they saying? That money is more sacred to them than sex?

Money *and* sex certainly became rather more sacred to me than my girlfriend. Ev and I, whose lives until then had been cramped into rather close quarters, now moved up in the world. We aspired to a semi-detached relationship.

I was almost twenty-one and wanted to mark the occasion in a significant manner – which of course doesn't mean a party. Everyone says that small talk is their idea of hell. And I would much rather find my own hell, thank you. So I did.

The train wound its way into the clapboard and concrete station. All was silence. A few dismal trees stood stranded amid blank fields. Grey pathways meandered away into loneliness. I had decided to spend my twenty-first birthday alone in a gas chamber at Auschwitz.

I spent the day wandering around. I wasn't particularly happy. I was starting to feel distinctly helpless in the face of something so enormous. What did I, an insignificant artist, have to add? Art shows us that men can sometimes speak as angels. But when they behave like devils how can it respond? Not even the Jewish prisoners could really tell us what happened here. Who would

understand? It's like trying to explain to a tree what its like to be a stone.

The lone and level fields stretched to the furthest horizon and yet all was still. The lands which had witnessed such atrocities, lay peaceful as the night. I walked down the alleyways of the barracks, through the ruined crematoriums. Later on I found the ponds into which the ashes of the murdered prisoners were thrown. All was bathed in voiceless sunlight. It was left to the reeds to whisper their stories.

Art seems so much about clamour. To those who are loud and full of noise, the world sounds loud and full of noise. I knew that. I wrote at the top of my voice. And yet here I was compelled to keep quiet, to say nothing, expose nothing, produce nothing. Genocide is a good substitute for conversation.

In the evening I bedded down in a little clearing in the trees outside the camp walls. I lay amid the sort of silence in which you can hear the world groaning on its axle and the swish of falling stars. I stared up at the night: voluptuous and vast.

I woke up hungry the next morning, to discover I was in Poland. I'm sure this country has in recent times improved thanks to the introduction of modern conveniences – such as food. But when I went to Poland, it was closed.

I wanted a birthday lunch. It took time to find a café which boasted one dish – meatballs. I wasn't complaining. I find choice so confusing. I mean, how can one sanely negotiate 132 brands of biscuits, decide between twelve different types of mayonnaise? On the train back to Warsaw I sat opposite an old Polish lady who was eating her lunch – a small loaf of dry bread. Tenderly she picked every dropped crumb from her lap and put them in her mouth.

I was twenty-one. A little older and a little more confused. What had I done? My career, such as it was, had been a head-long rush – downhill. I wanted to get back to civilisation. The noise inside my head was beginning to disturb strangers.

When I arrived in London there was a letter waiting for me

from Jimmy Boyle to say that he was to be released that winter. I immediately rushed into college and started making a sculpture for him. The secret of creativity is knowing how to hide your sources. I simply raped him of his experiences. I copied one of his pieces and prepared eagerly to give it back to him.

But as far as I was concerned I was the prisoner now. Saint Martins had me trapped – although the idea of a parole into the wide world of chance and accident and choice petrified me.

If I find myself in a situation with an ejector seat available, I will always press the button – if for no other reason than to see what will happen next. But for once I didn't need to. It had just dawned on the college bursar that I had been there two terms and no one was paying. I was summoned to the head's office.

I hadn't met any of the teachers – let alone the principal. I supposed he would be a thin, bespectacled, Gothic creature, hysterically worried about the reputation of his school. I was right. There he crouched, barricaded behind a big black desk, looking extremely significant. 'Mr Horsley,' he said. 'Leave. *Immediately.*'

The school took every effort to ensure that his instructions were carried out. A photograph of me – a flattering one fortunately – was blown up and pasted like a 'wanted' bill by the front door. Under no circumstances was this man to be allowed on to the premises, it thundered. This cheered me up. It was nice and public. I was a pin-up on Charing Cross Road.

My inclination has always been to be either an outlaw or an artist. Now I was both. They were both the same thing. I had been fined and given a conditional discharge for a drugs incident, made a full recovery from a broken leg and now this. Police files/medical reports/college bans – I loved 'em all. They were my only claim on immortality.

Besides, art education is a mistake. Cluttering one's skull with facts about any subject other than oneself is a waste of time. The only advice college can really give to would-be painters is 'marry a rich girl'. I was already firmly wed to one: myself. I

waved goodbye. With a red handkerchief full of cosmetics (and the college's paints) tied to a birch rod over my shoulder it was towards Jimmy Boyle that I turned my toes.

The day of his release came at last. He was now thirty-eight. Since the age of twelve, he had been in and out of institutions – and mostly the harshest and toughest in the country. In all that time he had spent only twelve months and two weeks on the outside. He had never been free for more than ninety consecutive days.

Evlynn and I were there to meet him at the gates at dawn. It was November – my favourite time of year. The mornings were sharp and pale. I had dressed for the occasion – as a Nazi: in storm trooper coat, combat trousers and jack boots. My hair had been crew cut – except down the middle where a Mohican erupted in spiky rays like a black sun over the horizon of my skull. Tucked tight as a rifle butt into the crook of my arm was a 1970 vintage Dom Perignon magnum. I looked immaculately frightful.

The portcullis, when we arrived, was closed. But the place had the atmosphere of a football stadium. Row after row of arc lights lit up the scene with their eerie glow. The world's media were gathered, lining the driveway. This was public entertainment. 'Ah hope yous are meetin' Boyle, ken,' our taxi driver had growled when we asked him to take us to Saughton prison. 'Fuckin' wide-o cunt deserves a bit a Nazi treatment. Likesay, fuckin' mollycoddled 'e is.'

Jimmy, in his book, *The Pain of Confinement*, doesn't mention that we were there. 'I was taken to the gate where I waited for Sarah,' he writes. And his wife didn't approve of some of my antics. As I saw Jimmy approaching, I popped the cork on the bottle of look-at-me DP. She hastened anxiously over. 'Put that away. *Please*. Put that away. There are people who are unemployed and starving.' All right, I might have been a bit brash. But Sarah had such a harsh personality that, in its chilling air, the orchid of my style could not blossom. Her husband had been in prison

all his life and if anyone was entitled to a little celebration surely it was him.

Back at their flat over a 'freedom breakfast' (no doubt there are Nelson Mandela dinners too), Jimmy and Sarah told us about their plans to set up a centre in Edinburgh called the Gateway Exchange. It was to be a sort of last chance saloon. 'People coming out of prison, coming off drugs and those with mental health issues', was the official line. Murderers, junkies and loonies off the record.

The hoodlum world of art would be at its core. No change there then. 'The artist, like the criminal and the neurotic, have unpredictability and perverted innocence in common,' said Mr Capote. Jimmy had been converted by his experiences in the Special Unit at Barlinnie. It was there that he had finally put down the butcher's knife and taken up the palette knife. These principles could be used in a wider context, he thought.

I was excited by the project. I only had one incentive. Ev. Even as I had been ejected from Saint Martins, she had been accepted, at last, into Chelsea. And, having taken so long to get there, she was not going to give it up – even, to my gall (though I didn't actually want her), for me.

I set off for Edinburgh. My heart was high. I had just been expelled from Art College. I was brandishing an apparent contempt for authority. But this only masked a more extreme passion for it – a wish to be governed by unrestricted force. Jimmy was my man. With a heart-rending scream of agony and ecstasy, I threw myself at his feet to be saved.

6

The worst has already happened

Edinburgh is the grimmest city on earth. It's all hills and steps and, at the bottom of the steps and hills, poverty. I take great pride in my prejudice. The city is a centre radiating universal dullness. Rows and rows of houses the colour of atomic ash, so picturesque at a distance; so austere when near. The transition between Edinburgh and a graveyard would be unnoticeable.

Of course, the city thinks it stinks of genius. In reality it is hops. It is cultural only in that nothing happens. For eleven months of the year it produces nothing but vomit. And then in August there is a welter of frivolity – the Edinburgh Festival. Suddenly entertainment starts at half-past eleven in the morning and parks itself on every street corner – a bit like the vomit. That they choose drama is understandable. The stage gets stuck with anything too boring to be shown on television. But why go to the theatre in Edinburgh? Theatre is just shouting in the evening. And the entire city does that anyway.

I have walked the streets of the world dressed like a prick. But from Trench Town to the Bronx there is nowhere more frightening than Lothian Road, Edinburgh on a Saturday night. In other violent countries you are robbed because the good citizens are after your cash. In Scotland's capital you are beaten up purely out of spite. In Edinburgh, envy has no holidays. It snaps and pinches at your face like the bitter North wind.

And so the city sits in endless censure. But what makes them

most angry is that we, in England, don't really think about them while they don't really think about anything except us. They are obsessed, hopping up and down ranting about colonialism, making their vitriolic attacks like a mosquito staging its spiteful little assault on a rhino's hide. 'Ye fuckin' radge wanker' and 'ye doss cunt' were the first words addressed to me. Grace is an exotic in Scotland and when I was imported from England I realised immediately I would not grow, suiting neither the acid soil nor the bitter climate – nor the quaint local custom of trampling beautiful Humberside gentlemen to death.

I arrived in a black van which, being big enough to sleep in, became for the next three months my sanctuary – and my home. I felt liberated and excited and happy about everything – except the Scottish weather. Edinburgh is not unlike Siberia. The daily forecast is merely made to distinguish between weather which will freeze the entire North Sea and weather which will only freeze your ice cream. Even wearing two pairs of arctic-quality gloves my finger joints remained iced shut. Even with a polar hat my skull was cold as a cannonball and, worse still, my hair style was squashed. But even worse than that, I submitted to thermal underwear. It was so cold that I was thinking of getting married.

Unfortunately Evlynn had the same thing in mind. She came up for a reconciliation and told me she would come back on one condition: that we would be wed. She had made her plans on the train journey up. She wanted a big church wedding with blessings, bridesmaids, bouquets, baubles, balloons and a banquet. I just wanted to leg it. 'Yir behaving jist like a fuckin' big bairn,' she persuaded. A woman flings the word 'immaturity' at anyone who doesn't want to marry her. I didn't care. Ice was forming on the upper slopes of Mount Sebastian.

I would rather have driven a red hot nail through my bollocks or chewed my own foot off than get married. I had no desire to live a life of bourgeois domesticity. Ev was up for a month, her art college holiday, and we spent the time painting the Gateway

shopfront red and black and arguing. The more she insisted the more I resisted.

A woman seeking a husband is the most unscrupulous of all beasts of prey. Getting nothing from me, she went to work on Jimmy and Sarah. Now this little cloud threatened to swell into a storm among us all. Sarah took my side. 'You are far too young to get married. Don't do it. You'll both regret it,' she repeatedly told me.

So Ev turned her attentions to Jimmy instead. This was clever. She knew I was more interested in having outlaws than in-laws. If she could persuade him then maybe the snow would begin to shift on the high slopes. They started having a lot of exclusive dinners and lunches together. Letters were exchanged. One evening Ev even stayed at Jimmy's house while Sarah was away, to discuss military tactics.

Jimmy suddenly started behaving rather courteously – which was odd. Certain sectors of society are, by convention, exempt from ordinary manners – gangsters, for instance. I should have been worried. Jimmy, after all, was a person who well understood that to be polite to a man before you pump him full of lead only added to the pleasure. Now here he was taking me out for lunch every day. A typical exchange went like this:

HIM: Jis marri her.
ME: I don't want to.
HIM: Goo oan. Dae et.
ME: I don't want to.
HIM: But she disnae understond.
ME: What part of 'no' doesn't she understand?

Once it hots up, the snow melts and you get to see the dog shit underneath. I was being submitted to a stereophonic attack. When I spoke to Ev it was obvious that she had spoken to Jimmy and when I spoke to Jimmy it was obvious he had spoken to Evlynn. I didn't care. I had made up my mind – both ways.

At the end of her holiday we drove down to the sea. I was in rare fettle; my heart fluttered high. I don't know anything to brace the spirits like discovering that you don't have to get married after all. Ev sat glumly in the front seat. Occasionally we exchanged inanities and if she looked unhappy I stared down at the accelerator pedals for what I hoped would appear an appropriate interval. After a bit the only noise was the sea. It churned its grey pebbles and spat them out on the shore. I stared out at the endless horizon. Here was space to stay free. 'We must keep in touch,' I told Ev. It was English for goodbye.

Suddenly, a black van hurtled round the corner, tyres screeching, rubber burning. The seagulls exploded. The tourists ducked. The van door burst open. Jimmy Boyle.

'Ah jist git tae sey,' he coughed into our car window. 'This is they saddist moment of yirs fuckin' puff.' His advice was chucked up like vomit on to my lap, complete with big undigestible lumps of expletive. 'Yous are makin a fuckin' missake. See this cunt here?' He jabbed a finger at me. 'This is a useless bastard. He mibbe a man ay wit. A man ay class. He may be lookin' fuckin' smert but he's a useless bastard.'

Then he stumped round to Ev's side of the car. 'Awright doll? Dinnae lissen to this confused cunt. Git it sorted oot.'

It was nice to have made a heroic decision and to be prevented by 'circumstances beyond my control' from ever having to execute it. I capitulated. The avalanche had entombed me in its fall.

'Dinnae be sae fuckin' silly,' exulted Boyle over a victory lunch. 'Appreciate whit ah'm tryin tae dae. Yous are made fir each other.' If Scottish is the perfect language to sell pigs in then I had been sold. We were at Edinburgh's finest restaurant and I wasn't paying. I should have been suspicious. It is important to watch out when you're getting all you want. Only hogs being fattened for the slaughter get all they want.

Where Ev had failed, Jimmy had succeeded. It was easy to see why. He had become the centre of my life. My fascination was like some intense love affair. When I was with him, I was watching

his every movement, devouring his every word. I was jealous of his every friendship. I was always by his side. When I was away from him I felt unsure. I adopted his interests, conformed to his codes. I over-estimated all his qualities and thought of him as some god. I was terrified of doing anything other than what he wanted in case he should cast me out and then I would be lost.

The marriage date was set for the summer. We decided not to invite our families. Of all my wife's relations I liked myself the best. Jimmy, Sarah, Ev and I set off for the Isle of Iona. This rock off the west coast is supposed to be the burial place of Macbeth and the sacred site where Christianity began. Not that we could see the place as we huddled against the wind on the little ferry across. In the west of Scotland, spring can fade imperceptibly into autumn. The weather report is really a recording made in the twenties which no one has had occasion to change: 'Drizzle. Drizzle. Drizzle.'

There were only two places to stay on the island and both of them, unsurprisingly, were unoccupied – even by the staff. Twenty-four-hour room service, we discovered, referred to the length of time that it took for a club sandwich to be ferried across from the mainland in an open boat.

The day of the wedding dawned foul. I went out alone for a walk on the beach. The ocean stretched deserted before me, black as far as the eye could see, flat beneath the flight of the gulls. What the fuck was I doing? A thin drop of yellow sun seeping through a chink in the clouds, like a spot of pus through the bandages of a wound, did little to dispel my despair. I was twenty-one and my life was over. I thought about walking out to sea. I thought about running away. I thought about Ev floating by – drowned.

I turned and trudged back to the hotel. The dread of loneliness is greater than the fear of bondage. That's why we get married. But I seemed to have the worst of both worlds. I felt imprisoned and forsaken – both at once.

Slowly and silently I got ready. I dressed all in white. I looked

like a glass of milk. But inside I was black. Walking through the graveyard towards the chapel I felt about as hopeful as one of the tombstones.

The priest was waiting outside the church, like a ticket tout at the gates of heaven peddling his wares for four times their real worth. I shook his hand. He had a soft pale grip. I walked up the aisle. My soles clipped against stone like the tick of a death-watch beetle. Sarah was standing there at the front. There were a few off-white flowers and a Verdi tune was tinkling from a tinny little cassette player in the corner. The rings in my pocket, spun finely in gold, had been copied from Jimmy and Sarah's wedding bands. All of this had been Ev's idea and I had gone along with it. People can only agree about what they're not really interested in.

Ev was late. It is always a mistake. I passed the time she made me linger there at the altar listing all her faults. I could have done with another hour. But she turned up before I could get to the end – arm in arm with Jimmy. They approached slowly down the aisle and, when they could go no further, Jimmy passed her on to me. I did my best to look grateful – but resignation was my bride. I looked at Jimmy who was smiling. Well he may. He had just handed me a life sentence – and without the pleasure of committing murder first.

'We are here today to honour the union of . . .' As the priest began to drone I drifted off. I was fantasising hysterically in my head. *Fucking hell. What a carry on. You go to church when you are married or buried. Matched or dispatched. One promises happiness; the other guarantees it.* I spied the large crucifix on the altar. *Oh well it could be worse, I suppose. Married and religious. How ghastly! Torment in this world AND the next.*

Looking down at Ev clutching her little bouquet before her I felt a heart-rending pity which made me want to pulverise her. She was here for *me*. All she wanted to do was be married to *me*. How utterly despicable.

'Do you . . . woman . . . take this . . . *Sebastian* . . . do *you* take

this . . . *SEBASTIAN* . . . WELL, *DO* YOU?' A sharp nudge in my left side made me come to. I was still here. She was still here. 'Err, what was the question?' Ev gazed up at me with her big, bug eyes. I stared back astonished. Women: sometimes murdered, often deserted, rightly ignored.

Eventually, we signed the register and left. I lagged behind. Gazing out over the fields, at Ev beginning to pick her way across them, I wondered about unexploded landmines. Sarah fell back to wait for me. 'You are married now Sebastian,' she said. 'You must walk alongside your bride.'

Yes, the first part of our marriage was miserable. But it was on the way back from the ceremony that things started to go wrong. We had lunch at one of the hotels, and lunch – as it tends to – turned into dinner. I had brought a case of champagne and then proceeded to get so drunk that there is an abyss like a black hole in my memory. All I recall is that *everything* seemed to have tumbled into this void – everything was black, including the wedding cake. Even our teeth became funereal. It was yet another reason not to smile.

After dinner I stripped naked and ran round the hotel letting off all the fire extinguishers, as you do. I was looking for Jimmy and when I couldn't find him I returned to the bridal dump. After ten minutes there came a knock on the door. It was Jimmy in his dressing gown. He came in and sat on the bidet.

'Fir fuck's sake. Doss cunt. Ye want tae git us flung oot? This is nae way tae behave in a wee family hootel,'

'Sorry,' I said.

'Dinnae gies yir crap,' he said.

Jimmy stood up and his face broke into uninhibited giggling. He had defecated in the bidet. Lying behind him was a huge, shining shit.

'Mind it dinnae bite ye,' he said as he left the room.

Ev and I were finally alone. We thought about consummating the marriage – but settled on a fist fight. First, she punched me

in the face. Immediately sobering up I looked about me. A gentleman, I had read, was someone who never hits his wife while ladies are present. I gave her a black eye. I wanted to give her more. You can tell it's love when you dream of slitting her throat.

'I never wanted to get married,' I spat, as I stormed out of the hotel. My marriage had ended on my wedding day, I thought. I walked and walked and walked, venomous in my anger, amoral in my tirades, murdering every sacred cow and pouring withering scorn on everything – except myself. What a carry on. At least I had got married early in the morning. This way, with it not working out, I hadn't wasted a whole day. I eventually found what looked and felt like a nice soft bed to sleep on. I lay down and shut my eyes.

The morning arrived, grey as a hangover. I was woken up by Sarah looking rather perplexed. And little wonder. I was spread-eagled on the beach. My entire body was covered in sand. Even my mouth was full of grit.

'I can't find Ev and Jimmy. Have you seen them?' she said.

'Mmmmmmaaaaaarrrrrghh,' I replied.

They were the last two fucking people I wanted to see. I was bloody sick to death of them. Getting married was the only way I could express my contempt for both of them.

Meanwhile, Jimmy had had to spend the night with Evlynn, persuading her not to leave.

Sadly she didn't. Back in Edinburgh we bought a little cottage next to the Gateway and moved in. I was not happy. I would have rather lived with a gas leak. But there was nothing to be done. I plodded into my new married life like a bullock to the abattoir. Ev wore her ring on her finger. I wore mine through my nose.

What kept me going was the Gateway and, more importantly, Jimmy. Evlynn and I became co-directors of the project with him and Sarah. Jimmy had announced to the media that he wanted to campaign for change inside the institutions which he

felt had brutalised him. 'If you treat people like human beings they will act like human beings,' he said. Within a month of its launch, the Gateway was full of murderers, junkies, lunatics and sexual deviants – I was well camouflaged. We all tend to idealise kindness and tolerance, then wonder why we find ourselves infested with losers and nutcases.

Jimmy decided it would be a democracy. We were to run the circus from the monkey cage. Weekly meetings were held in which we all sat in a circle and everyone had a say. It *was* the only system available. Communism was too dull. Fascism was too exciting. Democracy was the most palatable. Its drawback was its regrettable tendency to encourage people to believe that all men were created equal. You only needed to take a quick look around the room – not least at the strutting Jimmy Boyle – to see that this was not the case.

Basing itself on the model of the Barlinnie Special Unit, the Gateway put creativity at the centre of its programme. It had a gallery and a theatre, a darkroom, a pair of workshops for painting and for video production and a band rehearsal room. But it seemed to have escaped us that you can't create a career for someone without talent. Rather it made us even more hysterically generous. Painting and sculpting tools, courtesy of my time served at Saint Martins College of Art were provided. To my delight, this made me very popular. Criminals get along famously with artists. They recognise us as fellow thieves.

One day the Clash turned up. Nice middle-class boys who, of course, had been to de-elocution lessons – *nah wat i meeeeaaan* – but they donned our T-shirts and did two concerts in them. One was an impromptu acoustic set outside the Gateway. Strummer hung upside down like a bat on the gates of the centre singing his head off. The unfeasibly handsome Paul Simonon stood at his side strumming a guitar. All the traffic slowed. By the time the song had finished, it was stationary.

Mr Strummer was enamoured by Jimmy exactly as I had been. I imagined he felt that because of his background he hadn't

lived. Strummer was the son of a diplomat rather than a bank robber. He posed for the front cover of *Sounds* with his arm round Jimmy. And then he displayed himself in a double page spread in the *New Musical Express* wearing the Gateway logo, which *I* had designed. Before he left he took Jimmy aside. 'We are going to make a sizeable contribution to the Gateway, for the kids,' he confided. But judge a cover by its book. He never sent a penny.

We didn't believe in charity anyway. We were anti-establishment. Charity was useless. The poor were right to be contemptuous of it. It was better to steal than take alms. Someone who was ungrateful, angry and rebellious was to us a *real* personality. We, like the Clash, thought it was better to rob a bank than work in one.

Not that we needed to rob one. We could have opened a bank ourselves. The project was independently funded (state money would have compromised our autonomy, of course). We even refused Arts Council cash (we didn't want to sail off into a sunset of respectability). Everyone in the place, including the four directors worked for nothing, except Jimmy who slaved for his own glory – and me who serfed for it.

But we were not quite as rebellious, or generous, as we liked to imagine. You think of nothing but money if you don't have it. And you can only think of other things if you do. And we did. We had cash – from Sarah's family.

Sarah was the daughter of the film censor, John Trevelyan. I had seen his name flickering in the forgetting chamber as I grew up. He was the man who had passed *A Clockwork Orange* and wrote a book called *What The Censor Saw* which I stole from Saint Martins College of Art library and left ostentatiously on the table to impress Sarah. But the family's real money came from insurance. I don't know exactly how much she carried with the Provincial, but I suspect that when she goes, they go. She had the kind of fortune that made you want to show up on her doorstep with adoption papers.

Jimmy did not marry her for money. He was clever enough to fall in love with a millionaire before marrying her. To him romance without finance would have been no good. But I didn't particularly get on with Sarah. She had a menacing earnestness. And we only really tolerated each other for Jimmy's sake. She took her food and wine flavoured only with guilt. And why do people who care about world issues have to dress as if they have fallen into the ditch which they are trying to pull everyone else out of? She seldom smiled. When she did it was thin and flickering as one of those fluorescent light tubes that have gone on the blink. Difference in humour is a great strain on the affections. She was so *serious*. Conversation with her was as heavy as wading through treacle in flippers.

But through her and Jimmy's connections we raised lots of money. Jimmy went on the *Wogan* show. He persuaded Billy Connolly to do a concert. Sean Connery and John Paul Getty made contributions. The rich and the famous paid for the useless – a tax loss for a dead loss. Not that *the kids* noticed. Benefactors seem to love those whom they benefit more than those who receive benefits love their benefactors.

It's strange: art with political or sociological meaning doesn't interest me now. Only the second rate imagine that they have messages to deliver. And yet, in the same way that I mock Sarah, I realise that I too was suffering from Stockholm syndrome. The prejudiced idea that the 'working class is where it's at maaan', which I had first encountered with punk, as if going to university or coming from a middle-class background makes one less authentic than an unschooled intellectual barbarian.

I was a bit too daft to see that smart people can be just as sincere as stupid people. It hadn't yet dawned on me that Mr Dylan was middle-class and not a hobo or that Iggy Pop played golf. Also – the fact that people are poor or discriminated against doesn't necessarily endow them with any special qualities of justice, nobility, charity or compassion. In the Gateway the petty fights and vanities proved that no matter how much revolution

was going on, the nature of human beings remained exactly the same. Even the prison culture, to a certain extent, existed within the place.

I threw myself into the workings of the Gateway and set about writing to the incarcerated and visiting them. My first trip was to Peterhead, the long-term prison in Scotland. Set in the far North it was like travelling to the very edge of the world. I walked across the barren yard. I could smell the frost in the air. It prickled the lining of my nostrils. The prison warden strode ahead, his keys jingle-jangling amid the bleak stone.

Here in a cubicle no bigger than a phone booth I met a man who had been knocked off a wall during an escape attempt by prison officers throwing rocks at him. They had beaten him so badly he had been left a cripple. Sarah employed lawyers and helped with his case. When he was finally released he came to work at the Gateway. I was hoping that he would come in like the Sundance Kid all guns blazing for our worthy cause but instead all he ever did that I can remember was sit in a corner and smoke dope.

Some of our other 'causes' were even more celebrated. Visiting Durham H-Wing I sat opposite Judy Ward the convicted IRA M62 bomber (although this conviction was later quashed). I had never met a terrorist. They tend to be closety types. But I was surprised to meet one with a grasp of anything other than a hand grenade. How anyone's aims could be advanced by blowing up people unrelated to one's oppression was a complete mystery to me. Not that I cared particularly nor did it even occur to me to ask her about it. Rescue fantasies are as much to do with praise and reward for the rescuer as they are with altruistic concern for the one rescued. I was feasting off these people like a crow on carrion. I peppered off missives to the Kray Twins, to Frankie Fraser and – oh wow! – to Myra Hindley.

Better still, it had just been revealed that she and Brady had killed *far more* children than was originally thought. It was as if Raskolnikov had turned out to be a serial murderer. Sarah

had been advising the pair for years to come clean. Brady had ignored everyone – but at least he'd had the decency to go insane. If he had been a real gentleman he would have hanged himself. Hindley on the other hand hungered for freedom and had withheld information as a result. She was a vicious torturer. But my letters still began: 'Dear Myra.' (My esteemed Genghis . . . My darling Chairman Mao).

Naturally, my sympathies were with the criminal rather than the victim. They were so much more glamorous. Besides Jimmy had told me: 'It takes two tae make a murdah, ah'm telling ye. Thirs are born fuckin' victims, born tae have thir throats cut.'

I didn't really understand what I was doing. At that time I believed that anyone who supported capital punishment should be shot. Now I'm for a stronger death penalty. There are certain crimes that are simply too cruel, too sadistic, too hideous to be forgiven. More importantly it was not our place to forgive. It was Lesley Ann Downey's mother's place. Jimmy and Sarah sneered at Mrs Ann West every time she was on television revved up by the media to renewed rage and tears, swearing she would kill Hindley if she got out. 'She's stuck in the past,' said Sarah. It didn't seem to occur to them that if you pardon a murderer, you must also pardon him who will kill the murderer.

What I was espousing had nothing really to do with any of these people: altruism is the art of doing unselfish things for selfish reasons. I invented banners and clutched at them; hungering for slogans that would robe *my* life in meaning. Because I didn't comprehend what I was involved with, I floundered between indignation and an almost fatuous conception of justice. I festooned the dung heap on which I had planted my flowery theories as people grow honeysuckle around outdoor privies.

But of course idealism increases in direct proportion to one's distance from the problem. I was hated in the Gateway – and not just because I was a twat – or so invincibly middle-class, for that matter. Wherever they come from, people who mean

well are always a poisonous class. An ex-prisoner, Boyle's brother, got me against the wall once when I had politely pointed out that carrying a six-inch blade down his trousers was not so good for group morale.

'You want a fuckin' burst mooth, cunt?'

'Err, no thank you.'

'Yir a nice guy, pal. But yir a fuckin' radge. Stay oot ay it or ah'll chib yir ya crappin' cunt,' he spat.

I took the view that I didn't have to agree with people to defend them from injustice. But in truth it was all a bit much for me. I could barely understand what they were saying. These people found it difficult to express themselves without dragging their genitals into the conversation. If the words 'fuck' and 'cunt' had been deleted from the English language, they would have been rendered mute. When I finally translated what they were saying I found I didn't much like what they meant. That's the trouble with fighting for human freedom – you have to spend much of your life defending wankers and tosspots.

I was protected within the place because of my relationship with Jimmy. Perversely enough, I was seen at the Gateway, if not as a leader, then certainly as second in command. The people there were asked to find their identity in someone who barely had one. Jimmy ran the Gateway in the same way that he had run the Special Unit: democracy meant everybody agreeing to do what the leader wanted and team effort meant lots of people doing what the leader said. The leader was, of course, Jimmy. He would have liked to have claimed credit for the sun rising each day. And he probably could have. When he went away, even for a few weeks, the whole place fell apart.

I was his servant. Boyle was an imposing person, with a self-confidence bestowed on him by the violent edge that made others cower. When he gave commands there was nothing to do but obey. For me, he took the place of an absent parent. He knew just how to frighten and to be tender, a method of persuasion

whose efficacy has been proved for thousands of years in the relations of parent to child.

What I loved about Jimmy was that he allowed me to express forbidden impulses, secret wishes and fantasies. He seduced me because he did not have the conflicts that I had. As a leader he wiped out my fear and permitted me to feel omnipotent.

Much later, I slowly came to recognise that I was meeting the same person time and again in a thousand disguises on the path of life. Father. I was projecting my own Father image on to him, giving away my own authority and reverting to my early passivity. I carried within me the bondage that I needed in order to continue to live, craving my own subjection. As a slave, I was in love with my own chains.

When I think of my own eager fascination, I feel revolted by myself and by the obedience which looked with such timidity and satisfaction on Boyle. Look how I blushed, how my hands reached out tremblingly, how my eyes lowered and darted to one side, how quickly I choked up, ready for tearful and grateful submission. How smugly I, nearest to the leader, smiled how puffed up I walked. I remember how hazardous it could be to look him in the face and how blissful it was to bask trustingly in the glow of his power.

But back then, I was happy. It is dangerous to free people who prefer to be slaves. I wanted to believe that I could live in the land of my favourite movie, Sergio Leone's gangster epic, *Once Upon a Time in America*.

I was intoxicated by the romantic life I saw Jimmy and me leading. I was Noodles and he was Max and ours was true affection, tried and tested in the fire. Byron said that friendship was 'love without wings' but he was talking about man to woman. As far as we were concerned only men had the wings for love and no one else, especially our wives, could flutter up to our fire.

I detested married life. I didn't enjoy or want sex with my wife. I could not mate in captivity. Domesticity destroys desire.

I felt great guilt at marrying Ev when I hadn't wanted to. I resented having the pressures of house-training pitted against my muse and spirit. A dandy can be seduced, enticed, enraptured. But he cannot be caged any more than a butterfly can, without losing his beauty in the process. I hated having the mundane clutter of life – like my wife – standing between me and my mirror.

One evening she caught me masturbating into the kitchen sink.

'You goat a fuckin' problem ye bam pot. What's wrang wi me?'

Certainly it was a delicate situation. I tried a bit a smooth talking.

'Sweetheart, you are occasionally quite a serviceable substitute. But don't you know the proverb: one with the hand is worth two in the bush.'

'Ah dinnae ken whit the fuck yir oan aboot ye daft bastard – oh and by the wey – put yir knob away.'

We simply didn't understand one another. Masturbation is not only an expression of self-love; it is also the natural place for those auto-inventions who have accepted the melancholic chasm between fantasy and reality. I felt the same gulf when I thought about my cohabitation with Ev. It is easier to die for a woman than live with her.

We never treat anyone quite so badly as the person we profess to love. I didn't care. My attentions were directed towards Jimmy. He was the leader, and the leader performs the initiation ceremony.

This took place in Ireland, an appropriate spot: it is a country full of genius, but with absolutely no talent. And this was where we came in. Our exhibition was called *New Beginnings: Jimmy Boyle and members of the Gateway Exchange*.

Jimmy and I arrived in Belfast early in the morning. It was a wet, windy day. The sky was the colour of a battleship. But then the whole town looked like a war zone. The façades of the

buildings – police stations, television studios, even the dole office, were ironclad – like the sky and the sea and the faces of the people in the streets. Windows had been narrowed to slits or sealed up. Doors were firmly shut. And entire houses were kept in cages where they squatted, like some somnolent zoo animal, glowering at passers-by through the bars.

Our arrival, like that of anyone from Britain, was interpreted as a gesture of affirmation – a message of hope, even. The organisers of the exhibition competed with each other to treat us well. We held a press conference all sitting in a row behind a long table – Jimmy, in the centre of course, and answering ninety-nine per cent of the questions. I think about all I told anyone was my name. And I wasn't even sure about that. I was horribly nervous, swinging my crossed leg back and forwards so neurotically that eventually my foot appeared through the paper screen that covered the table front.

In the afternoon, after setting the show up, Jimmy went off to meet the infamous terrorist Gusty Spence. He had been the founder and first commander of the Ulster Volunteer Force and, convicted in 1966 for one of the early murders of the Troubles, he had served eighteen years in prison.*

We reconvened later for dinner. The table was reserved, but we weren't. Outside, night had spread her black cloak over the city. Inside, we drank Cordon Rouge, the champagne of Max and Noodles. We raised our glasses dizzily.

'God created alcohol just to stop brilliant deviants like us from ruling the world,' I crowed.

'Yir patter's fuckin' abysmal,' said Jimmy.

The evening glowed on. We knocked back the champagne like there were too many tomorrows, forgetting ourselves and doing something everybody else remembered.

As we weaved our way back to the hotel through the boarded-up buildings and road blocks and soldiers with submachine guns

*Gusty Spence has now renounced violence and is a politician.

we were happy. That night, if someone had thrown a petrol bomb at us, we would have drunk it.

Back at the hotel, our rooms were next door but one to each other. I was so drunk that I couldn't even find my door, or its handle, or my hand's way towards it, or the bit of my brain that would explain how to turn it. But I clearly had a plan.

I stripped naked. Now what? Aha! A balcony! Out the window and on to it. The view was a bit dizzying – for onlookers, not for me. Now what? I spotted another balcony about four feet away and made a bollock-dangling leap.

'Oy!' someone bellowed. I looked down and spotted a soldier waving his gun and gesticulating to me to get immediately down. I think for the first time it dawned on me that I might have made a bit of a mistake. I mean, who doesn't long to be worthy of assassination? But I had gone to Northern Ireland to be *shot at* – not to be shot. Still, once you have overleapt the halfway mark there's no point turning back. I made a leap for Jimmy's balcony and started hammering on his window pane.

I think I fancied myself as the elfin extra in *Wuthering Heights*. 'Fuck sake's man. Cannae even git a bit ay peace in yir ain fuckin hootel,' said Jimmy hauling himself out of bed and staggering towards the source of the racket. 'Whit is that oot thair anywey?'

I surveyed my tall muscularity in the plate-glass reflection with some satisfaction. 'Whit's oot here is pure Greek,' I told him. 'Now do let me in.'

He obliged and suddenly stood there in front of me, taut, tight, with a lean hungry look – and a turgid erection. We fell into a mutual embrace. Together, overhanging Belfast with the soldiers gazing up at us, our coupling seemed elevated into something exceptional, complicated, and ridiculously heroic.

Sadly I no longer felt so chipper the next morning. Boyle had fucked me all night and I couldn't keep my shit in. I appeared to have undergone a colostomy operation without an anaesthetic. I lay back defeated, and farted. A fishy spray of spunk sputtered out of my rear end.

We breakfasted in bed, and then reclined side by side, giggling like two schoolboys. The whole world was upside down. Certainly, the chandelier was in the bath and there was shaving foam all over the ceiling. We cracked open the minibar to fortify us for the day ahead. I looked across at Jimmy who suddenly looked a touch . . . well . . . posthumous. 'By the way, what was Gusty Spence like?' I asked conversationally. 'Ye better keep yir voice doon,' replied Jimmy. 'He's under the bed.'

The show included work from ten Gateway members. It was interesting for its failure to accomplish what it had set out to do. Jimmy had written a manifesto. Art had to have a social conscience. It had to encourage change, etc etc. I had heard it all before – I had written it – or rather I had sat up with Jimmy and Ev pretending to help write it. It was hopeless. Once you've created something you can't then try to support it with a scaffold of theory. Either it's worked or it hasn't. And it hadn't.

The show went on to Dublin. The worst of our charity, it seemed to me, was that the lives we were begging people to preserve were not particularly worth preserving. And their work, most definitely, should have been scrapped. Sure, I spouted the Gateway policy interminably. But I was like one of those tramps who shove their rusty trolleys of possessions along the streets. My baggage included no real faith or belief, just an assortment of prejudices. All I knew was that I wanted to be with Jimmy. I couldn't change the world. I couldn't even change a fuse.

We trundled our show about a bit – to Iceland etc. But I wasn't particularly interested in travel. It was only really glamorous – or indeed remotely tolerable – in retrospect. We were never going to be voyagers, returning home with a caged parrot and fantastic tales of foreign climes – we didn't even bring back the duty free because we drank it all on the flight. We crossed the world not to see but to be seen. Jimmy's notoriety was growing. It almost bordered on popularity. My name wasn't going to land happily in some far-off time or place. So I hitched my wagon to his star.

Whatever Jimmy Boyle did was front page news in Scotland. I would come out of my house in the morning and find photographers lurking in the privet hedge. (Extremely annoying – how dare they not be there for me?) 'Killer Boyle', 'Scotland's Most Violent Man', 'Mass Murderer Boyle Crucified Me' screamed the red tops. It was naughty of the tabloids to pander to its style-less readership by uttering 'tuts' of disapproval between thin lips. It expressed an attitude that bordered on perversity. Journalists need scandal as the police need crime. Their behaviour only bonded me closer to Jimmy.

One evening, after a drunken dinner spent with a female friend (I would of course tell you her name if I could remember it), he had disappeared into the bedroom with her leaving me staring at the wall for half an hour listening to the Smiths – who I hated. It didn't occur to me that they were having sex. I think I thought they were chatting about world issues or something . . . whatever it is people do. Eventually he returned, sat down next to me. 'Ah wanna dae Ev,' he said conversationally. To me it seemed a bewildering non sequitur. 'Ah wanna fuck the erse oafay it.'

This was not something I had prepared myself for. I didn't want anyone intruding on my relationship with Jimmy. But did I have the authority to stop it? Jimmy had told me from day one, 'Ah haeve tae be the doominant wan. Ah couldnae handle some cunt's knob up *ma* erse,' which suited me.

One evening, after a nice supper of cottage pie and ice cream, we were sitting cosily by the fire when Ev chirped up, 'Fuck this.' I began to suspect she had something on her mind. She did. And Jimmy had put it there. She wanted a threesome.

'Mibbe this is what ye want,' she suggested persuasively. It wasn't. I had chosen slavery because it felt safe and so meaningful. Now I was losing the meaning.

What distinguishes our little human society from a farmyard? This was a menagerie à trois. I remember the pounding, the rough animal grunts, the sucking and the slurping and the licking.

I remember the unforgiving slap of flesh and the awkward protuberances and the ungainly limbs. I remember lying there, my arms rigid as a semaphore signaller. I remember just thinking I wish this would stop.

'Leave Ev out of this,' I said to Jimmy the next day, mining some hidden seam of courage. 'I don't want that to happen again.' I went for a walk around Arthur's Seat and sat on the crag overlooking the city. I was not happy. When I had married Evlynn, I had been all but a virgin. Now my sexual feelings were coming properly alive, I didn't want her involved.

'Want tae talk aboot it?' said Jimmy. 'Mibbe yir a shite stabber, a buftie pal, ken?' I didn't have any way to counter his attack and sure enough it was only a matter of weeks before Jimmy and I ended up in bed with another girl from the Gateway called Suzi – a scenario that was to repeat itself with the regularity of a West End play – only the bit part players changed from time to time. Soon, practically everyone in the Gateway had been bedded.

It had taken a while, but finally I had discovered the joy of sex. Of course I had discovered it before – on my parents' bookshelves – and even then I had dived in avidly, thrilled by all those acrobatics – and those tits (though rather wishing that that bearded pervert would get off her). But this wasn't the theory any more. It was the practical. I plunged into a crowd of strangers. I didn't want my pleasure encumbered by the convolutions of romance. I wanted pure indulgence stripped of all that clutter of personality. I snatched as much as my nervous system could stand. My situation seemed to have changed. Even my attitude to marriage had changed. I didn't mourn anymore that I had tied myself to one woman. I was enraged that I had separated myself off from all the others.

But that was women. On the male front matters were slightly more complex.

Jimmy, Ev and I went out for dinner one night at one of those awful sort of restaurants where there are more waiters than diners and they hover anxiously at your elbow, leaking sycophancy and

hoovering up crumbs from the tablecloth at every opportunity – which was very often with Jimmy who ate like some milk-cart horse that has been offered a stale bun by the little boy up the street.

After drinking two bottles of champagne Jimmy suddenly stood up. 'Let's get ootay here. Ah want tae go hame.' 'Hame' happened to be my house. When we got there Jimmy helped himself to more drink from the fridge and sunk into the sofa. As usual, it was impossible to get a conversation going because he was talking too much and eventually the monologue moved on to some tedious Gateway project. There was a document he needed suddenly – and rather pressingly – from the office file. 'Go 'n' fuckin' git the cunt, Sebastian,' he persuaded.

Meekly, I trotted off. It took quite some time to find the thing he wanted. But, lost in a haze of alcohol, I was quite pleased to have found it at all. I set off back home, clutching the papers, dropping a few of them and then scooping them back up again as I fumbled to turn the key in my front door. I started up the stairs.

I heard the sounds first. A glutinous sucking. The intimate murmurs – their secret language. I walked down the hall. I suppose I felt resigned. Jimmy was shoving his way up Evlynn – and in my kitchen.

I just stood there and stared. His shiny tracksuit pants were wrinkled round his ankles. His little white bottom was bobbing about. I could see the soles of her feet. They were grubby and yellow. And her body was sprawled between the kettle and the toaster. Dignity is the only thing you can't preserve in alcohol.

I did not utter a word. I was shaken by this revelation – two people, whom until now I had regarded only as reflections of my own existence – in violent relation to each other. I was forced, for the first time, to admit that other people existed – or worse still, that for other people I didn't exist. Silently I walked away down the corridor and got ready for bed. Confusion is always the most honest response.

It was 1985 when the inevitable finally happened. I had been reading Mr Warhol's autobiography. 'Sometimes people let the same problem make them miserable for years when they could just say, "so what"' he said.

'My mother didn't love me.' So what.

'My husband won't ball me.' So what.

'I'm a success but I'm still alone.' So what.

When Ev approached me one afternoon with a face like granite I decided to try out this excellent little philosophy.

'Ah'm pregnant,' she said.

'So what.'

My ears would have been singing from her slap three weeks later if the sound of her nagging hadn't drowned it out long before.

Of course, I dutifully picked her up from the hospital after the abortion. I got there at the designated time and she was lying in a bed that had been soiled with her own self-pity. I knew it was a serious, painful, insomniacal time because she told me so. People who are unhappy, like people who sleep badly, are always proud of the fact. (The contrast couldn't have been more marked six months later when my sister Ash was in the same hospital for the same operation. When I arrived bearing flowers I found her already at the gates, dressed as if for the opera – not the operating theatre. 'What time is dinner booked darling?' she said.)

I wasn't very sympathetic to Ev. 'Ah've hud an abortion,' was all I heard from her the next time.

All Ev had wanted was my heart. That gone, I had so much more to give her. In a sexual encounter, there is a moment, which many people may never know, in which orgasm is followed by a lull of sad but transcendental peace. It flows out of every pore of the body in a surge of gratitude. I was buried deep in this experience one evening – with Suzi – when Ev walked in. That we happened to be lying naked on the carpet was certainly irregular – that it was Jimmy and Sarah's shagpile, merely a detail.

'Whit the fuck are ye daein' ye pair ay fuckin' slags,' Ev screamed. I knew she was stupid. *Was she going to believe me or her own eyes?* 'We're hoovering,' I ventured.

She wasn't wearing it. She glared at Suzi. 'Ye bag ay shite. Ah'm gaunnae brek that fuckin' trash up . . .'

Ev was thrilled to have caught me out. She thought she'd been shrewd. In reality she was only suspicious. She'd had a key cut for Jimmy and Sarah's flat and was ostensibly checking their mail. Never attribute to acumen that which can be adequately explained by straightforward malice.

Ev started reading my mail, listening in on telephone conversations and even following me. If her espionage had been truly professional she would have known that it was Suzi's turn next at the infirmary. As with Ev, Jimmy and I had no idea who the father was – not that I cared. I was *for* abortion – having come so close myself I could thoroughly recommend it.

I would have recommended pretty well anything at that time – even myself. I was constantly drunk. But I was disciplined in my destructiveness. Like Father, I would work until six o'clock and then breach myself with booze. I thought I was drinking because I was unhappy. It didn't occur to me that I was unhappy because I was drinking.

But nobody at the Gateway seemed to notice. I think we were all too self-obsessed to think that much about each other. Jimmy was kept busy staging smash-and-grab raids on the sexual organs of anyone who happened to be hanging about. I was pretending I had got over his affair with Evlynn. 'Greater love hath no man than to lay down his wife for his friend' and all that. And Evlynn was drowning in the sewers of her own insecurity. I am ashamed now to say that I didn't even notice. But that was the trouble with the Gateway. We all set extremely low personal standards – and then consistently failed to achieve them.

One evening there was a Gateway promotion at the Embassy club in London. It was a big deal. Pete Townsend and Richard

Branson had arranged it. They wanted to meet Jimmy and to give us some money for 'The Kids.'

Even in those days I hated those charity beanos – all those rich fuckwits buying a reputation for generosity on the cheap. I hated the jockeying for position, the hankering for priority, the looking over your shoulder, the fake concern for 'the cause'. Besides, it was 1986. 'Feed the World' had just happened. It had been blatantly absurd. AIDS, cancer, starvation, nuclear war, pollution, and the end of the world, are no more solvable than the problems of finding a smudge-proof mascara. The depletion of my hairspray is more important to me than the depletion of the ozone layer. Whenever I was forced to look at pictures of bouncy biafrans on the television, I only thought – it's little wonder they are all starving to death. The food there is inedible. I was not moved. Had it been 'Fuck the World' I might have sent a fiver.

I looked around the Embassy, seething with contempt. The fact the BBC wanted to film it only irritated me more. Stiff with authority, I strode over to their equipment, picked up a couple of cameras and walked out of the door. Finding a dustbin on Oxford Street I dropped them in. The next day the *Observer* ran a piece about the soirée, mentioning the fact that the BBC had been unable to film it because someone had stolen their equipment. I was pleased. Crime is as human as being charitable. Why help a bad cause when you could hinder a good one?

On another occasion we were commissioned to do a public sculpture for the centre of Hull. You might ask who on earth would have commissioned us? Well, Grandfather actually.

Grandfather was a touch vain. He couldn't walk down a street without trying to have it named after him. He had already published two books: *Poems at 70* and *Findings at 80*. (I had suggested a trilogy. *Bullshit at 90* would be the logical successor.) But, all joking apart, it was not surprising that his work was printed. He paid. Now he decided, with death approaching, to build a monument to his transience. An 'Alec Horsley Room' at

Worcester College, Oxford was clearly not enough. I mean who wants something so mundanely functional, so banally practical as a mere place to sit. He was after something even more inspiring, more profound, more enduring. What about a park bench? No. My family never had any taste. He decided on a sculpture. A sculpture by Jimmy.

Ten thousand pounds was the opening bid. Jimmy and Ev went down to Hull for a meeting at my grandparents' house – where they slept in the same room. Not that my grandparents would have minded. A golden wedding in my family means you've just got married for the fiftieth time.

Father had three wives – of his own.

Mother. Born mad. Remained so.

Stepmother 1. Had a long working arrangement with madness before finally deciding to put the relationship on a firmer footing and getting herself committed.

Stepmother 2. No mind to go out of. Face unclouded by thought. She once had a stroke but no one noticed. Father, having married two loonies had finally married his mother. These two ladies had so much in common. One was a moron and one was a golfer.

He was with Stepmother 2 when Jimmy and I came down to Hull for the second meeting about the sculpture. This time I decided that it would be better to stay in Father's house. I hadn't actually seen him since our fight over Mother's maintenance six years earlier. He had a way of ignoring all his children with complete absorption. But he seemed to save something special for me – an *utter* indifference which he, better than anyone else in the whole world, could induce effortlessly. He wasn't even angry with me. As for me, I guess I could have phoned him. But why? Why go for a pale imitation of nothing? I prefer the real thing.

But now I wanted revenge, again. Of all the passports issued by life – money, wisdom, beauty, fame – the Horsley family were interested only in the last. It was the only country for which

they craved an entry visa. It didn't matter if someone was fascinating. They had to be known. Then they were fascinating because they were known. Now, at last, I had a trophy. Jimmy Boyle. I dropped him on Father's doorstep like a cat drops a mouse.

Jimmy and I started drinking at breakfast, after we had opened all the cupboards, to find better bottles than those which were shaming the sideboard. We turned up a magnum of 1975 Dom Perignon and a particularly fine claret which Father would never have been capable of appreciating. The best revenge is to live well.

By the time Father and Stepmother 2 joined us for lunch, we were not just lit we were flaring like torches – or torched faggots maybe. I goggled over my glass at Father. Cunt. But he was interested only in Jimmy and directed all his discourse in the other direction. Cunt, I thought again. Look at him. Liquor certainly hadn't made him any quicker. He sat there in his wheelchair: dead to life, even if technically speaking he was still on the planet. The heart beat but you'd hardly know it. 'So what is Sean Connery really like?' I heard him asking. Cunt. I knew he was a groupie, but couldn't he even have the decency to be ashamed of the fact?

Jimmy was just fine. As far as he was concerned, if other people were going to talk, conversation became impossible. 'Ah jist git tae sey this' and 'Ah jist git tae sey that'. Once he had set off down a sentence, you never saw the bastard again. The nice thing about being a celebrity is that when you bore people rigid they assume it's their fault.

Boyle was a great flatterer – he would tell you to your face what he wouldn't dare say behind your back. And he was completely indiscriminate – which was most annoying. I loathe obsequiousness unless it is directed towards me. His techniques were predictable. Once the toadying tanks were empty he tried to fuck you. He had already made a pass at Mother, pushing her up against the wall and calling her a 'dirty wee hoor'. Now

it was the fat, flatulent Stepmother 2's turn. 'Ah'll fuckin' shag the erse oafay that any day ay the week,' he told me. 'I meen, *look* at the fuckin' erse oan that. Ye could eat a four-course meal oafay it.' He staggered off after her to the kitchen. After ten minutes I went to find him. He was loitering around aside the lavatory. 'Ah've goat a fuckin' hard-on, and ah'm even tempted tae have a wank. Naw fuck it – ah'll dae ye in the erse now,' he offered me by way of explanation.

The next morning when I woke, the sun was shining, the birds were singing in the trees and a mass murderer was buggering me in Father's bed. I had committed symbolic parricide while still dithering about the real one.

Back in Edinburgh we set about building the sculpture – our disaster in plaster. We bought a new building next to the Gateway which was an old 'steamie' so we called it the Washhouse. I was rapidly running out of money and was faced with a cruel choice – work or daytime TV. Jimmy and Sarah bailed me out in the end. They lent me the funds for this joint venture which was intended to be a commercial concern. By the main building and chimney was a boiler room and we converted this into a foundry. The sculpture was a massive scaling up of the first piece that Jimmy had made in the Special Unit – a crouched figure, slumped forwards with bars slicing through it. It was meant to symbolise that we are all imprisoned, internally. You wouldn't have had it in your front garden – even if you loved gnomes.

While we were casting it into bronze, a campaign started in Hull to stop it being sited there. The local citizens' group went to the press demanding that this 'national disgrace' wasn't displayed in their city. They presented a petition to the Lord Mayor with thousands of signatories. Their complaint was not against the piece formally (otherwise I would have signed the appeal myself) but because a convicted murderer was being celebrated in this way. They mourned the passing of capital punishment for Jimmy (who had missed it by months). I didn't believe in capital punishment (not since it ceased to be a public

occasion) but I didn't believe in our public sculpture either. There is, however, no stronger bond of friendship than a mutual enemy and when the good citizens rose up crying out that they would smash the statue to smithereens if it was erected, Jimmy devised a way to profit from the situation.

Writing to Grandfather, Jimmy asked for another £10,000, saying that the monument now had to be twice as thick to withstand 'the siege'. We invested this money in a red Rolls Royce.

The number plate was MOE 22P. You can't set the world on fire unless you are a consummate liar. Jimmy was a professional. Even if he caught himself telling the truth, he'd lie just to keep his hand in. He spun a yarn that we had been to see a music producer from LA called Moe Spence (hence the punning number plate MOE 22pence). This figment of his imagination had, apparently, been so impressed by our project that he had insisted on giving Jimmy a down payment for a sister piece in LA.

'I'm short of cash at the moment,' Moe said. 'Here. Take my car. It's outside.' He gave Jimmy a set of keys.

'Naw, we are no car salesmen, pal,' Jimmy said that he said. 'Fuckin' auld cunt. If ye don't get oan yir fuckin' bike, ah'm gaunnae tan your jaw.'

And then he went outside.

'Aye, we are car salesmen, ken?' he said that he said.

This story was told so many times that I actually came to believe it. I still do. Commit a sin twice and it will not seem a crime.

On the night before the unveiling Jimmy and I went out for dinner and got drunk. Over oysters and champagne we hatched a plan. It seemed reasonable at the time.

It must have been well past midnight when, hearts hammering and hammers in hand, we crept up to our sculpture, a tarpaulin-clad figure waiting patiently for its unveiling ceremony the next day. I took the sheet off, and looked around. All was peaceful. A pair of lovers were leaning together and laughing somewhere

down a side street. But they soon moved on. The wail of a police car's siren sounded far off. Away in a backyard a chained dog was yapping. Across the square a bedroom light was turned off.

I took a deep breath and brought the hammer down as hard as I could on the sculpture's bald head — just one of the many places that it couldn't be disfigured. We were going to destroy it, and then blame it on the noble citizens of Hull. That would pay them back. They had wanted to trash it. We would show them how it was done.

What we hadn't reckoned on was the noise that two tons of cast bronze can make when struck by a hard wedge of iron. The sculpture was hollow. It rang out like Big Ben.

Within seconds, police were swooping in from every direction. It seems that, after all the public threats, the statue had been given its own police bodyguard. I stood there bemusedly drunk. The most important thing, if you are going to do something Dadaist is to make sure you have someone on hand to record it for posterity.

'Fuck. Let's git ootay here,' screamed Jimmy.

It was too late.

''Ello, 'ello, 'ello.'

'But it's our sculpture,' I spluttered. 'We are making some last minute revisions.'

They looked, perhaps understandably, a little sceptical.

We were taken back to the station. Suddenly, it was quite serious. Jimmy as a lifer was on license which could be revoked for the slightest offence. We both turned on the charm — if you feel that you cannot comply with the morality of the world you must do everything else you can to be agreeable. Eventually the police realised we were legal, but brilliantly annoying. They let us go.

The unveiling the next day went off without incident. The playwright Alan Plater gave the address. It was another one of those dos: bottom-sniffing raised to the rank of a public ceremony. But because it was left-wing it had a preternatural proportion of smirking bureaucrats, tyrannous social workers, mealy-mouthed

psychiatrists and self-obsessed union officials. Mr Plater said this was 'for the people from the people'.

'For the people from the people', that was a laugh. The people of Hull hadn't even wanted the sculpture. Grandfather didn't care. Socialism is about giving people what socialists think is good for them. And as for the sculpture? Since excellence is the first casualty of equality, socialism is the standard bearer of the second rate.

To the citizens of Hull who may feel that their good city has been sullied more than is reasonable, may she or he read here that I apologise. I hope it is of some consolation for you to know that I did rob my own Grandfather. And fell out with him in the process. It had brought a tear to his eye and a lump to my wallet. Actually, it had been a very successful exploitative relationship for both parties.

As Jimmy's past had been exposed, so had Grandfather's present. Vanity, like murder, will out. He had wanted the bronze plaque on the sculpture to read: 'THE SURVIVOR BY JIMMY BOYLE. COMMISSIONED BY ALEC HORSLEY.' We had insisted on 'THE SURVIVOR BY THE GATEWAY EXCHANGE.'

Grandfather sent a smoking letter. Unless he could link his name with someone famous he had wasted his money. Jimmy returned fire. I was on his side, of course. I knew that Grandfather had taken the money out of the company rather than his own pocket. His virtue wouldn't have gone far if his vanity had not kept it company. Besides does a businessman ever really care about ethics, ultimate truths or morality?

After only another letter or two, Grandfather conceded. I was surprised. This was a man who tended to get himself confused with God. As for his Socialism? National Socialism more like; his natural gait was the goosestep. But I wasn't complaining. And we had the money. As the gold came in the guilt wore off.

A year later I was in Hull and I returned to look at the sculpture. The plaque had been changed. It read: ALEC HORSLEY AND JIMMY BOYLE.

At least Grandfather was clear about what he wanted. I was a mess. And Jimmy was still making the most of it. One night he fucked Evlynn on a hotel bed as I lay drunk on the floor. Another evening, at a benefit concert which Elton John did for us in Edinburgh, I watched him trailing her to the loos. Fifteen minutes later they returned from separate entrances. I watched their fake smiles of *faux* surprise as they feigned amazement at meeting each other. Did they think I was a fucking idiot? Of course they did. I was. But I had only ever asked him to do *one* thing. And all that was, was *not* to do one thing.

It takes a long while for a person who trusts in his faith to reconcile himself to the idea that, after all, God will not help him. For an atheist the revelation is no less awful: there is no strong dark hero. Under his armoured exterior, Jimmy was mortal. Where I had thought I would find strength, I was discovering force; where I had hoped for ruthlessness, I had unearthed spite; and when I thought I had found a rock to cling to, I found it was part of a landslide. Even with a man whose body was riddled with bullet holes, I was getting involved in an argument about who loved whom most. The trouble for Jimmy was that, even though he now found he had mistakenly bitten into a soft centre, he couldn't put it back in the box.

The voices started one winter morning. I had just returned from a disastrous holiday with Ev in Jamaica. We had broken up again over there and I came back later than her. She spent the night before my arrival with Jimmy. After a few days alone in London I flew to Edinburgh. Jimmy was there at the airport.

'How ye fuckin' daein', ya cunt!' he said. 'This you jist up fi London? Why didnae yir call?'

I looked away, stared at the milling bland faces about me.

(*Click. Whirl. Deep voice of doom.*) *He'll kill you. Don't look at him. He can see all. ALL.*

'You didn't call me,' I managed.

'Ah dinnae ken whit the fuck yir oan aboot. Ah didnae know

where ye were, Anywey, it's fuckin' great tae see ye cunt again.'

Unpleasant dreams, cunt. You are opposed to capital punishment. Yeah right boy. Murder should only be punished privately by murder.

Jimmy noticed my discomfort in the car. 'Whits up? How ye feelin'? Want tae talk aboot it?'

Don't listen boy. There's no answers because there's no questions.

I looked out at the countryside.

'There should be no more punishment at all for murder, since nature does not punish the killing of one creature by another. Nature *has* no principles. She makes no distinction between good and evil.'

'Whit ye talkin' aboot? Yir in cloud cuckoo land son. Yir fuckin' hopelessly confused.'

He was right. The containment of my confusions was what I called sanity. For the rest of the journey we were silent. Out of the corner of my eye I watched Jimmy watching me closely.

A few days later I resigned from the Gateway. What would I do now? I took to my bed. I didn't know what was wrong with me. Was I just loafing around trying out various illnesses? Was it all in my head? The year before I had become convinced that I had AIDS. At the time, a lot of people in the Gateway were dying from this new disease. It was one of the more serious side effects of intravenous drug use. However, as soon as I tried to get up and do something, the voices would start again. *You must kill Jimmy to live. You must kill yourself to live. Something has to die.* I remember thinking, 'Why are the voices never kind?'

I got up one day and drove off in my black van. I drove up to the top of Scotland, found what I thought was a wilderness and lay down in the back of the van to die.

I have read that dogs can sometimes commit suicide by drowning or by refusing food. They usually do it when they have been cast out from the household, but also from regret, remorse

or even sheer *ennui*. Animal suicide is often regarded as a manifestation of intelligence. But I couldn't even get it together to go to the dogs.

There was a banging on the side of the vehicle. I looked at the clock. Twenty-three minutes had passed.

'Git oot ay here. This is private property. C'moan – oan yir bike, or ah'm gaunnae call the polis.'

It was a farmer and he was right. This wasn't happening. I may have been insane, but I had lucid moments when I was merely stupid. I drove on.

Eventually I came to a quarry. I peered nervously over the edge of its cliff. Far below me was a pool. I had no idea how deep it was. I could see rocks in the middle breaking the surface. I deliberated momentarily. Fuck it, I thought. I jumped. The wind ragged at my coat as I hurtled downwards. I felt everything that I recognised being ripped away. I think I might have shouted. I heard a voice, torn into a thousand tiny fragments, scattering across the air. I felt the sudden rushing panic of emptiness; the sheer, deadweight drop of my body. My mind gushed away.

I hit the water. I didn't stop. I went on sinking. Bottomlessly. It took me a few moments to realise that I was still alive and a few more to understand, with an even more repulsive clarity, that I actually wanted to go on living.

I thrashed spluttering like a shark attack to the surface. I could hardly swim. I had lost my shoes upon impact but my wet coat was dragging me down, clinging to me and cloying my movements like weed. Every stroke was a struggle. I pulled frantically with my arms against the stony water, clutching it with outspread fingers, grabbing on for dear life. It slipped away, cruelly. It kept letting me go. My legs trailed limp as a cripple's behind me.

At last I reached the edge. I heaved myself out. Suicide might at least have added to my heroic stature, confirmed my nobility. But this? I looked down at my bedraggled body, my long black coat all whited with chalk. Generally, people who despise them-

selves actually esteem themselves as self-despisers. I didn't. I felt even more of a failure than I had before I had jumped.

When I returned home Sarah and Ev suggested that it might help to see a shrink. They packed me off for an appointment with one of those people who become the next person you start talking to after you start talking to yourself. In today's climate if you don't have a psychiatrist, people think you're crazy. Now, everyone goes to a therapist, is a therapist, or is a therapist going to a therapist. But then it was not so and I felt uncomfortable. I launched a pre-emptive strike.

ME: I know I am paying for this an all but I don't like psycho-analysts and the way they meddle in your private life.

SHRINK: You came here of your own free will Mr Horsley. May I remind you, in case you have forgotten, you have just jumped off a cliff.

(Pause)

She had a point.

ME: Yeah, but I even failed at that didn't I? I've always *wanted* to commit suicide but the truth is, I can't. I can't commit to anything.

SHRINK: Why did you fail? If you really wanted to be dead you would be dead.

ME: What has kept me from suicide until now is no special cowardice. I just couldn't bear the meaningless futility: that I, who could do nothing, wanted to do this of all things? If I were capable of killing myself, I would no longer have to do it.

SHRINK: Have you talked to anyone about these feelings before?

ME: I haven't got any feelings and nor do I want any. I don't want to be a man. I want to be a mannequin.

SHRINK: So you feel resentment towards life?

ME: Doesn't everyone? Life is only a spasm of brutality and
 suffering.

I was clambering on to my high Horsley. By now I was warming
to a familiar theme.

ME: It is a disease which progresses in three stages: Birth.
 Boredom. Death. I'm in the boredom phase right now.
(Silence. A little dry cough.)
SHRINK: 'You mentioned your parents?'

Now it was my turn to be silent.

SHRINK: Your Father is an alcoholic cripple. Your Mother is
 an alcoholic who attempted suicide four times. Your
 grandmother committed suicide, having spent half
 her life in an asylum. Do you think this might have
 influenced you?
(More silence)
ME: This is like a really easy game show where the correct
 answer to every question is: 'Because of my mother.'
 'Because of my father.' Just because I can win the game
 hands down it doesn't mean I approve of it. Not every
 problem we have in life is necessarily due to being unloved
 by one's parents. Yes, it is true, Mother and Father were
 uninterested, unloving and unconscious. But did this
 make me unlucky? I don't suppose so. It is so frightfully
 common to be loved by one's parents.
SHRINK: Why are you so antagonistic towards therapy, Mr
 Horsley?

I shrugged. What was so special about a person who owned
a couch and then charged you for lying on it, I wondered.
Actually I happened to think that therapy itself was the cause
of most of our problems. It made us remember them. But

instead of blaming our shrinks we started launching accusations against our parents, trying to dump everything back on to them, to make them the repositories for all our woes. And is this right? I mean, if anybody in the entire history of the planet had a watertight case against their mummy and daddy it would be me. But still I don't buy it. 'Don't worry about me,' I finally assured the therapist. My life is not worth the trouble it takes to leave it. I won't commit suicide. I can't. I'm too unhappy.'

The shrink looked a bit unhappy herself.

'Life can be about finding loveliness in little, ordinary things,' she encouraged.

A year later, she was not so sure.

'Maybe life isn't for everyone,' she said.

Still, I carried on living. It seemed the only way to show my contempt for survival. But I was not happy and my problems had a lot to do with my marriage. You could see from its hopelessness that it was indeed the real thing.

What had gone wrong with it? We'd got married: that's what went wrong. We never dislike anybody so much as when we realise that they are all that we've got.

We had yet another showdown.

'I can't stand this anymore. I can't stand living in this wastepaper basket of human emotion. I feel emasculated/domesticated/imbeciled/infantilised/neutralised. (The argument followed more or less the same lines every time.) I wanted, I insisted like some cut-price Greta Garbo, 'to be alone'.

'Dinnae fuckin' start. This is ma hoose. Ah'm no gittin oot ay here.'

Ev was deeply territorial. She had probably urinated down the side of the furniture for all I knew.

'I think we should get divorced.'

'Eh? Whit ye sayin' stupid?'

'What's stupid about it? Getting divorced just because you

don't love a woman is no more silly than getting married to her just because you do.'

'Whit the fuck are ye oan aboot?'

For a few months we had a stand-off. We never met by daylight or when both of us were sober. She nursed her wrath as lovingly as a little baby. I fostered my growing sense of resentment. Surely I was right. I was the lion king. She the snapping hyena. I was the archangel. She the moth in its wings.

I had a choice: murder her or desert her. It was going to be close. In the age of the Romantics, the young made death fashionable, and during the epidemic in France in the 1830s they practised it as one of the most elegant of sports. One man, when charged with pushing his pregnant mistress into the Seine defended himself by saying, 'We live in an age of suicide; this woman *gave* herself to death.' You've got to admit: that's style.

My wife was well insured and intensely irritating, a hazardous combination, especially in marriage. But in the end we decided to divorce. It is said that you get two good days of marriage. The day you bed your bride and the day you bury her. I wasn't able to get even that much.

The trouble is, marriage may not be for ever. But alimony is. Young, able and childless, she was out to fleece me. Under Scottish law she was entitled to half my wealth. Boyle set about brokering the deal so that she would get a bit less. (Maybe he had loved me most after all.)

'Dinnae think ah'm no gettin' ma share,' she fought. 'Ah'm equal tae him.'

As far as I was concerned, this was not the best line of attack. Glamour is more important than equality. Besides, how *can* we take women's liberation seriously while women still insist on alimony? Until they learn to eschew it we will continue to perform the same dreary dance: two steps forwards, two steps backwards – matrimony, acrimony, alimony.

I parted company with fifty thousand quid. I was very upset.

But not about the money. I was sad because I was now a divorcee – and I wanted to be a widower.

My marriage had been the unhappiest time of my life. If I had been blind and Ev had been deaf then, who knows, perhaps we might have made it. But even then I doubt it. Innocence is like a delicate flower. Touch it and it falls. I associated Evlynn with this loss. I hated her for it. But then, people always loathe those they have wronged.

I am often asked if I believe in life after death. I don't believe in life before death. But I can tell you from bitter experience there is no life after marriage. A life of bourgeois domesticity will slowly kill you unless, of course, you know true love – in which case it will be death on impact. It is hopeless. The reason men and women do not understand each other is because they belong to different sexes. While every woman is at heart a mother, every man is at heart a lover.

In 1987 after five long, miserable, monotonous, mind-numbing years, Ev at last left for London and went back to Chelsea art college. I wrapped my wedding ring in loo paper and flushed it down the lavatory. It's probably still there stuck in the U-bend – a symbol of all we had shared.

I was twenty-five years old. I was free. What to do? Back to a life of luxury. Forward to dandified propriety. Onwards into the most wonderful world. If the engaged man is a jackass, the married man a lemming, then the bachelor is a peacock: a thing of beauty and a jewel for ever. It was all for one – and I was the one.

7

Success is not spontaneous combustion . . . setting myself on fire

When someone at last finds a soul mate they are over-spilling with happiness. They can't be restrained from describing their new found elation: their heightened perception of the world around them, their inability to refrain from taking hoppety-skips, their soaring moods and their sense of contentment. All these were mine on realising that I might never have to live with anyone ever again.

I had only one problem now that Ev and I had separated. I was now living so far beyond my income that we too now seemed to be living apart. It was going out every night, drinking fine wine and carousing while I was loping around like an indolent layabout. A kind of spiritual snobbery makes people think they can be happy without money. Now that I, who'd always had cash was without it for a while, I soon discovered how quickly it became my chief concern.

I took a long look around and realised that there were different ways of rectifying the situation, the most honourable being looting, stealing and conning. The trouble is, it hadn't seemed to work for the Gateway gang – born underprivileged and penurious, they slaved their way up from nothing to a state of extreme poverty. But the only other option seemed to be that of the outside world. And this was populated by people so primitive that they did not know how to get money except by working for it. This also would not do. A gentleman is someone who,

however impoverished, will on principle refuse to do anything useful.

One needs quite a lot of cash to make a beast of oneself. After all my research it seemed that the stock market was the place to go. A gentleman can make more money with less effort in this market than in any other profession. I had already seen its magic. The shares that I had inherited from Northern Foods had started at twenty pence in the late sixties. They had risen to more than three pounds by the eighties. Just imagine if you had put £100,000 in that?

I yearned to be successful but I also wanted to carry on making art. I would do as much I could as a market buccaneer in order to do everything I could as an artist. But I was going to stay loyal to my outlaw instincts. I was going to kick the world away. I wasn't going to comply with any of her idle social rituals, observe her tedious canons or pay lip-service to taboo. I was going to go on as if nothing mattered – except me.

Going down to London, I embarked on an eight-week course to learn about the stock market. I don't think I knew much about money. Sure I had a bank. But I hadn't learnt much there. Why do they call them tellers? They never told me anything. And why do they call it interest? It wasn't. It was interminably dull.

Anyway, on the course, the teachers gave each student his own dummy portfolio to play with. To my delight, I did better (aka was luckier) than anyone else. Naturally, this went straight to my head. Now I was ready to start for real. I immediately went out and bought a state-of-the-art professional monitor to link me up to the markets – live. Rows upon rows of numbers flickered and twinkled. It was quite difficult for a dyslexic. But I had got the basic gist: blue for up, red for down. I secured an execution-only broker – i.e., an agent who only took orders. I was ready to deal. I pinned a sign over the terminal 'To the glory of the warrior, the good luck of the gambler' and placed my first bet.

It was 1988. The stock market had crashed. The sky was black

with ex-millionaires hurling themselves out of windows. A principle rule of the market is buy when everyone is selling; hold until everyone is buying – or, as Mr Rothschild put it, *Buy when there's blood on the streets, sell at the sound of trumpets.* I bought £10,000 worth of shares. Two weeks later I sold them for £12,500 – a profit of twenty-five percent – and all for nothing. I was hooked.

But there was even better news to come. Someone offered us £150,000 for The Washhouse, a property we had bought for £50,000 a few years earlier. Even after paying Jimmy and Sarah back, I was well up. It was the late eighties. My new career was looking good.

Jimmy and I had had a sort of reconciliation, not that we discussed it. My acute nervous breakdown had been completely ignored by him. But then this seems to be the dictator's way: 'Never complain, never explain', as Mr Pol Pot once said. For my part, I had decided that when two men quarrel the one who yields first displays the nobler nature. Or rather that's what I've decided to decide in retrospect. At the time I just capitulated. I didn't want to turn a personality clash into a cataclysm. It was better to paper over the cracks and assume that it might offer an opportunity instead. Jimmy and I went into business together.

We set up Champagne Scotland Limited. Very limited actually. We didn't know anything about wine, business, accounting – or anything else for that matter. As a couple, we were a perfect illustration of the equation zero plus zero equals zero.

But we did know how to drink with great authority. Funnily enough, I didn't even particularly like the stuff. Champagne tastes like an apple peeled with a steel knife. I could only tell it from vinegar by the label. But what I really liked was showing off. My whole life would be a bacchanalian.

We set off to France to purchase our stock. The Rolls started up gently, gladly, gratefully – like a well-goosed widow – and we drifted out of Scotland making about as much noise as a goldfish in a bowl. We were off to Épernay in our brand-new suits – like a couple of out-of-work actors on vacation.

Of course, in theory, we were going to taste and select – in practice: pose and get drunk. A general rule of wine-tasting, apparently, is to declare that the bouquet is more subtle than the taste, and vice versa. I could barely tell the difference between Piat d'Or and Pétrus – but I preferred the latter because it is so very important to show contempt for expensive things. Besides, if you can't annoy somebody, there's little point in drinking.

We stopped off in restaurant after restaurant.

ME: Oh God – can't we just have the house red this time?
JIMMY: Eh, wine list, girsson.
ME: (wrist limp at the weight of the bound crimp-edged folio) Do we really have to remind ourselves every time we go out that we have no idea what we are doing?
JIMMY: Shut yir fuckin' mooth. Aw ah'm sayin' is, nae cunt really kens but ah want tae ken. Jist tae learn likesay the creative process, ken, the creative process . . .
ME: Why not just ask for a Latin trigonometry test with your menu?
JIMMY: 'Allo, pal. A bootelle of yir best Petroos eightee-tou S'il voo peye . . . mercy.

(Matters weren't expedited by the fact that neither Jimmy nor I could speak French. I made absolutely no effort to do so. Jimmy spoke fluent Scottish with a French accent.)

SOMMELIER: I beg your pardon, Monsieur?
ME: Well, that was a success.
JIMMY: Ah'm a wordsmith, ken. A wordsmith.
ME: Clearly.

(The sommelier inclines deferentially over the table and a liquid of a rather lovely looking purple colour foams up in pleasing contrast to the pristine white linen cloth.)

JIMMY: (seizing a perilously fragile glass in his thick-fingered paw) Ah jist git tae sey. Ah hate the fuckin' Scots. Ah hate the fuckin' English. Ah'm a fuckin' European. Ah'm a fuckin' European, ken. Ah love this fuckin' place, ken. Bonjoore, ken.

We toured all the great houses: Veuve Cliquot, Moët & Chandon, Bollinger and Pol Roger. Seriously outclassed by the soft furnishings, we looked about as at home as some silver-bell embossed wedding invitation on the mantelpiece of some *Ancien Regime* marquis. And appearances don't lie. We stole bottles, nicked bibelots and pocketed cutlery while Jimmy waffled on his interminable drivel. I was getting sick of him. I will tolerate most things. Sexual deviancy, drug addiction, people who murder other people; but I won't tolerate people who murder the English language and bore me to death.

In the end, the champagne company, rather predictably, failed. We had only set it up in the first place to try and finance our drinking habits. But what we hadn't counted on was forging such a sentimental attachment to our stock. We couldn't bear the thought of other people downing our sacred elixir. We grudgingly parted with a case here, a case there, but before long we gave up and retired to our wine cellar – a garage next to the Gateway which we called 'The Cave' (I think Jimmy thought it sounded French) – and which had a ceiling so low that I had to charge through it, head bent forward like that of a Spanish bull (Jimmy could have stood on tiptoe of course and still not touched the roof). There we spent many a long evening dutifully drinking the company dry.

Next door in the Gateway, earnest citizens were still holding meetings, discussing issues, sharing real feelings and empathising busily with each other's problems. But I had at last figured out that, if I was going to be a champagne socialist, I might as well be the real thing. As I understood it, the Marxist distribution of wealth ensured that all shortages would be divided equally

among the surrounding peasants. But then, I've always believed in the trickle-down theory: if I am fed sufficient caviar, some of it will pass down the sewer to the brotherhood of rats.

Meanwhile, on the markets I was more than keeping up with the Dow-Joneses. I was making in a week what a diligent dock hand makes in a lifetime. I decided to really put my back into it. My days became so ordered they would have made the life of a Trappist monk look like an orgy. I got up at first light. I read the *Financial Times*. Prepared a canvas. Placed my bets as soon as the markets opened. Then I painted for three hours. After lunch (never alcoholic), I read in the afternoon.

It was an absolute necessity for someone as chaotic and unbalanced as me to follow these strict routines. If I let myself go, nothing would get done. Whole days passed without me speaking to anyone. But I never felt lonely – or at least never admitted it. And there was something liberating about not talking.

I preferred gambling instead. As I shuttled between my easel and my stock market monitor, I was beginning to understand that making money was an art more than a science. My two main pastimes had an awful lot in common.

A painting, like money, is *intrinsically* worthless. But I was driven by a craving to make something from nothing – and the fact that I could end up getting nothing from something only made it more thrilling. Life is only a game – and everyone loses. So why not just go on gambling anyway, careless of life? Why not try and see if the gods had decided to favour you?

Sales of my paintings would not have kept a dwarf in doughnuts for a day – not a healthy dwarf anyway. This worried me. Hadn't Kline and Pollock and de Kooning all starved for twenty years before finding success? I was not prepared to put up with this. I had to spread my bets. Hence the gambling.

I was raking the cash in. I didn't know what to do with it. Money is always so much more exciting than anything it buys. Now, the world seemed to be taking advantage of me. It was denying me the means to grow by giving me everything I had

ever wanted. I had to do something. One of the Mitford sisters, I had once read, had 'running away' money. I was more interested in 'leave me alone' money.

For the first time in my life, I seriously addressed the problem of shopping. Before, I had always enjoyed strolling down Bond Street. I liked being reminded of all the things that I *didn't* want. Its shops seemed to me rather like charities (and, as you know I hate charities). They helped the super rich (and the vulgar) to unburden themselves of their cash. They didn't actually sell objects – lizard-skin cufflink boxes, gold-plated noughts-and-crosses sets – they sold more exclusive commodities: Aspiration, Smugness, Eternal Life.

Expenditure soars to keep up with income. A shop, I realised, could serve as an armoury for a spot of consumer terrorism – so effective in envious Scotland.

First stop: a new car. Jimmy and I had already upgraded the first Rolls twice – we traded them in as soon as the ashtrays were full. Of course we spared no expenditure. And I never argued about prices. It would have been undignified for a man of my stature. We could have saved money on expensive personalised car plates by simply changing our names to match the plate. (LT06 WZY anyone?) But we didn't. Instead we did something completely ridiculous.

The Corniche convertible looked good enough to lick. Her polished flanks gleamed a luscious wet pink. I caressed the long slow curve of wheel arches like leisurely haunches. The soft white seats were perfumed with a leathery musk. I ran a fingertip along the little patterns of red piping, let my palm slip across the red-stained dashboard. My feet sank deliciously into the carpets and I curled my toes. I settled back and let the girl glide. Ahead, through the windscreen, the spirit of ecstasy ruffled her skirts, a gold-plated figurehead, her bottom teasingly lifted, her chin tilted upwards as she looked forwards. I fixed her with my eye as I followed her – like a riflesight.

I don't know of anything better than me if you want to spend

money where it'll show. I had just blown one hundred thousand pounds. I felt like a lottery winner – and I probably looked like one. But this was far more than a vehicle, it was a 'fuck you' to the Scots. And showing off is the only sure bait when you angle for abuse.

The car was the most marvellous conductor for the lightning strikes of local resentment. It was scratched, spat on and sworn at. Once, all four hub-caps (bespoked chrome) were stolen. Each would have cost as much as a council house. Another time a wheelbarrow was lobbed through her windscreen (odd what those gnomish little Scots like to trundle about with). But in the summer, the roof would come down, and then, like confetti, the missiles would fly in: beer cans, old shoes, crisp packets, bottles, coins, keys. An uneaten fish supper once landed beside me. I stared impassively ahead. It didn't smell any worse than some of the girls who had sat there (though it was rather better dressed). Besides, when people attack them, those with charisma always look like they don't have a care in the world.

My preferred entertainment was to pull over and ask for directions. The window would make its imperial descent.

'Excuse me sir but could you tell me the way to . . .'

'Git tae fuck, yir radge English cunt.'

'Oh, thank you, my good man.'

I eventually got a chauffeur to up the ante a bit more. After all I needed staff. This was not a car, it was a stately home on wheels.

All I had asked was a chance to prove that money couldn't make me happy. And it hadn't. The more money you accumulate the less interesting you become. I knew deep down that God showed his contempt for wealth by the kind of person he selected to receive it. And it affected me. I may have been gambling successfully on the stock market but I had gilt-edged insecurities.

Vanity is where the extremes of insecurity and arrogance meet. It is for the hugely self-confident who have low self-esteem.

No one with real self confidence would have behaved as noisily as I did. What was it that I was secretly afraid of? Was it that everything I appeared to have was an illusion – that I was a victory of style over substance? I knew that, like all frauds, I did best in professions where personality was more important than talent. In a way, I was a product of my times. In a world in which we see ourselves as both a commodity and its seller, to be flogged off on the markets, our self-esteem depends on conditions beyond our control. If we are 'successful' we are valuable; if we are not, we are worthless.

I was being 'successful', but I felt worthless. Anything that fell into my hands – however little work I had done for it – became as nothing and lost all value. I remember so clearly when the new Rolls was delivered. I looked at it in the garage and thought, 'So what? Now what?' Ownership had robbed it of all worth.

I certainly didn't have many friends. My relationship with Jimmy was so full of secrets and lies it had left me completely stranded. I could have built a cathedral with all the resentments I still had about Ev. We hadn't had a proper showdown and this was the problem. You can make up a quarrel, but it will always be weak where it was patched.

I resented the attention *he* received for the work *I* had done. I would seethe with hidden anger when people addressed him and not me. Once we picked up a prisoner in the Rolls and when the press photographer turned up I was treated as a non-entity. I was told to stay in the car while they lounged against it, posing for the front pages. I leant against the steering wheel covering my face. I hated having to stand in as their driver. They didn't notice. I drove home silently, my mind smouldering. It's unsurprising how much you can sometimes dislike your best friend.

I started to spend less time with him and more in my newly decorated flat staring at the wall. I'd spent a lot of money on it. The best thing we can do is make wherever we're lost in look as much like home as we can.

I had enough money to keep me from mundanity but not

enough to buy my way out of boredom. I worked sensibly all week and then drank myself insensible at the weekends. It quickly became unmanageable. I drank when alone for the same reason as every other lone drinker: to get rid of myself, to send myself away. In the evenings I sat listening to music with an aching heart, yearning for something to save me. *Ah bottle, my only friend, why do you empty yourself?* My loneliness moaned across the ocean of humanity like a fog horn. I seemed always to be warning other people away.

It is not our wrong actions which require courage to confess. It is our ridiculous ones. Convinced that it was my neighbour who had chucked the wheelbarrow into the Rolls and stolen the hubcaps, I decided to set fire to his MG. He came home one evening to find his beloved Imp burnt out. Only four hubcaps remained. I had removed them before dousing the car in petrol. I polished them and put them back after the chassis had melted, so he knew I knew, and there they glittered like medals of victory – my victory. To this day I have no idea if the attack was justified, but may it comfort my neighbour to read here that I was happy.

Next I went shoplifting. Stealing was something which had stayed with me from childhood and the richer I got the more interesting it became. My entire existence was dominated by an irrational fear of being seen as a bourgeois. But now, all the bourgeois values I most despised: careerism, opportunism, smugness, and toadying – I had acquired. I needed to address this. And I didn't care how. Morals? I couldn't afford them, darling.

Naturally, my rebellion was a form of intellectual discipline no less. My mind could be shaped by a Nietzschean act of will. A man is not honest simply because he never had a chance to steal, I reasoned. I would dispense with upbringing and background – but retain the lofty high ground. Or so I thought. Moral indignation permits stupidity to be acted out under the guise of virtue.

Anarchic events often demand the most rigid social conduct.

I rose early and donned a Savile Row herringbone, my boldest and brightest cufflinks and a fedora. Hooking a furled umbrella over one arm I slid into the Rolls and set off to the Iceland supermarket. It takes so much finesse to be impertinent.

I glissaded down Easter Road – one of the poorest districts of town. Getting out of the car – not forgetting to lock it ostentatiously with one of those remote-controlled keys – I minced away, daintily kicking an empty tin of Tennent's from my path with an immaculately polished leather toe. My iron-tipped heels clicked so satisfyingly on the pavement. My reflection looked dazzling in the supermarket's sliding door.

I proceeded on my way, sauntering up and down every aisle, filling my bag with all the most expensive items I could spot – which in the artic landscape of Iceland wasn't much. Then, nose tipped haughtily upwards, I marched out of the supermarket.

Sadly, I appeared not to have the gift of the grab. I was spotted immediately (how could they have missed those signs) followed into the street and brought back for interrogation. Taken into a back office, I sat down while the store manager phoned the police. They arrived: three of them with radios and truncheons and handcuffs. I took a deep breath, pulled myself up to my full height and boomed, 'DO YOU KNOW WHO I AM?'

'A shoplifter?' inquired the store manager.

Outside, the police and staff saw the Rolls. I overheard one of them whisper, 'Ye cannae dae nothin' with 'im. Gaun tae Easter Road oan Setirday in a big car like that? He cannae 'elp 'isself. Yis ken sey that.' He was right in a sense. What is a kleptomaniac but a person who helps himself because he can't help himself? Anyway, in the end I was lucky and the charges were dropped.

But I was still bored. So I started to look for some other entertainment. I found it one morning in the stock market. Warrants. Warrants are the crack cocaine of the city. They are basically long-term options which work on the principle of the butterfly that flaps its wing: a minute movement in the main share price

causes a colossal movement in the corresponding warrant. This can be up or down, of course. Warrants often expire worthless.

So, I decided to take it a little further. I borrowed the money with which to buy the warrants. Sure, it wasn't lost on me that the butterfly flapping its wing is all about chaos theory. But to be clever enough to get all that money, you had to be stupid enough to want it in the first place.

In 1990, I purchased £125,000 of BTR warrants at thirty pence. They had five years to run. *Buy early and bravely or not at all*. They immediately collapsed to twenty pence. I stared numbly at the monitor. I had lost £41,000 in a week.

I wouldn't trust a bank that would lend me money. But I went back for more. I had already put up my shares as collateral. Now I gambled with my home. That got me a £200,000 loan. I would now live within my means — even if I had to borrow money to do so.

I doubled up and invested in another £125,000 worth of BTR warrants at twenty pence. That should fix it. *Buy when blood is running on the streets*. It was. My own.

I had a million warrants. Every time they went up a penny I made £10,000. Every time they went down a penny I lost £10,000. Even I could manage the sums. I sat transfixed at the monitor — for weeks. The difference between something and nothing is nothing.

At least my lifestyle didn't require my presence. This was probably just as well. Scottish winters are incorrigible. They end in August and begin in September. Occasionally there is a bright patch during the day. However miserable you might want to be, cheerfulness can occasionally barge rudely in. But things always seemed to worsen again in the evening.

What if I am living up to my full potential? The thought was appalling. What could I do? 'You must risk your life to stay alive, Sebastian,' I said to my only friend — the mirror.

The forlorn always return to that familiar refuge — the comfort of childhood habits. I did. I had been trying to paint sharks for some time, striving to capture a sense of their elusive

streamlined force. Canvas after canvas was binned and stamped on and smashed. It was so frustrating. This was a subject that obsessed me – something I could hang my feelings on – and yet I couldn't paint it. I came to my conclusion. I had to meet this creature. In person.

There was just one slight problem. I could barely swim, let alone dive. I was a sea enemy. And the reason I hated it was because of the sharks. In fact, I had never ventured into it. After seeing *Jaws* (about ten times) I was pretty sure I would never go back into the bath again, let alone the ocean. But courage is not the absence of fear. It is the conquest of it.

I contacted Rodney Fox, an Australian who was infamous as one of the world's leading great white shark experts. The principal adviser on *Jaws*, he was one of the few people to have survived an attack. He had been out spear-fishing when a shark, attracted by the death throes of his catch, glided in out of nowhere. He didn't see it coming.

Teeth sliced through him like butter. He was being carried downwards in its maw. Helplessly, but with that cold, almost clinical detachment that kicks in above panic like a shrilling top note, he battered at its snout, stabbed and gouged at its eyes. The animal let go, circled tightly and came sliding back.

But just at the very last moment, Fox says, its attention was deflected by his fisherman's buoy. The shark surged to the surface and seized it and plunged back to the depths, Fox being dragged impotently by the cable that was clipped to his belt. What incredible bad luck. To escape from the grip of a great white and then to drown.

It was like one of those miracles. The steel-enforced cord snapped – or the belt clip gave. I don't suppose he remembers – or much cares. All that mattered was that he rose back up to the surface and someone – probably one of his fellow fishermen – found him and carried him to shore.

The hospital report was pretty grim reading. His chest wall was almost severed from his ribcage. Teeth had slashed through

muscle and ground against bone. And at the very core of the bite, surgeons later recorded, the jaws had surrounded the heart like a palisade. Practically bitten in half, held together by only his wetsuit. But it was the mental scars which were the worst. He would never forget, Fox said, the vision of a vast conical snout looming out of the darkness towards him through the crimson haze of his own blood.

Fox was vengeful at first. For the next few years he hunted the great white through the oceans. He came to know his enemy, perhaps better than any other man alive. And in understanding it, he found that he changed. Fear turned to awe, hatred to respect. By the time I met him, he was one of the world's leading campaigners for the protection of this species. Years after his attack and thousands of stitches later he had dedicated his life to the study of the animal which had nearly ended it.

'You're going to have to qualify as a diver first, mate,' he told me, when I asked if I could come along on one of the expeditions that he organised. This was easer said than done. I started in a swimming pool in Leith. Failing to see how this would prepare me for meeting seventeen feet and two tons of the world's most feared predator I got on a plane and headed for a crash course in Thailand. This was the first time I had been in the sea. It was not a pleasant experience. Diving is a dandy's armageddon. It is uncomfortable, unpleasant and unbecoming. Nothing for which the style beautiful has a name can be read into a wetsuit.

'I hate diving,' I said to my fat Thai instructor. 'I am *not* sporty. In fact while we are on the subject I am not interested in any of this – all I want to do is meet the great white shark.' He didn't believe me. When asked the question in the written part of the examination, 'What do you do if you see a shark when you are diving?' I had answered 'Close your eyes?' I passed. But then, I don't suppose they speak much English in Thailand.

In the gloomy month of January, when the English happily hang and drown themselves, I set off for sunny Australia. As a

rule I don't enjoy tourism. I'm a self-respecting citizen. I do not own Bermuda shorts.

The tourist advertisements only tell you half the story: 'Come to Australia. Where summer spends the winter.' They omit: 'And Hell spends the summer.' Here the forecast every day is to distinguish between weather which will melt your house and weather which will only melt your ice cream. This did not bode well. My personality tends to evaporate in the heat. Worse: my appearance is forced into a continual state of inelegance.

In a heroic attempt to battle the sun I declared wardrobe. I had brought a fine gabardine suit in a most appealing shade of pink. You only know what is enough, when you know what is too much – a pink lace parasol, I felt, completed the look. It was not quite as ridiculous as you might think. I was going to sea after all. And at least dressed as a woman I would get into a lifeboat first.

I set off for Adelaide where I was to meet the crew. On an expedition one must always choose one's companions carefully: you may have to eat them. They were all marine biologists and experienced divers. I think they suspected that I would prove about as useful on the boat as a bicycle. I did.

We set sail. Our destination was the windswept expanse of the great Southern Ocean. For the ancient mariners this was one of the most dangerous places on earth. It was believed that, if the cold did not claim those shipwrecked in its violent seas, the sharks were sure to. Nothing was more feared and detested than these devils of the deep. Matthew Flinders, the first European to chart these waters, lost eight men without trace when their boat capsized. The names that the sailors left behind read like a litany of tragedy: Coffin Bay, Memory Cove, Cape Catastrophe, and the place where we were bound, the reassuringly titled Dangerous Reef.

I suppose a ship is always called 'she' because it is over-painted, overweight and stinks of fish. *The Nenad* – a sixty-foot tuna fishing slime-bucket – was no exception. 'It's not the size of the ship, its the size of the waves.' Rodney reassured us. The shark

cages, fastened to the deck and lowered into the water by winches, had been designed by him. They were made of aluminium bars and were about five feet wide and seven feet high. But they looked alarmingly flimsy. And the observation gap through which a camera could be positioned seemed easily big enough for a shark to get its snout in.

'But not wide enough for it to open it,' laughed Fox. 'I haven't lost anyone yet.' Never the less the cameramen were instructed to keep filming – no matter what.

For a week we waited. Working in shifts, day and night, we ladled a slick of chum – chopped up entrails in a soup of blood – across the surface of the water to attract the sharks. As we gazed across the boundless seas, my furthermost fear at that stage was that they would not come. The great white is notoriously shy.

We whiled away the time on deck putting out lobster pots for dinner and discussing tactics for if and when the sharks came. There were guns on-board, which was fun, so we all learned how to shoot, not that there was much to shoot at. Just tin cans – and passing dolphins. The crew would talk about the great white with awe and reverence.

Very little is known about the shark – where it swims, when it mates, how it breeds. No one knows how long it lives, or even how many remain. Survivor of more than 400 million years of evolution, the great white has eluded, or ignored, man's every effort to control or even understand it. Imprisoned in an aquarium, it almost immediately dies. It needs to move constantly, to keep the water sluicing through its gills. The shark never sleeps. It just swims and eats and occasionally reproduces. It has no other hobbies. It is by nature a lone beast. It is an animal of such destructive ferocity that it devours its own siblings in the womb. And yet, it is also a creature of such attuned sensitivity that it can detect a heartbeat from many miles away.

Some suspect that that the great white may be one of the few creatures which man can never know. Yet when I saw that black

dorsal fin of myth and nightmare slicing the seas I felt a sharp shock of recognition.

Lowered into the water for the first time, I dropped to the bottom of the cage and cowered. My breath was shouting in my ears. As a shark slid silently out of the gloom the initial thing I noticed about it was its immense girth. I suppose I had known in theory that a shark might be long but I didn't expect it to be as wide as the boat too. Its scale seemed somehow out of place.

It flowed sleekly by, the evil grin of the jaw; the baleful eye; the gills like slashes in the hide; and the pale slab of the flank, rippling with silvery patterns of light. And then, with a twitch of its tail, it vanished back into the gloom of the centuries from which it had come.

From then on the sharks stayed with us for weeks, circling the boat. By day they would thrash and flail about the stern, churning the water into bloody foam. They fought for chunks of horsemeat. Emerging from the depths, they would break the surface of the sea to swallow whole haunches in a single gulp. And at night I would see black shadows gliding beneath the surface of the sea, caught in the glow of the lights. It was a humbling experience. Like the heedless pounding of the oceans or the flight of comets across the night sky, here was a force entirely indifferent to our desires.

Sometimes, down by the cages, they would slam against the bars, lashing to get at the divers. This creature is so powerfully driven that it can smash a small vessel into tinderwood. And yet once I actually reached out and touched one. Rodney had told us to be careful. Their hide is rough enough to cut the naked hand, he warned. I put on thick gloves and waited in a corner, watching it make several passes while I tried to work out the best angle of approach. When its flank skidded along the viewing window I darted forward and grabbed its pectoral fin. The skin was as tough as a car tyre and slashed with scars. I only managed to keep hold for a couple of seconds. But that

was exhilarating enough. I had touched a living fossil. I had held something that was older than our entire history.

The next morning did not go so smoothly. I was down with one of the other divers and there were three sharks circling. Their approach was tentative – almost gentle. They kept their distance from each other but they seemed to be working in harmony, circling and looping, skimming beneath the surface, trying to work out whether they could eat us. Even stalking on the periphery, the presence of the great white is utterly overwhelming.

Suddenly the mood changed. One of them plunged down beneath us then surged back up to the surface, crashing into the back of the boat. Another whipped round and bit through one of the cage's tethers. The two-inch cord snapped like a piece of cotton. The cage veered and tilted. I looked over at my colleague, knocked like a rag doll into a corner. Through his goggles his eyes were wide with fear.

Through the turbid waters I could see the rocks of a reef. The boat was obviously drifting towards it, dragging us, in our tilted trap, alongside. The currents were tugging and the sharks were circling. Where before they had seemed so placid and streamlined, now their backs were hunched, every muscle tightened. Their tails flicked sharply back and forth.

The Nenad lurched into life. I heard the roar of the motor as it caught. The propellers bit into the water churning white foam. The cage jerked forwards with such force that we fell back into a corner, our tanks clanging against the metal bars. The water flooded past us, tearing at our masks and snatching our mouthpieces. The cage door fell open as we bounced about.

Where were the sharks? I struggled to spot them through the rushing gloom. I tried to flick my head from side to side. Searching and searching. And then suddenly one was there, coming straight at me, tearing aside the water in its seamless rush. I stared into eyes, rolled back and ghostly white, saw the fiendish, crooked smile, the extruded gums and teeth like some

chain-saw accident, tattered with blood and bits of flesh. Oh my God. Oh my God. I fell back into the bottom-most corner of the cage.

When at last the boat cut its engines the sharks were no longer there. An eerie stillness washed over the sea. I turned and turned and turned about. Where had they got to? Everything was quiet.

Rodney was leaning over the side of the boat. 'Nearly lost you there mate,' he said.

On the last night I went down alone at dusk. I wanted to say farewell. I had been there for ten minutes when suddenly, over one shoulder, a vast pale shadow glided by. I was overcome by a feeling of awe for the magnificence of this beast. A profound respect. This was not the homicidal monster of action movies. It was one of the wonders of the world.

I felt giddy with desire to undo the hatch of the cage, to swim free and melt into that holy chasm. To float away and stop hurting. It was an eerie, alluring, enticing sensation. It sang like a siren. Man is the only animal who can willingly embrace the inky abyss, even while understanding that it means oblivion.

It was only when the oil drums of stinking chum were all finished that *The Nenad* turned back from Dangerous Reef. The sharks melted back away from where they had come.

I wasn't interested in seeing anything else. The others went on further dives but I stayed behind. Why would I want to go on to the Great Barrier Reef? It was the most vulgar thing I had ever seen: a clash of frightful loud colours. It was the most cheap and tasteless piece of trash in the whole wide world. It reminded me of, well, me actually.

Without consulting me, the sun came out again. I sat up on the deck and, from beneath my parasol, watched the divers' boat, crawling away across the green water like a long-legged insect over a leaf. The ocean, as ever, was an enigma. Why did it keep banging away, making all that noise? Whatever did it want?

What did I want? A lot of travel is a form of self-extinction. My passage had been the antithesis of this. I had looked survival

straight in the face. Now I wanted to travel again – but not to go *anywhere*. I just wanted to go. I had made my decision. I was going to leave Edinburgh – eventually.

It was a resolution, as ever, prompted by dinner. On 8 November 1991 at 6 p.m. sharp I started to get ready. I plucked my eyebrows into single file and blackened my lashes until they looked as thick as chimney sweeps' brushes. A dash of lipgloss then I dressed – like a parade float. A red velvet three-piece so loud, that if I had stood on a street corner, people would have mistaken me for a postbox and put letters in my mouth. Better than putting words into my mouth, I suppose. I stood proudly in front of the mirror, reflecting. Men, once they know they are beautiful, are far more besotted with their appearance than women ever are.

I met Sister in a grand new restaurant called Waterloo Place. Ash was living in Edinburgh at the time doing an astrology course. (Is that enough about her? Yes.) I saw across the room a woman with one of those faces of marvellous beauty which are seen casually in the streets but never amongst one's friends. It was perfect in its elegant classicality – an Egyptian face translated into English. And like the gold of the pharaohs she had a precious aura about her. A skin so pale it could only safely be exposed to fog, and an air of frailty – which I longed to violate. She also had a black man sitting next to her.

I summoned the sommelier and sent him with a message and a bottle (Dom Perignon 1982) to her table.

'This is from the gentleman in red velvet,' he told her.

'I suspect this is rather more for you than me,' said her date.

'The gentleman says you are the most beautiful woman he has ever seen,' confirmed the sommelier.

After finishing their supper the odd couple came over to join us. I was having problems sitting down let alone standing up but I weaved myself erect. *Right*. I thought through the haze of alcohol. *Tactics. Isolate. Attack.*

'Mr, ah, Pilkington,' I began, in that jovial, over-civil way in

which one addresses chaps whose skins aren't quite the same colour as one's own. 'Sit down and tell me the story of your life from beginning to end, in real time.' I was hoping to elicit the sort of endless answer that would allow me to tune in secretly to the girls' conversation. And fortunately he was the type who took me literally. Sometimes I wonder if he's still sitting there today and hasn't noticed that everyone else got up and left the table fifteen years ago.

'My disposition was always to the law. My grandfather founded the firm in eighteen ninety-eigh . . .'

Staring him determinedly in the face, I cocked my ears to the side. I was adrift amid the fragments of several conversations.

'Of course Proust writes with an exquisite beauty . . . a particularly tough case . . . Librans love beauty in all forms . . . He wasn't liable under the statute . . .'

'What oft was thought but ne'er so well expressed . . . moon in Scorpio . . . studying for a PhD . . . Counterpart License to Assign . . . Sebastian is a Leo and Leos are great readers you know. Isn't that true Sebastian? Sebastian? SEBASTIAN!'

I recognised my cue. 'Actually I don't believe in astrology because I'm a Leo and Leos never believe in astrology. But if you *must* know I have only read two books. One of them was Tintin and one of them wasn't. The one that wasn't I haven't yet coloured in.'

Conversation is like a sport. You get the ball, show off, then pass. When I got the ball I ran off the pitch. Pretending to ignore the beautiful Rachel I wallowed in the maudlin aphorisms that welled up upon my glossy lips:

'Movies are so much better than real life because they are shorter.'

'Madam, I would be the first to tell you how brilliant I am. You would be the second.'

'Theatre is so much better than real life, which has no plot and is *so* badly acted.'

Eventually she could stand it no longer.

RACHEL: Sebastian, you're drunk.

ME: And you Rachel, are beautiful. But tomorrow I shall still be drunk – and you shall still be beautiful.

I was reclining back admiring my verbal dexterity when Sister suddenly careered into the conversation like a trolley full of fruit. 'Sebastian, listen to me! I am the first woman you ever loved!'

Oh dear. The situation was getting *completely* out of control. I looked around the table. I suspected the black man was Rachel's friend – someone with whom she had got stuck. Rachel was what the word *star* implies – a distant, permanent, dazzling icon who evoked from me a loyalty and an adoration that only a fool would have lavished upon a lover – or a member of his family. Ash's lightest touch would have stunned a horse – and now Rachel thought that I couldn't resist my sister.

As they stood up to leave I tried desperately to save the situation. I managed to get a phone number – unfortunately, it wasn't hers.

For the next month I dedicated myself entirely to my quest. All I knew was that she was called Rachel and she was studying for a doctorate at Edinburgh university. I called them immediately.

'Good morning. I'm looking to find a girl called Rachel.'

'I am sure there are several Rachels at this university.'

'Yes, I'm sure you're right but this one is *extremely* beautiful. Makes all the others Rachels look like dogs. No offence to their mothers.'

The phone line went mysteriously dead. Fucking Scottish telecom.

A few weeks later Sister spotted Rachel in the street and reported back.

'She was wearing old clothes and didn't look *at all* glamorous.'

'Darling, we won't worry about that. It takes nine tailors to make a man – and one man to make a woman. This man.'

I drove around Edinburgh day and night scouring the squares and the avenues, the wynds and the closes, gazing longingly down the endless vistas. It was hopeless. There was only one option left – the man.

'I myself would not have the bad taste to give out her number,' he said.

At last I had her surname. I sent a letter to the university which began 'In the rather likely event that you no longer have the faintest notion of who I am, allow me to introduce myself . . .' I then proceeded to waffle on declaring that the reason it had taken so long to get hold of her was that I was visiting my tailor in Hong Kong.

Every day I stood at the top of the stairs and looked down at the mat. Bills. Bills. Bills. Eventually one day there it was. She would prefer dinner to lunch, 'a rule not as arbitrary as it may seem', she went on to tell me pompously. 'I rarely manage to return to my desk after a lunchtime engagement.'

Great I thought, she's up for it. Dinner. Back to mine. Impending sex definitely.

Within a week we were mounted in the Rolls, sucking our lungs full of that unparalleled smell of new coachwork, new hide upholstery. 'Isn't this nice?' I said to her in the back as we sipped Krug from the bar. *Is this working?* I learnt later that Rachel thought I had hired it.

She was cheeky at dinner too. I'm the ultimate vain bastard. For a successful first date with me, wear a full-length mirror around your neck and say nothing. Rachel looked exquisite and never shut up.

'Do you know that when I first met you I thought you were a complete prat?'

Occasionally, very occasionally, a woman will say something

vaguely witty and one gets a little thrill, almost as good as a few words spoken by a parrot.

'Er, thank you. And now what? You know I am?'

'No, actually, I rather like you.'

'Oh good. Well, if you want to kiss me anytime during the evening, just let me know and I'll be glad to arrange it for you. Just mention my name.'

Our progress home was almost royal; I found myself doing that wonderfully elliptical, downward-curving, quiet inimitable wave that the Queen so excels at as we noiselessly passed by her Holyrood house in a £100,000 worth of pure red Rolls Royce Corniche Convertible (with chauffeur.) Of course we arrived safely at Horsley towers but you don't expect me to tell you what happened next do you? Needless to say that in order to avoid being called a flirt, I always yield easily.

When a confirmed bachelor falls in love, he does it with a whole-heartedness beyond the scope of the ordinary man. Sitting in my studio day after night I had begun to think that love and artistic aspiration were incompatible. What I hated about women was the intimacy, the invasion of my innermost space, the slow strangulation of my art – oh, and the women too. The artist chained for life to the routine of a wage slave and the ritual of copulation.

With Rachel it was different. She had a poetic soul for a start, which nowadays has become a kind of embarrassment. She had inherited some good instincts from her Catholic forebears, and by diligence and hard work, she hadn't managed to overcome them. Her uncle on one side was the head of the Jesuits in Britain which was bloody useless for an atheist but her uncles on the other side were famous port-wine makers which was fucking fantastic for an alcoholic.

She wanted to become a writer. Her vision was essentially that of the Romantic – a striving for a transcendent ideal – and in keeping with this God had been most kind to her: she looked like the idol of the romantic myth. At least to me. She was always striving for 'Something evermore about to be' (some quote from

Coleridge that seemed to drop into the conversation with monotonous regularity), and which unfortunately turned out to be true of her novel.

An essential ingredient of beauty is intangible nobility. And Rachel had that rarest quality. What a woman has when she looks the same after washing her face. After the coarseness of Jimmy, Rachel's refinement was like an escape.

Of course my love was not entirely altruistic. What we all want is an object that reflects a truly ideal image of ourselves. Stripped naked when you see perfection staring back at you there's not much you can improve upon. It is a bit like looking in the mirror. For me not you. I genuinely loved her, but, above all, I loved the image which I had created of her. I needed to worship at a shrine and the very respect in which I held her made a commonplace liaison impossible. I magnify all my women. Clothe them in symbols and ideals. It is part of the illusions I use to clothe my existence and make it wearable. Fantasy, for me, is the proper riposte to the miseries of life.

New lovers should have a minimum isolation period of say, six months, so as not to nauseate everyone they meet. We complied with this rule and served our time in bed.

My heavenly spirits were not just to do with Rachel – a colossal income is actually the best recipe for happiness. I had bought a million warrants at an average price of twenty-five pence. Over the year they had risen to just over a pound. I had been half a millionaire for some time. I had the air but not the million. Now I was a paper millionaire. I was rich beyond the dreams of avarice.

It's an odd feeling, getting everything you've ever wanted and dreamed of. Almost as shocking, as violently draining as its opposite. I was a young man and suddenly I was in a position where I could do whatever I wanted – a man who has a million pounds is as well off as if he were rich. I didn't really feel as if I had earned this money, it felt more like a scam. Of course, I told lots of my friends – and even more of my enemies – some

of whom reacted better than others. I mean, what do you call someone that rich? 'Sweetheart', I'd say. Others would take me aside and lecture me about romance over finance but I knew all this already. Money is not the most important thing in the world, love is. Fortunately, I loved money.

I spent my thirtieth birthday with Rachel in Champagne. We sat on the terrace of the Royal Champagne Hotel looking out over the vineyards of Épernay. The haze of the sun, Rachel's hair, the spirit of ecstasy on the Rolls, Krug Clos du Mesnil in our glasses. It all seemed as precious as gold – but it had cost about twice as much. I was happy. There was only one last thing left to do – lance the Boyle.

As I had grown in strength Jimmy had become the focus of the problem of my freedom because I had been so compulsively dependent on him. He had been my first portal to the under-world. With him I had been excited at the idea of having a modern day Rimbaud and Verlaine type relationship: violent, passionate and creative. To a certain extent I had succeeded but my identity had been left in pieces. I had borrowed my opinions and now it was time to repay my debt. After meeting Rachel, this I was prepared to do.

I also had some unfinished business. After our divorce, Ev and I had started talking honestly for the first time. It was during an evening dinner in London that she dropped her bombshell. I asked her just when her relationship with Boyle had begun.

'Mibbe yir better no tae ken.'

'What do you mean?'

'Just what ah said – yir better no tae ken.'

'But I want to know.'

There was a long pause while Ev looked down at her plate and fiddled with her half-eaten food.

'Ah wis sleeping wi Jimmy before we wir mahrid.'

My stomach fell to the floor carrying with it a thousand horrid fancies. Pennies dropped. Bells rang. Lights flashed. Sirens wailed.

The dinners, lunches, letters before the wedding, the night of our marriage when they disappeared, the Elton John concert – *fucking hell*. Despite my behaviour *after* my marriage I was stunned. You don't expect me to confine myself to the emotions to which I am entitled do you? What angered me the most was that I would never have married her if I had known. I had been a trembling naïf of twenty-one. I had been the victim of a conspiracy. My aggressions were hardly gentled by the fact that I was now £50,000 down as a result. What a mug I had been. We keep hearing that men have lost their role in society: not so – it is actually women who are now redundant. They used to be a means of acquiring property – now they are merely a nuisance. A thieving nuisance at that.

He who screws a man's wife before, during and after his marriage, is the best man to this man, cannot expect to sit at that man's table without the subject occasionally coming up. For months as I prepared to leave Edinburgh I procrastinated. Jimmy was a bully and a dangerous personality, toward whom only a passive masochistic attitude was possible, to whom one's will had to be surrendered. I was afraid.

The showdown finally happened in London. I had come down to meet Rachel and look at the new flat we had found. I prepared it exactly. I was leaving that night on the overnight flight to New York and I met Jimmy at the Oak Room in the Le Meridien Hotel, Piccadilly. My Papworth suitcase was already packed and left in the foyer. I walked into the restaurant dressed in gun-metal silk. Tonight my clothes would be my armour.

We embraced as usual and sat down for the last supper.

'How ye daein', ya bastard!' he said.

He immediately ordered the most expensive bottle of wine from the menu.

'Actually Jimmy, I'm not drinking. I have taken the veil of abstinence.'

'Whit the fuck are ye oan aboot? Ye fuckin' awright man? No

drinking ma erse. Ye boring bastard.'

I studied his face knowing it would be the last time I saw it. I had known Jimmy for over ten years. When I met him he was tough, trim and restrained. Now he was flabby, fleshy and free. His features seemed indistinguishable from the congealed roast beef and dumplings I was about to leave behind on the plate.

I listened to him waffling on for the last time. For ten years he had not stopped talking and almost nothing of any fundamental value had emerged. I nodded and smiled – if you weren't talking about him, he wasn't listening.

I was getting nervous. I tried to prepare inwardly. I excused myself and went to the lavatory. When I returned I felt like Al Pacino in *The Godfather* – but without the revolver. I walked slowly towards the table breathing deeply. A sharp knife cuts the quickest and hurts the least – as my dinner companion understood only too well.

'Jimmy, there is something I want to talk to you about.'

'Aye . . . ?'

'I've been seeing a lot of Ev over the last few months . . .'

He stopped chewing.

'Go oan . . .'

'Well . . . she tells me that you and her were sleeping together before we married.'

Jimmy's conversation was the nearest thing to eternal life that we'll see on this earth. For the first time ever there was silence.

'Ah dinnae . . . ah dinnae ken whit the fuck yir oan aboot Sebastian . . .'

'Yes you do. Ev has told me everything.'

'Ah couldnae give a fuck whit Ev sais ah'll fuckin' tell ye. Ev's a fuckin' lying bastard. It's a loaday fuckin' shite! That's fuckin' oot ay order! It wisnae like that.'

When there are two conflicting versions of a story, the wisest course is to believe the one in which people appear at their worst. I looked him straight in the eye. It is hard to believe that a man

is telling the truth when you know that you would lie if you were in his place. But I knew Jimmy well. To him, lying was simply talking.

I stood up, pushed my chair back and threw the napkin on to my half-eaten food.

'I *know* Ev was telling the truth,' I said.

And I walked out. And I kept walking. I didn't feel as if I was getting anywhere, but I kept walking. I passed The Ritz, hailed a taxi, got to Heathrow and on to my plane. I never saw him again.

I was feeling extremely pleased with my good self. I had finally stood up for it and if I may say, unlike Boyle – with a dashing dignity. A true friend always stabs you in the front.

I was slumbering peacefully at 30,000 feet having broken my vows of abstinence and partaken of the best part of a bottle of champagne followed by a plummy little claret to accompany my plastic dinner. Lulled by the growing distance I was untroubled by the fact that there was one minor flaw in my plan. I've always been rather good at abandoning damsels in distress – once, in Paris, Sister stood up an Arab and he attacked her in the street. Well, running is an unnatural act – except from enemies or to the bathroom (having just placed a stupendous order with a dealer who has promised to be round 'in ten').

Jimmy bombarded my new flat with threatening telephone calls all night. Rachel was staying there.

Rachel had never liked Jimmy. She had wanted to. She had read his book with all the wild-eyed admiration of a young woman brought up to believe in redemption. He must be some-thing akin to a living saint, she had thought. She was bitterly disappointed, she confessed later, to meet a stumpy little runt who'd assembled an array of middle-class people all as impres-sionable as herself so that he could bully them into agreeing with everything he 'jist git tae sey'. But then as Rachel told me afterwards, 'The idea of the Pauline conversation was always a

bit of a con. St Paul didn't undergo some radical change, he just went from harassing Christians to harassing non-Christians. Jimmy Boyle has just moved from bullying people of the Gorbals to people of the suburbs.'

She was right. Jimmy didn't want friends. He wanted disciples. And he hadn't changed – his manipulation was simply violence with gloves on. Despite telling me that Rachel 'hud a face like it'd been sat oan', when he met her he made a pass at her.

'Ah wannae fuckin' shag the erse oafay ye, ya rid-heided cunt.'

'What a pity you shall never have the pleasure,' Rachel replied airily.

'You're fuckin' pathetic,' he spat.

Jimmy and I could both be very rude, the only difference between us being that I was trying to be, and he couldn't help it. He always tried to get off with women because he couldn't get on with them. And he wanted everything that I had. And everything he had was better than what I had. If we both owned the same CD his would somehow be superior to mine.

The new flat in London was completely barren. There was no bed and only one piece of furniture – a little chair that Rachel had pushed over to the corner where the telephone had been connected – her one lifeline to the outside world.

Every hour it rang.

'Pick up the fuckin' phone Sebastian. Ye gaunnae regret it.'

It might not have been so frightening on a sunny May morning but at night when you've been woken from sleep and every shadow is a werewolf, every creaking floorboard a thief, Rachel's imagination ran riot. She had enough sense to know that Jimmy, a convicted killer on lifetime license, probably wouldn't come round himself, but feared even worse that he might send round someone else who not finding me at home would make do with her as second best.

She thought of calling the police but was scared that by so doing she might get Jimmy into serious trouble. All night long she crouched in her T-shirt and pants on the little chair, her

finger poised to press 999 at the first sound of a kick of the locked door below.

Every hour he got noisier and angrier. By 3 a.m. he was talking so loud he didn't need a telephone. I was halfway across the Atlantic, having just broken the sound barrier on the Concorde, and I could still hear him.

At 6 a.m. the calls finally died away. Rachel eventually fell asleep. She woke up freezing with a crick in her neck and her T-shirt quite literally wet with sweat.

Meanwhile, having freshened up in the first-class lavatory, with a music-hall song on my whistling lips and a fold of silk underpants trapped between my well-powdered buttocks, I sauntered on to the tarmac at JFK.

When Rachel told me the story I was afraid for myself for a few months. I had good reason to be. Scratch a lover and you find an enemy. In the past Jimmy had liked hurting people. A lot. But he never killed me, which was disappointing. After all, as a test of whether I was still in touch with him, being loved could never have been a patch on being murdered. That's when he really would have risked his life for me.

When I returned to Scotland I turned on my market eye screen and found I was £50,000 richer. Making money is all very well – but it's pointless if you don't abuse the power it brings. I had already been accused of being crude. So what – I was – I had decided to spend to offend. The vulgar man is always the most distinguished, because isn't the very desire to be distinguished vulgar? Besides, who wouldn't rather be vulgar than bored to tears?

I held a party at the banqueting hall of the George Hotel. 'Au revoir et allez-vous faire enculer.' (Goodbye and go fuck yourselves.) Billy Mackenzie sang 'Breakfast' for me, and Jimmy Boyle – thankfully – didn't get to hear it. I arrived in a £250,000 stretch Rolls, ate a gram of sulphate and got ready for the real hate. If you can calculate the worth of a man by the numbers and quality of his enemies, and the importance of a work of art by the harm

that is spoken of it then I was finally valuable and important. Hundreds came. Drank my champagne. Then, later, looted my home. And wrote 'wanker' all over my walls. Only the last activity impressed me. Any Scot who can read and write is a nobleman. My hate affair with the abhorrent, green, slippery city of Edinburgh was finally over. For a while it had been perfect. I had needed a platform of society from which I could flaunt my persona, my detachment, my notional insurrection against a society in which I was seen as a glittering and irritating adornment. But even I was at the end of my impertinence. I just couldn't go any further. I had been trying for ten years to like the Scots but I had given up the experiment in despair. The noblest prospect which a Scotsman ever sees is the high road that leads him to England. By the time the tinkling of my party was over and there were no more lips to kiss and no more drugs to fix I was finally on it.

8

Mein Camp

Mayfair is always well tailored, glittering as though going to the ball, while the rest of London has to stay at home and clean the oven. I *adore* luxury. I have a greater need for a chateau than a peasant has for a loaf of bread. But I also adore filth and steeping myself in sin. It was hard for Satan alone to mislead the whole world, so he appointed priests and prostitutes in different localities. There is only one place in the world where there are both: Shepherd Market. The red-light area of establishment London.

I moved into my flat at 15A which by a stroke of good fortune had my initials carved in stone outside – a dandy should always have a monogrammed home. For once, I rented the property. After ten awful years in Edinburgh I had learnt my lesson. Never hope of ground that is yours. And the key to happiness: avoid the imprisoning events of life. Property. Possessions. Marriage. Babies.

I had already sold the Rolls to Jimmy and ditched all the expensive clutter of the Edinburgh house. By the time I moved into my London flat it looked as if I had been robbed. You can tell who a person is by what they throw away. I wanted everything in my home to be as useless, as beautiful, and as vacant as its tenant.

I blacked out the three studio windows which opened on to the street. Other painters bang on about north-facing windows

and morning light, but I had found that you could see more through a closed window than an open one. Art for me had always been a way to forget life not recreate it. I wanted to paint the night. Because I saw things darkly, I painted darkly.

I was happy in my new home. I lived by my bank which was nice as I liked to be near my money. And the whole area was lousy with bars and brothels. I should have been able to tell that I was going to hell. In only a few short years, I would sit alone in this luxurious flat and wonder where my glittering life had faded away to, where my disastrous life had materialised from. Had some butterfly flapped its wings in darkest Africa, causing the total collapse of personality in Sebastian, Mayfair?

But that was all some time away. When I arrived back in London I was thirty-two. I was at the age where I had to prove that I was just as good as I never was.

I set about announcing myself as a dandy with renewed vigour. Dandyism is as natural to my personality as a petal is to a flower. Artificiality had become my reality. My essence was embodied in my veneer.

As I shed the ridiculous affectations of youth I began to make way for the monstrous postures of middle-age. Of course, everyone accused me of 'showing off'. And of course they were right . . . and rightly, I ignored them. No dandy should ever be afraid of this criticism. Who, without an element of vulgarity, can become a work of art? Look at the three most outstanding artists of this century: Mr Dalí, Mr Warhol, Mr Bacon. Their personalities touched the imagination even more intimately than their work. Pictures are only things, but artists are individuals. People bought their work so that, in some tenuous way, they could spend time with the man – share a fragment of his shamelessly exotic life.

I set out to broadcast myself, borrowing quite a lot from the wardrobe of the Regency. The period had always interested me. It was an era which had swung between extreme elegance and sodden brutality, an age of excess and exoticism, when the ruling

class blazed, cracked and fizzed in a torrid Indian summer before the dismal winter of democracy descended. Rakes, strumpets, gamblers, murderers, drunkards and artists. Here was a devil-may-care individuality. Gentleman were having their shoelaces ironed while half-naked children were sweeping their chimneys. Wilberforce was denouncing the slave trade while Beau Brummell was denouncing an imperfect cravat.

Mr Brummell was the original and most celebrated dandy but he was no hero of mine. He was so refined that I do not regard him as a dandy at all. I am more concerned with style than breeding. And the key is to dress in such a style that you would attract attention at a Liberace concert.

When it comes to dress, it takes a strong man to be an extrovert. A true dandy needs a complete conviction that he is right; the views of the rest of the world simply don't matter. 'If someone looks at you, you are not well dressed,' Mr Brummell tells us. But then Mr Brummell would say that; prissily precise, he was essentially a conformist. True dandyism is rebellious. The real dandy wants to make people look, be shocked by, and even a little scared by the subversion which his clothes stand for.

And yet, dandyism is social, human and intellectual. It is not a suit of clothes walking about by itself. Clothes are merely a part – they may even be the least important part of the personality of the dandy. Dandyism isn't image encrusted with flourishes. It's a way of stripping yourself down to your true self. You can only judge the style by the content and you can only reach the content through the style.

Being a dandy is a condition rather than a profession. It is a defence against suffering and a celebration of life. It is not fashion, it is not wealth, it is not learning, it is not beauty. It is a shield and a sword and a crown – all pulled out of the dressing up box in the attic of the imagination. Dandyism is a lie which reveals the truth and the truth is that we are what we pretend to be.

If a snob is someone who treats the commonplace accident of birth as a sign of moral worth, then Mr Brummel was atrociously

snobbish. He had the pride of someone who wasn't sure of his position. To be a dandy is to aspire only to the sublime.

And where was the wit? His most famous remark was to refer to the Prince Regent as 'your fat friend'. If wit allows us to act rudely with impunity, this hardly qualifies.

It was only his ending which truly became him for how a man dies shows his true character as much as how he lives. Mr Brummell spent his last days in poverty, in squalor, and in France. It would be difficult to decide which of these three conditions is the most deplorable.

I was moved. His posing had come from the heart! An artificial heart, but a heart none the less. A mass of contradictions, he was obviously vulnerable under stress. Stripped of his self-image clearly he was nothing. The personality he had so painstakingly constructed fell apart. He ended his life slobbering in an asylum no less. Mr Brummell didn't need to commit suicide, I gushed. You can die of a broken heart. Artificial hearts are the most fragile – and so the easiest to break.

And then I learnt he had syphilis. Even his insanity was artificial.

Whichever way, the rebel crumbles into his own ruins. But that, at this time, was too far in the distance for me to see. I had a more immediate concern: where in Edinburgh a pink suit had had the power to make even the most affable yob hurl his fish supper after me – in London it was merely accepted. I was standing around on street corners causing no sensation whatsoever.

This would not do. A man with no talent must have a tailor. I selected from the most exclusive list: Mr Khan of Huntsman fame (and offensive flattery – I hold him personally responsible for the daffodil gabardine and the prawn cocktail pink suede. If I could get the money back from him, I would spend it on suing him for defamation of the characterless); Mr Powell, the Soho spiv; Mr Pearse, the Soho snob, oh, and Mr Eddie, the cut-price version for leisure wear.

Shopping list in head (and hole in my pocket), I set off on my spree.

Suits: sixty-nine (you need to be prepared for all permutations).

Fabrics, I wanted to try out the cut (single-breasted, double-breasted, big-breasted, drape jacket, box jacket, straightjacket) of every cloth (except corduroy, of course). Wool, silk, cashmere, felt; suede, gabardine, worsted, tweed, velvet, mohair, pussyfur, bunnyfluff, moleskin, sharkskin, swansdown, eiderdown, seersucker, cocksucker etc. etc.

Good. Now for colours and patterns: herringbone, houndstooth, dogtooth, tartan, chalk stripe, pinstripe, Prince of Wales, Prince of Darkness, dot, spot, polka dot, plonker or what?

Black: jet black, inky black, ebony black, and drug-dealer black.

White: only in velvet and with a nacreous sheen.

Blue: sky-blue, cobalt, peacock and big cock.

Green: I don't go to the country.

Purple: Imperial, amethyst and mauve with lilac stitching.

Orange: I can't remember – even *I* never wore it.

Yellow: Primrose, crocus, daffodil and sunflower.

Red: Scarlet, cardinal, crimson, cinnabar; blood red, sin red, shoot-the-red, light red, great big fucking flag of danger red.

Pink: Soft pink, hard pink, petal pink, shell pink, shocking pink, even more shocking pink, flamingo pink, salmon pink, prawn-cocktail pink, spam pink. In the pink pink.

And that – even with a mutiny of shimmering satin linings to select from – was just a start.

There were coats – with their cuts and their plunges, their sweeps and their collars. (I found the Vicuna particularly satisfactory, though the wolfskin combined with tight astrakhan curls – from the fleece of an aborted baby lamb – made an appropriately queasy combination.) There were ties – handmade of course and always gratifyingly expensive – even when I started to wear them round my arm instead of my neck. There were scarves. My favourite was

the rabbit, but I'd don any fur. An animal should be delicious and fit well. There were socks (if you haven't got any you can't pull them up), and they came in an impudence of colours and endless materials to match the climate and were all monogrammed, just in case I forgot who I was. And of course there were shoes. I made straight for Lobbs, famously the finest makers of footwear in the world. Everyone who is anyone – or else absolutely loaded – goes there for brogues. How pointlessly boring. I commissioned a pair of Paul Stanley-style high-altitude platforms. Swaying and swanking across the shop floor in my stout, black-calf knee-high leather creations with their seven-inch heels, I attained six foot nine. I was well worth the climb. Such height lends a spurious air of nobility. But – oh God! – why such rare restraint. I commissioned only a single pair – at a cost of four grand.

Gloves. It was time for some real sartorial terrorism. Time to hurl the hand grenades. Women think that it's shoes that set off an outfit. But I don't pay much attention to womanish matters, except of course when it comes to gloves. And it's ladies gloves I like most – the softest kidskin with fur trims and silk linings, buttons at the wrist or little encircling puffs of fluff, brushed seal-grey suedes and dark hushed velvets, sleek cerise leather – perfect for cherry picking. The slipping off of a glove can make a lady tremble.

The slipping on of a shirt can make me tremble too. I devoted myself to their design. Destination: Turnbull & Asser, shirtmakers to the shirt-lifters: Liberace, Skirt Bogarde, Sir John Gielgud and me – not in order of importance, I hasten to add. It is upon the parchment of Turnbull & Asser's sacred tomes that my great legacy is recorded: The Horsley Shirt. Four button cuff. Five-inch turn back. Collar point: five inch (wide enough to fly). But it is the buttons that I will be remembered by – the covered buttons to be precise. There is something so rude about a naked button. I am the only male customer ever to have insisted upon covered fastenings for his shirt. They are essential. Though a shirt offers plenty of scope for the inessential, also, of course.

Engraved silver stays, for instance. 'There's no point,' complained some dimwit, thereby reassuring me that that was *precisely* the point. Double cuffs are also an option – though it's mandatory that a few should be adorned with real diamante. A bit of spare adornment never did anyone any harm, which brings me to the umbrella. The paste ones are cheap at £200 a pop. Custom-made is a little more costly, but worth it when you can have ebony shafts, silver ferrules and embossed tip cups. It is so magnificently expensive that one can't bare to get it wet – which is all the more reason to invest in an array of summer parasols. They look so charming when furled if trimmed with red fluff.

Hats are the crowning glory of a dandy. Beau Brummell and Byron went to Locks. So did I – for four fedoras: fur felt, antelope velour, grosgrain band and bow (with feather mount), satin lining, roan leather – in four different colours. Few things look more ridiculous than a hat on a man who doesn't suit hats. But nothing looks more ridiculous than an ivory-white fedora on a man who doesn't suit hats. Which was why I wore one. I firmly believe that a hat should be kept on when you greet a lady – and left off for the rest of your life.

But what if you go bald? Baldness runs in my family. I am hysterically worried. Only losers lose their hair. Arthur Rimbaud, Oscar Wilde, Lord Byron, Tintin, Marc Bolan, Johnny Rotten, Quentin Crisp, Francis Bacon – all had full heads of hair. Name one great bald person. 'Oh! . . . Shakespeare.' See, you can't.

Baldness is genetic – on the mother's side. I didn't have a indisputable case. Mother never met her father but her brother had a full head of hair *after* chemotherapy. OK, he's dead, fair enough, but at least he died a great man.

Father and Grandfather however were both bald. This was *extremely* embarrassing. I would rather have inherited Father's spastic condition than his conditioner problem. Apparently it's to do with too many male hormones (those eunuchs are shaven you know). I wish I'd known this earlier. Mother thought she was kind because she didn't have me circumcised. I'd rather she'd

lopped off my testicles. I would have got to keep my hair – and have no children.

This treachery of the scalp would not do. I decided to keep my hair. By sheer force of personality. Only as a last resort would I try the fail-safe cure. It was invented by a French doctor. His name was Monsieur Guillotine.

The look was almost complete. To hide my pallor and to show my disdain for public opinion, I resorted to cosmetics. It takes a real man to wear make-up. I wore it for revelation not concealment. My face was simply a document, a leaflet thrust into the hands of astonished bystanders, evidence that what I had seen was interesting.

It was done. I was an exquisite little monster, admiring myself in the mirror of my own creation. Everything about me was now phoney. Even my hair, which looked false, was real. If I had never existed, it is unlikely anyone would ever have had the nerve to invent me. Even I, who invented myself, had my doubts.

At home I remained in a self-supporting universe enclosed in a hermetic, hermaphroditic narcissism. I lived in my boudoir amidst rails and rails of suits all protected by clear-plastic covers. When I woke in the morning I thought I had died and gone to a dry-cleaners. Actually that would have been heaven because I had no washing machine – even my socks had to be dry-cleaned.

I had spent £100,000 on my wardrobe. I simply *had* to squander oodles of money as fast as I hadn't earned it so as to escape the tortures of having to do something sensible with it. Once I had tired of a Huntsman special I would wear them as painting overalls. It is important to show disrespect for things that cost a lot of money.

From Savile Row to B&Q. Of course dandyism fails. How can originality replicate to create a whole movement? How, on the one perfumed hand, can you talk about freedom when you willingly give it up with the other un-gloved mitt? How can you be unique and yet part of the gang? There are two universal truths about human beings. One: they are all the same. Two:

they all say they are different. Two is, of course, the result of one. The dandy just happens to be the biggest, the best and most beautiful fraud of them all. His doctrine is a laughable conceit, a delightful illusion.

Dandies come out pretty well in history. They take pride in trying to add to the world only something that's special. But my clothes were also a barricade to hide nothingness. Of course, eternal nothingness is all very well as long as one is properly dressed for it.

And so every day in Shepherd Market I put on my best trousers to go out to battle for freedom and truth. One must always look beautiful, look up and smile at the camera – even if it's only a security camera – or a satellite. Contra Mr Orwell, I was grateful to be worth watching. I curled my skip into a smile and my smile into a show. My gait, for those of you who missed it, was a purposeful lope, taut with authority, and I walked in the perfect glow of self-adoration, striding invincibly through London's awestruck and fawning populace.

I was happy even when I was ridiculed. To be derided was part of the plan. I looked for ways to act and speak in a way that would be mocked. I wanted to make clear to the world that I knew what it was they were laughing at. This was the only way I could get the joke on to my own terms.

That which cannot be wholly concealed should be deliberately displayed. I hired the downstairs of Claridge's and held a party to announce as loudly as possible my arrival in town. I had a job to do. 'SEBASTIAN COMES TO SAVE LONDON.' I sent out the gold-embossed cards.

The rich, the famous and the useless turned up. A hundred people standing smiling and talking to one another, grinning like gooney birds. A string quartet played. The menus had more braid and badges than a military general. I looked around the room. It was utterly absurd – watching them, all reading each other like price tags, deciding whether they wanted to buy into each other or not.

What the hell was I doing? Staying unsaved is no easy business in the modern world. I was a member of the dandy aristocracy. But I was just middle-class – and with no redeeming fortune. My status could only be maintained by sham, by sheer nerve, by unconquerable self-assurance. I braved it out but I felt strangely detached. I had spent £10,000 but the event was so dull that if I hadn't been there myself, I would have been bored to death. All I'd wanted was a cosy get-together with sixteen thousand of the poshest nobs. But it was a shambles. I reviewed the situation. And this is what I learnt.

I learnt that I did not have the aspirations of Mr Brummell – he was merely an average dandy – and scratch an average dandy and you will find a social climber. My role as a poseur was itself a pose. I adopted it like a gardener adopts gauntlets to weed his social patch. Not that anyone noticed. They all stuck it out. They swilled at my trough. I thought about feigning death but decided against it. Kings should disdain to die, and disappear instead. But could I go anywhere when I was nowhere? I stood there and smiled insanely all evening – then slunk off home and took a gram of sulphate.

Having been only an alcoholic for the last ten years I had some serious drug catching up to do. During my time in Scotland instead of putting them up my nose I had been forced to strike a pose – of looking down my nose – because of (as always) Jimmy. As a typical Glaswegian alcoholic, he would 'nivir touch that shite'. Now I was liberated. I started to dabble again.

One evening I was at a party with my old friend Ben Bream and my sister, Ash, who introduced me to her new boyfriend, Giles, and her new drug – Ecstasy. Cautiously she gave me half a pill. It is just too sordid to take half of anything. I downed the rest. As the first rush came on I was overcome by an overwhelming desire to kiss someone. Anyone. I grabbed Ben.

Only then did I finally get round to studying Giles. He did not look out of his face, he looked inward, like Hamlet but without any of his misgivings. Everything seemed right with

him: the mood. The room. The world. From my eyelids I dripped love.

Ecstasy, contrary to popular opinion, is not an aphrodisiac. It is a sensual rather than a sexual drug. And the worst of it is that it gives you severe idiot-compassion; you feel benign towards the most pointless of people. You can convince yourself that you actually like your family, that you want to hold your girl-friend's hand in public. Worse still, you are compelled to feel compelled to dance. This is dangerous. Dancing with me is like trying to assemble a deckchair.

I was hooked. For me, sex has always been the bad news that we have no supernatural powers. At the moment when we most want to transcend ourselves, we run up against the barrier of skin. With Ecstasy I had found a chemical that could heal my sexual nihilism. With this drug I could satisfy my urge to merge. I could break my imperious isolation.

Besides, I had bottle fatigue. It didn't matter what drugs cost, it would be worth it to stop drinking. That was my real curse. What a relief it would be to wake up remembering how I'd got home and what I'd said the night before!

Apparently Ecstasy affects your memory too. But I remember 1995 well. It was the year I took 500 of the fuckers. Rachel bought me a silver pillbox embossed with a wicked looking lily. It held exactly twenty pills. A suitable ration – for a day. In the evenings Rachel and I had a table at The Ritz to which we would invite our friends. After dinner the passing of the pills became a ritual akin to the passing of the port – except the women weren't sent out, they passed out – and there was never any left.

But it wasn't long before we began to grow impatient and take our pills before dinner. We would sit there staring at our food all evening. Rachel was like one of those dogs that nod in the back of a Ford Cortina. Or a newly hatched chick – plonk her down anywhere and she just stayed perfectly still looking about herself and peeping vacantly. Eventually in a burst of energy she

would heave a carrot across the plate. Then, exhausted, sink back into her chair weighed down by Catholic guilt.

HER: Darling, this is so awful. This is so wasteful.
ME: Yes darling, you are right. There are people starving for drink and drugs all over the world.

Some mornings I would just pop one for breakfast out of sheer *ennui*. It seemed a simple way to elevate the more mundane chores of life. I would glide into my local friendly-Asian-retailer feeling *so* benevolent I actually paid for the goods. At 8 a.m. I informed my dry-cleaner that I loved her.

I was starting to look at other women. The honeymoon period with Rachel was over. Actually it had been over for months. There were problems. The first was that Rachel had got everything twisted up. She was a whore in the kitchen and a cook in the bedroom. Her idea of cooking was to slip your evening meal into your hand – a packet of frozen soup. 'Hurry and eat it darling,' she would say, 'before it thaws.' As for sex? Rachel was the sort of woman who gave necrophilia a bad name.

It wasn't really her fault. If I was the victim of a broken home, Rachel was the victim of an intact one. Her mother spent her life washing her clean linen in public. She had a punishing selflessness. Her father was slightly more wayward but not much. Rachel's family's idea of a good night out was an Oxfam barn dance.

I was the first lover that Rachel had taken home. 'Rachel only had two things – her virginity and her faith and Sebastian has taken both,' said the mother helpfully. This was not *strictly* true. Rachel was of the faith chiefly in the sense that the church she did *not* attend was Catholic. As for being a virgin – a no man's land – Rachel was a recovering Catholic. Her family believed in God; a God that made their body and yet they thought that they couldn't do anything with that body because it was dirty. Of course, they did not blame this fault on the manufacturer.

Nor did they understand the implicit atheism of regarding their God-given parts as dirty.

Rachel struggled for years with the word faith. Eventually she gave up, dropped the i and the h and concluded that she was fat. Sweet Lord, nothing for which the life beautiful has a name can be read into a potbelly. But believe me she didn't have one. It didn't matter. Rachel became a diet waiting to happen. 'My skin doesn't fit me anymore,' she said.

Worse was to come. When a woman says she wants to go out and get a job to express herself, it usually means she is hopelessly behind in the ironing. Rachel didn't own an iron. She lived in one room which was totally bare – a bit like one of those genetic aberrations that families keep in the attic and throw a cabbage to from time to time. Not that she wouldn't have loved a cabbage. She'd have stewed it up and tried to survive on it for a week. One of her diets was just that. The cabbage-soup diet. Her clothes, her hair, her room all reeked of cabbage. Even the books which lined her flat from floor to ceiling stank of this erection-withering pottage.

I banned her from my flat, so she went out and got a job at a national newspaper. This in itself did not interest me. I had long since given up magazines and newspapers – I was worried that they might lead to harder things like books. But her reasons for taking up employment did. When a woman inclines to academia you can be sure there is something wrong with her genitalia.

There was. In our first year together we hadn't made love. We had had it tailor-made. Now it came off the peg. Foreplay was quick and consisted largely of the words, 'Are you awake?' I tried to keep my mind focused on the job. I gazed lovingly into the mirrors beside her bed – until eventually I made so much noise when I came that she woke up.

Rachel took moderation to extremes. Even the Ecstasy pills weren't working. Nick Cave is the only man I have known to take the drug and hit someone. Rachel is the only woman I have

known to take the drug and become completely self-enclosed. She slammed shut the doors of her psyche and just sat there. She didn't care how loudly I knocked. And like some door-to-door salesmen I soon learnt to cut my losses and give up.

Women generally respond to my skilful caresses – from the top of their heads to the tags on their toes. They like my sophisticated cocktail of wit, intelligence and, well, chemicals. I was starting to miss the whole allurement routine. Seduction, after drugs, is the most important thing in my life. To seduce! The very word is beautiful – it gleams like crimson. But Rachel couldn't be roused. 'Come up and see me sometime,' she might offer, in her more generous moments. 'Thanks sweetheart, but I've already been.'

There's only one trouble with the multiple routines of the drinking and drugging life: they have a devastating effect on the multiple routines of the writing and painting life. I'd used to think that I was a painter who drank a lot. But it slowly began to dawn on me that actually I was a drunk who painted a bit. I was drinking to forget – that I had given up drinking.

Obviously I had swallowed the Romantic myth down with my Ecstasy tabs. I had decided that drugs and art were linked. Don't the best poets and composers take chemicals to engender creativity? Can you trust the ones that are too careful – as writers or drinkers or drug-takers? Surely dull old Goethe can't have been as great a man as Keats? Carlyle can't compete with Rimbaud, Wordsworth with Coleridge? *The ones that burnt.* Was that why they drank: to put out some of the fire? Far better that than to simmer like some old saucepan cooking up platitudes on the stove. Far better to burn too bright – and then explode.

Or is it? All that stuff about drugs may be Romantic myth, but it's nonsense too. I don't know who's responsible for it – me, probably. Of course drugs and creativity are linked, but not in the way that I thought. Taking drugs doesn't turn you into an artist. You can't write on drugs any better than you can drive

a car when you are drunk. It works for a bit but then you run into a hedge. But the type of person who creates tends to be the sensitive sort. The whole point of being an artist is to feel and think and imagine a lot – mainly about yourself. And that, paradoxically, is why the sort of person who is drawn to art is also drawn to drugs. The drugs save you from that endless, exhausting self-examination. It is so tiring always thinking about yourself. The point of taking heroin is to make you forget that your leg's just been cut off in the car accident that you had when you were driving drunk. Unfortunately (for you, though not always for everyone else) it also makes you forget about everything that had made you an artist in the first place.

One day I looked up at my latest work on the easel and realised that I was no longer a painter with a drug problem. I was a druggie with a painting problem.

There had been a few amusing deaths in the family recently. I had made them my subjects. Grandfather had finally died at ninety-two. The good die young. He had kept his defiance to the end. When asked to what he attributed his longevity he replied, 'to bad luck mostly.' At his age he couldn't expect to excite anyone but an archaeologist. He looked like a mummy escaped from the British Museum. But he was still pursuing young girls. My last memory of him is making sly lunges at Evlynn's bottom from his wheelchair. By the end only he didn't know he was dead. Eventually, the doctors generously overdosed him, and the man who had made such a tumult all his life lay silent as the night.

Grandmother followed him within the year. Then Stepfather copied. The smell of slaughter was in the air. I guess husbands die younger than their wives, because they want to. But it suited Mother too – when he died, her hair turned quite gold from grief. She had been utterly fed up with him. For several years before his timely demise he kept leaving her, making trips to the Rajneesh community in Oregon. Mother had gone along with it until finally he came back. She was rightly suspicious of his

motives. If you love someone, you set them free. If they come back, they're probably broke.

We can't really look on death anymore than we can look at the sun. Here was my chance. I watched him die.

I arrived the night before. Mother was now living in Bath and Stepfather had contracted liver cancer. (Not cirrhosis of the liver – it costs money to die of cirrhosis of the liver.) It was weird – unlike Mother or Father he hadn't smoked, drunk or taken drugs. He had done yoga every day. He looked pretty stupid, lying there in bed dying of nothing.

His physical deterioration was shocking, Mother had warned me. Within weeks of the diagnosis he had waned and wilted. Excitedly I prepared myself for the worst. He lay on the bed. His skin was sulphurous yellow (No wonder. He was drinking pints of carrot juice a day in some mad holistic attempt at self-medication). His cheeks were sunken. His beard was like dried bracken around his mouth.

'Hello Sebastian,' he whispered. 'Thank you for coming.'

I had barely seen him in years. I had ranted to him in fury when Sister had finally told me about his trying to seduce her when she was just seventeen. And then I had remained silent – the most perfect expression of scorn. I had never forgiven him – for not driving me to see the Sex Pistols.

But here he was. In the game of life and death no one stands taller than anyone else. I watched him hobble to the bathroom for one last pointless piss. I was hoping he might say something or do something on this momentous occasion. (I know I will. I have already prepared something.) I wanted at *least* a last insight. What was it *like* to die? 'All we can do is be lovingly together,' he said.

The next morning Mother called me into the room. He was already unconscious and slumped over to one side, like a bag of refuse. The last drops of carrot juice dribbled down his face. Mother was clutching him like a withered bunch of flowers. I heard the death rattle in his throat, warning life away. Mother let out a long moan of pain. It was over.

'You know, Sebastian, I don't miss him *at all*,' Mother suddenly announced a couple of weeks after the funeral. I rather agreed. You wouldn't have warmed to him even if you had been cremated next to him. 'I did have him cremated you know,' Mother said. 'I didn't want him to become at one with the earth. I'm not sure I wanted him to live on in a *flower*. It's what *he* would have wanted – but not *me*. Can you imagine? It would have put rather a ghastly pall on all those pretty, yellow crocuses.'

She brought his ashes back and kept them in a box on her coffee table for a year or so. No doubt he would have wanted to have had them strewn upon the Ganges or something. But Mother was having none of it. She strewed them upon her porridge, one morning, instead. She ate him – with crunchy brown sugar.

In the lavatory later that day, she told me, she had giggled hysterically at herself in the mirror. 'That'll teach him,' she had said.

Of course, I would have liked to have set up an easel at the death scene but that was a touch too vampiric even for me. Still, the spectacle haunted me. I had seen a man become extinct. After a lifetime of pain and misery it was the final, brutal humiliation. It was this that I wanted to capture, when I returned to my studio.

But paint is such an unforgiving medium and I simply wasn't good enough. Besides, I was breaking all my rules. I have always despised narrative painting, the canvas that tells a story, or even worse, attempts to moralise. Painting should be like poetry. It should create atmosphere and leave room for the imagination. But my vast paintings not only told the story but begged for sympathy. No wonder they failed. I hate art that has a palpable design on me. But the real fault was mine. I hadn't got enough talent. My skills were like the wings of an ostrich. I could run, flapping madly, but never take off.

The deaths of my various relatives were a subject of interest only to myself. I should have kept it to myself. But I didn't. I

hawked my work round endless galleries. No doubt they all thought it stank – but they couldn't say they liked it that much.

I tried not to allow rejection to dent my determination. Rather, constant dismissal taught me that it was perfectly possible for me to want something badly but then immediately declare myself infinitely superior to it as soon as it became manifest that it didn't want me. Besides, I had wealth to insulate me from profounder feelings of failure: even though, shallow down, I knew it was fame that I craved. Why wouldn't I? This was the mid-nineties. Success only counted if it meant acclaim in your time. Every career was shaved down to one bald rubric: are you famous or not? It didn't matter if you were a missionary or a murderer. As long as you were a celebrity you were a success. And I wasn't. What the hell would I do? Go and be big in the Third World? Or move back to Hull? Failure is far less apparent in the suburbs.

I needed some new way to fill in the gap between now and the grave.

Sex. That was a good answer. What better way to break the boredom? Who gives a toss about the ideal?

My affair with Rachel had run the familiar course: Fever. Boredom. Trapped. The happiest moment of any affair happens after the loved one has learned to accommodate the lover and before the maddening personality of either party has emerged like a jagged rock from the receding tides of lust and curiosity. Rachel had just done this. And the jagged rock – it turned out – was an iceberg. But the cold of polar regions are as nothing to the chill of an English bedroom.

Rachel, who had used to give such good head, now gave nothing but very good headache. It came to its climax – or rather didn't – in Portugal. Waking up with a morning erection, I politely suggested that Rachel might like to hop on.

'Sweetheart, I don't want to do this anymore. I really don't.'

'Check your pulse darling. You may be dead.'

Rachel smiled at me, but she was looking out of the window.

Her smile and her face were never in the same place at the same time.

'The truth is I don't like sex with you anymore. I have been faking it since we met.'

'What you've *never* had an orgasm?'

'Yes, I have had orgasms, darling. You've just never been there.'

Suddenly I was faking an erection.

'Why?'

She shrugged, rather too indifferently for my liking. 'I don't know. To make you happy? To get the job?'

But it turned out to be more than that.

If I had delusions of grandeur, Rachel had delusions of inferiority. Never knowingly oversold, she wallowed in an exaggerated sense of her own unimportance. And now she had decided, without even consulting me first, that she was fat . . . too fat to expose her flesh to anyone . . . in short, too fat to fuck.

When I'd met her, I had blasted her with adoration. It must have been like having the door of a furnace flung suddenly open in her face. But as she grew used to it, perhaps she began to fear it would fail. So she kept on testing the heat. It was a sort of defence: like flinging the first punch – even if you fling it in your own face. 'I'm too fat,' she would say. And wait for me to give the Pavlovian response. 'No you're not, you're beautiful.' If I said it she disagreed with me immediately. If I didn't say it she was even more sure she was positively gross. It was a no-win situation. She was gorging on my reassurances. Her swaggering insecurities could never be satisfied.

So that was when I learnt that women can fake orgasms. Now for the next lesson. Men can fake entire relationships. Now it was time for my personality to emerge like a rock – a punk rock. I was fed up. Of all the sexual perversions, monogamy is the most unnatural. If you say you're enjoying sex with the same person after a couple of years you're either a liar or you're on something. Love is merely the delusion that one woman differs

194

from another. But my awakening was worse than that. As soon as I thought that I loved somebody, I started to feel trapped — and the arms that close most tenderly around you are the strongest chains.

As a dandy, I had learnt to shed my fetters and don my crown. But Rachel wasn't prepared to put up with being a rose in my lapel. When I tried to buttonhole her I bloodied my fingers on her thorns. Besides, it wasn't just a rose I wanted, I was after a triffid. I wanted someone to run riot with, to take over life with — or low life at least. Rachel was not the girl for this game. Sure, I like women with depth — but depth of cleavage.

The break was final. I had fallen in love with myself. To have a girlfriend would now be unfaithful. Worse, by remaining monogamous I would be making one woman happy and all the other women in the world unhappy. What right did I have to do that?

None of this was Rachel's fault. What woman would I choose now? The trouble with dandyism is that it leaves no space for *any* woman. Besides, all that ridiculous reproduction business can crumple your suit.

Anyone fool enough to have read this far, will understand what my problem was. Sex is so horribly about the body. And a body that will die and decay at that. Nature perpetuates itself by allowing crawling, ephemeral creatures to procreate. And I can't have that. I can't simply be a link in the chain of being, exchangeable with any other and expendable in myself. I am not a piece of animated meat. And I will not become a fornicating carcass. And besides, I take indignant exception to the fact that we are designed to make love with our excremental organs.

So what to do next?

The best way I had found so far to deal with the body was to deny it. All my life I had used dressing up like a magical charm to transcend my earth-bound form. And of course I had failed. I had become a baboon in a velvet cocoon.

The other method I had adopted was money. Money meant power over other men, freedom from obligations, an elevation above my faeces – and meant a license to act like a complete wanker to boot.

Now it was all suddenly starting to make sense. If x is a conventional relationship and is equal to utter mundanity, and y is loads of money and equals soaring individuality, then x plus y plus a dandy twerp can only add up to one answer when an unemployed sex maniac (who had never been any good at maths) also came into the equation.

Whores.

A gentleman should always have an occupation of some kind.

I set off on my journey that was to lead me through the twisting, swarming streets of Soho and Mayfair, snaking through the seedy body of the city. But I began in a brothel two doors down from mine. Aren't you supposed to start out with the girl next door? I was nervous – and drunk.

I navigated the rickety stairs of the little old house.

'Hello,' I lied.

She stared back and gave me a gormless pools winner smile. But the whole room felt malevolent. The bed, stripped of sheets and covers, the striped mattress as naked as a rape victim. The chamber was like a morgue in which love was laid out.

I didn't care. I felt like I had come to commit a crime and I wanted her to save me. Save me like an alibi.

I moved on to the bed and studied her bosoms. She giggled and pulled my pants down cooing professionally at the view. 'Take good care of this my darling. It enjoys an international reputation,' I wish I had said.

Her hole was warm and wet, like the mouth of a cow. I fucked her to the point of cardiac arrest but although I was hard I knew I wouldn't come, a taste of the experienced alcoholic whoremonger I was to become.

As my habit grew I took to brothels in the daytime when I was still sober. I wanted the sensation of sex without the

boredom of its conveyance. In a brothel you can buy physical closeness without the intervention of personality. It was an artificial paradise. I used money, the most impersonal instrument of intimacy, to buy the most personal act of intimacy. Lust over love, sensation over security – and to fall into a woman's arms without falling into her hands.

All my inhibitions (well, my one inhibition, actually – the cost) vanished. I threw myself into whoredom with complete abandon. Before long I was visiting four a week. I was becoming a connoisseur. I savoured the bouquet, sipped at the temptations, rolled the pleasures around my tongue. I appreciated a fine vintage. But I knew also where to get the good *vin ordinaire*. I went to brothels, saunas, private homes that I found on the Internet and sometimes I ordered girls round to my flat – prompt as pizza. Over the years I have slept with every nationality in every position in every country. From high-class call-girls at £1,000 a pop to the meat-rack goods of Soho at £15 a bang, I have probably slept with more than 1,000 prostitutes, at a cost of £100,000. I wish I was more ashamed.

But my love of prostitution was more than simple sexual release. For a start, I love prostitutes and everything about them. They are the most honest and open people on God's earth. But it was also the whole idea of prostitution which thrilled me. 'Lust, bitterness, nullity of human relations, muscular frenzy and the ringing of gold,' was how someone once described it. I stared into the abyss and felt deliciously giddy.

Once, with Rachel, I had used to think that it wasn't who you wanted to have sex with that was important, but who you were comfortable with spiritually. Now I decided with equal inflexibility this was rubbish. The problem with normal sex, I concluded, was that it led to kissing and then, pretty soon you're going to find you've got to *talk*. And once you know someone well the last thing you want to do is screw them. Yes, it was who you wanted to have sex with that was *really* important.

Of course I didn't tell Rachel about my burgeoning hobby. I pride myself on my honesty (as you, dear reader, might unfortunately have noticed). But you lie to two types of people – your partners and the police. Everyone else gets the truth. Even though Rachel and I were no longer lovers, the relationship had not changed. And though, naturally, I was pretty peeved she hadn't killed herself for love of me, selfishly insisting on going on living instead, we remained on pretty good terms.

I enjoyed the deception. A secret life is exhilarating. Rachel would still stay with me in Shepherd Market and I would sneak out and escape into the arms of a whore. Half an hour later I was back, chatting to Rachel pretending that I had just been out for a stroll. Naturally, I thought my behaviour was honourable. The only thing I despise are heartless one-night stands where you tell all sorts of lies to get a woman you don't care for into bed.

One evening I brought a prostitute back to the flat while Rachel was staying. I fucked her on the sofa while Rachel slept in the next room. I remember the spine-tingling stimulation of fucking fully clothed as every creak and groan made me think the whore was going to be discovered by Rachel and Rachel was going to be discovered by the whore. I was the only one who was in control. I liked to give, never to receive; to have the power of the host, not the obligation of the guest.

When we were done I gave the hooker fifty pounds and let her out. Then I undressed and climbed into bed beside Rachel. I snuggled into her warm body and wrapped my arm around her. It was strange. Deceit always made me so loving.

Besides, squalor makes for a rattling good lifestyle. Where society sees the 'dirty' prostitute as degraded, for me it was the dirt which gave texture. It was enthralling to touch. I loved the crumbling make-up, the stale aroma, the bitter smell of the skin. I liked shuffling up broken-backed staircases into seedy dim rooms. I felt like a blind man groping his way through a velvet darkness.

Are men exploiting women? I don't think that prostitutes necessarily feel frustrated and exploited. But middle-class intellectuals who sit around dinner tables formulating their opinions for them always tell me that they do. I think that if they took the trouble to try to find out for themselves they would probably discover that the prostitute and the client, like the dealer and the addict, is the most successfully exploitative relationship of all.

And the most pure. It is free of ulterior motives. This is no squalid power game. The man is not taking and the woman is not giving. No one is attempting to cheat on a husband or humiliate a wife. No one is trying to prove anything or get something out of someone. The whore fuck is the purest fuck of them all.

Still, I liked to have two women: one to feed the flesh, one to recite the poetry. One to revel in the squalor with; one to dust and clean and cook.

I carried on with my quest to find the true hooker. I trawled the brothels – and since lust is merely the interval that passes between imagining a bosomy beauty and encountering a flat-chested tart, I often had to leg it – and often rather fast – and once with the boot of the disdained girl up my backside. But I liked and deserved punishment. And I liked the life. In the mornings I worked. And in the afternoons I fell in love. And then one day I *really* fell in love.

I met Claudia by chance and it is only chance that can really speak to us. An event is more significant the greater the accident necessary to bring it about. I passed her in Knightsbridge one morning and was so taken by her haunted beauty that I actually followed her. This was a first. And, if it was not sexual obsession then it was at least love.

Love makes the world go round looking so dowdy. But there was nothing dowdy about her. There was an air of great quality about her. The faces of English girls look as if there is not enough material to go around. They have thin lips and papery

eyelids, box jawbones and withered hearts. Claudia was luscious. She looked Mediterranean. Her lips were plump and they curled and pouted. Her nostrils flared. Her eyes were black and big as saucers, her eyelids as thick as pastry.

When we concentrate on the idea of beauty we are without realising it, confronted with the darkest thoughts that exist on earth. And yet she rose like a flame to lighten my darkness and I was Icarus, burned by my love of the beautiful.

She walked and I stalked all the way to Soho and down Berwick Street. *No. No way. She couldn't be!* She turned, and walked into a brothel. I couldn't believe it. I could fuck Raquel Welch for £25. This was an abnormality in the market that would have confused even Mr Keynes.

In a suit made to measure I went in pursuit of pleasure. I knocked on the door of the brothel. 'Busy, come back in half an hour,' came the reply. I came back in half an hour. 'Busy, come back in half an hour.' At 6 p.m. that evening I eventually got an appointment with Claudia.

I walked into her boudoir and disposed myself upon the bed. She sashayed in wearing lace bra and pants.

'Make yourself at home,' she purred. 'Get undressed.'

'Make *yourself* at home,' I replied. 'Get dressed. I'm taking you out. This beautiful pale face is your fate.'

Twenty minutes and £250 later we were walking arm in arm towards The Ritz. As I opened the door for her I remember being truly happy for once in my life. All the quality of that evening, and all the evenings like it that never came, have remained with me in all their splendour ever since, each memory chasing the next, merging with the next in an endless dreamy chase for lost sensation.

We were led, amid grandeur and glitz, to our table. There is nothing in all of nature like this ridiculous rococo palace. To me it is the single, tolerable form of theatre: to sit amid such lush ornamention, fussed over by servants with a plush, pink carpet caressing the soles. For the first ten minutes we hardly

exchanged a word. What's the point of speaking unless you can improve on silence?

I studied Claudia's hands, then her face. About twenty-two I reckoned. I like younger women. Their stories are shorter. And on top of that, she was exquisite. Beauty is not so much a woman as a man's idea of a woman – preferably born of a different race from his own or into another class so as to add a pinch of unattainability. My first impressions had been correct. She was Italian.

This is a form of depravity in itself. Italians are bewitchingly beautiful. So where the ugly Japanese work insanely to save themselves from fucking each other, the lovely Italians don't work a minute longer than they have to, so they can have all that extra time off for making love. Claudia went one better. I had found the most voluptuous, most sensual, most languorous specimen of a voluptuous, sensual and languorous race – with an added intoxicating pinch of the puritanical – who had found a way to let her work and life merge. She stayed in bed for her job. My pleasure was her business. It was well worth the price.

Women are always asking me, 'why pay for it?'

'How else would someone young, rich and handsome get sex in this city?' I reply.

'But they're prostitutes,' they say with a prim little *moue*.

'Aren't we all, darling?'

I looked across the table. Claudia smiled a little shyly and shook her mane of dark hair, sending a shower of glitters tumbling amid a delicious perfume.

I have sat across this very same table at the Ritz and stared at the shallow greed of some moralistic little madam in a bosom-spilling dress who expects me to pay for her and then fund the taxi fare home. Isn't she just a whore – but one who refuses to deliver the goods? She looks down on the prostitute. How horrible to have to strip for a living, she says. But she does a job too – she's a journalist, or a lawyer or a TV presenter or

something. Her job strips her of all that she's got, including her mystery.

'But it's so *horrible* to have to be a prostitute,' she squeaks.

But aren't you, I wonder. Aren't so many London girls? Except, where a good to honest whore would keep the promise that a nice girl wouldn't make, these teasers accept the terms of the contract that they then proceed to break. The 'grasping whore' at least pays up the pound of flesh that has been haggled for. The so-called 'good girl' does a runner with the goods. The main difference between sex-for-money and sex-for-free, I've found, is that sex-for-money usually costs a lot less.

I prefer to pay.

I took Claudia's hand across the table. It was cool. Her long delicate fingers faintly returned my grasp.

'Claudia, my darling, all the worst things in life are free,' I said. She giggled cosily and picked up her fork to start upon the asparagus.

I gazed in adoration as the butter greased her lips. There is an allure about the illicit that makes it achingly attractive. I mean, you can't think that Adam was hungry when he took that apple. He only took it because it was forbidden – and because it was offered to him by a girl.

It was December and after dinner we strolled, arm in arm, to my flat. I was hoping for a Christmas present: her presence all wrapped up with me. I leant over to kiss her. She turned her face abruptly away. Hookers (as well as wives) don't kiss.

'I'd rather have two cocks up my arse at the same time than kiss,' Claudia elucidated elegantly. 'I don't like to get personal.'

A kiss is usually an application on the top floor for a job in the basement. With whores the basement is permanently let, but the top floor is locked. But I had been reminded a little too abruptly that I was paying and I felt a stab of hurt.

Still, I wanted to see her public parts. I started to unwrap her. She was perfect and dark and voluptuous. And she lay, limbs

scattered across the carpet waiting for me. I too undressed, and lowered my sorrowful white carcass down beside her. My body is merely an insect crawling about in the mad cathedral that my mind has built. But her physique was pitch perfect. Her performance as a complete fantasy woman was flawless – and maybe because she didn't want me at all.

If you hear that I'm dating someone, then you can be sure it's simply because I'm too lazy to commit suicide. But the trouble with Claudia is that she made me want to live. I started seeing her regularly. I accompanied her to the Connaught and to Claridge's and to her smelly little walk-up in Berwick Street. She was wooing me softly with her moans and coos. I lived, ate and slept for her – and certainly dressed for her. 'Am I handsome enough for you?' I asked. But is modesty in a beauty as fake as passion in a prostitute?

We were both dealing with unreality. Hookers and drunks both instinctively understand that common sense is the enemy of romance. But our imaginary relationship could never truly be realised. It was impossible from the start. She was yearning for that tall dark figure which stalks so many female dreams. I looked a bit like it in outline, but I was paying for her. I couldn't become a real person. I could never be her man because I would always know she was a whore. It was irresolvable. But that didn't make me give up.

Proust's first law came into play: love does not cause jealousy; it is jealousy that engenders love.

I remember dating a lady once. She was pretty good-looking for a super model. But I was mortified when I found out she had fucked Mick Jagger. I didn't want her anymore. She felt sullied to me.

In the beginning, it excited me to know that Claudia slept with twenty men a day. Why would I use it against her? I mean, a man can sleep around, no questions asked, but if a woman makes a couple (of thousand) mistakes, she's a slut?

Oh no. He who never subjugates himself to another nor

seeks subjugation, will never be betrayed. Besides, how could I, who so valued my personal freedom, try to curtail the liberty of others – even if it was the liberty to become a living public lavatory?

The trouble is, the green-eyed monster was stirring; the dragon which slays love under the pretence of keeping it alive. 'The man who loves without jealousy does not truly love,' I suddenly decided. It sounded like a marvellous philosophy. I didn't want one of my girls sleeping with a single other man.

It was the beginning of the end. A man can be happy with any woman as long as he does not love her. Now I would go up to her brothel and wait without an appointment – and often in a queue – outside her boudoir. Beyond the thin plastic shower curtain I could hear her, hear the thrusts and the murmurs; the moans and the creaks; then, even worse, the little giggles and the post-coital chat. It was ridiculous and I knew it was ridiculous. But I kept prodding at the wound.

And still she wouldn't kiss me.

I started to visit more and more . . . and more . . . girls. My lifestyle was costing me a lot of money – it's so *expensive* being rich. And since it naturally takes greater character to handle good fortune than bad, I quite naturally failed. Excess had gone to my head – so I had to have more.

Enter Hugo Guinness (through a trapdoor). I had met him originally at my coming-out party at Claridge's. I had watched him hovercrafting across the carpet with his purple velvet smoking jacket, his mouth puckered like a cat's anus with upper-class snobbery. He wore the fatuous expression of an old lady. He was marvellous: incandescent with moral decay.

'Well, this is very un-English,' he said offering a limp hand. 'These pre-dinner drinks seem rather drawn out, but I know you alcoholics like to be given as long as possible to stand about glass in hand talking interminable drivel,' he drawled.

He looked over at Rachel. 'Well, I like *her*. She obviously needs a good seeing to.'

He sidled up again later. 'Darling, I need someone to fondle. What about your Mother? Is she available?'

The next thing I knew he was waltzing her across the room. 'My dear, the fact that there is no music is a mere detail.'

Don't trust first impressions. They are always correct. I have often opined (to anyone who will listen, and that includes myself) that friends are not necessarily the people you like best. They are merely the people who got there first. But had I been given the run of a Fortnum & Mason's of friendship, I would have picked Hugo out. Yes, he was to prove pretty expensive. But then I have never shopped in Woolworth's.

Hugo was wonderful. He was vain, selfish, amoral and weak. And this was not all that I loved about him. He was so empty of content, so content with his emptiness. We all search more or less consciously for someone who shares our profound beliefs. Or lack of them. And at last I had found him.

A month after the party, he called. 'Basti-Boy, sweetie. I shall be round at 6 p.m. I have arranged a shipment to come to you this afternoon. I know that normally in Mayfair if you see a black man walking down the street you phone the police immediately, but please don't. He is called English and he is my man. There is something I want to introduce you to. And then on to fetish clubs and kinky places with lots of bottoms and aerosols.'

English turned up, as predicted, in the afternoon bearing gifts: four neat little packages wrapped in cling film. Hugo burst through the door at 6 p.m. and bolted past me, disappearing into the bathroom with, inexplicably, a roll of Bacofoil.

I was expecting to go out for dinner. But by the time I caught up with him he was perched on the sofa, a sort of Blue Peter contraption held in his hands. It was a bottle, half full of water, with a Bic biro sticking out of a hole in the middle and a piece of tin foil fastened over the mouth. It was on to this that he proceeded to shake a portion of the contents of

one of the little cellophaned packages. I stared bemused. But he didn't notice me. Flaring a lighter up to full flame, he held it up, hand trembling, to what, it now emerged, was a makeshift pipe.

I watched the languid white smoke curling into the bottle and then, like a genie, vanishing into his lungs. He held it, suspended in time for a moment and then, leaning back he slowly exhaled. His face which had been tight and anxious relaxed, his eye lids slid back into his head like a rolltop desk. He was subsumed in complete contentment.

'Happy Fucking Christmas,' he wished me in a voice like a tracheotomy. And he passed the pipe.

I had to get him to perform the ceremony.

'Hold it down Basti-Boy, hold it down,' he coaxed.

I held it down. And I held it down. And then, when I was just about to pass out, I held it down some more before I finally exhaled. Then I closed my eyes and waited for lift off.

Nothing. Absolutely nothing at all.

'Well, that was dull. What was it anyway?'

'Er, crack,' said Hugo.

'Oh. Good to know.'

It was an abstemious first date. We smoked a bit of heroin to 'come down' even though I wasn't up, popped a couple of Ecstasy pills and then went off to Annabel's where I dropped a tab or two of acid for the sake of variety. I was off on an adventure and I was absolutely dazzled. This was the life – I was watching the imperious antics of the well born, the well heeled and the well endowed.

As with all great and grand friendships, our foibles were part of our attraction for each other. It was *Brideshead Revisited* except I was Sebastian without the house and he was Charles with it. I had the aristocratic soul of the dandy and the poverty – he had the dosh and the commoner's heart. We met in a compromising position in the middle. 'Oh please don't dress quite *so* ridiculously,' he would say before taking me to some posh do.

'And don't say *such* stupid things all the time. Just a few will do.'

We made a marvellous couple. For several years there was no man with whom, when present, I was more delighted or of whom, when absent, I more often thought. It hadn't been easy, but I had finally found a friend more self-centred than myself.

Rich, monumentally useless, and caked in foundation, we disappeared into the pink triangle where people of no talent vanish without trace.

We went out to Miami. I flew Concorde (bad news travels fast) and awaited his arrival at the airport dressed as his chauffeur in a grey suit and peaked cap. There were ranks of blank cabbies awaiting the passengers that nobody loves enough to meet – the faceless Mr Joneses and Mr Smiths and Mr Patels. But my card read 'Big Boy'. People stared as he swung behind his trolley.

Too much of a snob to travel in the same car as his chauffeur, he ordered me to take the bus to South Beach. 'Spend two thousand pounds on extremely dangerous drugs,' he instructed. 'They are, you will understand Basti-Boy, a moral necessity.'

Back at the house, a letter awaited me. 'The Society of Palm Beach Queens and Substance Abusers Welcomes Sebastian.' I sat down and waited. And eventually the limousine drew up. There were two people inside. For a moment I felt a stab of jealousy. Then out of the car stumbled a lemon and pink mess, its mouth hanging open like a zoo animal inviting buns.

I raised an archly pencilled eyebrow.

She waddled past.

'Basti,' Hugo whispered – perhaps a little sheepishly. 'I know that she looks like a couple of tons of condemned beef but remember she is *very* rich. So be *nice*. *All* heiresses are beautiful.'

Our holiday had got off to a flying start. And it would continue that way. We would pass this beautiful high summer

season like true Englishmen – locked up in the dark snug of our crack den.

South Beach is a holiday paradise – of sorts. No one works – except in the guest houses, piano bars and restaurants where everyone always wears white. I have always taken against queers. It's a question of style. They all look the same. And I am all for the primacy of the individual, the one against the many, the living man against the deathly unknown. What was the point, I philosophised pompously, of the fag who, having struggled through layer upon layer of offended disapproval, only embraces another form of convention at the end?

Ah to hell with it. The definition of a queer is someone who prefers men to drugs. And the difference in my case between heterosexuality and homosexuality was about two bottles of wine or one pipe of crack.

Yes, the drug was slowly winning me over. It was out to seduce. It was making me feel warm and sexy – and tolerant. Even Hugo seemed sweet. How disorientating. A caress is like a blow in the face to a masochist. We slept every night, all wrapped around each other like hibernating rattlesnakes. I dreamt of dying with him, a senile delinquent after a lifetime of defeat.

We did not stir from our bunker for over a month. Why would we when we could slobber about in an idiot stupor, smoking rocks in the hot sun, sucking cocks and oh what fun. Our humble home looked like a police narcotics laboratory. Water bottles, tin foil, wraps, cigarette butts, baking powder and hundreds of Bic lighters. But we were happy. And on drugs you know you're happy.

The only problem was Emily. She may or may not have been the descendent of a rich American dynasty but it wasn't trickling down to us. This was extremely annoying – being a miser is only useful and agreeable in an ancestor. Here was the woman who had picked Hugo up in the limo and delighted him. 'The carriage of a queen! What a *marvellous* start!' he had cooed, sliding down on soft leather, while a scenery of Class A moun-

tains drifted through his head. 'But do you know what happened then, Basti-Boy?' he later informed me. 'She sat back in her seat and waited for *me* to pay!'

Emily was the only fat junkie I have ever met. She looked like a condom full of custard. But she didn't seem to mind. She just sat on the sofa all day smoking smack. It was a quite intolerable situation. If we weren't going to fleece her, we might as well be foul. She was an easy target. It was like hunting a dairy cow with a bazooka. Fun.

Occasionally she got up after a few days and decided to get changed.

'Awww, I'm real bored of these clothes. How can I improve my look?'

'Er, two more legs and a tail?'

'I feel kinda nau-tious. I wanna to go for a swim in the sea.'

'Darling, I think you should find out whether the whaling moratorium has been lifted.'

'You are both so hos-tel to me.' She burst into tears.

'I'm sorry darling. Let me cover you in kisses. On second thoughts, forget it. I would have to take a week off work. And you *know* I don't have a job.'

Every three or four days we made a drug run into town. We crawled around the streets looking for the right neighbourhoods. You sense them like a dowser can sense hidden water. But there are telltale signs – second-hand clothing shops, dollar stores, pawnbrokers – a point where dodgy business merges with Skid Row.

The eyes of the gang leaders scraped the flanks of the car. They knew we were clients. A limo with two dandified fags in the front seat (and a whale in the back) edging gingerly by. Besides, Hugo was proving an inordinately noisy driver. He appeared to be orientating himself largely by the use of his horn – like a bat. Even to me this seemed a slightly ostentatious approach to the ghetto.

But once we had got the goods, the scenario was always the

same. As soon as we scored Hugo and I would run off to the nearest lavatory leaving Emily babbling alone in the back. Cocaine always makes professionals lose control of their bowels; it makes amateurs lose control of their vowels.

She never shut up. Her mouth was permanently open and her cheque-book permanently shut. Returning we would start puffing away in the front. It was utterly disgusting. She hadn't paid! She was mean *and* boring *and* smoking our drugs.

Back in the bunker while Emily heaved around the place like a heavily impregnated hippopotamus, Hugo and I found new ways to amuse ourselves. One memorable afternoon, he pulled his belt from its loops in a single deft movement.

'Basti. Your backside is aching for the lash. Bend over, be a good Basti-Boy. It would be nice if you were ready saddled and bridled to be ridden next time.'

'Darling, as you well know it is true that I worship the odd, the queer and the strange, even the monstrously morbid, slimy and unwholesome, but I have always drawn the line at being beaten. There are some things a white man simply does not do . . . Oh, all right then'.

He led me to the toilet.

'Now down, down . . . on all fours, like a good dog.'

I obeyed.

'Now . . . head in the bowl.'

I paused, suddenly uncertain. I looked up at him in that way that dogs do when they are not quite sure.

'Now lick the bowl.'

I lapped at the greasy waters. My stomach clenched up to retch. I kept my eyes closed. I didn't want to look. But I could feel Hugo positioning himself behind me.

'I hope you realise that this is going to hurt me more than you.'

'Don't mind me,' I whispered. My voice sounded oddly echoey in the porcelain bowl.

I felt the swing of the belt before I tasted its bite. A crisp hard

sting which made my head lurch forward. I was determined not even to let out a little yelp. After about twenty lashes he suddenly stopped.

He placed his foot on the back of my head and pushed it further into the toilet. I felt anxious, exhilarated, unsure, intrigued, all at the same time. He pulled the flush and the water cascaded over me. I was gulping and spluttering. In a split second of panic, I was certain I would drown. It was at that split second that he jabbed his booted heel even harder into my head. It was love.

I was definitely the woman in the relationship which was quite an achievement given the effeminacy of Hugo. My school careers adviser would have been delighted. Almost two decades had passed since she had asked me what I wanted to be when I grew up and I had replied, without heartfelt irony, 'a woman'. Now at last, an ambition was being fulfilled.

Occasionally the roles were reversed. One evening Hugo hovered into view naked, brandishing a rather large cucumber like a knight with a sword.

'Basti, darling. Din dins. Cue Come ber time.'

He positioned himself in front of the mirror and gazed into it admiringly. 'Yes, I adore mirrors but simply can't understand why others do.'

His bottom wiggled toward me. There is a traditional Greek saying. Life's a cucumber. One minute it's in your hand, the next it's up your arse.

I thought of the Greeks. They had been so indulgently homosexual. They seemed to have got the point. It was all about looking into mirrors, about finding a replica of oneself in another man. I lost myself in a stream of narcissistic musings about the mundanity of reproductive sex – or at least I did in retrospect. And a greased vegetable up the backside seemed a gloriously *against*-nature way of shoving my philosophies home. After all, it takes so much finesse to fall in love with yourself.

We finished the last of the drugs and I returned to London.

I felt fine about the binge. Crack? I had enjoyed it but I could take it or leave it. Sinking back into my plane seat, I smirked with the pleasure of a man still at the honeymoon stage of his habit.

9

The one man slum

Crack takes you like an eagle seizes a rabbit. I still remember the moment. It was in the taxi from the airport back home. I remembered (like elephants crack fiends never forget) the rock I had left in the top drawer of my desk. My heart started beating. I leaned forward in my seat. 'I'm in a bit of a hurry, cabbie, if you could drive a bit faster . . .' The car lurched abruptly forwards. The plastic safety handle felt slippery in my sweaty grip. Now my heart was hammering – rather hard – in my throat.

I didn't bother to wait for the change from the driver. I ran into the corner shop and grabbed a bottle of vodka. 'Have a nice holiday?' chirped Tariq behind the till. I slammed a note on the counter. 'Yeah, great.' I was out through the door, fumbling for my keys with one hand, trying to open the bottle with the other, while my brain was completely preoccupied with the location of a biro. Surely I had left one in my desk. Yes definitely. I had bought quite a store. And there was mineral water in the fridge, and yes, I had baking foil too – or did I? Yes, there was definitely some.

With the bottle upturned between my lips, I dragged at the curtains and then, cuing up a favourite porn scene on the video, I took two hours to fumble about for two minutes with a pipe. At long last I took a deep breath and prepared for my own blackout – standing up of course: it gives the lungs more space for expansion.

I sucked down the entire rock.

The first thing you notice about crack is the taste. It's like gun metal: like the deck of a battleship – hard, clean, metallic. The first trigger is the tongue. Then it explodes in your lungs like a hand grenade.

Oh my God. The vast rush overwhelmed me. 'Oh my God, oh my God,' I kept muttering in my head. I flipped the video button and sank giddily back. Consciousness was bursting open like a firework along every nerve. The woman in the movie lifted her silk bra. Oh, what heartbreaking ecstasy. I felt an orgasm spilling from the end of my cock. I could feel everything, even my fingernails, thrilling with life. It was a whole-body orgasm. My brain had been blasted through the lid of my head. Nothing could contain me. Oh my God. How could it feel so good? This was the kiss of the archangels. Oh God! If that God had created anything better than crack, he sure had kept that shit for himself. It was so unbearably pleasurable. It had to be evil.

I let out a long slow groan. At long last I had found what I had been looking for all my life. I was home.

I remember waking up the next day and feeling pretty damn good. Who cared about Hugo? I had a new friend now. Why go back to the old ones – to boring old Ecstasy or baby's stuff speed. Drink was for kids. I abandoned it overnight. I wasn't going to find the answers to life's problems at the bottom of a bottle. I knew they were waiting at the top of a pipe.

I decided to start working again. I was still doing pictures of sharks, sunflowers and the occasional dead relative – and the world was still ignoring me. I was giving failure a bad name. But I felt like a success – even though, a couple of days after my latest encounter with the crack pipe, it finally started to dawn on me that nothing was really happening on the canvas at all. Could there be some link? I decided there was: it was not drugs which enabled me to work, but their absence – and to feel their absence I of course had to take them from time to time.

I immediately addressed the matter. I called English, the dealer,

and scored. 'I'll give you a fifty quid tip if you can be here inside half an hour,' I told him, and then whiled away the interim with a phone call to Hugo, still in the States. 'Darling, this stuff is so more-ish,' I simpered.

It was a bit of an understatement. Crack is overwhelmingly compulsive. And no wonder. It works like a dictator taking over a country. It reorganises the entire brain, downgrading all humble pleasures, putting itself to the top. It knows it is king and demands that you worship at its throne.

English turned up with the drugs (late but, still tipped – I didn't have time to quibble over petty details) and I started again. As the high priest of the aphrodisiacs kicked in, I could no more stop myself reaching for hit after hit than a laboratory monkey with an electrode up its backside can stop jumping on a switch to give itself an orgasm.

Crack is sex. But a thousand times stronger. It compels you to fuck. Porn, hooker, lover or blow-up doll – it didn't matter much. I would rifle through the phone book looking up escort agencies. It was a reflex.

'Good evening. I am looking for company. Busty and quickly . . . yes, if you please.'

The first time she arrived as fast as a debt collector. I paid with Amex while she undressed. And then, like a suicide hurling myself into the sea, I launched myself at her. But, oh God, what had happened? She was utterly disgusting. I was coming down from the hit. I rushed back to the studio and took a fresh puff then dashed back up, sweating. She was so magnificent . . . for all of three minutes. Then the loathing returned. I stumbled back down. This was terrible. I was stuck on a see-saw of lurching vacillations. My entire lifecycle had been condensed into a three-minute frenzy. And worse – my anatomy was in a sorrowful state. And that, I discovered, was the sod's law of aphrodisiacs: soft drugs make the dick hard, hard drugs make it soft.

'I don't think you are going to be able to do this,' she eventually concluded.

I was sure she was wrong. I knew it. I could feel it. I was about to come.

Three hours later, notwithstanding that she charged by the clock, she could no longer take it. 'You're not nice on that stuff.'

She had a point. I wasn't robbing old ladies on the pipe but there was definitely a deterioration in my manners. As I ran down for more refreshment, I saw her bolting downstairs. I was still inhaling hard, when I heard the door bang.

No matter. It might even have been a relief – if not quite the one I had paid for. There were still twelve hours of masturbation to go before the dawn broke hideously over a ruined city, sending lurid tentacles sliding through a slit in the curtains.

I stared at it blankly. Suddenly the world made no sense. I felt utterly stranded. My stash seemed to have vanished like a phantom of the night. I decided to spend the rest of the morning constructively – searching on all fours for any stray grains that I might have dropped. Surely there were some left. My hand swept back and forth over the carpet like a radar scanner. I picked at paint chippings, breadcrumbs, glittery specks, bits of dust. I gave up defeated and went to my bed to lie jingle-jangle awake, gaping skywards like a corpse on a battlefield, my brain screaming aloud with self-hatred and remorse.

Over the next few months, I started to see more and more sunrises from the wrong side. In the early days I used crack once or twice a week, scoring a couple of hundred quid's worth to see me through a session. It would take me a few days to recover each time. A few days of relative normality before the next bender.

But soon even this normality was contaminated. I felt lonelier and lonelier. I felt almost abandoned – but not enough to stop me. A vice, after all, is a habit in which the addict persists even though he is aware that it is injurious to his well-being. The crack smoker, I reasoned, must make some small sacrifice – of charm, happiness, companionship, health and wealth. And even if it was going to get worse – so what? What did the eternity of

damnation matter to the man who had found in a second the infinity of delight?

Summer turned to winter. My life kept shrinking in. The circles were getting smaller. Time span on its pivot – and that was the pipe.

Still, I still had two other constants in my life: Rachel and Hugo. They were my friends. They were the high points from which I could safely bungee jump. And of course I had introduced Rachel to the third person in our relationship. She had loved the pipe. It would have been perfect if we had been in therapy or something. Crack made her talk ... and talk ... and talk. And when she had run out of subjects, she would consult her address book and discuss every person she found listed in it ... and if I was very lucky, I could persuade her to phone them – which would get her off my case for a few happy hours.

Ah, how little it takes to make life unpleasurable: a pebble in a shoe, a cockroach in a soup, a voice in a woman. Add crack to the equation and it becomes utterly unbearable. I was rendered completely speechless by the drug and here was Rachel inspiring bores (herself) to the highest flights of art.

One evening, Hugo started kissing her – I presumed to shut her up. Then he began to admire her right bosom – with his mouth. I remember it was the right one because I was so jealous that I couldn't touch it for days. And this gave me – as if I needed it – another reason to hate myself. What ill-breeding. Who wants to live in the Barratt house of the heart?

Actually, I was a little confused as to who I was actually jealous of. When I was with Hugo, women, along with the rest of the world, were merely spear carriers at our parade. And when I was with Rachel ... well, what most men see in a woman when drunk, shone out of Rachel even to the most sober. We were no longer lovers. And yet, in some way, this increased my desire. Nothing is more romantic than not having intimate relations with the woman you love. It's so nice to actually like the woman whom you love.

Never say I'm not chivalrous. I wanted to treat her courteously – so I neglected to tell her the truth. For her part she didn't ask, which always works. If you do not wish to be lied to, do not ask questions. Why would she? She was completely trusting.

Meanwhile, my relationship with Hugo was warping. He was doing nothing so extremely well that even he was getting bored. The trouble with doing nothing, you see, is that you can never take any time off.

He had amused himself for a while with a little pottery business. The pinnacle of its achievement, as far as I could tell, had been to sell a scented candle to Joan Collins's ex-boyfriend. It seemed to have been too much for him. Wrecked by success he had collapsed again. And no wonder. Even the most generous would find it exhausting to enthuse over pots.

But he determined to expand his business to the States – maybe, there, Joan herself would buy a candle. Turnover would double in a stroke in this land of opportunity. He started making regular trips to New York. 'The thing is Basti, I have slept with everyone in England,' he wrote wistfully.

'I do hope that I am one of the few things in England you leave with regret and return to with pleasure,' I replied.

For a while I was. Every few months he would visit. And I was pleased. I was happy to have to drink my champagne standing. And then one day the letters stopped. My calls went unreturned. I hoped he was dead. But it was worse than that. Eventually he turned up to explain.

'Er, Basti, sorry I've been a bit out of touch. This whole thing is taking rather longer than I expected.'

I nodded agreeably. It's amazing how long it takes to complete something you're not working on.

Obviously he spotted a certain scepticism. 'Well Basti, I do have to keep the wolf from the door.'

'What? By showing him your pots?'

'Actually I've decided to move out of pottery.'

'Oh yes. Couldn't stand the excitement?'

'Actually, I'm getting married.'

People who bite the hand that feeds them usually lick the boot that kicks them. Even I was not in the mood for this.

Had his intentions been strictly honourable – i.e., to dispossess a lady of her fortune – he would have had my blessing. I would have been his bridesmaid.

'Actually, I love her and want to start a family.'

'Oh *Lord*. I can imagine you dating children, darling, but not having them.'

'But I want them, Basti-Boy.'

Homosexuality is God's way of ensuring that the truly gifted aren't burdened with brats. Until now there had been only three things in this life that I could be certain of: death, taxes and the fact that Sebastian and Hugo were not on this planet to push around prams. 'Now *please* sweetie. Tell me you are joking. I don't want you to raise anything except your cock. Come on, now, have some of this.'

I loaded a pipe for him. I felt very loving.

'I want to stop this, Basti, I've had enough.'

'I don't know what destroys a man faster, crack or marriage,' I drawled. 'Maybe go for both? Marriage on the rocks.'

'Can't you be serious about anything?'

'What? – and ruin a perfect record of levity?'

'Just because your marriage was a disaster doesn't mean mine has to be.'

Thankfully the pipe had been prepared by that point.

As the hit came on we undressed and climbed into bed. He put his finger up my bottom, and then slowly withdrew it, first sniffing then sucking it.

But I knew it was over. I was about to be replaced. By a woman.

When I met her, I realised that he was ready to wed her because she was the most safely unimportant person he could find. In some ways they were made for each other. He was a potter, poor darling, and she made wallpaper disguised as art.

I guess this was none of my business. Abstract art and pottery should be treated as a matter between consenting adults in private.

Scrawny, blonde and straggly, she loved nature (in spite of what it did to her), cooking and tidying. But her most interesting feature was her dullness. Her mediocrity spread itself out with impudence. Her conversation was almost – but maybe not quite – as boring as her work.

We all went out for lunch. She ordered a whiskey, 'To keep me waaarm.' Then she put ice in it to make it cool, then sugar in it to make it sweet, then she said 'here's to you' and drank it herself. It was intolerable. Hugo was getting all excited about nothing and then saying that he wanted to marry it. I could have done with a pint of whiskey – with sleeping pills. I looked at her pinched little features. Then I peered happily, as well I might, into the mirror. Lastly I looked over at Hugo. I couldn't believe it. Men may show some discrimination about who they sleep with but they will marry anybody.

'I'm afraid Miss Puckett didn't see the point of you,' Hugo informed me afterwards. That was the first – and last – thing on which we ever agreed.

I never saw her again. I saw Hugo a few more times, had a few more crack sessions. But they felt like the last days of summer. Then he stopped calling. I heard they had a big wedding – the only person in London that they didn't invite was me. I am extremely sensitive. I feel snubbed if an epidemic overlooks me. Was I hurt? I was really upset. There is nothing worse than not being invited to a party that you wouldn't be seen dead at.

The worst sort of bourgeois hypocrisy had won. Hugo and his wife both moved in bohemian circles while demanding conventional behaviour. They cut me out. I had never thought that my behaviour was that naughty – I mean, anyone would have thought that I was addicted to Class A drugs or had buggered someone else's husband with a cucumber.

As for Hugo? Well, I missed him. He had been cruel and

vacant. He had been vacantly cruel. But he had introduced me to crack. He had beaten me and whipped me. So I knew he cared in his own sweet way. I left him to marry in haste and repent in the suburbs. He moved to America permanently and started a family. The best thing between us now is the sea.

I returned to my own little life. I was still seeing Rachel occasionally. But, on drugs, solitude is not just bearable, it is indispensable. And the person I saw most of was English.

For the addict, the dealer is like the loved one to the lover. When he is away, you can conjure every detail of his appearance. You search for his face amid the faces in the street. You think that you glimpse him and then your heart stops. And then you make that call. And the wait is so agonising. You listen out for the sound of his step on the pavement. You recognise his knock. His light step on the stair makes your blood rise with pleasure. His final appearance is like a rescue. You feel an exultant overspill.

'Check it out. I got goo-ood stuff man. Phar-ma-ceu-tical rock-et fuel man.'

Beware of whites who understand the Negro. I can't say I did. The sentences tumbled from his mouth in incomprehensible fragments. He held back the words as if they were earning interest. But he had explanations for everything (and not just his constant lateness). 'Shee-eet, I knows just how Jesus rose from the dead, man. Ju sees, he wasn't *really* dead.' He looked at me as if the whole of mankind was stupid for ever imagining otherwise. 'He just *pretended* up there man and then . . . man, he legged it. What-a-dude. Outta sight man.'

English believed in reincarnation. He was Martin Luther King – or Lenny Bruce or Miles Davis – not a shoeshine boy, or a porter or even a drug dealer funnily enough. I suppose the nobodies of this world are mightily inclined to believe themselves somebodies in another. But I liked him. He was no different to anyone else. People generally, no matter what they are talking about, talk exclusively about themselves.

It was not him but his goods that were giving me a problem. Crack had at first seemed like the kiss of the gods. But now I was beginning to suspect it was the elixir of the damned. I was starting to feel paranoid – I knew because I could hear the telephone wires talking about me. That layer of cellophane between myself and insanity was breaking. And the drug was having a devastating effect on my wealth.

I tried to stop. But the trouble with crack is that you can get it out of your body but you can't get it out of your mind. I wanted to want to stop. But I couldn't get over my cravings. And so I would come to the conclusion that if I thought about drugs that much I might as well take them. So I did.

I suppose my on/off relationship with crack could be seen as an external expression of my internal struggle. I would sink to the depths of self abuse, and then begin a quest for redemption. I couldn't escape my own body or the compulsion to destroy it to the point of self-loathing, followed by the compulsion to deny it so I could get back in shape.

You don't take crack – crack takes you. This relationship was now consuming my whole life. I was either taking crack, recovering from taking crack, thinking about taking crack or thinking about not taking crack, or thinking about not thinking about taking crack.

I had reduced all of life's experience to one experience. I wasn't living. I was taking drugs. My friends had scattered to the wind. My existence made the very air echo with nothingness. I hardly stirred from my room for months on end except to score. Iron rusts, water turns stagnant, plants rot. I fell into decay.

Occasionally I left my flat to stalk the dark alleys of Mayfair and Soho. I had made a handy little portable pipe so that I wouldn't get caught short. It was the only creative thing I had done for months. Lurking in a doorway, I would take a hit and rush upstairs to a brothel, exploding with sweat and an insane desire. No more able to speak than those girls in the movies

who try to explain to the cops about the bogeyman under their bed, I would splutter and cough like an untuned radio. Mostly I was thrown out. When I was allowed in, I would be unable to perform. It did not deter me. With crack the compulsion to repeat what one has experienced is a force as unarguable as gravity; it is impossible to break away from it.

Hours later I would slink back to my room. Fuck it. I was content with the cliché. A woman is only a woman, but a good crack pipe is a smoke. I would lie on the bed puffing and watching porn. That was better. That was the life – or at least the living death.

As for normal women – I'd completely stopped seeing them. Don't get me wrong. I didn't hate them – only the ones I'd met so far. Why waste five pounds on dinner when I could simply toss off and then have the rest of the evening to myself?

It was final. I wasn't going to listen to their life stories – told in real time – anymore. They were so unenlightened. In my experience, the smartest thing ever to come out of a woman's mouth was my cock.

Still I had to have something. So I set off for Soho to get yet another girl. She was called Debbie. She looked deliciously plastic. Her price was one hundred pounds. 'The girl who never says no' was her tag line. She didn't say anything else for that matter. I like silent women. It seems like they're listening. How perfect. I took her home lovingly. And then I took her out of her box and puffed her up.

Dressed in a pair of Rachel's silk knickers and a balcony bra she looked so temptingly pneumatic. But to make the whole process even more titillating I then slipped her into a tight white T-shirt. She waited quietly, her big butterfly eyelashes wide open, while I infested my system with a massive hit of crack. Her lashes fluttered back down in ecstasy as I climbed on. I tried to ignore the rubbery squeaks. But it was hopeless. She squelched about awkwardly as I tried to straddle her, help-lessly limp. It was like trying to fuck a Li-lo with a damp piece

of lettuce – not that I've ever done anything as disgusting as that.

Let me tell you: there is post-coital depression and there is post-coital depression. An hour later I lay there spreadeagled, flooded with sweat and crucified by a terrible sense of my own emptiness. I was racked by the awful, mind-curdling futility of my fugitive, fleeting existence. It is one thing to be nothing *vis à vis* God, a divinity who alone can make it right in his unknown sacred way. It is another thing to be nothing to oneself: nothing to a man who is nothing having just ejaculated into the specially greased-up vaginal hollow of a blow-up plastic doll.

Meanwhile my crack habit was rising on an exponential curve. I was using pretty much daily. And at what a cost to my soul and, as I realised once each binge was finished and I collapsed beached on the shores of my own lonely life, my bank account. Addiction is like standing in hell, kindling ever hotter flames with one hundred pound notes. On a good day I would boost up the fires with two hundred quid. On a bad day five hundred would go into the furnace. A dealer is a pick-pocket who lets you use your own hands. But still, I wasn't satisfied.

As my dependence soared upwards my standards fell. I shuffled around in a dressing gown, head fallen, shoulders hunched. Sometimes I caught sight of myself in a mirror. I looked like a Carthusian monk at the brink of the grave he has just dug for himself. It was enough to make me shiver. But I was dripping with sweat. Outside it was winter. A frost sparkled on the pavements. The iron railings if you touched them would have burnt your hand with cold. But inside, where I stayed as much as humanly possible, I was basting like a pig in my own perspiration.

My whole body went into revolt. My face blistered up into a burning crimson rash. The effort not to claw myself into rags was totally exhausting. My nose, which I had always considered a feature of some importance, dried and hardened and cracked round the nostrils. It dropped scrofulous white scales. Welts

sprang up round my lips. It looked as though a pair of jelly-fish were fornicating on my mouth. Clearly the misery which had percolated through my entire system, was now making itself physically manifest on my face.

I was finished. Spent. The old performer had finally abdicated. Dandyism had gone. I looked fit only for the undertaker. The whole world that I knew had walked out into the night.

English, on the other hand, was thriving. When I had first met him he had been a scruff. His T-shirts and jogging pants looked as if they had been thrown on with a pitchfork. His trainers (surely the ugliest form of footwear ever devised by man) were split. To finish it off he sported that symbol of man's inhumanity to man – a baseball cap swivelled backwards. He was always in a scrape. One day he turned up with a big white bandage on his head. He looked like a pint of Guinness. But even in Shepherd Market with its Irish theme bar the drinkers didn't so much as look at him as he walked from the Tube station to my flat.

But within a year he wasn't walking any more. He was driving: a spanking new M3 BMW – Black Man's Wheels. The rest of the changes happened gradually. I don't think I noticed at the time. I never noticed anything but the cellophane packages that he brought me, tucked safely in his mouth. He would spit them out when I let him in, slippery with saliva. I would have unwrapped them even before I had got upstairs.

But one day it dawned on me that I was looking into the mirror of my former self. He was wearing tailored black suits and crisp cotton shirts. And he had a new swagger in his stride, and his talk.

'Hey, man, What ju want? Look what I's got for ju . . .'

'I've got to be quick English . . . please.'

'Now just wait a minute man . . . I's got some drawing for you first . . .'

English had decided to become an artist. He laid his sketches out on the studio floor and walked round them beaming. He

had stolen my identity off the peg. It was as if he had gone to a fancy-dress shop and asked for the Sebastian Horsley. His tailor-made impersonation of me was uncannily precise.

With my character now walking around the world without me, I moved through my life as if it had nothing to do with myself. I wanted to hear nothing, see nothing, do nothing. I couldn't even be bothered with Rachel. She would come round and I would sometimes try and pull myself together. But by then I think it might have finally dawned – even on her – that I was living a lie.

'Darling, you don't look great. Are you taking drugs?'

I still respected her too much to want to sully her with the truth. Actually that's not true, I just wanted her to fuck off and leave me alone with myself – and my pipe. Why couldn't she just fucking leave me alone?

One evening she stayed over. I couldn't stop her – though God knows I tried. 'Haven't you got to get home for that call from your mother. Didn't the Jehovah's Witnesses have an appointment to come round? Darling, I don't want you to miss them. Surely you ought to go back.'

But she persisted in spending the night in my bed. I waited until she was sleeping and crept down to my pipe. I crouched over it, paranoid and listening, jumping at the slightest noise. Was that Rachel waking? Was she on her way down?

There were hundreds of false alarms – until eventually she was. I heard her footsteps on the staircase. 'Basti?' she said. I shoved the evidence as quickly as I could behind a box file and pulling out a sheet of file paper pretended to write.

'Basti? What are you doing?'

'Nothing. Nothing. Just writing my journal.' I started to hum and tapped idly with my pen – which unfortunately, since it was soon to serve as a pipe stem, had already been eviscerated. A few acrid wisps of smoke curled mockingly through the air.

'I know you're on drugs Sebastian.'

I knew I was too. And I knew I was in trouble because she only called me by my full name when I had been bad.

She started to root around the room. It didn't take her long.

'You love this more than me, don't you?' she said coldly before going back to bed.

But I didn't go up to her. I just stayed smoking all night. There is always something ridiculous about the emotions of people whom one has ceased to love.

She left the next day.

As soon as the door slammed behind her I returned to the pipe.

She called me the next evening. 'Do you want to talk about this?'

She was right. I did. I called English to discuss the situation with him.

I was alone. So alone. I couldn't even bear to see myself. It used to be the high point of every day, that first glimpse of myself fully dressed and resplendent in the mirror. Now the glass revealed nothing but a morbid lump of flesh. My lines of suits hung unused under dusty plastic coverings: clothes with no emperor.

I didn't care. Catastrophe appalled me. But attracted me at the same time. I knew it was coming so I laid myself bare. I welcomed it like a whore who welcomes her murderer. The idea of annihilation only whetted my appetite for the thing that would bring it about. I welcomed disaster with open arms – and as far as I was concerned I was on to a good streak of luck; everything that fell into my hands perished immediately. That was enough. At least something was happening. And that was all I wanted. I wanted something – *anything* – to happen. I couldn't bear the arctic wastes of my own wilderness any longer.

I moved Jackie into my flat in the summer of 1996. She was an old hooker who hawked her wares around Shepherd Market. I liked her. She had a burned-out understanding of life. Her face

was cracked with broken commandments. Her flesh had fallen off the bone. And she definitely looked like my sort.

I put a sign on the doorbell saying 'This is not a brothel' and we opened for business. Every evening she arrived, rolled a spliff and pulled an old futon out on the floor of my studio. This was her boudoir – a spunk-spattered mattress on the paint-spattered floor.

Meat was cheap. But her clients were rich. They pootled down Piccadilly from a gentlemen's club. Jackie wasn't fussy – though a few of them were. She discomforted the afflicted and afflicted the comfortable.

I would sit in bed listening to her croaked encouragements, to her harsh reprimands and the hiss of her riding crop. Evidently you don't appreciate a lot of stuff in school until you get older: little things like being spanked every day by a middle-aged woman. These are the things you have to pay good money for in later life.

I retreated to live in my bedroom. I put on a lock. It was fine. I was no longer interested in the rest of my flat. My idea of exercise is a good brisk sit. And I didn't want that. A bed alone would do – being awake was not necessarily a desirable state of affairs. Beside the bed was a table on which all my important accoutrements were kept: my pipe. At the end was the TV. I had the remote. If it wasn't for the fact that the remote and the pipe were so far apart, some of us wouldn't have got any exercise at all. Beside the bed I lined up a row of empty family-sized Coke bottles. These were for pissing in. The next-door toilet was far too far. If I had started by saying 'yes' to everything, I was ending by saying 'no' to everything (apart, of course, to more drugs).

I was content in the prison of my solitude. So content, in fact, that I was going to make sure it was absolutely fast. It wasn't me who was the problem. It was other people. *They had to go.*

First Jackie. That was clearly a mistake. Her mistake. She

wasn't even paying me rent anymore. It had stopped when she realised that the landlord was not really a landlord at all. 'I've left a joint for you,' she would say generously. Oh that's just fine. Dope happens to be the only drug in the world I can actually say no to. I changed the locks and snipped the wire in the doorbell. Good. Done.

Next up. Debbie.

Sure I had been fucking her. But why is it that girls always want a relationship? With this one I had to wash her out in the bath. It was so squalid. I blew her up one last time. Then I took a ten-inch blade and plunged it into her neck. I have never quite forgotten the way she looked at me: that sad deflated look of a woman for whom life suddenly made no sense. It was over. For a while I have to admit I felt orphaned. I was stirred by regret. But then I realised that a toilet roll wedged between the bed-frame and the mattress would do just as well.

I didn't need to get rid of Rachel. She got rid of me. She wrote me a letter. 'I am leaving you because you are taking too many drugs,' she explained.

'What's the catch?'

Still, as a gesture of obedience, I sent back a card. I have never been good at spelling. 'If you leave me, you will leave a dessert in my heart,' I said. I presume I was hoping that the dessert would be ice cream. That was about all I could stomach at the time.

Rachel wrote back saying something or other. I don't remember. A woman always tries to become a man's friend in the same old stages: first a mistress, next a mattress, and then a nuisance. Her letter kept getting smaller and smaller – not just in my mind as I forgot her, but physically. I was tearing it up to use for putting rocks on the pipe. I expect it was something about love being the opposite of hate. Girls like that idea. Yeah that was it. I lit the pipe. *Love is something you can't feel . . . for more than a few minutes at a time . . . so what's all this bullshit about loving somebody for the rest of your life?* Yeah, that was it. I

turned on the porn, lay back, exhaled and grabbed my scabbed penis. I'd just got rid of three girls in a week. Pretty good going, even for me. To love at all is to be a loser – but you know that already if you're reading this book.

There was only one last person to get shot of: English. I could no longer bear to see his smug black face. I needed a plan. It came to me with impressive speed.

'English, from now on I shall be placing the order each day. I shall put the money in an envelope and Sellotape it to the inside of the letter-box. Put your hand through the door. Grab the cash. Drop the drugs. NEVER, under ANY circumstances, do I want you to KNOCK. Do I make myself clear?'

'Sure, man . . . sure, man . . . are you OK? Remember to come up for air, man . . .'

Air? Air? Who needs fucking air when you can have smoke? What the hell was he saying? He was up to something. Scheming black bastard. I wasn't letting him in. I installed another lock. It was essential. I could see faces watching me from the street below. Spying. Trying to see what I was doing. They were in the buildings opposite. Didn't they have anything better to do than sit there peeking out from behind their curtains?

'HAVEN'T YOU FUCKERS GOT ANYTHING BETTER TO DO?' I bawled out of the window.

They just carried on. Smiling like insane people.

'RIGHT, THAT'S IT YOU FUCKING FUCKERS, WHY DON'T YOU ALL GO AND EAT A BIG BOWL OF FUCK.'

I set about sealing the entire flat. I stuck newspaper across every windowpane and then covered them, for extra security with black drapes. I stuffed every key hole. And every door frame. There. Not a glimpse of fucking sunlight. Not a fucking breath of fresh air. That would fucking do it. Let's see what they did about THAT.

What's the difference between a cushioned boudoir and a padded cell? I was living in a madhouse. My mind was like a darkroom in which negatives were developed. Everything was hateful,

detestable, rancid, disgusting. Everybody was out to pester me, to annoy me, to confuse me, to get me. The whole world was on a mission. I didn't want it to save me. I would get rid of it instead.

There was only one slender connection I had to maintain. I still had to go to the bank. It was in the next street. That was incredibly inconvenient. So I developed a system to keep contact to a minimum. I would buy a big stash, divide it into three and then, keeping one for now, put the other two portions in a package and post them to myself – one first class, the other second. How ingenious. Junk mail. Yes! That would do it. Excursions from the bunker would be kept to a minimum.

Finally, fucking *finally*, I was alone. Alone with my cold sores. Perfect. His and herpes.

But still I had company. Insects and snakes seemed to have crept under my skin. They were crawling about there. In fact everything was crawling. The whole world around me seemed to be on the move. Pieces of furniture sidled insidiously along corridors. Doors opened and closed. The mirror leered like a leprechaun. And when I looked into it there were black worms on my tongue. I knew it. I could feel them squirming. They writhed like the shadows, like the flocks of vultures that flapped and preyed around my bed, opening hideous beaks and exhaling their foul, tainted guts. I struggled not to breathe, to seal myself up. But I couldn't get rid of them. I tried chasing them downstairs. But they banged and thumped about in the studio. I could hear them crashing sullenly against the studio walls. It was too much. I had bouts of fainting. When I came round my body was cramped by convulsions.

No question about it. I was under attack. One evening I heard a loud dragging noise on the outside wall. I pulled back the layers and layers of newspaper and blankets and peeped out of the window. There, crawling like Dracula bats up the walls were Special Branch policemen. Fuck! *FUCK!* They were coming to arrest me! I resealed the opening again. Keep calm. Stay concise. I could outwit them. I started to prepare elaborate plans for machines that would annihilate my enemies on this battlefield.

I called an old gangster acquaintance and procured a gun. A Colt .38. With seven brass bullets. It cost me one thousand quid. It seemed cheap at the price. I slept with it, fully loaded, right next to my bed. There, that would fucking do it.

Occasionally, very occasionally, I left my flat. Then my dead world took on something of that hideous semblance of life that a cavorting skeleton has. Held together by wires, I jerked on hidden strings. One evening I found a girl in the street. Normally, we wouldn't have exchanged greetings even if we had met in the Sahara desert. But tonight I was feeling on form. 'Suicide or the Ritz?' I sneered. She didn't so much as smile. So to punish her I took her to the hotel and forced her to have dinner while I watched.

We walked silently back to my flat. I stared at her as she undressed. A hollow-cheeked harlot and an empty scarecrow. She was hideous. She asked for twenty-five pounds. I would have fucked her for free, she was so foul. But she was so repulsively . . . available. Why didn't a prostitute ever say no? Come to think of it, why did she bother to exist at all? *If I looked like her I'd commit suicide. Not that one needs an incentive.*

Still, if I wasn't going to fuck her – which I wasn't, because as usual I was incapable – I might as well torment her. I picked up the gun and took out all the bullets but one. Then I spun the chamber and closed it again. I was entranced by that lovely mechanical click: the clean, cold precision, the satisfying clunk. I inhaled the oily smell. The weight felt so right. So permanent and blank and true.

'That's not real is it?'

The only fake thing in that flat was me.

I raised it to my head, shut my eyes and pulled the trigger. The rush felt so brutal. It swept my brain away. I shook from the violence of my own heartbeat. Then I collapsed with that blissful, head-giddying, fainting sensation, lost in that heartbreaking moment of pure terror in which sound twists and turns, rising and falling, billowing and dancing like an angel along a beach. I was speechless with happiness; choking with love.

Ha! Life is nothing! I am everything! I'm here! I'm still here! Oh heaven! How can one live after such heady delight! I am radiant as the sun! Oh what a beautiful life! Why hadn't I noticed it sooner! I would live for ever! (Or at least die in the attempt!) I was glowing with love! And using rather a lot of exclamation marks!

Still . . . better calm down. Doesn't do to enjoy yourself too much. You'll only be brooding upon it for years to come.

The exhilaration of not dying was almost as spectacular as seeing the face of my new friend. The blood drained out of her body; she almost looked attractive for the first time that evening. I spun the chamber again and then passed her the gun. 'Your turn,' I offered. 'Trust me. I know you'll enjoy it.' But I didn't know why I was being so sweet.

Still, it was useless. She was ardent in her senseless commitment to existence. She ran . . . for her life.

Of course, looking back, it all seems rather silly and melodramatic – even for me. I may in theory have had a one in six chance of success. But in reality there was never much likelihood of me blowing my brains out. I'm not *that* good a shot.

Another evening I went out and rounded up three whores at once. I tried for a fourth actually. But when I found her, she didn't look like she would fit. 'Thanks anyway,' I told her. 'Fucking faggot,' she spat as I left. Well, even burning the midnight foil, that was one dragon that I wouldn't chase. I set off home with the three that I had got so far. A three-piece suit with a three-piece suite. A *demi-mondaine* with the fully mundane. 'This your pad,' said the first, with a slight look of scorn. 'I fort you were posh.' 'Or a pervert,' tittered the second. I didn't deign to answer as they slopped on to the sofa. Sleeping with either of these would be like being crawled over by slugs.

But the last was lovely. Slim. Busty. Sweet. I wanted to stroke her soft rose-tinted skin. If drugs are like a woman you want to stay in bed with for ever then I'd found my girl. A triple Southern Comfort with pills.

I suppose it could have been a bad mix but the chemicals bonded us. They tend to. They bring people together from the extreme ends of the social spectrum. They unite the very rich and the very poor – probably because they share the same curse. It's called unemployment.

The pretty one curled soft as a kitten at my feet on the floor.

'Could you help me with this?' said the first one as she struggled to undress.

'No,' I said, applying my lips to the crack pipe. 'I'm working.'

'What's with the gun?' said the second one, unpeeling a sticky-looking condom.

'I, like you clearly, don't think much of unprotected sex.'

You might assume a revolver would prove a guarantor of good manners. But you would be wrong. A little dispute had whipped up. They wanted more money. I expect they had realised that this was not going to be a quick job, that, caught between a rock and an unhard place, I wasn't going to perform.

'In this world there are two kinds of people,' I started pontificating, 'those with loaded guns and those who suck cock . . .'

Suddenly the pretty one picked up the pistol and pointed it. At *me*. And in my *own home*.

Well, I wasn't going to complain. But I guess 'bet you haven't got the guts to pull the trigger', was probably not amongst the wisest things to say. Not when the barrel was aimed at my head.

The next thing I knew there was a loud noise and something extremely hard appeared to have hit the door. I supposed it must be a bullet. Then I supposed that I should react. But I couldn't quite muster the energy. So I just stared instead.

The bullet had embedded itself in a brass coat rail. Otherwise it would have gone through the door. The girls, however, were going through the roof. The next best thing to being shot at and missed, I decided, was watching a whore's face when, for the first time, it dawns on her that, something is not fake. 'I didn't know,' she kept jittering. 'I didn't know it was real. It's so lucky.

So lucky I lifted it at the last minute. So lucky. I didn't know it was real.' The other girls ran about screaming hysterically. But I remained calm in the face of adversity (I'd had plenty of practise). I watched the girl turning white, well whiter, while I sat on the bed looking blank, well blanker.

Mother tells me that I was an impish, mischievous child. But I can't remember. How could I? It was before my time. I wasn't happy now. I was a haunted, half-frightened, half-fatalistic creature, adrift between disaster in this world and doom in the next. It was high summer outside. But I didn't notice. From then on, like Electra, I shut the windows of my house for ever. I lived in a land without seasons or even diurnal rhythms. I never wanted to set foot into the outer world again. At least sitting in a room taking drugs all day kept me out of mischief.

I was fading away. My weight had fallen from thirteen stone to nine. I looked like an X-ray. My clothes, when I wore them, hung like coats on a scarecrow's stick.

I'd never been particularly interested in food in the first place. An artist who drinks is in a bad way, but the artist who eats is lost. But on crack you lose all appetite. The only reason you even attempt to eat is because, with food inside you, the effect of the drugs can be enhanced. That's why, occasionally, I tried to get something solid, apart from a bullet, inside me.

As I grew thinner, my self-hate seemed to glut. I was crushed by the weight of my own weakness. As a last resort I decided to run away to Paris. I would stop there for sure – or at least I would as soon as I had got through the five hundred quid's worth that I had scored before leaving . . . and the five thousand francs worth that I secured as soon as I arrived.

It was my birthday. But I sat alone in a tiny hotel for a week. Home from home. I was the loneliest man on the planet. I was like a stopped clock. So I decided to go back.

Nothing had changed, oh, except the front door was missing. Someone, it seemed, had not only kicked it in, but stolen it – as

well as the contents of the flat. All I had left was my paintings. The thieves were clearly discerning. They obviously realised that they were worth no more than the broken cheese toasty machine that they had dropped on the kitchen floor. Jackie's semen-splattered mattress was also left behind. But still, my career as a madam looked suspiciously over. Oh well. If you can't brag about doing something well, then brag about doing it badly. At any rate, brag.

I was finished. You know when you are broken. I had run to the end of my personality. I called Rachel. She would recognise who I was.

'You are going to die, my darling, if you don't do something now,' she said. But she was wrong. I was dead already. She booked me into a clinic. Clouds House in Wiltshire. They had a place free in a week. So I made the most of my reprisal. Seven days and seven nights. The length of a penance – or a wedding feast.

I could barely walk when she came round to collect me in a borrowed car. She had to support me as I stumbled from the flat. The glare of the sunlight, I remember, was like an atomic white-out in my head. Stowing my pipe in the glove compartment we set off.

It seemed to last for ever, that journey. And for no time at all. On and on along long straight roads that led nowhere except to a horizon that we would never reach. I remember passing Stonehenge and wondering what the fuck that thing was doing there. We drew into a lay-by for tea. I was sick. I lay down on the back seat. That made me feel a bit better. When you are flat on your back there is nowhere to look except up.

And then we were turning down narrow country lanes. A wide avenue of trees was stretching out ahead. 'Stop for a minute,' I asked Rachel. She did. We got out. She huddled in the cold while I lit up what I thought would be my last ever pipe. My last ever rock disappearing like a wraith before me. Melting

away in a curl of grey smoke. Rachel looked down at the mud. And then we got back in. 'Wind the window down,' I told her. 'Let these goldfish out.'

10

You can't fall off the floor

Two days later I woke. I pulled back the curtains and looked out of the window. It was all very nice. The air. The mountains. The peace. What a good place this would be to smoke crack. I collapsed back into bed.

I was exhausted. I was beaten. But I took it like a man – I cried for a week. Every now and then the doctor shuffled in and examined me. I had malnutrition, he told me, but apart from that that I was fine. I filled his questionnaire on addiction. I scored ninety-six per cent – the highest mark I had ever achieved in any test. Then he put me on tranquillisers, which cheered me considerably until I saw the dosage. Pathetic! What was I paying for? What did he take me for? I didn't want to get better. In fact, quite the reverse. When someone you love falls sick, there is always that faint animating hope that they could die.

Failing that I would just sleep for ever. Or at least I thought that I would. 'No snoozing during the day now.' Some bossy matron would bustle into the dormitory every time I had just settled down for a kip. 'Time for group therapy. Come on. Trot, trot.'

Crack is not physically addictive. But mentally I was wrecked. But even then, group therapy? For fuck's sake! I dressed all in black and balanced awkwardly on a wonky chair and said nothing for two hours. 'How do you *feel*?' asked the counsellor. His liquid gaze dripped mournfully into his beard.

'Like Satan,' was about all that I could muster up.

'That's a very strong thing to say.'

I hadn't an answer. I gazed helplessly round the room. Look at these people. Who were they? Eternity bracelets, tattoos, skinheads, crystal gazers . . . trainers! . . . what the hell were they all doing here? What the hell was I doing here . . . Satan or not. What was this exotic dandy doing in the hands of this HM Prison mob? How had a nihilist fallen in with new agers? It was perfectly horrific. Like seeing a piece of Ming porcelain in the hands of a chimp.

I felt about as vulnerable. Not that I actually felt very much. I just sat there, lost and alone amid the echoing psychobabble. On and on it went, like some unreality TV channel – not that these people could have got on to television – which was prob-ably their problem. They came here instead; here, where they were provided a guaranteed captive audience to bore into slow submission with the details of their endless empty lives. It was intolerable. I glanced at my watch. It was ten o'clock. They went on talking all day. I looked at my watch again. 10.20. Fucking hell. Where was the remote?

This was not for me. I took refuge in the shell of my shot personality. Always make a molehill out of a mountain. Shoot up and shut up. They were my mottos. I should have probably put them on a signet ring. And if you have any further problems, then they are nothing that a trip to the tailor won't sort. The sense of being well dressed gives a feeling of inward tranquillity which psychotherapy is powerless to bestow.

I isolated myself. Creating a little lair by a window, I minded my own business – in the form of months and months of unopened bank statements. It was time to review things. When I had started on my new career, there had been so much money coming in that I'd had to take up crack on top of the alcohol just to get through it. But now, even I was shocked. I started to add it up. £2,600. £3,400. £4,900, £10,500. My God. More than £100,000 on rocks in a year. I know quantity isn't quality, but even so, you have to be impressed.

'You are not allowed to read anything which we haven't authorised.' A counsellor was passing. He bundled up my statements and took them away, leaving a little blue wake in their stead. It appeared to be a medical volume about the detrimental effect of drugs. It was appalling. I resolved to give up reading.

I took up eating instead. I was seized by a sudden ferocious appetite. I spent all my spare money on chocolates and biscuits and sweets and sat in a corner gobbling. Alone.

'You are isolating, Sebastian.' Another counsellor was passing. I gazed out of the window. She was right. I mean, I like an audience as much as any other monomaniac — except when that audience happens to be myself. I didn't want to look at that creature that much — at least not right now. It wasn't my choice to join the group. But I did.

It was made easier by Valentina, an orange-haired, red-lipped, amber-jewelled counsellor whom I had developed a crush on. Better to look at her than look at myself. Besides, she was friends with Chelita Secunda! Chelita Secunda, the woman who had dressed Marc Bolan. The woman who had put the glitter on glam rock's cheeks. A tenuous connection, granted, but this was the middle of nowhere. Out on the lawns, they would still point if an aeroplane passed.

Clouds ran the twelve step programme of Alcoholics Anonymous. That afternoon Valentina was explaining step two to us. She wrote it on the board: 'Came to believe that a power greater than ourselves could restore us to sanity.'

'Does anyone here have a problem with this?'

I raised my hand.

'Yes, Sebastian?'

'I don't believe there is anything greater than myself.'

The whole room burst into laughter. I was beginning to like this group stuff.

'Sebastian. You, like everyone else in this room, are here because you are a drug addict. You are in denial. You are using humour as a shield. You need to look at yourself.'

'I can assure you, I do little else.'

'There you go again. You are frightened of intimacy. Your openness is an illusion. You don't want to be known.'

Well, that made me feel a bit better. Therapy after all has a point. Simple people can feel satisfyingly complex for a moment or two.

And so it went on. My fingers will not type the word 'co-dependent', but there you are, they just did, which proves that therapy has a point, I suppose. Rachel was a 'co-dependent'. I had a disease. Fantastic. A biological alibi. It had cost me £100,000 to nobble the jury – but what the hell? I imagined myself swanning into the hospice where my stepfather lay dying, riddled with cancer. I lent over the bed. 'Hey! Guess what! I've got a disease too!' I whispered into his ear.

But in the end there was no getting away from it. After all I had paid to do what I was doing: a two-month stretch in a crack-head's boot camp. Clouds was not The Priory. You didn't have your own room. You couldn't go out on day release. You couldn't order in. And you weren't going to share with Elton John in the anger management room. At Clouds you lived in a dorm with nine other snuffling, snoring, farting losers without even a TV to distract you or a book for escape. There was no privacy at all. And most of the food looked like it had been eaten already.

A bell rang at 5.45 a.m. Soon after began the first of the day's chores. I was put in charge of breakfast. It was not a success. I put cream on the table instead of milk. Everyone slopped it happily over their cornflakes until one inmate had the temerity to challenge me.

'This is cream.'

'No it's not.'

'Yes it is.'

'Look, are you going to believe me or your own taste buds? (Tasting it) Fuck, so it is. (Annoyed) This is not my fault. I'm from London (Mayfair, actually). I just go out and ask for a

carton of milk. Like normal city folk. But you country people insist on squeezing the stuff out of a cow – are you blaming me when it's you who are eccentric?'

But I had *chosen* to come here. And I had *paid* for it. It wasn't that smart. And if I only had half a brain, why hadn't they charged me half price?

I stuck it out sullenly. But I remained detached. And unsympathetic. And unappealing, no doubt. When a man insists on talking about his misfortunes, I mused in group sessions, then there is obviously something about them that he must enjoy. Besides, the right to be heard does not include the right to be taken seriously.

The group noticed. They all turned on me one afternoon. It was led by a great big tattooed cockney.

'Why are you here, mate, if you fink there is nuffink fuckin' wrong wi' ya?'

He had a point. Though I resisted it, of course. I still hate the way illness has become a fashion statement. Confession the new handshake. The way mere survival is hailed as a 'triumph'.

'I don't really believe in problems,' I said. 'The problem with problems is that they imply solutions. And there aren't any solutions. And even if there were I wouldn't want them. Who wants to have all their sharp edges smoothed off?'

People were thrown out of Clouds every week. Stealing, fighting, having sex. They were all grounds for expulsion. Even breaking the rules was a risk. I had already been officially admonished for wandering off without an escort, and for being late for group. The counsellor took me aside at the end of the session and gave me a third and final warning for 'resisting recovery'. 'Next time, you will be out,' he said. 'You are not helpful to the others and that's not fair. You have to give them a chance. And hopefully that will give you one too.'

I retreated to my corner. Fucking dogs, I fumed amid a fug of cigarettes. Who the hell did they think they were? What was

wrong with this bloody enterprise? Is psychiatry the only business in which the customer is always wrong?

What was wrong with me? Why was I so *FUCKING ANGRY?* I looked around at all my fellow inmates, slouching around on tatty sofas, smoking and gossiping and playing cards. The truth was I liked them. I admired them. They had had the courage to collapse.

Did I have the courage to get well?

I looked up at a yellowing poster on the wall. 'Hugs not Drugs!' Not much of an exchange. I mean why not 'Millions of Pounds not Drugs'? or 'World Glory not Drugs'? Even 'Death not Drugs' would have hit the spot.

That night I was unable to sleep. Anger begins with madness and ends in regret. Fuck. My bravado wasn't convincing me, why should it convince them? I thought that my pseudo-eccentric reaction to therapy was a mark of my wonderful individuality. But eccentricity is to individuality what 'a character' is to a person of real character. It is willed. Even worse it is a mask for nonentity. True individuality, like true character, is earned and involves moral effort.

And just what the fuck was I doing with *my* life anyway? All the therapy in the world will never allow you to find out who you are and why you are here on earth. But still, something good was *trying* to happen to me in this clinic. Why was I trying to sabotage it?

Wasn't I the one who had always tried to be truthful to my inner life – even to the point of discomfort? When the morning bell rang I hadn't been to sleep.

But I knew what to do. I was going to get well.

Over the following weeks I threw myself into the system. The counsellors launched an attack on me – Red Indian style. The circles of abuse, intoxication, and destruction – heroin, crack, alcohol, gambling, prostitutes, got smaller and smaller until I arrived at the centre. Myself.

Valentina had noticed the change. Six weeks into the course

she suggested we have tea. I leapt at the chance. It would be fun to have someone to flirt with. We sat on the balcony in the streaming sun.

'What a lovely day.'

'Thank you.'

I liked to take credit. But it soon became apparent that Valentina had more serious things on her mind.

'I want to talk about your family, Sebastian.'

'I don't.'

'I think we need to.'

Oh God.

'We are conditioned from an early age. We grow up with shackles. When you take these shackles off the wrists, they are still left bruised.'

'What do you mean? If you enjoy being made to feel inadequate, why not just call one of your family? Is that what you are saying?'

'Well, why don't you?'

Oh God. I'd tried to keep my family away from me. Mother wrote regularly. The letters always began sober and ended drunk. I'd had no contact with Father for years. And I didn't want that drunk knowing I was a crack-head. I asked my sister, Ash, to visit.

She arrived with Giles, a marble mason, whom she had recently married. Quiet and reserved, he was a simmering volcano who had got off heroin five years earlier and fostered an obsession with fossils ever since. His flat was lined with cases of glimmering minerals and smelt of the ammonia that rose from the tank of a pet iguana in the corner.

I liked him – and respected him. He had not only salvaged his dignity from the mess of heroin but he had resuscitated his spirit too. Besides, I was fed up with cynicism. The armour of the romantic, it may be intellectual dandyism, but still I was fed up with it.

We strolled around the grounds of the clinic. The September sun hovered without heat above us.

'Have they told you the statistics?' said Giles. He was something of a veteran of these places. 'A third of you will stay straight. A third of you will use again. And a third of you will die.'

'Yeah – but the fatality rate of people with a breathing habit is one hundred per cent.'

'If you keep taking crack you know what is going to happen.'

I nodded.

'But remember too, that if you don't take crack you don't know what is going to happen.'

'Such as?'

'Well, anything. You might change despite yourself. You might write (I blame the bastard for this book). You might paint. You might even get a job.'

'I feel a pipe coming on.'

'I'm serious. You can come and work with me if you want when you get out.'

I still look back with some nostalgia on the day that I left. Despite all my initial resistance I had enjoyed my time at the clinic. I had handed myself over to someone else and found that for once I was in safe hands. And I had grown fond of many of the other inmates. They lined up and clapped while I passed down their ranks like a queen at a victory parade when I left. They always did that. And then after that everybody hugged. Hard to remember how I would have detested that two months earlier. But now I felt deeply moved. It felt like the last day of school. Rachel was there to pick me up – I was so changed that I wasn't even embarrassed to be making my getaway in a borrowed sardine can. I would have gone to have lunch with Cliff Richard if someone had required it – as long as it wasn't in a pub.

I woke up the next morning in Mayfair. Aside from the clinic it was the first time I had woken up straight in years. It was October. The sun was still shining. I wanted to shine. I wanted a new life. I certainly had a new respect from all the locals.

Apparently, in my absence, Lady Diana had visited my flat. (I had rented it to a friend who knew her and she had come to pick him up). Everyone – rather gratifyingly – had seen her and been gossiping about it for weeks. I tried to look indifferent for a moment or two but then couldn't contain my curiosity. 'What was she wearing?' 'Jeans and a baseball cap,' Tariq from the cornershop told me. I was rather disappointed. If I was a royal I would wear my crown to breakfast . . . and after lunch I would ride out and mow down tourists on the Mall.

But first I had to get things back on track. I started to go through the mountainous backlog of mail. I was hoping for some cash. Hardly likely – have you noticed that bills travel through the post at five times the speed of cheques? I waded through the invoices, statements and magazines selling office furniture and thermal underwear. One letter caught my attention. Not only was it embossed with a logo, but it appeared to have been hand-written by a human being. I opened it up.

It was a letter from the director of the Grosvenor Gallery in Albemarle Street. He was offering me a show. And this after ten years of rejection slips – surely nature's way of telling me that it was time to stop painting, and now, I was being offered a solo show.

My entire outlook changed overnight. No one hates the world so much that, when it begins to like him, he does not start to love it. I began my new life by tearing the seals from the window. The light flooded in. The next thing I did was hire a cleaner.

I got to work. I had six months to get this together. I was going to make work on the great white shark. I was going to capture the power and the grace of the creature, the spilling wash of blood and light through the water, the thrash of human fear. Working businessmen's hours (without drugs, I would have been a policeman, no doubt about it), I stood in front of the canvas from seven in the morning until four every evening. Emerging out of a dark ground, forms began to take shape. But

they could just as quickly be lost. Beneath every finished picture another ten were being buried – and a drug addict, or so I hoped, was being laid to rest.

I stayed sober. The invitations went out. I embarked on the pre-show publicity. This was the moment I had been preparing for all my life. To appear in the newspapers – it was proof of my existence! I rushed out and bought dozens of copies of every one in which I appeared – gift-wrapped for the world. If this made me a lesser artist, a dilettante, a *poseur*, then so be it.

On the day of the show I went alone to Albermarle Street. I patrolled slowly around the room, my boots clipping against the floor. The paintings gleamed behind glass so that the whole room looked a bit like an aquarium. I savoured the moment. Here was the best of ten years' work. I was pleased with it. I had tried to distil that haunting moment where violence and beauty merge, to paint a vision of the abyss, of the knife-edged balance between being and nothingness. And the big gilt frames were pretty nice too.

Usually at a party, I find myself talking to someone I have no interest in about something I know nothing about. Not tonight. A man is rarely so well inspired as when he talks about himself. And still I didn't drink. I didn't need to. I was drunk on my own glory.

But the show wasn't a success. It was ignored by the art world. And that didn't help. Mostly people aren't really interested in art; they are interested in what other people are interested in. Hardly anyone bought a painting. I came away with a cheque for £5,458. Well . . . if people didn't want to buy my work, who was I to stop them? Fortunately, art is the only profession in which no one considers you ridiculous if you earn no money.

As far as I was concerned, I had arrived – in an exuberant explosion of velvet and silk. There weren't enough trees on the planet to make the paper to describe just how marvellous I was. For the next few weeks I sat in my little flat reading and re-

reading my press cuttings. 'That bastard sounds like he's having a really good time.'

I wasn't. I should have recognised the warning signs: the euphoria, the inability to sleep, the incessant – and apparently brilliant – ramblings of my mind.

Next thing I knew I was trawling the porn shops, investing in twenty different titles. I wanted to have them in storage – just in case, of course. A few water bottles and biros might be handy . . . who knows when there might be an emergency. Elastic bands. I had them. Tin foil. Well, I could cook a chicken.

Stocked up for armageddon, I would lie about fantasising about the first hit. I had been straight nine months. But fuck it. Who wants a stay of execution? I overcame my willpower and returned to the crack.

Of course, the dream which brought me back to drugs was brutally betrayed by the actuality. How could it be as good as it had seemed in anticipation? There was the memorable first hit and the breath-taking, heart-stopping, brain-burning pleasure. 'That's it, I'm going to smoke this for the rest of my life.' And then there was the usual quick decline when I was just wanting to get rid of the stuff in front of me as fast as possible – which I did – and then immediately it was gone I wanted it back again, as quickly as possible, I mean what the hell happened to it . . . surely it wasn't me who had done *all that*?

The road of excess leads to the palace of wisdom, said William Blake – which was rather naughty of him because it doesn't. I sat in a darkened room for six months watching *Home and Away*.

I returned to Clouds for after-care.

It wasn't all that successful, travelling up on the train twice a week and constantly relapsing and missing my sessions. But it gave me a week or so off the pipe every now and then. Then, restored to health, I could at least feel well enough to start destroying myself again.

And so it went on – month after unhappy month in a miser-

able limbo. I used to be woken every morning with stimulants to drift through the rest of the day on sedatives. And what now was there to look forward to? I had given up everything and taken nothing up instead. I had quit painkillers only to find myself lost amid the dumb ache of an unpindownable pain. My new-found self-knowledge had done nothing except enable me to suffer more lucidly. I had descended from the lofty misery of drug addiction only to discover myself opened up to the common misery of being alive.

'I wish I was dead, I wish I was dead,' I would constantly intone as I watched the kettle boil or emptied the bin. Day after day I sat in my flat, staring at the wall. I was marinated in failure.

I was thirty-six. Mozart at my age had already been dead for a year. Marc seven years. One of the many troubles of growing older is that it gets progressively harder to find a famous historical figure who hadn't yet amounted to anything by the time he was your age. Unhappiness lies in that gap between our talents and our expectations. I moped about. To be a failure in London is to starve to death outside a banqueting hall, the delicate aroma of an exquisitely cooked dinner entwining your dying breath. I had gone from loser to user to has-been without ever passing through the middle bit.

I decided to act. I became a prostitute.

An agency that advertised in the back of soft-porn magazines went by what it clearly imagined to be the sophisticated name of 'L'Homme'. It turned out to be based in cosmopolitan Leicester and was run by a distinguished duo called Cheryl and Rio. Cheryl, who wrote those Black Lace novels that dally about with women's bits in the boudoir, was the company director. Rio, a diminutive, ringlet-haired, snake-hipped gigolo, was the goods.

I applied to be taken on.

'We are relaunching,' said Rio. 'We are wondering whether you might like to come along to a photo shoot for the ads.'

Soon, quarter-page advertisements featuring me, beetle-

browed amid the deep shadows, were appearing in women's magazines. I was the man – or L'Homme, I should say. 'High-calibre male escorts/chaperones for discerning ladies who deserve nothing less than the best.' That was the promise that was given to the good readers of *OK!*

'You are now the public face of our enterprise,' Rio informed me. 'Our flagship.'

This was consoling. It is nice to be in the same boat as one's betters – especially if it's sinking. I sat back in my flat and waited for the customers.

The first point of contact was the telephone. This proved to be to my advantage. I have the voice of a lobotomised, homo-sexual drug addict who has decided to keep his head in a bucket. Clearly, it put off all but the most courageous. The first ten calls came to nothing. Phew. Thank God for that. 'Yeeeeees,' I drawled to the next caller. 'This is Sebaaaaaaastian speaking (albeit in a ludicrous voice). May I help you?' Oh fuck! I had just got myself booked.

Fuck. Fuck. Fuck. What was I going to do? I had wanted to turn myself into a slave and sell myself into freedom and all that . . . but I hadn't imagined for a moment that anyone would be buying. Right. First things first. Wardrobe. People call me a whore and a pimp. How I wish they'd just make up their minds so I would know how to dress for the compliment – beyond the call of beauty. All that glitters was now sold – for £150 for the first hour and £100 an hour thereafter that, with a flat rate of £500 for an overnight stay. It was expensive at the price.

I arrived cap in hand (and condom in pocket) in front of a portico'd door sleepily invigilated by a pair of stone-composite lions. Ding-dong. Ding-dong. I performed my last frantic OCD rituals on the passive leonines as I waited.

'Good evening, Sebastian,' a voice purred as I performed my thirty-sixth pat on the left animal's head.

'Errr. Hello. Nice pets.'

'They are rather winning aren't they.'

Taking her in for the first time, I almost fainted with relief – not because she was Raquel Welch but because she *wasn't* Gertrude Stein.

'We are going to a swimming pool party,' she told me over a glass of Campari and lemonade. 'My husband, from whom I am separated, will be there with some new brunette.' The ice chuckled in her glass, as she smiled and tossed her shiny blonde bob. 'So I want you to pose as my latest beau.'

I nodded willingly. That was a good start. Posing is about the only job I can do. 'He won't hit me though, will he?' I asked nervously. 'My life is a credit to my cowardice, if that's all right with you.'

She giggled prettily. I watched the tremors fading amid a plump embonpoint that a pink, scoop-necked dress (nicely rucking around the waistline, I noticed) revealed.

She drove me there in one of those massive four-wheel drive cars that mothers kill other mothers' children with. We went into a yellow-striped marquee, and started mixing with the guests who were circulating amid the forests of cut flowers. I smiled and said as little as possible but gazed – with what was beginning to feel like genuine adoration – at my employer. She would look up at me and smile back. Some women have a second string to their bow. Others prefer a second beau on their string. I'm not sure that she didn't have both. I was starting to enjoy this game. Sex, like all games of chance, is more interesting when played for money.

I kissed her goodbye the next morning and thought, slightly wistfully, that I would have visited her for free. But £500 cash had replaced the condoms in my pocket. And I have to say I felt pretty chuffed. I rate prostitutes, because they obviously rate themselves.

Sadly, it was all beginner's luck. I wasn't so fortunate next time. I was called to a flat late at night in Chelsea. And arriving in the state of violent excitement that, I was to learn, always

preceded a job, I found myself staring into the face that would have launched a thousand dredgers. Good on the phone, add on two stone, is a general rule of thumb.

Oh Lord. She was dressed in wool. Forget a chastity belt – an alpaca jumper will do.

'Good evening . . . yes, thank you, I'd love a drink (very strong, very very strong) . . . what a nice flat.' Courtesy is opening a door for a woman you would not wish to open a bedroom door for. Unfortunately I had to open the door to the bedroom.

She kept worrying that the condom was going to burst which I thought a bit rich. She was a dog – I was more worried about having rabies than babies.

I crossed the line that night. It made all my next jobs easier. I took the view that if someone wanted my body more than I did, they could have the damn thing. After all I hadn't cared for it much myself. I had never gone to the gym, or entangled myself in yoga, or succumbed to any other such corporeal diseases. They rot the soul. The only function of my body, as far as I was concerned, was to carry my beautiful face around. It was merely a pedestal for my head.

I liked this work. I may *like* my friends, but I *love* strangers – for a start, they haven't (yet) heard all my tired old lines. I had gone into this job looking for love, not money. And what better proof of love can there be than money? There were plenty of women I didn't particularly take to. But sometimes it's a form of love just to talk to somebody that you have nothing in common with and still be fascinated by their presence. I turned my entire persona into a commodity. It was charming. I'd always had problems with unpaid sex. It never really works, does it? No human relationship is adequate to any human desire. And what is love, anyway, but prostitution? At least I now had a valid reason for liking my lovers; they paid me.

But then I got the job I had always feared. I was summoned to meet a man at Windows on the World, the restaurant which

tops the tower of the Park Lane Hilton Hotel. He was vast and pallid and had the sort of corn-coloured hair in which it looks as if someone had started to cut a crop circle, but failed to finish. Over a dinner of calves' liver he explained his proposition.

'I want you to fuck my wife while I watch.'

I had no problem – not with this nor the £500 that came in a brown envelope. My virtue can withstand anything – except the highest bidder. But there was still a massive hurdle to overcome – I didn't realise how insurmountable it would be until I met the wife. Joan – as she was called – had evidently swallowed the whale. Blimey – there's no way she'd get on Noah's ark, I thought, not just because she would break the gangplank but because they couldn't possibly find another animal that looked like her.

But shouldn't £500 be enough to mask the disgust?

I had a kind of out-of-body experience. We were already at the top of one of London's highest buildings. I winged it out of the window, and hovered there, looking down from the heights upon our gathering around the table. Look at us all – insignificant mites – even Joan looked pretty small from that vantage point – and what did it matter. The human struggle is no more momentous than the scuttling of insects amid the grass. What was the problem?

The problem was that it makes a world of difference whether you hear an insect in the bedroom or in the garden. Suddenly I wanted to be out in the garden.

'I'm sorry. I can't do this. I have to leave.'

I fled.

As I slunk back home to Shepherd Market I knew it was my last job. My appetite for depravity had finally sickened upon what it had fed.

Prostitution may be the mirror of mankind. And mankind has never been in any serious danger of getting bogged down in beauty. I had wanted to sell my body just to get rid of the

damned thing. But I had found that man cannot get rid of his body — even if he throws it away.

It was time to get back to work. Over the last six months I hadn't exactly been prolific. The few bad paintings created during brief interims of abstinence were of no interest. I was too bored with my life. And no wonder. I had been living the same routine for more than quarter of a century. When I was ten years old I had sat alone in a room making and breaking things. And nothing had changed since then.

I adopted a new muse for a start. Baudelaire. It was his taste for unhappiness that appealed. He knew all about the bitterness and disappointment and drudgery of life, and also its flip side: the longing for escape. And yet he wrote about it with a dizzying relish. There was an unbelievable contrast between the squalor of the life and the splendour of the poetry.

I had been obsessed with sunflowers since childhood. They were big, bold and brash. But as an artist I was not interested in portraying things as they were. I wanted to paint them as I sensed that they were: like leaping demons, like serpents casting themselves upon their prey. I wanted to paint these flowers as though there were scorpions curled up in their petals. I wanted to capture the carnage which coils inside creation, the violence that seethes beneath every surface.

I thought back over the time I had dived with the sharks. As the beasts thrashed the waters, ripping at hunks of meat, I remembered being forced back against the bars of the cage. I stared astonished at the gaiety of so much blood. The wounds burst like red blossoms into the sea. It was a slaughterhouse of flowers. And that was what I thought of as I started my new paintings.

The Flowers of Evil opened at the Grosvenor Gallery in March 1999. I had not shown for two years — death for a man who exists only if he draws the public's breath. But nobody much gasped, or bothered to comment, or even came along. I remained so little known as to be almost confidential. I came home with little to support me except a cheque for £5,518.54,

inflation of £60.54 on the last show. Things were looking up . . . a bit.

I pretended failure no longer upset me. That was my salve. Each unsuccessful attempt to win wider recognition brought me nearer to the moment when victory would be useless even if I had it for the taking. And that was a comfort. Publicly I would profess indifference. But inside I would twitch with bitterness whenever I met someone who had achieved what I wanted.

My life had always see-sawed between grand aspiration and grounded reality. I was constantly buoyed up by the fresh hopes which brought fresh disillusionments in their wake. I always ended up exactly where I started, with nothing left to do but to embark upon the next journey. What was there left to do but wait for death in the hope that this final voyage may bring me something new?

You put on a show full of high hopes and plans. And then you see the pictures on the walls. It's so disappointing. 'Is that it?' you wonder. 'Is that all that it is?' 'It is', comes the answer.

Sitting alone in my empty flat I felt like a cat whose kittens had grown up. Or a father who had just taken his child out in the yard and shot it. What to do?

Score, seemed like an answer. I phoned my dealer the morning the show opened. So, it was true: the same sun that brings out the sunflowers brings out the scorpions.

But that wasn't the answer. I decided to move into a new flat that I had just found in Soho. I would keep it, emphatically, drugs free, I vowed. And to that effect I spent several weeks, shuttling between the abodes. Sleeping and taking crack in one and visiting the other occasionally to plan my new life. This way, I reasoned with a brilliant logic which surprised even me, *I wasn't taking drugs.* And even if I was, when I got to Soho I would definitely stop.

Sitting in Shepherd Market with nothing except an oatmeal carpet and crack pipe for a friend, I realised that a junkie is

simply the larval stage of an artist. They both like to be alone and left to feed on whatever material they have alighted on.

I finished the last of the drugs and walked (a little worse for wear it has to be said) out. I left everything behind – the memories that haunted every nook and cranny of that flat, the cues that could be spotted at every false turn, the compulsions that crept out of every dark corner. There was never any question as to where I would head – Soho.

It started promisingly enough. True to my word I remained clean for several months. There was much to do. I set about my new home in the usual manner. There were two rooms – a studio and small bedroom, both lined in panelled wood. Even this was too much for me – I have never known what people do with the room they are not in. The kitchen and bathroom were tiny. I had been in bigger women. And I couldn't work out my oven. It seemed to flush. I didn't care. I didn't want a nest. I was a cave-dwelling creature.

I had no furniture. No chairs, no sofa, no coffee table. I didn't even have a decaffeinated coffee table. I kept one spoon, one fork, one plate, one cup so that, in my weaker moments, I could still eat. What was left I entombed in red velvet. I bought an old bed which was too small for me – I had to sleep diagonally in it. It was cheap but this made sense to me. A wooden bed is better than a golden coffin. Lastly, I bought a throne (from which to drone). It wasn't particularly stately, but then even the grandest throne in the world is just an upholstered bench. I was happy. The studio had a desk at one end and an easel at the other. The floorboards were bare. This was my pared-down life as I had planned it, the springboard from which to sally forth and dazzle. In my little room I could be my horrible unique self.

Outside was perfect too. The street was called Meard Street – shit street – that suited me. With a name like that, who could blame me if Soho became a sewer with service from my flat?

The ideal view for painting is a brick wall. There are few things more reassuring. And I had two – one for each aspect. And I had shutters as well. A gentleman never looks out of the window, unless he is working. I kept them firmly closed. I had mirrors instead. I like mirrors. When you look out of the window all you see is ugliness. In the glass of the mirror all is perfectly divine.

It was ideal. I had constructed a cage to trap my dreams. Here I could fester like a disease.

Something else kept me off drugs in my new home: employment. I was given my first job in the outside world. I was asked to write a monthly column for a new magazine that appeared to have been set up by the St Trinian's hockey team, schoolgirls who liked to gossip and giggle about sex – probably because they didn't dare actually have it. It was called *The Erotic Review* and its form mistress was Miss Rowan Pelling. It was rubbish. Neither high-brow enough to titillate intellectuals nor low-brow enough for it to be something you could disappear into the lavatory with, it just about catered for the more outre members of a Surrey Golf Club.

I didn't care. I took my new job seriously. I don't want to be to blame for my anonymity. I can't afford to say no to anything. Besides, it is not enough to know how to make a dazzling exit. You need to know how to enter the stage with the same panache. My first words to the world were: 'I am not a writer. The only thing I have ever written is a cheque. That said, I can hardly wait to hear what I've got to say.' The column was like me: a lighthouse in the middle of a sewer – brilliant but useless. It was called 'Sewer Life.'

It had never been an ambition of mine to become a writer and this worked in my favour. If you go into battle and you don't care if you are killed it makes you strong. Good art is possible only after one has given up and let go. I let rip.

Trouble was I couldn't really write. I didn't understand pace, or plot or punctuation. Worse, I didn't understand that I didn't

understand. If the editor dared so much as move a comma I would try and put her in a coma.

'Right that's it. I'm resigning. You are censoring me. You are frightened of offending the silly old twats that buy your crappy magazine.'

'Er, no actually, we just thought the first 400 words of your piece were irrelevant—'

'How dare you! Considering your whole magazine is irrelevant . . .'

'Well, you are in danger of losing your tiara. Your last two columns were crap.'

'Now look here. All of my columns are great. Some of them are crap. But they're all great. And nobody's as good as me in *The Erotic Review* when I'm bad. Why don't you come down here bitch and milk my cock?'

It seemed fine at the time. Why be difficult when, with a little extra effort you could be impossible.

The column ran for six years. I'm sure people who read 'Sewer Life' did so in the spirit of those who slowed down for accidents. But, without fail, every month I defiled my copy.

Over the last ten years I'd kept journals full of quips, gags, aphorisms, and epigrams. By the time I came to write the column I didn't really speak anymore, I quoted. As I honed my performance I found that I had gone beyond my original aim of emptying my speech of the nonsense of honesty. I had robbed it of all meaning whatsoever. To my friends, listening to me became almost unbearable. I would follow a conversation like a seagull follows a trawler waiting to dive in on the first glittering opportunity to scatter with patter. The opposite of talking for me wasn't listening. It was waiting.

Still, my reputation grew with every failure. The column had gained a cult readership and I was asked to give public readings. It was here that I finally arrived – though unfortunately quite a lot of the audience left. So many people walked out during my tirades of abuse that I was forced to respond. As I

watched them walk towards the door I said, 'Oh please don't go. I'll say the opposite if you will stay.' Surprisingly they often did. Lots of them even liked the nihilistic playfulness in the end. Besides, laughter was much more important to me than applause. Applause is a duty. Laughter is a reward. After my readings they tended to clap more when I'd finished than when I was introduced. They were exhilarated that I had stopped. I didn't care. You can't make a fool of yourself as long as you are on the stage.

At first my new career seemed strange. I didn't want to tell Mother I worked as a journalist. She thought I was a prostitute. Locking yourself in a room and inventing characters and conversations which do not exist is no way for a grown man to behave. Then your work is published, the sun comes up, as usual, and the sun goes down, as usual, and the world is in no way altered, and it must be someone's fault. This did not appeal to me.

However, as it progressed I realised that writing was not a literary career but a personality racket and this seemed something I could exploit. It is not human nature to write the truth about itself. We all rewrite our own pasts to reinforce our present view of ourselves. I was the classic unreliable narrator whose passion to entertain overrode my duty to inform. My highly enamelled prose was merely an extension of my rather gaudy clothes.

I am not a writer. I am a performer. Writing is merely a way of bringing myself to the notice of the world. And it is the world I care about, not the writing. The fact that I could not live by words alone – despite the fact that often I had to eat them – did not dismay me. I would take my wages in people. And in becoming a millionaire of love I would be paid by the interest of strangers.

Soho was perfect. It became my Queendom. And monarchy is the one role for which I was born. This was my home. If you have never seen a total eclipse just watch my subjects as I stride through the West End. I stroll, sleek with significance, smiling

and tipping my boater to all and sundry. I was kind to Soho. I was to sleep with most of it.

Soho is a madhouse without walls. Men impersonating women, women impersonating men, human beings impersonating human beings. Millions of people being lonely together. Soho is about hunger and Soho is about need. It is like a creature possessed of nothing but a stomach and a penis. I had never loved a place more. Especially the edge of danger. On a good night here, I reckoned I could get my throat cut.

I was at ease. Besides, after all that flurrying activity surrounding the show and the column I had an uncontrollable urge not to do anything much. I pottered about the studio, avoiding the dirty looks of the easel, the accusing glare of the typewriter growing dusty in the corner. I was an abstract painter, I decided – extremely abstract. No brush, no paint, no canvas, just pure emptiness of thought. As for writing – well, I would get round to it one day – even if it was just a suicide note.

I spent the afternoons in Soho clubs, in the Colony Room, the Groucho, or the French. I paused at them all like a devotee pauses to pray at each station of the cross. But the Colony was, and will always be, the best. It is so delightfully loser-friendly.

I first visited it when I was twenty because I'd read that that was where Francis Bacon used to hang out. I ran up the narrow stairs and was promptly told to 'fuck off' by Ian Board. I knew all about rudeness masquerading as honesty. A decade later I returned. And this time I was allowed in by the much kinder new proprietor Michael Wojas who came from Poland and looked like grass under a bucket.

I adore the Colony. It's the only bar that I know where people actually talk to you. It is the only bar that I know to which you can turn up to alone and be made to feel welcome. It is full of writers, artists and poets – the sort of people that in other bars would be called drunks. It reminds me of the Tardis. It's minute on the outside but huge on the inside and you go there for love, which they serve by the glassful.

At first I wasn't drinking, just lime and soda. *Fucking hell.* Not having a drink in the Colony was like having a shit in a church. Seven months clean and I was bored. The real difference between being clean and being on drugs, I began to realise, is that clean I knew I was having a bad time whereas when I was stoned I only suspected it. If you give up smoking, drinking and drugs, you don't actually live longer: it just seems longer. And I have always found everyday life difficult enough anyway – it's very hard to walk with wings, even if they are made of tinsel.

I finally went to see my doctor.

'I've stopped taking all chemicals, owing to side effects of euphoria,' I told her.

'Get to the point.'

'Er . . . can I have some sleeping pills?'

'No.'

'Then will you give me a lobotomy on the NHS instead?'

'No.'

'I'm miserable.'

'Have you tried NA?'

'I don't want cough syrup for the soul. I want drugs to make me feel better.'

'Look. I'm busy. Have you got any real problems?'

'Yes. I've got Tourette's Syndrome, you fat ugly cunt.'

There comes a time in any good man's life when he has to rise above his principles. I went back on drugs.

This time it was heroin. I took it as an escape from un-endurable life. I took it because I enjoyed taking it. Of course I'd used it before. Crack and smack are the perfect narcotic part-ners. The yin and yang of the chemical world. If crack is the sexual frenzy, heroin is the transcendental peace that comes after. Crack is the whore. Heroin is the mother. Together they make a mother with a cunt. It doesn't get any better than that.

But after a while most crack-heads seem to cut out the first bit and go straight to the smack. They probably need to catch up on their sleep. Unfortunately in my case it was the sleep of

reason I had been missing out on. I began at the end and started injecting myself.

I'd first seen someone shoot up in the ladies at a posh members' club. I had found myself in there with Nick Cave and Shane MacGowan, as you would. And I can clearly remember the shock that I felt as I watched Nick go through the process. I remember the sudden pity I felt for his violated veins. But there was also a macabre fascination. Why did so many rock stars take heroin? Was it to soothe the pain of their horrible music? Or was there something else? Within months, some old heroin hand was injecting me. We spent the night together. But it was never to be so good. Our relationship had gone downhill from injection to common intercourse. The fix was all I remembered. It held me in its arms so tenderly, so sweetly, so full of love.

You're not really taking drugs unless you're shooting up. The fixing ritual is the sweetest form of pleasure a man can have. The needle, the belt round the arm, the powder in the spoon, the cut lemon, the fag filter, the flame applied, the bubbling golden liquid drawn up through the cotton filter into the syringe, the hungry vein, the first feeling of the spike sliding through the flesh with a pain too exquisite to be borne, too beautiful to be withstood. And then the back-draw . . . oh the back-draw, a beautiful plumed explosion, blossoming like a flower. The ecstasy of hitting a vein is incomparably pleasurable – and then the final plunge of the barrel. Complete happiness is about to be yours. A massive infestation of pleasure follows, the chemical sweeps around your body like a torch-lit procession. You hear the angels sing. You feel the kiss of God. The whole world is bathed in the luminous glow of entrancement, of contentment, of peace.

Those who have never taken drugs will never know bliss. When you inject yourself with heroin you fuck yourself. How could I turn away from it? This wasn't mere pleasure, it was my entire life. I had always been absorbed by the idea of the decadents, of those doomed visionaries, strutting peacocks possessed of an arrogant lust for life. I wanted to wear their

outlaw colours. I wanted to share their fearlessness. Some see addiction as weakness. But for me it was a strength. It was the strength to lose control, to run counter to convention, to escape the banal confines of what I saw as bourgeois life.

Besides, as a dandy heroin suited me. I needed a new look. I'd got bored of most of my suits. I tried to flog the brightest of the bunch. But their glare made your eyes ache even to look at them. Eventually I found a client. Billy Smart bought them for his circus . . . for the clowns. Thousand-pound suits went for fifty quid a pop. It was the sort of depreciation that I could understand.

Next, I went to my tailor and had him customise all my remaining suits to hold syringes. Now, like cowboys slot their bullets into belts, I could slide six pre-filled spikes into the inside lining of my jacket. Ideal. Never offend people with style when you can offend them with substances. I was a disciple of satin and Satan.

Heroin is the paedophile of the drug family. It may be not merely acceptable but positively *de rigueur* to snort cocaine in some members' clubs. But get caught fixing (as I was) and you were chucked out. My drugs of choice were deliberately secular. Hallucinogens may often be considered sacred – there are peyote cults and bannisteria cults, hashish and mushroom cults – but no one ever suggested that heroin is holy. There are no high priests of crack. These drugs are profane, pernicious. When you are in the grip of them you might almost imagine you are suffering some diabolic possession. When you come down you are swamped with guilt and self-loathing. This suited me. I hate the idea of a mind-expanding drug. Glamour, to me, is a greater asset than spirituality. I am more hara-kiri than Hare Krishna.

Heroin gives and takes away. It bestows what feels like perfect contentment. Nothing becomes a presence. And it feels profoundly deep. And you drown in the syrupy delights of the ideal illusion that has no bottom and no way out.

I couldn't stop. There are degrees of addiction. But with heroin you are drowning before you even realise that you have

swum out of your depth. You don't realise you have a habit, until it is far too late.

The physical dependence comes quickly. And though pure opiates in themselves are apparently not damaging (heroin, in fact, is a wonderful preservative of everything – except secrets), it is the lack of hygiene that brings the problems.

After a few months I had deteriorated shockingly. My clothes were stained and stiff with booze and blood. I never bathed. I lost stones. I was always spilling things, knocking over furniture, and falling down. My hands shook. My body looked like a battlefield. Heroin makes you itch and scratch. I would sit and tear strips of flesh off my feet until I could barely walk. The needle did its own damage. My battered veins shrunk in on themselves, as if hiding from the brutality of their torturer. My arms, purpled and yellowed and tracked, almost made me weep. Eventually I could no longer use my main blood vessels as they formed protective callouses. They wouldn't allow me in. I took to shooting in my hands, my feet, my crotch, my cock.

If that wasn't degradation enough then there was the lavatory. Both crack and heroin wreak havoc with the bowels. With the former, you lose control of them. As soon as I lifted the phone to score I would have to rush to defecate. Once, queuing in a Mayfair *bureau de change*, I got more and more agitated as the time for the dealer's arrival approached and the cashier still remained distant. A minute felt like one hour. I shifted and shuffled in my fine purple gabardine suit – and then defecated freely all down the trouser leg.

With smack, the reverse happens. You never go to the loo – which in theory sounds nice. Of all my vices, the one that I long to give up the most is defecation. I have always been disgusted by the stinking body that follows me about wherever I go. When I am straight, I bathe obsessively. So you might think that smack was a blessing. I could stop shitting and become the perfect gentleman overnight. I had at long last found the sovereign remedy for the curse of defecation.

Or had I? The constipation of heroin is nature's way of making junkies understand childbirth. I would squat on the toilet for hours, weeping with pain, my feet on the rim of the bowl and a spoon up my backside, excavating a dried turd.

You start taking heroin out of a desire for life, a yearning to find meaning, a longing for salvation. You end up lying on a piss-soaked brothel stair with a bloody syringe in a bloodied arm.

I had started with an obsession with freedom. I had ended in a prison of my own making. Day after day, I sat in a dark-ened room staring at the wall. I was interested in nothing except the next hit. Addiction, is the heaviest stone that the devil can throw at a man.

What was it in my life that was so awful that I had resorted to this? What could be worse? What was wrong with me? I was not even atrocious enough to be well adjusted. I stared bitterly at my own crippling futility. There was nothing to hope for. This was all that I wanted to do. You would not drag a corpse from its grave. So leave me in my studio. I had met everyone I wished to meet . . . except my maker.

I was completely enslaved. And heroin is a cruel mistress. You need to take bigger and bigger doses, not to feel good, just to feel normal, just to be able to get up in the morning. You need to take a shot before you can brush your teeth. You need to keep taking it so that you don't start feeling sick. You need to close yourself tighter and tighter and tighter into the terrible cycle of desire and arousal, despair and disgust. You are utterly stuck.

But I had to stop – not that I could know this, or even contem-plate it, until I had taken a fix. I had become a hermaphrodite, a vampire at my own veins. And, also like a vampire, I was scared that if I withdrew my fangs I would starve.

I mustered all my willpower. I already knew the drill, though the first time I tried to give up it had taken me by complete surprise. You don't realise you are getting a habit until you try to give up. That time, lying in bed after six months of using I felt terribly ill. I called a junkie friend. When I described what

was wrong with me, she said simply, 'you have a habit'. I had attributed my symptoms to some other cause.

That time I went back to using immediately. But now I was determined. The withdrawal symptoms were mild at first. But over time, and as you get more and more habits, they get worse. By now they were terrible. I was soaked with sweat. My eyes were stinging. My whole body was afire.

I twisted and turned in the bed for two days, arching my back and straining my limbs. Then came the stomach and leg cramps, the fever and the sweats that burn the skin like frost. I was first boiling, then freezing. It was as though a furnace door was swinging open and shut. Sleep was out of the question. My entrails were twisting. I was so thirsty but it couldn't be quenched.

But all this was nothing to the mental pain. I shuffled around the flat, weighed down by a lethargy so deadening that every movement was a burden on my limbs. It was an effort to sit up in bed, to turn on a light, to get a drink. I didn't want to go anywhere or do anything. I lay in bed listening to sounds of life rising up from the room below, overwhelmed by my loneliness, my inability, my abandonment. They sounded so distant they might have come from another world. I burst into tears for no reason. If I mustered the energy to go over to the telephone, I would put it down immediately, I couldn't even talk. Hell was hello. The entire infrastructure of my character had collapsed. I was utterly desolate.

Eventually, I called Giles. He would understand.

'How much were you on?'

'Dunno. About a gram a day. Maybe two. Enough to get fucked.'

'Take it from me. You really will be fucked if you go back. You'll be dead.'

I could take it from him. When someone who isn't a user drones on about junkies I feel nothing but contempt. Opinions aren't easy at the best of times – but the uninitiated tend to get

completely hysterical. Still, what was I going to do? I couldn't face going back to a clinic. I couldn't face going back to drugs. I couldn't face being straight. I couldn't face anything.

'Try Narcotics Anonymous,' Giles suggested. 'You can come with me. I've been going for at least five years and you know it's not that bad. Not after a bit. Not once you've got used to the set up. And then, when you're feeling better, you can come and work with me. It would be good for you. Because your problem is that you're far too isolated. One isn't much company in your case.'

NA + job? I said yes to both. What else could I do? With addiction, the only victory is an admission of defeat.

The first meeting was ghastly. Huddled in a smoky base-ment in deepest Pimlico, I sat staring up at the strip lights. Twenty or so other people were sitting in a circle. Track marks. Tracksuits. Wrong side of the tracks. Fuck. Was this what my life had come to? But I was in no fit state to resist. Drug addic-tion is the one place where all the show is stripped of the human drama. My character had been undressed down to the exposed nerve endings. The slightest thing made me cry. I would have sat down and wept if the bus conductor had said good morning. The sight of an old lady with her shopping was enough to start the sobs. Even as one part of me scorned the entire NA experience, I felt the tears welling up as they welcomed me in. And I wanted to join. The world was so full of love. I loved all these people. I wanted them to save me. To save me like a tourniquet: to staunch the piteous flow of blood. And I sat there in my overcoat as they babbled on about God and higher powers, and praying and miracles – planning my suicide.

'I'm Sebastian,' I said when they asked me to introduce myself. 'And I'm just sitting here looking at my arms and thinking they would look better with needles in them. But thank you for having me.' When I came to the end of my story no one spoke. Magical 'sharing' wasn't allowed to degenerate into mere conversation.

After the meeting a one-legged man with lots of tattoos drew me aside. 'Have you tried praying? Well try. It's a miracle, you'll see.'

On a good day I wouldn't believe in God – even if he existed. To all things clergic I was allergic. But I've noticed that there aren't many atheists on turbulent aeroplanes. Today I would pray to the Teletubbies if they kept me off drugs. I was sick and tired of myself. I couldn't bear it or all its absurd grandiosity. I was even prepared to stand and hold hands with everyone in the room and say the 'serenity prayer'. I resolved to go to NA every day. I would do whatever it took to stop feeling like this.

When you are off heroin you slowly start to feel well again. You can drink, you can feel real hunger and take pleasure in food. And your sexual appetite also returns. Everything looks and feels different: sharper, more acute, like someone has twisted the focus on a telescope and all the blurry ungraspable edges are suddenly crisp. Slowly, rung by rung, you climb up the ladder of the game board. You even start looking forward to the view you might get from the top. Then suddenly, without warning, you are swallowed by a snake. You slide to the bottom. You are back where you started. You don't want to do anything. You don't even want to take drugs. Even destroying yourself seems like too much trouble – and obviously this was a problem for me. Apart from making toast, self-slaughter has always been my only talent. 'I'll teach you some new skills,' said Giles.

Giles had a workshop in Fulham from which he restored marble mantelpieces. So I went along to work for him for fifty pounds a day. It was a pretty odd experience. In the past, as far as I was concerned, work was just something that interfered with drug taking. It was what dullards did to avoid pangs of unmitigated boredom. But by now I would have done anything – anything to keep the demons at bay. Besides, my daily routine of back-breaking idleness was proving too much – even for me.

I took my job seriously. I have always believed it is important to have a wholehearted commitment to something that might turn out to be nothing. Giles taught me how to strip and carve and set and I was given the keys to open up and close the business. The job seemed pointless in the way that a regular job seemed pointless. So what? I tried to be as professional as I could. If you want to do a thing badly, you have to work as hard at it as if you want to do it well.

'You're the only person I've had working for me who hasn't robbed me,' Giles told me one afternoon.

'Sorry to disappoint you,' I said.

His predicament was hardly surprising. Everyone he employed was either a junkie, an ex-junkie or an about-to-go-back-to-junk junkie. But Giles tended to think with his heart. He was off heroin and he wanted to help others do so. And he was good at it in his quiet way. The best healers are the wounded. Not that he would have said that. He never said very much. But he was kind. At best this kindness seemed the highest form of wisdom. At worst it looked like a bad case of idiot compassion. Whatever, my work was like an NA activity weekend.

A few months later I was getting really sick of NA. As I got stronger all my old prejudices were bubbling up. Hadn't I always been a non-joiner? Large groups of people who insist that they have things in common make me feel uneasy – probably because they make me feel shockingly ordinary. There is danger in numbers. They can nudge you into action which you wouldn't otherwise take – and in public.

Groups acquire group markings. At NA they all said the same things. And besides, this God lark was really beginning to irritate me. Talk about God has emptied more NA meetings than all the counter attractions of overdoses, poverty and misery. Besides, surely a blaspheming junky was a spectacle more pleasing to the Lord than a praying sober one? Didn't he love sinners? And if God knew for all eternity that I was going to be a drug-addled failure why did he make me so photogenic?

Well, the most I can say is that God must be beautiful – he made me in his own image, the NA groupies said. But where does that leave the guy in the corner with the welts and the toupee?

My contempt for everything that these people believed in rose to almost sublime levels. But what good would despising them do me? How could I rail against something like NA? No one forced me to go. No one declared himself a leader. No one asked for money. All they were trying to do was help other people like them to stay off drugs. And so what if they chose to use this language? They had to say something. NA, I began to realise, is better than an oyster at absorbing outsiders, at de-activating its own dissident elements to make pearls out of swine. Why was I at war with it? I mean, I could have just walked out?

Instead I sat there in meetings searching through 'the programme' for loopholes. If I drank from a hand slipped inside a white silk glove would that constitute 'never touching a drop again?' What about still taking drugs but changing my name? In Clouds they had told me that I short-circuited 'the programme' with my intellect. 'Drug addiction has nothing to do with the intellect, Sebastian,' they explained. Of course, that had set me off on a rant. 'You even call it a *programme*!' I stormed as I marched mechanically round the room. 'I'm on the programme, I'm on the programme,' I repeated in an electronic Dalek voice.

To be honest, I railed against NA for the simple reason that I was afraid – afraid that it might work. Who would I be without my addiction? Where would I be without posturing self-loathing? If I kicked out my devils, would my angels leave too? Without my caricature to clothe me, how could I go about in disguise? I was frightened that I had become a self-parody – but without going to the trouble of acquiring a self first.

'I think I am going to have to leave NA,' I told Giles at work. 'Why?'

'I just hate the way they talk about their lives as if they mattered as much as mine.'

He smiled his usual, indulgent wry smile. 'Forget that shit. You've been off drugs for six months. It works. Why don't you put your recovery first for once?'

He had a point. I could always hang myself later.

'There is a saying. Don't leave before the miracle. I'm over five years straight. Believe me, it's worth it.'

'Miracle! Yeah right. If I could just see a miracle. Just one, tiny, little miracle. If I could see an angel or the great seas part or someone walking on water or one of those bores silent in a meeting.'

Not likely. That night, after work, Giles drove me to a West London meeting – he thought I should try a different area. Here everyone spoke incessantly about 'feelings.' They were all 'in bits' or 'riddled with defects' or 'dealing with issues.' Fuck. Here they go. To have feelings is a weakness; to give expression to them is disgusting. I needn't have worried – the only feelings they tended to be in touch with were their own. Look at them. Half of them were posh Shopping Hill girls whose standards of intoxication were miserably low – a lot of these girls weren't drug addicts at all, just silly neurotics who'd once accidentally inhaled a puff from one of the passing Rastas whose crack dens, incidentally, are the only redeeming feature of the Rotting Hell that they live in.

As for the rest – I suppose you had to admire the way they had worked their way up from nothing to a state of extreme poverty. But they looked so defeated, shuffling from meeting to meeting drinking herbal tea. Surely they could find a more pleasant way of being miserable together? It was hopeless. I could never get to that place where you 'surrender'. It was against my religion. As a dandy I have always elegantly acknowledged the fact that to live is to be defeated while steadfastly declining to surrender to that knowledge.

Over dinner, Giles sensed my disillusionment.

'Why don't you try Alcoholics Anonymous rather than leave the fellowship altogether. You may find it more real.'

I gave it a go. But to do so I asked him if I could leave work for a few months. I wanted time alone – and, besides, one should always be suspicious of anyone who promises that their commitment will last longer than a weekend.

In AA the people tended to be older, redder and more respectable. They looked down their broken-veined noses at us lot. We were law-breakers. Criminals. Some of them didn't like it if you mentioned drugs in their meetings. Alcohol, I guess, was some sort of legal medicinal tonic or something.

Fuck. This was even worse than NA. I guess you had to admire them. To say nothing even when speaking was quite an art. The stories were so interminable. My ears slammed shut. My eyes glazed over. My whole body began to embalm itself.

At the end of the meeting the woman sitting next to me in the dingy church hall basement spoke to me. It seemed she had noticed my squirming, sighing discomfort.

'It's all about honesty.'

'Really? Well that's no good to me. It is better to be quotable than to be honest.'

'Why don't you let go? Let God in.'

I really couldn't be bothered to slap her.

'God cannot corrupt a good man anymore than Satan can reform a bad one,' was the best I could do.

Anybody who has endured AA meetings will admit that even suicide has its brighter aspects. There were occasional meetings which made it worthwhile. Once in a posh Soho gathering the chap doing 'the chair' had been talking for some time. All the usual platitudes had been used. Years ago he had been doing his Step Four, 'a fearless and searching moral inventory,' and trying to 'hand it over' when he had got into an argument with his wife and stabbed and killed her. While in prison he had read the 'big book' which said that people had a 'fear of success' and he wondered if this was his problem too. He wanted to finish

on a 'positive note' for the 'newcomers.' 'Keep coming back,' he said. 'It works if you work it.'

After these resonant words the secretary threw the meeting open for others 'to share.' There was a fifteen minute silence. The Tamaras and the Sophies seemed to have lost their tongues.

But generally, I sat it out growing more and more restless and distracted. Maybe I was cured? It was true sometimes smoking crack didn't cross my mind for a full five minutes. Maybe I wasn't even a drunk? Maybe I was just thirsty? The fellowship did seem to transform and rebuild people. They came in as pigs and they went out as sausages. I wasn't having it. It was time to sabotage my recovery.

I had been approached by a television production company who were threatening to make a short documentary about my life. 'But I don't do anything,' I protested. This didn't seem to deter the director. 'We just want a day in your life.'

I listened for the last time to the 'Twelve Steps' followed by the 'Twelve Traditions' the last of which stated that 'Anonymity is the spiritual foundation of all our traditions; we need always maintain personal anonymity at the level of press, radio, and films, ever reminding us to place principles before personalities. Who you see here, what you hear here, when you leave here, let it stay here.'

I waited until the end of the meeting when the chairman asked if there was any other business. 'I'm Sebastian and I'm an alcoholic,' I began. 'Hello Sebastian,' the room echoed back. 'A film company is making a programme about a day in the life of me. I come to these meetings every day and was wondering if it would be acceptable to bring them along to film the proceedings?'

The entire room looked at me as if I had just dribbled sherry trifle in front of starving biaffrans. Blank indignation eventually gave way to smirking, sneering, and finally laughter. I fixed my eyes on a door frame and stared impassively ahead. I couldn't see what their problem was. After all, it is far more depressing to be Anonymous than to be an Alcoholic.

Well, that was that! What a way to go! I walked out of the meeting and I did not return. I was free. I wouldn't go back again – I would just send in my empties. That would show them.

But what would I do now? My job as a trainee marble mason was over. I was unemployed. I'd had a burst of humility, but thankfully it hadn't lasted long. I drifted back into my life of having nothing to do and all day to do it. There was nothing wrong with that. There was nothing so boring in life as the boredom of being excited all the time. I was moping about the flat one such day when the phone rang. I answered it – a sure sign I was not on drugs. It was my sister, Ash. She was weeping uncontrollably. 'Can you come over?' I knew from her tone that it was serious. I prepared myself for the worst.

She was standing on the doorstep when I arrived. Her face was blotched and swollen with tears. But she wasn't crying now. She just looked pale with shock. 'Come in,' she said. So I did. I followed her down the echoing wooden hall, past the cases of glittering fossils, past the iguana cage, and into the drawing room.

What was my first thought? I remember the bulk of the sofa, the TV set in one corner, the design of the rug. What's wrong? And then there it was. Slumped slantwise against a wall, the pattern of sharded sunlight that had slunk through a crack in the curtains playing jauntily at its feet, sat the corpse of Giles. In death it had folded over itself – like it had some secret that it wanted to hide I remember thinking later. But at the time I felt nothing except the numbness of silence, that silence that roars like a snowstorm inside your head. I was blank. I was getting no signals. I just stared at the body. It looked so solid, the flesh seemed so mockingly present in its immobility. But there was nothing beyond it, behind it, within it. I looked at the motes that dizzied about in a sunbeam. Where there is a lot of light, there is a lot of shade.

No ideas about death have anything in common with the

presence of death. This was not a grand tragedy full of soul-searing drama. It was the tiny details that crept into the spirit and curdled: the half-drunk beer can that stood beside him, the abandoned syringe, the soles of his socks with a hole in one heel. But we all have a dark room inside ourselves, a place in which to lock up all our vulnerabilities, fears and doubts. He had died in this room, in this room.

Ash was weeping on the sofa now. And I sat down beside her. What had happened? I hadn't seen Giles for a few months. And now look at him. He had been my friend. Now he was nothing but refuse. Death had opened its childish eyes and looked at me straight.

I felt pain. I felt shame. Shame because shame is the feeling you have when you agree with those who love you that you are the man they think you are. I was angry that someone seemed to have taken away the drugs which could have been mine. All Giles's friends had robbed him in life, he had told me. But now here I was wanting to rob him in death. I walked over to the window and looked out. I felt a flare of excitement – excitement that it was he who had died and not me. Death's shadow quickens the radiance of life.

'He just turned in on himself like a scorpion,' Ash said between sobs. 'I couldn't reach him.'

Who could have? Words, words, words – at best iridescent flares that flash up in the darkness and die. They could not save Giles from himself. I had come to the end of words. The deeper the sorrow the less tongue it has.

I walked over to Giles and kissed him on the head. 'Goodbye.' The word sat mute as a stone in my head.

I never really spoke about him again. 'What a cunt,' I would quip when people asked me about it. 'You lend some people a fiver and you never see them again.'

Within a month I was back on heroin.

I remember the first fix well. I was like a chef with a well-tried recipe. I mixed the heroin, lemon juice and water in a

blackened spoon and simmered it over a light heat stirring gently. As soon as the golden liquid started to boil I took the spoon out of the flame and allowed the cocktail to cool. Then I added cocaine to taste, as much as I felt would take me to the frozen suburbs of heart attack. I wanted to find that crystal moment of sheer terror where all is clear and all is forgiven.

The molten sunshine streamed through the needle and into the barrel of the syringe. I wound a belt tightly round my arm and, gripping it in my teeth, bared my gums like a rabid dog. 'Come out, come out wherever you are.' I dug around for a principal vein. Then I pulled the plunger smoothly back. A thin stream of blood plumed into the barrel of the syringe; a feathery crimson wisp. And I broke like a dam, hysterical with gratitude.

'This will be all right,' was the last thing I remember thinking as the needle emptied. But I knew it wasn't all right. I felt a soft blow to my heart. The room began to blacken around the edges. And then the darkness spread, until my eyes were clouded with a velvety shadow. I could feel them rolling back in my head.

I woke up five hours later with the needle still hanging from my arm. I stand firm in my refusal to remain conscious during a crisis. But killing yourself on drugs is too chancy. I had miscalculated the dosage and I was just having a good time.

I had disappointed the vultures yet again. Even a cheap death is hard to come by. I staggered on like an escapologist struggling with his ropes. I tried to give up . . . then I gave up giving up . . . then I gave up giving up giving up.

I was completely stuck. I had created two distinct worlds and I was not happy in either of them. Sober was the place where no harm could come and therefore the place where nothing at all could come. Stoned was the place, in theory, that all harm could come and yet I couldn't even seem to kill myself with any authority. I felt a complete failure. Winter had set in with its usual severity and I was left with the same old dilemma: if I

couldn't go to heaven I would go back to drugs but, then, to me they were the same place.

What if I went abroad? Somewhere where there were no drugs? NA calls it 'doing a geographical'. This clever little device involves going somewhere without taking yourself. I had done it a few times. (You go to the middle of nowhere. Then a few days later phone your dealer. Class A drugs. Hardback book. Courier bike. Work it out.)

I got to thinking about Barbados. It wasn't the vision of living a life of voluptuous calm under azure skies on wave-lapped beaches tended by naked slaves perfumed with musk. And it wasn't like I wanted a holiday. The only thing I needed a holiday from was myself. No, I'd heard there was no heroin on the island. That should do it. Brilliant! What a plan!

There was only one downside. Father lived there.

He had taken early retirement. He had made a disastrous business move. He had launched a left-wing tabloid, *News on Sunday*, which had been even more of a catastrophe than I even dared to hope. Six million pounds of union money down the drain. He had even raided the company pension fund without asking the old biddies. Funny how left-wing tycoons love humanity but don't care for humans. When the paper went down he had tried to get family members to buy the shares, to take the hit and spare the embarrassment. All agreed. Except me.

A book had been published about the fiasco. Titled *Disaster: The Fall of the News on Sunday*, it had described one of the people working for Father as 'the brilliant but wayward son Horsley always wanted, but never had.'

Clearly I had some work to do with Father. I knew him so well that I hadn't spoken to him for ten years – though of course I made sure my press cuttings had got to him by giving them to his friends. I knew it was sad. But surely my paltry celebrity might impress. Fame was the only thing that interested Father.

Arriving early in the evening, I sashayed on to the tarmac. The first thing I saw of Father was a surgical stocking sticking out of the car. His physical deterioration was marked. His face was even more closed in on itself than it had been. His hair was grey and thinning. Not that he seemed to care. He spent his days hunched in his wheelchair with a tanker of rum nearby.

On that first evening we got on. But by the next morning we were back to the old pattern. Clearly rum is thicker than blood.

Father had an uncanny knack of letting me know that he was deeply disinterested in me. He never asked me what I was doing, how I was getting on, where I was going, what my favourite colour was. He wasn't interested in anything at all. He had a handful of pretend friends. But he never did anything much. He was alive . . . but only in the sense that he could not be legally buried.

I would watch him sitting by the pool all day. Occasionally he would drag himself out for a swim, his withered legs trailing uselessly behind him. Then he would haul himself out and start drinking again.

In the afternoons he would watch television and cry if he saw so much as a kitten with its leg in a splint. 'I hate cruelty. I hate violence,' he would say. 'Except to your own children,' I muttered in my head. Father was a sentimental man – mawkish on the outside, brutal on the inside. He was weak in everything except business where he was completely ruthless. And it is the weak who are cruel; kindness is to be expected only from the strong. I looked at him wincing at the television screen.

Retirement is half as much life, twice as much wife. Poor Father. He had always had bad luck with all his women. The first two left him and the third one didn't. When I heard that Stepmother 2 had moved to Barbados, my first thought was 'Oh really? I didn't think they had caravans in Barbados.' Actually,

I didn't dislike her in the least: I prized, cherished and pitied her. To think of the poor wretch having to waddle through life with all those absurd fatty appendages attached. And to have to cope with this handicap with only a fuzzy half-brain – why, it wrings the very heart.

She babbled about. According to Father she'd had some sort of stroke. Yeah right. That's a good alibi, I thought. In the evenings she amused herself by pouring salt on frogs so that their insides came out their mouths and they eventually exploded. 'They are pests you know,' she said by way of explanation. How she could do this was beyond me. She had just enough intelligence to qualify for pond life herself.

I didn't really care for Barbados either. The sun shone, having no alternative. The heat was crippling. The lush vegetation lounged about in a haphazard, sloppy fashion, offensive to the tidy mind. And in countries where nature does the most, man does the least. The whole place had gone poolside. Gin and tonics. Eternal leisure. Barbadians have invented the concept of happiness. This alone warrants their doom. I would rather wash dishes in England than live in this tropical paradise. Besides, I've never seen the point of the sea. Except where it meets the land. Yes, I was miserable here. But what did I expect? I had brought myself along.

I was sleeping in the spare room. To my left was a bedside table. Looking for a book to read I opened the drawer. There was a solitary white document. It was Father's will – that most loved of all literary works. Funnily enough I got to reading it. Suddenly I didn't care about fame anymore. How would I really like to be remembered? In somebody's will, that's how.

Bloody hell, I was wrong about Stepmother 2. There is nobody so irritating as somebody with less intelligence and more sense than we have. I knew $he liked money – now she was going to end up with all of it. She and her two children from her first marriage. Sister Ash got a cut. But Brother and I got nothing. Not a photograph album. Not a set of cufflinks.

Not even a mention. Not even a mention to say that we hadn't been mentioned. Nothing.

I felt rage: that fury that I remembered from when I had been a child, and thought I had almost forgotten, welled up in me. Fucking dog. Look at him. A drunk and a cripple. I had nothing to be grateful to him for, except the fact that he broadened my emotional range: I had never thought it was possible to want to murder a drunk cripple. I should have filled a bag with sperm and sent it to him. It was the only thing I owed the fucker. Well maybe now I was here I could save on the postage.

I looked out the window. Thank God the sun had gone in and I didn't have to go out and enjoy it. I walked down to the beach anyway.

An hour later I was standing on the beach (fully clothed if you please) when a black man strolled by with a basket of fruit on his head.

'You wanna mangos man?'

'No thank you.'

'Pineapples?'

'Most certainly not.' (I always stay away from natural foods. At my age I need all the preservatives I can get.)

'What ju wan, man? What ju looking for? You wanna some crack?'

No matter where a man travels there is never any escape from his own wretched identity. You can make the journey only to find the very thing which you have fled. It was true. There was no heroin on the island. But nobody had thought to tell me about the crack.

After six days, six nights and no sleep I returned home. I had seen Father for so little a time. Just beheld and lost. I never saw him again.

In London I managed to get a few months' straight again. I started planning a new exhibition. The days stretched out again.

As usual I had very mixed feelings about being sober. I wasn't sure whether I was happy or sad. It was like watching Father burn to death wearing one of my Huntsman suits.

I wanted a girl. I'd been single for a long time and I was getting sick of finishing my own sentences. What could I do? In choosing a woman you have to decide between something tame and uninteresting, like a goldfish, or something wild and fascinating like a sheep. But how could I choose a girlfriend when I couldn't even decide what to wear?

For months and months I had flicked through my days and weeks and seasons like the pages of a calendar – one of those calendars that get pinned up on motor mechanics' workshop walls. And my attention, of course, had been faintly and fleetingly stirred by the pneumatic contours (marginally more interesting than the spare tyres). But then one day the calendar girl was shot by Pirelli. And I was offered a date with Miss March. I had gone for dinner with Willie Donaldson and there she was . . .

Most men, when they cannot catch a bird of paradise, settle for a chicken. I have never been a chicken kind of guy. My God, look at her. Nature never blunders: when she makes someone beautiful, she means it. Here was a girl who could not have been invented if the whole world had sat up all night. Squaw, doormat, trophy, Barbie. She had the shy, modest, virginal, sexless look of the professional nymphomaniac. When I looked at her I almost fainted with pleasure. Her figure resembled a giant economy size tube of toothpaste squeezed in the middle to acquire a shape that defied definition. Her long smooth neck, and the elegant S of her body, exaggerated by the extraordinary curve of her spine that made her breasts swell further forward and her bottom further back. She looked as though she were offering to kiss the whole world across an invisible shop counter. God would have made everyone like her if He had the money.

'This is Rachel,' said Willie.

My God this was going to be useful. I couldn't get her name wrong in the middle of the night. I could get all the love letters I had sent to Rachel 1 and send them to Rachel 2.

'Has anyone ever told you that you look just like Ingrid Pitt?'

'Yes,' she purred.

'Well, I am a man who hates women almost as much as women hate each other. My perfect woman is one who turns into a rock of crack at 4 a.m. But I like you. The first thing I say to a new woman is that everything she has read and heard about me is true.'

'What, that you're a complete twat?'

I felt myself becoming erect.

Rachel told us that she had just seen Bob Geldof announcing at 'some concert or other' that by the time it had finished 9000 Africans would have starved to death. 'Well,' she said, fluttering her big black lashes 'I just thought to myself, good – that's 9000 less traffic wardens.'

Rachel had become, by accident, one of the most famous Page 3 girls in the business. She had adorned magazine covers and sashayed through movies. And she had the added distinction of a fan club, with a website, devoted entirely to her bottom. And no wonder. It *was* quite a bottom.

'If you were to get drunk at the office Christmas party and photocopy your posterior I think you'd have to press reduce seventy-five per cent,' I said.

A glare.

I changed tack. 'What films were you in? *Midsummer Night's Dream*? Did you play Bottom?'

Silence. A flicker. A pout.

'I fell into Page 3 by accident. It wasn't something I wanted to do.'

'What I like about you is that you seem to have no ambition,' I said.

'I can't have, dining with you.'

A look. And what a look.

It was coming to the end of the century. Should I defer a general reform in my behaviour until the next millennium? No, I was fed up with all that. But if only I could get this woman, I would definitely give up drugs for ever – or at least have someone really sexy to take them with.

11

Acting like a pig, feeling like a God

Dandyism is a form of self-worship which dispenses with the need to find happiness from others – especially women. As far as I am concerned, ladies are on this planet only as trumpets of my glory. However, I liked Rachel so much that sometimes it was an effort to remember that she was a woman at all.

Maybe she wasn't? Maybe she was more sea squirt than human?

The juvenile sea squirt wanders the ocean searching for a rock to make its new home. When at last it discovers it, it immediately takes root and then sets about busily digesting its brain. It no longer needs it. It's in domestic bliss.

Of course, it is seriously marvellous to be untainted by education. It means that you move among real things, and not amid the second-hand. I have always preferred simple people to sophisticated people. Rachel had only two faults, both unpardonable in a woman – she could read and write.

It was Christmas and she gave me a card. In her big loopy hand she wrote: 'What do you get for the man who has nothing and should have even less? Hard cash for hard cock.' Inside, in ten crisp notes, was £500.

Half an hour later she was on the telephone.

'Happy Christmas sweetheart. I want you to give me a little present. I want you to go to Amsterdam and fuck a different whore for me each day.'

'I . . . er . . .'

'Don't say yes until I finish talking.'

She had a point. Yes *is* the best answer to an indecent proposal. All my life I had yearned for a woman who would caress the hand that struck her, kiss the lips that lied to her and suck the cock that crowed over her. Now I had finally stumbled across her, I was scared limp.

My God. What game was she playing? The lady who knocks on the door of the dandy's dressing room is either a philosopher or a complete imbecile. Which was she?

'Every time you fuck one, phone me,' she purred.

How could I say yes? Yes, I said and set off on my journey. I was stricken by a terrible anxiety that something stupendous was going to happen.

I checked into The Grand and got dressed, punctiliously. I put the tie around my neck instead of my arm. My eyes were a triumph of mascara, my cheeks rouged. I was ready.

I counted the money out on my bed. 'You are only allowed to use it for fucking,' Rachel had sternly instructed me. So that was about ten encounters catered for. It had come at a good time. I had only been clean a few months and I was prey to the most ferocious lust. My reputation was terrible – which comforted me a lot. It was about to get worse.

I spent a happy day window-shopping. But only when I reached the last canal in the red-light district did I spot her, shimmering like a tropical fish behind aquarium glass. What was it that made her special? The wit? The wisdom? The womanly wiles? No, it was the tits.

My tastes are to the tacky and tasteless. I like the literature of the illiterate, the culture of the low-brow, the wealth of the poor, the privilege of the under-privileged, the exclusive clubs of the excluded masses. I waltz through life with one foot in the grave, the other in Woolworth's. But at least I'm eclectic. I like to draw on several different varieties of rubbish. And boy, was this girl trash – and fake trash at that.

She wore fishnet stockings through which whole haddocks could have escaped. A leather skirt which would barely have done service as a belt. Soaring boots – and, sweet heaven, there is nothing like the spiked heel in all of nature. It pierced me to the soul. I was lost. But there was her bosom – my saviour, my lifebuoy in the storm. And who cared if it was plastic? Beyond good taste lies the confidence to make mistakes – the mistakes that one can truly claim as one's own.

I opened the door and stepped inside.

'Goedenavond. Hoe kan ik u helpen?' she said.

'I don't speak Dutch,' I boasted.

No, I don't. I regard foreign languages as a kind of speech impediment which can be overcome by willpower. Only stupid people can learn a language quick and easy because there is nothing going on in there to keep it out.

I had a hard-on which was beginning to feel like a part of the home furnishings. It was time to ride her senseless into the softest mattress. I threw her on her back. But the more I made my intentions plain, the more determinedly she guided me on to her silicon valley. It was fine for a bit. But Rachel had paid me to fuck. Maybe from behind would be better. I turned her around. She cupped a handful of oil to herself. Then another. Then another. What on earth was wrong? And why wouldn't she let me remove her skirt? The leather was creaking a little. It was slightly off-putting. Oh well. It takes all sorts. I rammed the bone home. It was a nice tight fit.

A nauseating smell wafted subtly nose-ward. It smelt like, well, shit frankly. I began to feel a touch queasy. I sniffed again. I mean there's a time and a place for everything. A piece of shit in the right place is fertiliser, but in your pants it's a kind of embarrassment. I looked at her again: at the big meaty hands as they clenched on the pillow.

Pennies dropped, bells rang, lights flashed. The realisation dawned on me like a clatter of falling coins.

'*She* was a *he*,' I told Rachel later over the phone.

She couldn't speak for laughter.

'I have such poor eyesight I could actually date pretty much anyone,' I tried to explain.

She didn't even bother to stifle her laughter.

'Well, let's just say it was one of those Hamlet moments,' I went on.

'You're not a pervert. You're a loser!' Rachel yelped.

She had a point. The main point of women is the fact that they are guaranteed to have about them at any time a pair of tits for sucking and a cunt for fucking. But I hadn't even managed to find these dinky little trinkets.

In retrospect I respected that woman. Real freedom is the freedom that everyone has to discover and re-create himself. If it is hard enough for a man to imitate a woman, imagine how much harder it is to imitate a woman who never existed, a woman who was only ever a fantasy in the first place. He had chased shadows and held on to their dreams. And besides she was pretty good-looking for a man.

Who was I to have wrenched his dreams from him? I had known instinctively how I wanted to behave. I had seen a shadow cross his face, watched that secret flinching of the iris as he had pulled his clothes over him, a protective camouflage. It was unmannerly enough of me to have lost my erection. I thanked him, kissed him and tipped him before I went away. 'You're a gentleman,' he had said.

'Well, that was a good start,' was all Rachel said. 'Just when you think you have scraped the bottom of the barrel of indecency you lower the bottom, so to speak.'

Every day there was a new whore. White ones, black ones, tall ones, small ones, fat ones, skinny ones. Some of the girls had faces that doubled up as chastity belts. Obviously, I don't really care for ugliness. It shows such bad judgement. But whatever it took for another story. And another phone call.

Rachel wanted *all* the details. As I delivered my accounts, blow by blowjob I could feel her becoming aroused. The telephone

was the perfect means of communication. I am far too artificial, or vulnerable, to withstand actual closeness. Fantasy love for me is so real.

Rachel was intriguing me. I had no idea who she was. The reason I rated hookers was because they obviously rated themselves. They obviously rated themselves because they charged for their services. Normal girls gave themselves to you for nothing and then wondered why you pissed all over them. What was I going to do with her? Was I attracted to her mind? Or was I attracted to what she didn't mind? Was there anything she minded?

But after a week I was growing jaded. The palate is picky. I remember reading about that famous plane crash in the Andes in the book *Alive*. The survivors at first had to fight to overcome their natural scruples and start eating the bodies of their dead friends. But after a bit they got sick of their staple diet of breast and fat and became more venturesome. They started foraging for testicles, entrails and tongues.

'I want to buy you something *really* deviant,' declared Rachel one morning.

I already had an idea. I'd seen a fluorescent postcard glowing away to itself in the gloom of a phone box the day before. 'Mature woman' it had said. Well, by the time a woman admits she's mature, it obviously means that, like some delectable lump of French brie, she's run amok on the cheese board amid a riot of smells.

I'm not renowned for my tolerance of old people. I have even contemplated starting a charity for them. 'Hinder the Aged' it would be called. And why not? I mean, look at them, babbling away to themselves, wasting taxpayers' money on heating, rotting on valuable pavement space, holding me up at the shop till chatting to the cashiers . . . I mean do they think they are people or something? Oh, do go away and die of hypothermia.

At the door I paused and took a deep breath. I needed that extra bit of oxygen or I would have fainted. Sure, there can be no exquisite beauty without some strangeness in the propor-

tion. But wasn't this pushing things a little too far, even for me? She was around seventy and had been spread like butter all over the bed sheets. I mean I like lots of butter, and especially with cheese. But without weighing her I'd go for thirteen stone.

Actually, I suppose she looked all right if you like septuagenarian stretch marks, if your idea of beauty is to have a face like a toilet – as Picasso would have painted it. Her eyelids hung like an impending avalanche over her cheekbones, her mouth was a crevasse waiting for the fall. And her skin was so caked with cosmetics that the floor of the Amazon jungle probably saw more natural light. She was wearing stockings, I noticed. They were horribly wrinkled. And then I noticed that she wasn't wearing stockings at all.

I undressed and moved on to the bed beside her. We came together in our grotesque embrace.

When I stroked her flesh it didn't spring tautly but crawled back like the skin on a bowl of cold custard. Her neck was wattled like a turkey's cock. Her cunt looked like a bowl of offal and I imagined that it was a-buzzing with flies. The flies were fat and happy.

I shot my load into the old toad and love – physical love in those organs designated for it – vanished and shrivelled with an almost audible rustle. I was disgusted with myself. I looked down at her carcass. It wasn't her that I hated. It was me. This was my fate. The old are preserved in the young, waiting, like hatchlings to come out and peck. I smiled and she laughed. And her laugh was so lovely and free.

'But you know Rach,' I found myself saying into the telephone that evening, 'I envied her. I yearned to be old like her; to be free of the terrible waiting. I want to just wither away and stop hurting.'

Silence.

'Well, at least I will overact appallingly. I mean what is the point of attaining some idiotically advanced age if one can't be outlandish?'

289

More silence.

'Er, try praising me, even if it does frighten you at first.'

'I want to fuck you.'

'Oh goody. Occasionally, I like normal sex. Like after a ciga-rette.'

'You have two days and one hundred pounds left. I want one more story. Something special.'

When I had first met Rachel, my Page 3 girl, I had assumed she was no more than a life support machine for an enormous pair of mammaries. Now I realised she was the sweetest thing that God had ever made – and forgotten to put a soul into.

This time the brothel was a dungeon surrounded by churches. Hell is the red-light district of Heaven. I had been given a pass-word to get me through the pearly gates.

I was greeted by a dwarf. Half a motherfucker. Was that all they could afford? He was attached to a three-quarter mother-fucker with a wooden leg. *HA*! I thought. All these tosspots with wooden legs – it's pathetic, they're not fooling anyone.

I didn't want wooden legs. I wanted hardcore. I was taken into a dark chamber. My mascara fluttered and scraped against the black. Slowly my eyes adjusted. The dregs of human bodies dragged themselves around me. This was the shambles of human life. The wrecks of carcasses salvaged from the genetic battlefield.

A bald pate gleamed in the light of a flickering candle. Under its umbrella was a woman who was covered with fur. A woman laughed. She had a skull like a donkey. Another cried out in anger. Someone had just tangled his whiplash in her leather studded chaps. And in the far corner, lying on a bed in an alcove, lay a beautiful amputee. She had no arms. And no legs.

She was my choice. We came together in our coupling, flailing my four limbs and her four stumps like some giant insect.

What on Satan's earth was I doing? I looked down at her. *There's so much to say, but your eyes keep interrupting me.* Was it the soul which cried out from those insatiable eyes? They were

open but they were closed. What was she saying inside what was left of herself? Was she asking when she was going to be let out? This was a woman who needed someone to feed her, to pick her up, to clean her. I had fucked her.

'I've gone too far Rach.'

I had. You need deep resources of character, resilience of mind and spiritual stamina to make of decadence a virtue. But this was vicious. I had thought that the soul should be made monstrous. That to let this happen one must assume the mask of the beast. But was it a mask? Or had I become a beast? The idea was horribly exhilarating.

I had grown up with cripples. I went through a period in my twenties when I was terrified that I would get the same disease as Father. I wanted to attack life for what it had dared to do to him – and to us all. I wanted to revolt against its horrible gift. Life was just a disco for cripples and spastics. It was just a dance of deformed and decaying animals on their way to dust and oblivion.

And what about that woman? Had I abused her? Or was that to see her as a victim? She wasn't a victim. She was a warrior. She was an empress of style. Rather than run away from what she was, she had set it like a jewel. She swam with the tide but outraced it. It took courage. Deformity *is* daring, as Byron said.

'Do you think God will strike me dead on the spot?' I asked Rachel, half laughing but also desperate for reassurance.

'We'll just give him a moment, shall we?'

Life does not cease to be funny when people die or are crippled anymore than it ceases to be serious when people laugh. If you can't laugh at spastics who can you laugh at? Myself?

In reality, the whole experience had softened my heart. In some funny way the brothel is the home of spirituality. It is almost like you go to there to pray. You have to take your clothes off to walk into the holy of holies. Then, on your knees you find that virtue and sin exist in everything. You have presented yourself with your soul laid bare. Stripped of your

finery, your humanity is revealed. This is the holy prostitution of the soul.

I flew home to Rachel. She cooked a cheese soufflé for my return – and it rose. She laid the table and after dinner we snuggled up together. I was no longer afraid of her. She was like a marshmallow by the fire. And she noticed the change in me. If treated circumspectly I am domestically pliable.

There are no exceptions to the rule that everybody likes to be an exception to the rule. But I had found a girl for whom there are no rules for the exception. I worshipped the air she walked on – and if you *really* worship a woman she'll forgive you everything. In turn she knew that when a woman *really* loves a man, he can make her do anything she wants to. A Page 3 girl understood what no feminist ever could: an obedient girl commands her man.

Rachel felt what other women only knew. To succeed in the world we must look like a bimbo but be wise. A woman must have just enough intelligence to adore me but not so much that she can see through me. Rachel went one step further; she could see through me and still enjoy the view.

Love is the lavatory of the emotions. But I had finally given myself completely to someone who needed me. When I did, she had opened up like a rose in the light. For the first time in my life I was happy with a woman. Lovers generally want to share the loved one's thoughts and to keep them in bondage. They say 'no strings' and then fashion a noose. Never again. I was free for ever from the damp, dark prison of eternal love.

It was Rachel's birthday and I wanted to show my appreciation. What should I buy her?

The doorbell rang. I told Rachel her birthday present was on the bed. And there sat Claudia, my favourite hooker, demure beneath her rich shelving bosom. Oh pleasure, the fatal egg by pleasure laid! We were three stranded smiles in the desert. And a smile is half a kiss . . .

And after years of trying, now, with Rachel here, Claudia finally let me kiss her.

True happiness is to live in the continuous present. I was happy at last. If only it could have lasted.

I was greedy. I wanted more. I wanted Rachel and drugs.

Being clean is all very well, but it's pointless if you don't abuse the power it brings. I knew that somehow I had to discover beauty in ordinary things. But how? I had renounced everything in life – except Satan. And what can one do when one has bitten the apple?

The trouble was if you simply put heroin down you are avoiding the issue. It wasn't the horse. It was the pale rider. It wasn't the heroin, for all the melodramatic talk about withdrawal symptoms. It wasn't the horse. It was the Horsley. And it was only a matter of time . . .

'Darling, I am lying here fantasising about playing doctors and nurses. I want to laze on your bed with my bosoms in a white bra bursting through the dress. I want you to shoot me up. Please darling. Pleeease.'

The speedball is a cocktail of heroin and cocaine. The coke blasts you into an orgasm of inner space while the heroin ensures a soft and warm landing as you fall to earth.

Rachel stretched out on the bed and proffered her arm. I administered the dose. Her legs parted and she ran her hand with vermilion nails over her knickers. I was overwhelmed with tenderness and love as she squeezed my hand and pulled my face down to her breasts. Her eyes closed and her face glowed.

'This is . . . too much . . . pleasure . . . my darling . . . too much pleasure.'

A trickle of dark blood flowed from her pale arm. I lent over her like Dracula and licked it off with the tip of my tongue.

Within weeks Rachel discovered that she had a talent as the doctor as well as the patient.

'Darling, you're so good at this, you always hit the vein.'

In the opening months these were the good times. For what love is more open? We slid the needles into each other's flesh,

using pain to open up pleasure, forcing pleasure back into the openings of pain.

But the allure couldn't last. In the end, taking heroin and crack is about as glamorous as swigging meths. Within months Rachel was like a pig at a trough. The pipe was never out of her hand or mouth. She would take a hit and then immediately start preparing another one.

'Lie down and enjoy it. You are wasting it,' I ticked her off every few minutes.

I was overcome with loathing and contempt. She was completely out of control. There was something unsettlingly familiar about her obsessive greed – which made it even more insufferable. On coke she would stand in the middle of the bedroom blowing her nose until it bled. 'There's just a little bit of stuff stuck. It's almost out,' she repeated for twelve hours.

The heroin made her mushy and lovely and we would take a hit, wrap ourselves around each other and discuss our plans for marriage. But as the heroin supply dwindled I would start stashing it away for myself. Once she took a little too much and collapsed unconscious on my kitchen floor. God, how melodramatic, I thought as I stepped over her. More drugs for me though. I took a shot on the toilet. Fuck, I hope she's not dead. I don't want the police round here. I kicked her as I went back to the bed. A groan. Good, I'll get some crack down before the pig awakes.

Then it was my turn again.

Rachel had brought a friend of hers to the flat who was also a well-known topless model. Sober I would have been dreaming of sleeping with two Page 3 girls or three Page 2 girls but we had more important business. My syringe binge had been going on for some time before they arrived and my body was already full of heroin, alcohol and crack cocaine – an unusual combination, usually only found in dead people.

It was around 5 p.m. Rush Hour. I prepared a large speed-

ball and I sat on the throne to administer it. A shot in the arm. A shot in the dark. A shot in the head.

I knew immediately that I had taken too much. I stood up thinking that if I moved around the room enough to increase my circulation I wouldn't overdose. In fact the reverse is true. A sensation of gradual bodily dissolution spread over me. I moved to the window to try to find something stable. I felt my legs go from under me and I collapsed.

The girls looked down at me and saw I was blue on the brown. They considered writing for an ambulance but instead wrapped my head in cold towels and gave me the kiss of life. Heroin is non-toxic – you suffocate from an overdose by forgetting to breathe.

They finally managed to get me on to my feet and walk me round and round the studio. There was embarrassment between us. When some moment of shared danger is past people regret their indiscriminate expansiveness – emotions that have been displayed must now be lived down. It didn't last too long. After I finally came round I remember the night well because I think a bomb went off at the Admiral Duncan, but we were all kinda busy in the bedroom and we didn't notice what was going on outside.

Everything that goes up must come down. But there comes a time when not everything that's down can come up. Oh God, it was cold turkey time again. The siege of the room. I lay in bed for a week. But this time it was even worse. Rachel was lying next to me. In the past she had come down to see me when I was sick. She had brought fruit and chocolate. Meals on heels. But now look at her. Twisting and turning and moaning and sweating. It was unbearable. I watched *Bend it like Beckham* and sobbed like a child.

As usual, after a month or so I was back up to strength. Or so I thought. Sure I had taken drugs like a demon. Big deal. Now I would go straight like a demon. I had to admit there was a kind of consistency about it. I would put 'No' where 'Yes'

used to be and sneak up on extremism from the other side. That should do it. If you think my drug problem was bad, just wait until I've solved it!

And did I have a plan.

12

Life is so pointless we might as well be extraordinary

In August 2000, three of us met at Heathrow airport. We were a mismatched crew. There was Dennis Morris. He was an East Ender of West Indian origin and a well-known punk photographer. I have to say, my interest in photography is largely confined to portraits of myself but I suppose he had taken all those iconic Sex Pistols images.

There was Sarah Lucas. She was soaring high on her fame as a Brit artist, not that I was really aware of her work. Worse still, I'm not sure she was aware of mine. Artists are not really interested in anything apart from themselves.

And there was me. And I was on the brink of an exciting new discovery. I was off to be crucified.

The flight was to the Philippines, granted, not the sort of place that I would even fly over normally, but you must admit that a crucifixion is a fairly novel attraction in our day and age.

It is an annual ritual in the Philippines. Every year, on Good Friday, in a small dusty village a few hours from Manila, local people take part in what has become a quite well-known event — probably thanks to assiduous promotion by the local tourist authority. If you can't recommend the food you have to try something else.

The more understated, it seems, are content with mere flagellation. Hooded and stripped to the waist, they walk the perimeters of their village lashing themselves with whips of

slatted bamboo in which tiny glass fragments have been set. They strip the skin from their backs. They atone for their sins, while in wayside shacks devout women chant their Lenten penances and onlookers gather in ever growing hordes, buying popsicles from the little boys who peddle them from bicycles competing with the local hamburger outlet which advertises discounted 'Lenten Bites'.

The whole event is a seething, chaotic, blood-spattered circus in which the profoundest devotion and the most avid entrepreneurship meet. They make a grisly mix. It has all the aura of some Victorian vaudeville. And you would probably treat it as such if it were not for the 'martyrs', the small band of penitents who choose to be crucified – lashed to a cross with nails driven through their hands and feet.

They are mostly young Filipino men who annually offer themselves up to the most appalling suffering for their faith, though one tiny little white-robed nun has been among them for several years. They believe that through pain they may reach more closely towards the divine, that their prayers for sick relatives, for the abeyance of floods, for the flourishing of crops, will be heard by a loving God. For them it is a profoundly important occasion, inextricably tangled with a fundamental Roman Catholic faith. But for the crowds of international media who now annually fight for prime position, staring at the event through the lenses of huge TV cameras, it has become a freak show – a reliable story for a slow Bank Holiday news day.

Once, a foreigner underwent crucifixion, I was told by the head of the village. He had been Japanese. And he had cried out in pain. He had howled from the cross. 'He is a man of little faith,' the local people had whispered. And they had been right. Apparently he had sold film footage of his ordeal for an S&M porn video. It had upset local sensibilities terribly. They had said that an outsider should never be allowed to be crucified again.

But I had been out there to convince them that they should

let me take part. They took a lot of convincing. I had to prove that I was an artist, that art is less a pastime and more a sort of priesthood; that, though we talk of religious art, art is in itself religion, a devotional act offered to some transcendent aim. They eventually agreed to allow me to stage my own private ceremony. I was to be the first Westerner to take part in the event, known as 'Karabrio.'

As a dandy I was excited about the project. Christ, after all, had profound style. He was the ultimate dandy. He created a stir through force of personality and example alone. One does not become a guru by accident. If Gandhi proved that you can rule the world by being polite then Christ proved, once and for all, the power of personal magnetism and what it can accomplish. What's more, on the cross he created an image to be gazed at and adored. He is worshipped on church walls. And style is a way of buying people rather than things. Its values are spiritual values. All great stylists borrow a lot from the wardrobe of Christ − everything in fact except those dreadful clothes.

But of course I was afraid. The thing about pain is that you don't normally have a chance to prepare for it. But I had two months of knowing and waiting and worrying. I had nightmares. I was scared something would go wrong. I was an artist. I didn't want to ruin my hands.

I read all about the crucifixion. A medical study was particularly helpful. 'Hours of limitless pain,' it explained. 'Cycles of twisting, joint-rending cramps, intermittent partial asphyxiation and a searing pain as tissue is torn from the victim's back as he moves up and down against the rough timber.' This peculiarly cruel little pastime, it explained, had been invented primarily as a torture rather than a means of dispatch. It was a favourite form of execution because it offered a prolonged display of dying. Most people expired only once their legs had been broken − then, when their rib cages could no longer rise and fall, they suffocated. But they could be up there for three days before that, often dying of heatstroke or thirst before the planned end. The

Romans had taken it to sophisticated extremes. There is a nerve that runs through the centre of the palm, apparently. This is what they aimed for. It would make the hand curl into a claw. I was fearful of pain. But I was also fearful of being a fool. I believe that the artist has at least to be prepared to make a fool of himself. He is somewhere between a performing seal and a suicide. But I was worried that this act of wanton self-vandalism was taking it too far.

Did I feel courageous? No, in one way for me it wasn't a courageous act. I had got to the point where I felt for some reason that I had to do it. For me, the true test of an art form – and of a human being – is whether it will stand laughter, whether it can test itself to the brink of destruction. I wanted to break the limits of life, run up against the boundaries of my own reality. I wanted to get past the armour-plated fantasies. I wanted to strip myself bare and, maybe, by doing so find out what I was. It was in my character to do this. And that's why it wasn't an act of courage. Courage is the bravery to act beyond character. So no, I *wasn't* a hero. But I'm not quite sure what I *was*. I was scared for sure. Maybe courage is doing what you are afraid to do, and you can't prove your courage without first feeling scared. I don't know. All I knew is that a real man must not think of victory or defeat. He plunges recklessly onwards towards an irrational fate.

And so there I was at Heathrow, embarking for the Philippines with Dennis and Sarah. The most important thing when you are going to do something this drastic is to have someone to witness it. There is nothing more annoying than to be hanged in the private yard of the jail. So Dennis was going to take photographs and Sarah was going to film.

I had actually been approached by a TV production company. But I turned it down – which might seem odd, given that my vanity is cosmic. But I wanted an intimate portrait. Besides, what if it went wrong? It wouldn't be so clever then. And my doctor had warned me severely that there was every chance of

a mistake. I did think of slipping a donor card in my pocket which said 'In case of a heart attack, call a press conference' but decided against it.

We were a curious band of co-workers. Dennis and Sarah are complete opposites. Sarah was lively, Dennis was surly. His enduring commitment to resentment became almost touching. He was always insisting that service was slow, or people were inattentive because he was black. But why discriminate for skin colour, when there are so many other reasons to dislike someone? Dennis sulked through life always demanding to see the manager. His firmest conviction was that he was being 'done'. The 'powers that be' were always conspiring against him. After a bit you rather hoped that they might finally stamp on him – like when Sarah stamped accidentally on his white gym shoes. 'You never fucking step on a black man's shoes,' he stormed. He was threatening to hit her. Fortunately Sarah had the joyous free spirit just to stamp on them again.

I couldn't have chosen two more contrary companions. Sarah was like some magical child who had been glitter-dusted with sparkling charisma. She danced like a marionette with angels pulling her strings. Dennis sat like a ventriloquist's dummy on the knee of a very belligerant cabbie.

We had five days together before the day of the crucifixion and so we set off for a hotel by the beach. But when we arrived we took one look at it – nature *is* only a good place to worship the city, we decided – and sent the driver straight back to Manila to score. He came back with enough marijuana to get us a respectable gaol sentence and we spent the rest of our time lying about in paradise wondering what to do.

The final night was my birthday so we had a last supper and then retired to the balcony to smoke. I couldn't tell whether I was having a good time or a truly horrific one. Sarah had no such problem: she was definitely in Hell. Completely paranoid she dashed around hiding her stash. She looked very shifty indeed, like someone who hangs around public lavatories. I was

not making the situation any better. 'Apparently if we get caught with dope here we get *executed* you know.' There was a rather long pause. 'Well that's put a bit of a dampener on the proceedings hasn't it?' Hysterical, I fell off my chair on to the floor. I looked up at Sarah. 'If I get *one* drop of blood on my velvet suit at the execution . . . you're *dead*.' I stood again. 'Tell me, what would your last request be before the firing squad?' 'Sex,' said Dennis. 'Drugs,' said Sarah. 'Well,' I said, 'mine would be a bullet-proof vest.'

But then the morning of the crucifixion dawned. Fear strips the human drama down to its bones. And yet in a strange way I wasn't scared. I felt calm. It was too late to get out of this. I was in the eye of the storm. It felt strangely peaceful.

I warded off the chaos with my usual obsessive rituals – touching and counting things, repeating my actions over and over and then, just when I thought that it was finished, doubling back suddenly to do them again. I was trying to assuage a God I didn't even believe in with quasi-religious rites that meant nothing at all. If this crucifixion would just go well, I prayed, then that would be the sign: I would be able to give up this debilitating compulsion once and for all.

In the hotel bedroom, Sarah helped me pin a piece of white muslin into a loincloth of sorts. I got dressed on top of it. I felt fraudulent wandering around in sunglasses and suit with my loincloth underneath it. Sarah fetched her first-aid kit and suddenly the whole thing seemed utterly ridiculous: a little Boots first-aid kit to take on your travels in case of accident – in case, on the off chance, you find yourself being nailed to a plank of wood.

I was ready. I looked at myself in the mirror. A gentleman should always be impeccably dressed for the firing squad. And give the order himself.

A local tourism officer who had made many of the arrangements for me turned up to drive us to San Pedro Cutud, the village where the crucifixions take place, a few hours away on

the outermost edges of Manila's endless shanty sprawl. On the drive we were quiet. My thoughts flitted about unbidden. One moment I was imagining blood and nails, the next I was wishing I had shaved that morning. We bumped along dirt roads, past lines of wooden shacks and mud-patch backyards where a few vegetables sprout or rot – it was hard to tell which. It was poor and dirty. I felt painfully conspicuous.

We went over all the last details. Whatever happens up there, I told Dennis and Sarah, just carry on shooting. 'I asked you to join me as artists, not doctors. You must not look away.' I looked at my foul-weather friends and was suddenly very grateful that they had come.

Arriving at the home of the head of the village, we sat round a table, in the centre of which a glass jar had been placed. In it were two nails – the nails which, I presumed, were to be driven through my hands. They were so much bigger than I had imagined: about three inches long with large round heads, thick at the top but tapering to points. They were being sterilised in alcohol. I noticed how beautifully they were made. But all the villagers gathered around the table were flicking idly through the pile of press cuttings that I had had to send to prove that I was an artist. They picked up the cuttings, peered at them, looked at the nails – and then looked at me. The curiosity was plain in their quizzical faces. They smiled.

I was introduced to Ricardo. He was to be my crucifixioner. It was like meeting your anaesthetist before the operation – except he couldn't speak to me and he had bare feet.

He took my hands, rubbed my palms between thumb and forefinger, felt for the bones, for the point where the nail could be driven without causing permanent damage. It was done almost casually. But then he was an expert. Every year on Good Friday, he nailed the 'martyrs' up. He only knew two words in English: 'no' and 'problem'. I yearned to believe that they could be linked. His face was gentle and kind. I looked to the others for support. 'Ricardo obviously knows what he's doing, doesn't he?' 'Oh he

does,' said Sarah loyally. 'Anyway, even if he doesn't, there is nothing I can do.'

I was asked to sign a legal document testifying that: 'I am subjecting myself to the ordeal of my own free will and volition and that I am ready to suffer whatever physical and emotional or psychological consequences that this crucifixion may bring upon my person.' It exonerated all those involved from any 'criminal, administrative or civil liability resulting from physical injury or death following the crucifixion.' My hands were sweating as I scrawled my signature. Someone asked me if I wanted painkillers. But I didn't. It was funny. I seemed to have spent so much of my life either blasting myself free of all feeling or numbing myself off from all sentience for no apparent reason. Now, the one time I actually needed drugs, I declined.

Outside it was a beautiful day. The sun was shining. The parrots were singing. There were a few puffy white clouds in a picture-book sky. A perfect day for a crucifixion.

'I actually feel quite excited now,' I encouraged the others. But I was nervously touching my hands. 'Hands are quite tough things, aren't they? The pain won't be too bad,' I insisted. I think I was too frightened to show my fear, even to myself. Soon it would be over. They said I would be up there for half an hour. Half an hour! That's quite a long time when you are nailed to a cross.

'Well,' said Dennis, 'five minutes is not enough . . . I mean don't get me wrong . . .'

'What, don't assume you're a sadist?' asked Sarah.

'I'll use the time to get some serious thinking done,' I quipped, but my mouth was dry.

'You must tell us what's going through your head,' Dennis told me.

Sarah gasped: 'Oh no! Are you going to talk while you're up there?'

'You're not going to be able to shut me up,' I said. 'Can you imagine . . . Well, on the one hand . . .' We all burst out laughing – it is the best painkiller there is.

The cabaret had obviously been kept a closely guarded secret. Inquisitive people rushed out of their houses as we drove slowly through the village. They peered in through the windows. I looked into their faces. They were smiling and chattering. What were they thinking? Did they see me as a devout fanatic, or a nutcase . . . or just an Englishman abroad?

We stopped and three young women climbed into the car, robed in blue, pink and white cloth. They had volunteered to stand like the Marys at the foot of the cross. They looked so fragile in their home-made clothes – like little children dressed up for the school play. I felt tears tightening my throat. I was embarrassed that they should have gone to all this trouble for me. I wanted to be invisible, to close my eyes and vanish. I wanted to make the whole world disappear just by refusing to look. 'How are you feeling?' I asked Dennis. It seemed easier to ask him than myself.

'Excited,' he said.

'I thought I'd be really frightened,' I told him, 'but actually, now I'm not.'

'You seem very calm,' said Sarah.

The field outside the village where the crosses were set up had been flooded by monsoon rains. The tump of earth that the villagers call Calvary was a far-off island amid a glittering lake. We climbed on to makeshift rafts, Sarah perched like Cleopatra on a wonky plastic throne. 'Just as well it's flooded,' I said. 'Otherwise the whole village would be out to watch.'

Sarah laughed and tapped me on the shoulder. 'Look behind you,' she said.

I did and saw the whole of the village taking to the water in whatever ramshackle vessel was at hand; everywhere I looked were dark bobbing heads. Even the babies were being brought along for the ride.

Three men were raising the cross from the ground as I stepped off the raft. It stood black and brutal against an azure sky. It looked like a tombstone.

And suddenly I was uncertain. What on earth was all this about? Why was I doing it? Could I take on a symbol that was more significant than myself? I felt inconsequential and silly. Who was I to be doing this? I felt as if the experience would smash me to smithereens.

'Please don't film me undressing,' I told Sarah. I felt like a peeled prawn – sunburnt and pink. 'Do I look silly?' I was desperate for reassurance. I felt acutely embarrassed. Vulnerable and naked. *Jesus was wrong. It is better to go to Hell well tailored than to Heaven in rags.* 'You look fine,' Sarah said, 'though if it was me, I would have worn vest and pants.'

I was still obsessively touching my clothes and counting when I was told the cross was ready. I lay down on it, holding out my hands, first one then the other to Ricardo, who bathed them in alcohol before pressing his thumb down in the centre of the palm, feeling again for the right point of entry. My arms were strapped to the bars with two ribbons of cloth on each side – presumably to prevent me from jerking them away, from tearing the nails loose. My feet were supported on a small platform of wood.

I was searching Ricardo's face for a sign that it would all be all right. He saw me. 'No problem,' he grinned. And then carefully positioning the point of a nail, he tapped it with a hammer, surprisingly gently, six or seven times.

I had wanted to think of something ennobling at this moment – of the Rachels and how much I loved them, perhaps – but the pain of each hammer-fall drove all thoughts from my head. It was indescribable. So much worse than I had imagined. I had never experienced anything so excruciating before. 'This is it,' is all I can remember thinking. 'This is the end.' But I did not cry out.

By the time the second nail was going in, I was already falling unconscious. My eyes were filled with tears as they raised the cross. I think I passed out and then came to again. I gratefully recognised the warm flood of endorphins. Sounds twisted all

around me, then faded, then cut out, then came back in again, rising and falling in spirals that twined round my head like wreathes of fluttering angels. The cross was upright. I gazed out into space. There was nothing. Just the light on the water. Just the endlessness of the air. I was so small. I was pinned like an insect between two eternities, between the infinity of the lake and the infinity of the sky. Sometimes I was aware of colours getting richer, of the skies darkening, of the dazzle of reflections that seemed sharper than spears. My body was releasing hallucinogens into my system. Sometimes I was aware of people below me. Sometimes I heard the camera shutter's whirr. My head fell like a rag doll's. And the next thing I knew I was falling, tumbling, spinning into blackness. I was blank.

Water was being splashed on my face. Hands surrounded and supported me. Anxious voices echoed and cried. I was conscious again. Sarah was lying on the ground. 'What the fuck is wrong with her?' I wondered. Later I found out she had fainted.

Later I also found out what had happened to me. The foot support, weakened by rain, had broken. Ripping loose the nails, I had fallen from the cross. The screams had been those of the villagers, running backwards appalled. Only Ricardo had run towards me. He had caught me in his arms.

Apparently, they told me afterwards, the foot support had never broken before. If the nails had been driven into the cross just a few millimetres more, or if the arm straps had not also broken, I would have been left hanging by my hands or ripped apart by the nails. Instead, they had bent with the weight of my body and then given and come down, still in my hands.

On my back there were six long bloody gashes where the fastenings of the torn-out footrest had slashed down my skin as I fell. They thought I may need stitches. I couldn't see or feel them and my hands felt strangely numb too. I shut my eyes and said a prayer. I tried to move my fingers. I could move them all.

For me, the immediate effects were not of relief, or joy or achievement. I was inconsolable. I had been humiliated. There

was no question in my mind. I had lost. I had been rejected by a God I didn't believe in and he had thrown me off the cross for impersonating his son, for being an atheist, and for being a disaster. I had made a complete fool of myself. I was going to be a laughing stock. The film would end up on Jeremy Beadle.

Before my crucifixion I knew that I had to take chances, to go too far and risk complete failure. Now faced with it, I was speechless. We drove back to the hotel in silence.

I'd yearned for a blaze of glory. I'd got a blaze of ignominy. I had failed.

But by the evening I was feeling a little better. The physical pain was growing clear and definite. And the stronger it grew, the stronger life started to feel. My appetites flooded back. I was immersed in a gush of gratitude. I wanted to eat, drink, and have sex. Anything to affirm life.

But my hands and body were swathed in bandages. It hurt to move about. Sarah walked me back to my room. 'The fucking crucifixion was pure sex really and I totally lost my legs on that one which was nice,' she said.

I fumbled with the doorknob until Sarah moved gently in front of me and turned the handle. I looked down at her gratefully. Sarah had become like a sister to me – only we didn't have sex quite so often.

It was only the next day that I started to feel a quiet pride – not arrogance, but pride, that I had been through it. I had survived and I had this wonderful thing to work with. It gave me a rare and intimate knowledge of myself and my subject. It centred me and made me feel humble. It was as if I had this warm and cosy room within me, wherein a strength and a secret lay, like a clandestine lover, but the lover was myself.

Dennis and Sarah forced me to watch the film. It was difficult but strangely moving, as if I was watching a stranger and not myself. I was infused with an awkward combination of pity and love. But without the accident, I realised, it would not have worked so well. They would have lowered the cross, pulled out

the nails and I would have got up. It would have looked more prosaic. Instead, here was something completely unexpected. It came like a shock. Disaster, it seemed, had been transformed into art.

I watched myself fall from the cross, the Filipinos reaching out to help me, touching me gently as if they wanted to infuse me with life, Ricardo massaging my heart which he thought had stopped. I am totally unconscious, mouth hanging open, lips slack. They lay out my body, like a corpse in a painting by Caravaggio. I look so pale and yet so serene. As if everything that is me has been drained out of me. I look like the marble that has been laid on a grave.

I spent three days recovering in the Philippines. Sarah had to leave and I had little to do. Sometimes I just sat in the village and talked to the people. They told me that they thought that I had been cast off the cross because if I'd stayed up there I would have died, but that God had spared my hands because I was a painter. The reality, I realised, as I watched them treading delicately through the mud, going about their daily work, was that I was just much heavier than any of them were. Bad carpentry was the cause, as Jesus, the carpenter, would probably have well understood. Dennis wanted to call the piece 'Surrender.' I wondered if we should call it: 'Is There a God or Am I Too Fat?'

On the plane home I sat in silence. People kept asking me what I had done to my hands. Eventually, after too many long, lying explanations, I decided to tell the truth. 'I've been crucified, actually,' I told the man as I waited in the queue for the lavatory. He burst out laughing.

Two weeks later the bandages came off. My hands were a little stiff but apart from that, disappointingly, almost unmarked. I wanted to have scars – as proof that it had happened. I needed it. Word had spread. As I walked through the streets strangers would say to me, 'I don't believe you were crucified. Show me the wounds. Show me the nails.' There were few who believed without seeing.

But strangely for me I didn't want attention. I felt completely isolated and alone. As an artist I want the world's love and adoration and yet this act had removed me to some other sphere. 'I am ready to suffer whatever physical and emotional or psychological consequences that this crucifixion may bring upon my person' was the affidavit that I had signed without thinking. Now I understood. The physical wounds were nothing to the mental pain.

I looked at the paintbrushes strewn about the studio. I looked at the box of one hundred needles. Had I just been looking for another hit?

I hit a vein first time. I had aspired to raise my game as an artist. To get to the point where I was painting, metaphorically, in my own blood. I wiped the blood lovingly off my arm and flushed the syringe out six times. What pain . . . ? Who cares . . . ?

Rachel came to see me. I sobbed into her arms. 'When is this going to stop?' I said to her. 'When you want it to,' she replied.

As I slowly got stronger I tried to start painting again. I wanted my work to have the mystery and power of religious art. When artists try to make art that is universal and not personal they always fail – it's being personal which makes it universal in the end.

I prepared large canvases and set about them excitedly. I was going to attempt to make darkness visible.

I failed. The paintings couldn't find my mind. After months of working I was left with almost nothing. All colours agree in the dark. What was left on the canvas was barely decipherable.

Was I wasting my time? I couldn't compete with the three-dimensional kaleidoscope of reality. I slouched about the studio, sneering at the paint. I wasn't happy with the results. By being crucified I had tortured myself to find out why I was so devoted to myself. Now I was torturing paint – and it wasn't confessing anything.

A year went by. I kept relapsing on drugs. I kept restarting on art. I did some stuff I was pleased with and began to approach

galleries. It was not a success. Some thought I was sick and disturbed. Some found it far too intense. And some could barely contain their indifference. But what they all had in common was that none of them offered me a show.

I'd like to say that I took it with proud bravado. But I was devastated. I felt even more vulnerable and exposed than I had in the Philippines. I had shown the world the unpainted Sebastian, the raw material, and it had been dismissed.

Self-pity is the most destructive of all narcotics. The trouble is, it is very addictive and very pleasurable. And I had a huge stash. My get-up-and-go had got up and gone. It was over between me and the world. That would show them.

'Why don't you just put on a show yourself?' asked Rachel.

I hadn't even thought about that. Typical that Rach got it right. What is wisdom but the capacity to confront misery with a smack in the kisser? Why did I need these art-dealing dogs to piss on me, to mark me as their territory? They were detestable. It was I who had done the work. Why should they make their money off my back? I ranted and raged. But in truth I would've loved to have sold out – but no one was buying.

My show opened early in the summer of 2002. Crucifix Lane, London. It was purely accidental but nothing succeeds like an address. I had found a cavernous railway bunker over which the trains thundered every ten minutes and which no revolting natural light could ever penetrate, though the rain had no problem. I didn't care.

My film *Crucifixion* was screened at the ICA. On the opening night there was a talk: 'Nailing an Illusion: Will Self and Sebastian Horsley in conversation.' It should have been called, Will Self in stream of consciousness and Sebastian Horsley in quite a lot of silence. It was a sell-out. I think they had come along to see Will – probably because his face looks like a bag of genitals.

I had worked with Will before. He had written the catalogue notes to my *Flowers of Evil* show – in return for a free

painting. They had been absolutely marvellous. Just two small problems. They were completely incomprehensible. They made no mention of me. They made no mention of the paintings, now I come to think of it. Or did they? I can't fathom from his sentences: 'I replace the bindings, cover up the campaign, and wait for Aurora to ride ahead of me, inaccessible, inviolate in the microwaveable bag of her perfect dermis.' And I hadn't even painted a microwave. I had no idea he disliked me as much as this.

After the film was screened Will cross-examined me. He used lots of big words, strung together in sentences that probably ended somewhere near East Harlow – I don't know, I never bothered to go and look. He was using words around people that they couldn't understand, which meant he was stupid in a sophisticated way.

'You're profoundly post-Christian, aren't you?' said Will. 'This was a purely existential act.'

Sarah Lucas reeled up, belching and swearing and talking while I was interrupting, which was rude. 'Lord Byron, LORD FUCKING BYRON FUCKING FANCY A FUCKING SHAG?' was her considered opinion.

Will was incredibly irritated. I was quite frankly relieved. I'm more at home with drunken bores than post-Christian existentialists. The evening soon wound up and was parodied afterwards by some prim tart in *The Times*.

But over the next few weeks the press covered me in words. Though not always so eloquent. 'Art Freak Crucifies Himself' ranted the front page of the *News of the World*. I had always suspected I was tasteless but it was nice to have it confirmed. 'A blasphemous insult' they blasphemed against me. 'It is grossly offensive to the vast majority of people,' a politician stormed. 'The most sacred tenet of Catholicism is turned into a cheap publicity stunt.' In Ireland 'politicians apparently urged everyone to boycott the exhibition.' Why don't they urge their own people to stop planting bombs?

It was all for the good. Soon everyone was piling in. I went on the *Today* programme and faced the grumpy John Humphrys:

'Well, Mr Horsley, you may have been trying to imitate Christ but you didn't die up there did you?'

'I am very sorry to disappoint you, Mr Humphrys.'

Everyone it seemed had an opinion from 'Our Own St Sebastian' in the *Independent*, to 'a narcissistic, nihilistic nutcase' in *Hot Press*.

I read all my press. I needed to find out who I was, a shaman or a showman – 'a posturing popinjay, neon narcissist' (the *Observer*) or someone attempting to 're-invest art with beauty, urgency and power' (*Sunday Times*). There was plenty to choose from: 'pervert' (Radio 2), 'arrogant' (the *Telegraph*), 'a flagrant exhibitionist' (*Time Out*) – well, at least they were calling me names I liked.

I was accused of perpetrating a publicity stunt – which seems a bit rich when it's a newspaper pointing the finger. But no artist should ever be afraid of this line of attack. The important thing is that nothing reported about one should ever be humdrum. And so of course a painting is a publicity stunt. A poem is a publicity stunt. A song is a publicity stunt. The motivation of all artists is 'Look at me, Mum'.

It was only when someone declared that my paintings were 'feeble and conventional' that I overreacted wildly. I downed three bottles of claret after dinner and seriously contemplated sending round a hit squad.

The next morning I collected myself. An artist, I reminded myself, should always remember that no one asked him to write, paint or exhibit himself in the first place. Bearing this firmly in mind he has no right to complain or become discouraged. He invited publicity and he must therefore take the publicity that comes along.

I took a stroll along Bond Street and popped into Tiffany's. They had lots of little trinkets that came in beautiful gift boxes. I bought one and gave it to Rachel. But I asked for the box back.

I shat in it. Drenched it in perfume and then wrapped it back up.

When the offending journalist got home that evening, she found an exquisite little present on her front doorstep.

She wasn't pleased. She took it to the police. And then her own kangaroo court – the media. I had my defence. This was an artwork. 'The Shit Has Hit The Foe.' I had given Will Self a painting for his kind piece of writing. Now she had her very own post-modern pseudo-Manzoni. She was a critic. I was an artist. I could take art. She could take criticism. I know you are supposed to turn the other cheek – I decided to part them.

The charges, like my pants, were dropped. But when I calmed down, I felt increasingly disturbed by my behaviour. I had completely lost it. Nobility grows out of contained emotion. Revenge and the desire for it, has a negative effect. If you've been hurt by somebody, then you're controlled by that event. If you go into revenge mode, you're still at the mercy of that event. Worse, it showed I could take any amount of criticism, so long as it was unqualified praise.

But even worse: I didn't care what was written about me so long as it wasn't true. She had claimed that I had nothing to say in the paintings. I think she may have been right.

'If you go up there empty, you come down empty,' Dennis had said. Listen to your friends' criticisms of your performance. If they make sense, change your performance. If they don't make sense, change your friends.

I had decided to explain my artworks in interviews by describing myself as a sort of 'Method Painter'. 'An artist has to go to every extreme to stretch his sensibility through excess and suffering in order to feel and communicate more,' I declared (a little long-windedly I admit). 'How can you paint the crucifixion without being crucified?' I demanded.

It was not only stupid – I mean look at Rembrandt, Rubens, Caravaggio, Grunewald, Francis Bacon – but it wasn't true either. I got crucified because I wanted to get crucified. I knew it wasn't

a fashionable pursuit but I didn't care. I simply wanted to make and do something special in an environment hostile to poets.

Because of this the paintings were the weakest part of the show. But I have always spelt art with a capital 'I'. But did *I* have the airs and graces of a genius and no talent? The real truth is, I'm not actually interested in art. My paintings reflected this. For a monkey, they were terrific – or at least I thought so until I saw those paintings that Picasso had by a chimp.

What, you may ask, have I got against painting? What have you got against the wall? Pictures deface walls more often than they decorate them. What have I got against sculpture? What have you got against the sofa? Let's face it, there is no furniture quite so dull as art. Because of this I never go to galleries. Art galleries to me are the cemeteries of the arts. Where art goes when it is dead. A public urinal is more interesting to me than a public gallery – and far more interesting than a public urinal in a gallery.

Producing art is essentially conservative. Unconventionality can be a convention within a certain set. It would have been far more radical if I had taken up knitting. Art is no more than a commodity, an object much like a washing machine, only rather less useful.

The secret, the key, to being a warrior in this world is: leave no traces. Neither good nor bad. The dandy himself is both revolutionary and illusionist who makes you believe in something that does not exist. Like them, I wanted to be as radical as reality itself. Being crucified was the act, all the rest was a falling away. Just the slime a slug leaves in its wake.

The show toured to New York, Ireland – and then I took Lithuania by calm. A year ago I had been unknown throughout England. Now I was unknown throughout the whole world. Of course I loved it. I had always been noticed in the street. Now occasionally I was recognised. But it was strange. I used to have everything that I wanted. Now I was on the point of getting everything that other people wanted – which isn't nearly so interesting.

Why does everyone in this culture from Beckett to Beyoncé want the same thing? I knew the whole thing was fraudulent. Isn't it better to be an anonymous celebrity than a famous non-entity? Where once I was a universe had I become a mere star – maybe a black hole?

I pulled the paintings back and pushed the performance forwards. After years of honing at last, I had found my voice. What I had done was expression itself.

I was finally happy. I'd done my bit for art – I'd stopped making it.

Jesus was crucified to save humanity. I had been crucified to save my career. In my opinion neither of us had had much success.

13

Death would be the birth of me

It is astonishing. If I had known I was going to live this long I wouldn't have taken such care of myself. The good news is that being clean adds ten years to a man's life. And I am planning to spend those extra ten years completely stoned. But it's a little bit worrying. I may have a problem. I seem to be losing my will to die. I do keep on trying to go on being miserable; but somehow a cheerfulness keeps spoiling it.

When I was young, I was always being told: you'll see one day, you'll understand when you're older, when you've got a bit of experience. But how old exactly? And how much experience? I'd gone through forty and I hadn't seen a thing. I had been crucified. But I couldn't really explain why. Had I really exposed myself, stripped the dandy right down? Or had that all been yet another type of performance? Had I taken off the face to reveal the mask underneath? Was I hiding in full view?

Was my crucifixion an act of patricide, a shot in the dark aimed at an atheistic Father, a man who wouldn't even go to church when his daughter was getting married, whose only spirit was distilled?

I was never to find out. Soon after the show he died. It was a satisfactory condition, as the doctors would have said.

As usual, I was coming off heroin at the time. I was in my sickbed. He was on his deathbed. 'Have a nice life,' were his last words to me – his first words to me for years. His voice was

barely audible down the phone. Maybe I should have been there, in at 'the kill,' but instead I wrote him a letter to try to make my peace. Heroin withdrawal makes one appallingly sentimental. Besides, I guess you have to forgive your enemies – if you can't get back at them any other way.

On hearing of his death I experienced a startling surge of pleasure. It suited me in so many ways. As a dandy my earthly father accused me of my impotence. He had the audacity to remind me that I was born of man and not God. So I never felt so fervently thankful, so soothed, so tranquil, so erect, so filled with a blessed sense of peace, as I did the morning when I learnt that he was dead.

I didn't go to his funeral. It suited his style. Where were you when I wasn't there, was the question he had always begged. Nobody else went either. He had no friends. They could have held the service in a phone box – in fact they probably would have if his wife hadn't been too fat to fit in. But of course I marked the morning of the service. I rose and attired. I decided on pink gabardine with a magenta and diamante tie to match. By the time I was finished my look was like Wagner – only louder. Nothing grave about that. What a vast wardrobe of sartorial opportunities sorrow can provide!

My only concession to misery was hidden – my heart was black. I was in mourning – and no wonder, I wasn't in the will.

It seems amazing that so close a tie as father and son could have existed between two men who had known each other hardly at all. Perhaps the fault was mine. I have always demanded too much of life and people and relationships – far more than exists, really. And when I find that it doesn't exist, it seems like rejection. It probably isn't a rejection at all; it simply wasn't there. But losing a father, like any personal disaster, was not the event of a single day but the atmosphere of a whole life.

Maybe that was his legacy. I have much to be grateful to Father for – without his neglect I would never have become an

artist. My entire self-creation had been some kind of act of obscure revenge against him and the world. I paint and write in self-defence. It's great to be thought great. But opposition tests the soul. So thank you for thinking I'm trash.

My ex-wife, Ev, died at around the same time. This came as a shock. Generally, men always have a much better time of it than women. They marry later and die earlier. It seems a great waste to allow anyone to die a natural death. But, sadly she did. She had an aneurysm. Falling silent suddenly on the telephone one morning, she had her life-support machine turned off a few days later. She was only forty and she was in love.

I don't believe in the obedience of grief. When I hear of a bereavement, of course, I say how terrible and look at the floor for the appropriate interval. But really death seems the least awful thing that can happen to someone.

I didn't feel that I had failed Ev in the way I had failed Giles, letting my friendship subside as his needs increased in the perverse ratio of the mathematics of life. But Ev and I hadn't had time to make up after all the misery we had dragged each other through. We had shared little of that strange intimacy which former lovers can so enjoy.

When I think of her now, instead of some expansive vision of a life, spreading out between birth and a final dissolution, I am left with a few drifting fragments – cheese and pepper sandwiches in the park, Ev dying my hair pink, Kate Bush's song 'Under the Ivy', bits of Edinburgh accent. And I am glad to have these few things to remember amid the regret.

I went to her funeral. Her friends had draped her coffin in a day-glo pink shroud and Beth Orton sang 'It's a Wonderful World'. An address was made to the congregation which told Ev's life story. The speaker omitted to mention that she had been married. Her friends had edited me out. But still, it was a beautiful service. They say such nice things about people at their funerals that it makes me sad to realise that I'm going to miss mine by just a few days.

Still, I seemed to be pretty eager to get there. I was still taking drugs. But I was completely fed up. I would have happily died if there had been any point – which there wasn't. I don't think that anyone would have even noticed the difference.

I was worn out. I had tried clinics, I had tried white knuckle denial. I had gone to NA and CA and AA and the RAC. I had tried therapy cures, reduction cures, exercise programmes and endless rehab. And sometimes I'd managed – for maybe as long as a month. For a short while I put all my faith in Ibogaine, some African root-bark extract that got Bwiti tribesmen in touch with their dead ancestors and English drug addicts out of touch with their smack. It worked. I got six pages in the *Observer* magazine to extol its virtues before, a week or so later, I was back on crack. But then how could I have contacted the Horsley forebears? They wouldn't have turned up at the meeting. They would have stayed at the pub.

But something, at last, was beginning to dawn on me. When I was on drugs my life went down the drain. When I was off drugs – well, I was still down a drain, but at least I was crawling back up. Drugs promise freedom. But they put you in prison. Sobriety feels like a sentence. But it's offering a new lease of life.

As I slowly awakened, I found myself halfway through my fifth decade. I had spent twenty years taking drugs one night. The purpose of drug taking is to get it over with as long as possible. But it always comes to an end. People always flatter themselves that they are giving up their vices. In reality, however, it's the vices that abandon them. I gave up drugs because the pleasure and the pain became simultaneous. I gave up drugs because they were making me too happy. I gave up drugs because they were making me too unhappy.

I went back to NA. Previously I had been inoculated with small doses that had stopped me catching the real thing. Now I was going to give it a proper try. When you make your peace with authority, you become authority.

I can't put into words how much I despise religion. It is an

illusion fit only for children. But weren't drugs the same? Didn't an addict fundamentally have a religious outlook on life? The faith of oblivion – just another evasion of the courage to be, just another way to comfort us for our deficiencies, to shelter us from the hurricane of life? I had always suspected that spirituality was a form of drug pushing. Were drugs a form of God pushing?

Not that I regretted for one moment the drugs I had taken. If I had to live my life again I would take the same drugs . . . only sooner . . . and more of them. I had taken them because they made me feel good. It seems a perfectly legitimate reason. But I had been ready to give up. It was not so impossible. When the sin is so sweet, the repentance cannot be bitter. And now looking back, that trail of destruction, that wanton carnage, seems instead like the clearing of new ground.

I have been straight for a year now. I still have a habit. I would be bereft without one. But I have replaced the habit of using drugs with the habit of not using them – but quietly. The whisper can be louder than the shout. And it's OK. If you eliminate heroin and crack cocaine, I am amazed to find that almost all my pleasures can be, and mostly are, shared by a dog. And the dog is man's best friend.

The only truly stylish ending to an autobiography is a suicide note. Well, here is mine:

'I have decided to stop living on account of the cost.'

As all self-respecting dandies know, suicides are the aristocrats of death. They represent a triumph of style over life. My existence is a work of art. It deserves a frame – if only to distinguish it from the wallpaper. Suicide will look nice. It will match the home furnishings.

Not that I have many home furnishings left. All my life I have behaved like a lavatory attendant who has just won the lottery. Well, now fortune has emptied her chamber pot on my head.

I am almost bankrupt. I have squandered money like love.

And now I have reached that nerve-racking position – I'm a rich man without any cash.

Dandies, like all gamblers, fight against fate and are finally conquered. I understand the compulsion to keep playing the game. Each flip of the card and each roll of the dice adds excitement. I have always lived in the hope that I can stoop to conquer in the end. I have invested ninety per cent of my money in prostitutes. The rest on class A drugs. (Never put all your eggs in one basket.) The remains I squandered. Oh well.

I came into this world a king, I leave it a wild card. I believe in being nothing – but with as much style as I can. Our most treasured things are just junk that hasn't been broken yet. I would have made a first-class tramp, if I'd had more money.

I am a man of cheap tastes without any visible means of supporting them. Yes, I make my economies. I walk to the Ritz. At times of financial crisis I find extravagance sometimes helps me. Where we are worth nothing we should want nothing. A modest sufficiency cramps style; extreme poverty, like great danger, enriches it.

Dry your tears – I've got all the money I'll ever need – as long as I die by 4 p.m. this afternoon.

I once read a story about a gentleman from North Carolina who was awoken by a telephone call. He fumbled for the receiver, but unfortunately picked up his Smith & Wesson instead. It discharged in his ear. He got cut off for life. Well, I'll be off for a nap soon. My Colt .38 lies fully loaded on the bedside chest. I await your call. But remember, like God, I want nothing but praise.

And so I'll go on for a bit longer. My song is not quite yet sung. London is not yet tired of my wardrobe, for a start.

Sometimes I ask myself what went wrong? What do I feel that I missed?

Love?

Not at all. Why share your life with one person when you can share it with the whole world?

Happiness?

One is never as happy or as unhappy as one imagines oneself to be. I am happy because I have realised the limits of happiness. Happy in the knowledge that there is no real happiness. Contentment consists not in great wealth but in few wants.

I have wanted only one thing to make me happy. That thing is everything. It is art. And yet no artist can know if his work has any permanent value. He can never really tell whether perseverance is noble or stupid until it's too late. Still, dying is often the best career move an artist can make. Once you're dead, you are made for life.

What about fame? We all thirst for it. Our ambitions burst like some brightly coloured insects from the earthbound grub. But then we get captured, chloroformed by convention, pinned down in little suburban boxes for the rest of our life. I have fluttered like a mayfly. I have danced my glinting puzzles over life's flowing stream. Mayflies may only live for a day. But so what? To live for the day is all that there is. Besides, to be a dandy is to live as a martyr. And if a martyr is someone who becomes famous without ability, then I'm not doing badly — at least not on the ability front.

What more could I want? In the long term I'm sure I will achieve nothing. My name will lie still. I won't leave a great work of art. I won't have streets, or hospitals or charities named after me. I won't even have a disease named after me.

But it has been worth it. To *become* a work of art was the object of my life. And you should never judge a work of art by its defects. Yes, I am preposterous, vulgar, absurd. But I answer no social need whatsoever. I am a futile blast of colour in a futile colourless world.

I regret everything. But so what? At least I have cause.

Life is a tragedy. We get washed up on some random shore and spend our lives building shelters and waving at ships. Then the tide turns. The waves crash inwards and sweep the lost away.

We are left with a desert. We end up weeping alone in an empty church. Remember me, whispers the dust.

Oh well – if my face is going to look like an old boot, it will unquestionably be a hand-made Oxford button boot by Lobb.

The world was up and running before I was born (I don't quite know how) and no doubt it will dribble on after I'm gone. You may look back on your life and accept it as good or evil. But it is far, far harder to admit that you have been completely unimportant; that in the great sum of things all a man's endless grapplings are no more significant than the scuttlings of a cockroach. The universe is neither friendly nor hostile. It is merely indifferent. This makes me ecstatic. I have reached a nirvana of negativity. I can look futility in the face and still see promise in the stars.

Looking back, I am glad to say that I haven't really had a life. I've just sat in a room and died. But it doesn't seem sad. It seems comic. I have travelled my road in a tinsel-adorned tumbrel. And so what if there's only an audience of one? We must give our all when the guillotine is about to fall.

Let's not carry on as if things end well. They do not end well. Anything that consoles is fake. I shall continue to lift up my face to the last rays of sunshine. I am now a reconciled Sebastian. I can allow the arrows to rest gently in my wounds.

There comes a time in every person's life when they realise they adore me.

Yours has come.

Acknowledgments

You will find nothing wrong with this autobiography – except a poor choice of subject. But if you're not fully satisfied with the product then don't come whining to me. It's not my fault. *Surely*, you didn't imagine that I actually wrote this book on my own? Here are the people you should blame.

I would like to thank Maria Alvarez for believing that a dyslexic crack-head could even pick up a pen; Rowan Pelling for having the foresight to see that twisted roots grow monstrous flowers; Annie Blinkhorn for tending the triffid. Patrick Walsh for being my double agent. Giving a book to him is like turning your daughter over to a pimp. Fun.

Leo Hollis for hiring me and Fourth Estate for firing me.

I bow down in homage – or at least I would do if it didn't crease my suit – before Rachel 1 who was like a mother bird feeding me with words. It's *so* difficult to persuade a busy ex-girlfriend to write a book for you – but thank you my darling. Did you have to remain so nauseatingly adorable throughout? And to Willy – the camp scarecrow – for bravely lending me his girl, his house and his children.

I owe *everything* to the greatest editor in the world – Matthew Hamilton who built up a Trojan Horsley to destroy the enemies and to his fellow editor the impossibly glamorous Jocasta. If it's really true that writers are screwed by their publishers, then I can only say that I'm greatly looking forward to the experience.

I want to thank Alice Wright, Liam Relph and Polly Borland for the beautiful cover. Due attention to the outside of a book and due contempt for its inside, is the proper relation between a man of sense and his reading material. Where would I be if people judged a cover by its book? Well . . . they probably will – which gives plenty of work to my dishy publicist Henry Jeffreys who must be commended for stepping into the firing line on my behalf.

I am very grateful to Mother for failing so stylishly to be a matriarch and to Sister Ash and Brother Jake for bearing the load. The problem with the gene pool is that there is no life-guard.

I also want to thank Jessica Berens for synchronized drowning and Catherine Blyth for sending a wave and Alexander Larman for blowing a whistle.

I gladly acknowledge my many muses: Baudelaire, Rimbaud, Wilde, Byron; Tintin, Marc Bolan, Johnny Rotten, Quentin Crisp; Paul Stanley, Francis Bacon, Axl Rose and the Dadaists: there they were ahead of me, all dandies, roped together like mountaineers heading for the highest summits of beauty. I unabashedly declare my adoration for all of them. You can track me everywhere through their snow. The only original thing about this book is the sin.

And last of all, bringing up an extremely impressive rear, I would like to thank Rachel 2. Dippy, daffy, flaky, scatty. Head of feathers, heart of mush. There is no other woman on the planet like her. If she were typical it would be the end of civil-isation – no bad thing.

Oh, and I suppose I ought to thank you, the reader. But I don't suppose it matters that much. I only write to get my knob sucked – and the kind of girls I am attracted to are illiterate.

Insights,
Interviews
& More...

About the author

About the book

Read on

Throwing Down a Perfumed Gauntlet

WRITING A BOOK IS, of course, a form of failure. As a dandy I seek to be somebody rather than to do something. What I *am* matters more than what I produce. Why produce anything save my own carefully cultivated self? My greatest work is my personality. My life—and my death— are my art.

But art itself is worthless. It is material, earthly, impermanent. No matter how great, it still pales besides the transcending majesty of nature— or the simple beauty of my face. In his highest aspirations man is still mocked. No wonder that art and psychosis have been such tender lovers for so long; that the road to creativity passes so close to the madhouse and, indeed, often ends there.

About the most terrifying burden a human being has to bear is a sense of his own isolation. We plunge into pools of shared meaning to escape. We take refuge

© Nick Cunard

Sebastian with Rachel 2 and Tampon

in shared pastimes and customs and codes.
We are all actors. We think we are safe when
we hide in our roles. Look at the doctors, the
accountants, the preachers, the plumbers, the
poets, and the playwrights. They think they
are real people. But they are only face paint.
And what happens when we stop feeling safe
in our camouflage? What happens when we
feel the chill winds of uncomfortable truth.
How do we then find our place?

A dandy discovers his own distinctive
answer. He has looked at the world as so
many have seem prepared to accept it
and decided that, in all honesty, it's pretty
humdrum. He wants—like all of us do—
to be special. But he's prepared to throw
down a perfumed gauntlet and fight. So he
sets out to write his own rulebook, to make
up his own codes, to revel in the glory of
his own individuality. The dandy makes
explicit an urge that lies latent in everyone.
In creating himself, he creates his own hero.
He flouts isolation by flaunting his own lone
self in its face.

Though life means one man alone with
the darkness, in being a dandy I was never
alone. Baudelaire, Rimbaud, Wilde, Byron;
Tintin, Marc Bolan, Johnny Rotten,
Quentin Crisp; Francis Bacon, the
Dadaists: all dandies, roped together like
mountaineers heading for the summit of
beauty. I unabashedly declare my adoration
of all of them. They have been the beacons
in my night. I looked into all their mirrors
and saw myself. You can track me everywhere
through their snow. I am a dandy. A dandy
is a poet. But I do not create. God creates.
I assemble. I am a professional plagiarist.
I will steal from anyone and everyone and
everywhere. Plagiarism is an art: the art of ▶

> ❝ I am a professional plagiarist. I will steal from anyone and everyone and everywhere. Plagiarism is an art: the art of stealing from thieves. ❞

Throwing Down a Perfumed Gauntlet
(continued)

stealing from thieves. I put my hands in my
pockets and find someone else's fingers and
give them a friendly squeeze.

Of course, sometimes my life and art seem
to me nothing but slops—a thin gruel with
undigested lumps of Baudelaire, Byron, and
Bolan. Of course, sometimes my art seems
like nothing but mediocrity on stilts. Oh well,
I shall stroke my mediocrity 'til it purrs, prod
it 'til it springs yowling from my lap like crass
vulgarity to stalk off round the world.

Being a dandy is a condition rather than a
profession. It is a defense against suffering
and a celebration of life. It is not fashion; it is
not wealth; it is not learning; it is not beauty.
It is a shield and a sword and a crown—all
pulled out of the dressing up box in the attic
of the imagination. Of course life is nothing
but a game of dressing up and make-believe.
All dress is fancy dress except our natural
skins. I know I am a pretend artist and a
pretend writer. But I play with all my heart.
Play transforms us, magically. Dandyism is a
lie which reveals the truth and the truth is
that we are what we pretend to be.

Dandyism is a modern form of stoicism.
It is a religion whose only sacrament is
suicide. And so, like a suicide, I open my
veins. I am here to bathe you in my little
universe of melancholy. I am here to bleed
for you. I may dress for Sebastian, but
I undress for everybody else. If I had not
had to live I would never have had to let
any of this out. Now, writing this book,
my only terror is the terror of being
understood. ∾

The Chap
Questionnaire

What is your idea of absolute sophistication?

Complete vulgarity. The vulgar man is always the most sophisticated, for the very desire to be sophisticated is vulgar. And without an element of vulgarity no man can become a work of art.

Who, in your opinion, is or was the quintessential English gentleman?

HRL His Royal Lowness—Satan

And the quintessential lady?

In my romantic view a woman may be a prostitute and she may be a destitute but she can never be less than a lady.

Where do you think the best-dressed people are?

In my flat. It is a lighthouse ▶

© Rachel I

I have a greater need for a château than a peasant has for a loaf of bread. Oh and the car . . . well, it isn't a car. It was a stately home on wheels. Fancy a fuck? Don't fight over me, girls, there's plenty to go around.

for losers. They get off at Dove and make their way over.

Name three favorite items in your personal wardrobe.

Me, my makeup, my mirror.

Which accessories do you never leave the house without?

My sin. My suit. My squaw.

What single situation has been the greatest challenge to your wardrobe and your personal grooming skills?

Being crucified in the Philippines in August 2000. Nudity is a threat to my existence. There I was—the raw material, the unpainted Sebastian, in skimpy loincloth. A stylist's Armageddon. Jesus was wrong by the way: it is better to go to hell well-tailored than to heaven in rags.

Which aspects of contemporary life do you think are most prohibitive of a gentlemanly lifestyle?

All of it. I find everyday life quite hard. It is very difficult to walk with wings. Even if they are made of tinsel. But especially love. It makes the world go round looking so dowdy. And equality. Glamour is, of course, a greater asset than equality.

What items of clothing do you consider to be the height of vulgarity?

Our natural skins. The trainer—surely the ugliest species of footwear ever devised by man. The baseball cap—a symbol of man's inhumanity to man. (And worn backward

66 In my romantic view a woman may be a prostitute and she may be a destitute but she can never be less than a lady. **99**

like their brains.) And Denim. There are only two actions I cannot tolerate. The first is denim. The other is murder. If denim is not wrong, nothing is wrong.

How do you think young people can be prevented from becoming bad mannered, sportswear-clad ruffians?

By being shot. The young actually spend a lot of money to look cheap. But I welcome them really. We can't all be stars because someone has to sit on the curb and clap as I go by. ∽

The above questionnaire appeared in The Chap, *March 2003, and is reprinted by permission of* The Chap. The Chap *is a British gentlemen's quarterly that examines contemporary culture through the monocle of a more refined age. Visit the quarterly at www.thechap.net.*

> 66 If denim is not wrong, nothing is wrong. 99

Relative Values
An Interview with the Author and His Mother

by Ria Higgins

SEBASTIAN HORSLEY, forty-five, is an artist and writer whose memoir, *Dandy in the Underworld: An Unauthorised Autobiography*, was published on Thursday. It coincides with a retrospective of his work "Hookers, Dealers, Tailors," which is running at Spectrum London . . . until September 30. Sebastian lives alone in Soho. His late father, Nicholas Horsley, founded the food-manufacturing company Northern Foods. He has a sister, Ashley, forty-six, a psychotherapist, and a brother, Jake, forty, a writer.

His mother, Valerie Walmsley-Hunter, is seventy-three and lives alone in north London.

I can't believe this one. I know exactly what I was trying to do. The way people look has a lot to do with the way they behave. Have a pink suit made. Buy the FT. And you're a trader. Were my clothes a barricade behind which I hid my nothingness? You bet, baby. So what? It is only shallow people who do not judge by appearances.

SEBASTIAN: When Mother found out she was pregnant with me, she took an overdose. It didn't work. Neither did nine months of heavy drinking. Had she known I was going to turn out the way I did, I'm sure she'd have gone the

© Evlynn Smith

whole hog and found the cyanide. Of course, I didn't find that out until much later. We were led to believe it was my sister she'd tried to terminate. She thought I was too touchy to hear such truths. And she's right. I'm a tad sensitive—I feel overlooked if an epidemic misses me out.

Father was wealthy, so we grew up in an enormous house. My first memories of Mother couldn't be more vivid. If you were standing in the drive and saw this Technicolor explosion out the corner of your eye, it was either a fruit cart or Mother. She'd pick us up from school in a hat that looked like an exotic bird had just landed on her head. And she'd think nothing of combining it with long, cerise velvet gloves and an ostrich-feather boa.

On sports day Father would turn up in the Jaguar and Mother in a skirt so tight it looked like she had more legs than a bucket of chicken. She wallowed in vanity; I wallowed in ▶

> 66 I'm a tad sensitive—I feel overlooked if an epidemic misses me out. 99

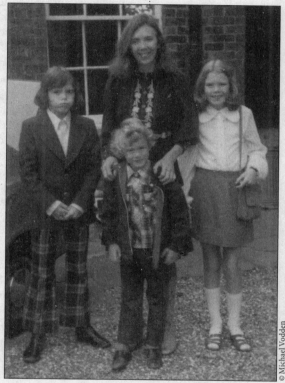

© Michael Vodden

I love this picture. It is proof that my character was deformed from a much earlier age than even I dared to hope. I am ten. Top button done up. All trousers and no mouth. I am the only one not smiling. And note, the only one not touching. As a natural loner and auto-invention I grasped early the irrelevance of family life.

9

embarrassment. Then there were her more informal dress occasions.

Taking us to school when we'd missed the bus was one. She would get out her open-top blue Triumph and drive us in wearing a silk negligee and a fur coat, hair so disheveled you weren't sure it was her.

But really, Mother oscillated between two extremes. She was an intoxicating cocktail of glamour and suffering. If she looked like an opera diva one day, you'd mistake her for a bag lady the next. She lived on a diet of booze and pills, and as a result spent huge amounts of her time in bed. She had as much chance of bringing structure and discipline into our lives as of growing orchids in the Moroccan desert. Motherhood wasn't her thing.

The situation with Father didn't help. I have no recollection of a time when she was happy with him. She was only twenty-four when they got married, and hardly knew him. When they turned up at the registry office, a local journalist asked her if she and her new husband were compatible and she replied: "I have no idea. I've only known him a week." As a child, all I remember are the fights and misdemeanors—burning his stuff, crashing the car, shoplifting from his shops. Then there were her visits to the "bin" when the drinking got really bad.

Father was no better. He was also an alcoholic—and a womanizer. He died from alcohol a few years ago. He also suffered from a spastic condition that eventually left him in a wheelchair.

By that time, though, they'd divorced, and I hadn't spoken to him for years.

He didn't give a toss about me. And I

> 66 When [my parents] turned up at the registry office, a local journalist asked her if she and her new husband were compatible and she replied: 'I have no idea. I've only known him a week.' 99

hated him. But I hated Stepfather even more. He was a tosspot. I'd come home to find him in bed with Mother, and Father in bed with someone else. Clearly everyone in my life who should have been vertical was horizontal.

Anyhow, although we called him Stepfather, Mother never married him, and when he died I was pleased to learn Mother had got up one morning and rather than sprinkling his ashes in the Ganges, she'd sprinkled them on her porridge. Revenge? Amusement? I'm not sure. Knowing about her own family I can sympathize with her moments of madness. Her father, nicknamed Jack the Bolter, did a runner before she was born.

And her mother suffered from depression and eventually committed suicide.

When I reached my twenties, I went through a phase of not wanting to see my family. I wanted to create my own world, which, as it turned out, was equally mad. I realize now that my childhood was probably the happiest time of my life— which gives you an indication of the ▶

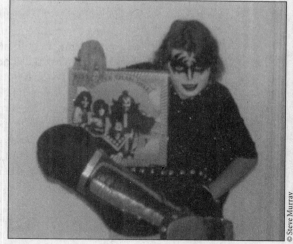

It is time to take off my face and reveal my mask. Me aged twelve in KISS makeup. The reason my hand is behind my back is because it was bandaged after the electrocution. I am wearing Mother's boots and the bat wings are made of an umbrella. Ahhh . . . so sweet. I am a puss in Jack boots.

11

Relative Values *(continued)*

hell I've endured since. The funny thing is, life is really no different now than when I was seven—I'm back to sitting in a darkened room, making and breaking things.

Mother lives on her own now. She's a bit like a boat without a rudder: she's been blown around all her life—by family, by the breath of other men. She may not have been a good mother, but that's not a criticism, it's an accolade. She's been more like a muse, a coconspirator. And underneath all her vanity, insanity and green silk dresses is a compassionate, poetic soul. Without her influence, both good and definitely bad, I'd never have become the artist and writer I am today.

VALERIE: I was not a great mother to Sebastian. I'm not being hard on myself, or even reveling in guilt, it's just true. They say lovers don't make good parents, and my husband and I were besotted with each other. We'd only known each other thirteen days when we got married. But not only were we both young, we were heavy drinkers.

I don't think Nicholas ever went to bed sober and I was always in a fog.

Sebastian and my other two children were accidents and, though it seems shocking to admit, I drank all the way through my pregnancies. Fortunately, Nicholas's family were wealthy, so we lived in a huge house. It had endless rooms, endless places for children to hide—which meant I didn't have a clue what they were up to half the time.

Sebastian was mischievous. Once, he set fire to his sister's doll's pram. Then wheeled it next to our oil tank. His sister

came screaming in to tell me. I rushed down to find him standing there waiting to see the action unfold. Another time, fire engines came roaring through our village to put out a haystack ablaze in a field. The whole place could've gone up. Only later did I find out Sebastian had started it.

I tried not to be drunk when the kids came home from school, but ultimately I just wasn't good at coping and the drink was a form of escapism. I ended up in the bin on more than one occasion and, in the end, my marriage broke down.

Sadly, Sebastian's relationship with his father had never been good. He'd always made Sebastian feel inadequate and stupid, which he wasn't—he got a place to study English at Edinburgh University.

But he never forgave him. His father died a few years ago of alcoholism and Sebastian refused to go to the funeral.

Sebastian ▶

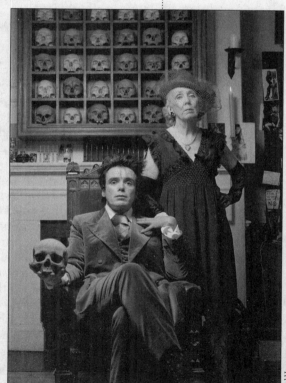

Sebastian with his mother, Valerie Walmsley-Hunter

Pal Hansen

opted out of university in the end because he met Jimmy Boyle.

Jimmy was regarded as Scotland's most violent gangster. He was just out of prison and had found a new calling as an artist.

Sebastian was fascinated by him and found out he was setting up an arts center for ex-prisoners and addicts. He offered to help and Jimmy took him on. The two of them became very close. Jimmy was like a substitute father. He was even best man at Sebastian's wedding.

I didn't hear about Sebastian's marriage to Evlynn until afterward.

That's just the way he is. I was also in the dark about his addictions. Initially it was drink, which I understood because of my own problem. But then he switched to drugs. By this time he'd moved back to London and broken up with Evlynn.

She was great—it was tragic when she died of an aneurysm a few years later.

But by then Sebastian was addicted to heroin. I only found out when he was so ill he had to go into care. I freaked out.

Luckily he pulled through.

Sebastian can come across as extrovert— the way he dresses, talks, his smile, his wit. He has always been able to make me laugh. But then there's a part of him that runs very deep. He's sensitive, emotional, easily hurt. I think that's why he keeps a distance from his family. Being too close makes him feel vulnerable. And yet it's his sensibilities that make him so creative, whether it's through his painting or writing or any other means of expression he can find.

66 I tried not to be drunk when the kids came home from school, but ultimately I just wasn't good at coping and the drink was a form of escapism. 99

He can also be unforgiving, vengeful even. Once, when a woman offended him, he went to Tiffany's, got one of their beautiful boxes, put one of his turds in it and sent it to her. Let's just say he has his bad days, and it's times like that when he'll say: "Why did you give birth to me? That's the worst thing you ever did."

I always have to say to him: "Sebastian! You couldn't wait to be born. I barely got to the hospital when you came out like a shooting star." And that's what he's been like ever since. The only difference is he couldn't possibly share his universe.

He'd insist on finding his very own. ∽

The foregoing interview was first published in The Sunday Times *(London), September 9, 2007, and is reprinted by permission of* The Sunday Times.

❝ [Sebastian] can also be unforgiving, vengeful even. Once, when a woman offended him, he went to Tiffany's, got one of their beautiful boxes, put one of his turds in it and sent it to her. ❞

The Twelve Disciples
On Music

"The Twelve Disciples" is dedicated to Carrie Kania. Melancholic. Solitary. Discerning. Shy. Witty. Sharp. She will blush if she reads this in company. Look at her. Thank you, my darling. You have had the courage not to grow up. You have given me the opportunity of offering myself "gift-wrapped to the world." I have always been American in my artificial heart. Life for the Americans is always becoming, never being. Thank you for making me edible. Americans will eat garbage provided you sprinkle it liberally with ketchup.

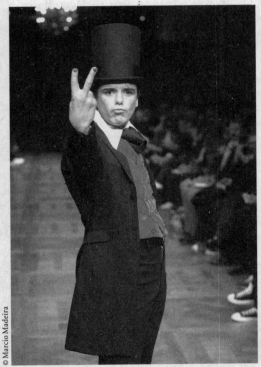

© Marcio Madeira

ALL ART IS FAILED MUSIC. The chief knowledge that a man gets from reading books is the knowledge that very few of them are worth reading. The stage gets stuck with anything too boring to be shown on television. And my interest in the cinema has lapsed since women began to talk. As for art? It's like watching a chicken try to fly. It can run, flapping madly, but never take off.

But music releases us from the bonds of gravity. We connect heaven with earth by its threads. No other activity or art form provides so reliable an antidote to

life, just so long as we can bring to it the necessary surrender. And surrender we must. Music has saved more lives than the Samaritans and God put together.

I have to say, I wish you were sucking my cock while I was having this conversation with myself.

Music takes the innermost part of you and puts it outside. It is an art which can name the unnameable and communicate the unknowable. I would throw all the paintings that have ever been painted, all the books that have ever been written and all the films that have ever been filmed into the Atlantic Ocean for these twelve tracks. I listen to them all practically every day of my life. If you want to know where my book came from and where it is going, look no further.

1. "20th Century Boy"—Marc Bolan

In Marc Bolan beauty was the glove into which charisma slipped its hand. He was transcendent trash. He had one foot in heaven, the other in Woolworth's.

Marc was my first muse. I was only eight, but I already recognized his music as the thing that every young man will recognize he is destined to most love.

Like all innovators, he got left behind. The New York Dolls opened the door for KISS. The Sex Pistols opened the door for the Clash. The Pixies opened the door for Nirvana. Marc Bolan opened the door for David Bowie. The real thing is not something that you'd want to idolize.

The song reminds me of childhood. And it reminds me of transformation. I would steal into Mother's dressing room and, draping myself in her black feather boa, slide on her pink silk gloves. I sat at ▶

> 66 [Marc Bolan] had one foot in heaven, the other in Woolworth's. 99

The Twelve Disciples *(continued)*

her dressing table and painted myself with her brightest vermilion lipstick. I remember miming along to this record in front of the mirror.

"20th Century Boy" has a monstrous vitality. The bellicose brace of blocked E chords announces the song in electrifying fashion, and then we are off. Four minutes of pure fuck music. Four minutes of pure self-belief. Marc Bolan was radioactive with belief in himself. It is a great help for a man to be in love with himself. For an artist it is absolutely essential.

2. "Word on a Wing"—David Bowie

I was never a massive Bowie fan. I never quite believed him. But I adore this song. It feels so effortless. It is airborne with sangfroid.

"In this age of grand illusion you walked into my life out of my dreams." I just love the sentiments behind this line. A true dandy will never abandon his mind to the grossness of reality. He knows that art with the illusion of meaning is the highest achievement for man.

This song reminds me of heroin. I would take a shot and listen to it over and over. Heroin makes you feel like a water lily on a Chinese lagoon. As does this. They are both dreams for which I will have nostalgia.

3. "Personality Crisis"—New York Dolls

This song has the three essential ingredients of all great rock 'n' roll: Style, subversion, and sex. I defy you to listen to the opening and not be roused. It is a shot in the dark, a shot in the arm, a shot in the head. It is a

66 Heroin makes you feel like a water lily on a Chinese lagoon. 99

war cry for the freaks. A miracle that can transport us from the drab sands to the dazzling stars.

It reminds me of being thirteen and dressed up in Mother's clothes. I would clap on as much makeup as the forces of gravity would allow and then stagger into the streets of Beverley. Hours had been spent painting my eye shadow, lipstick, and rouge. Oh how I marveled at the faces of astonished bystanders!

This song is eternal. What people want is both classics and trash. This is both: classic trash.

4. "C'mon and Love Me" (*Alive!* Version)— KISS

KISS is one of the greatest, most authentic bands of all time. The music of the Beatles is just KISS on the wrong notes. That was a good sentence wasn't it? The music of the Beatles is just KISS on the wrong notes! When you read it you just wanted to fuck me, didn't you? Well, you'll just have to wait an hour until I finish this.

KISS just go out and serve. As loud and calculated as they appear, they are a relief from most of the lame, white, phony country-rock singer-songwriters who everyone drools over, who are just as calculated, but no one wants to admit it. Tom Waits? For God's sake! What a fake!

I vaguely remember my school days. They were what was going on in the background when I was trying to listen to KISS. Everyone else was listening to the audible wallpaper of ELP and Yes and Peter fucking Frampton. ▶

> " KISS is one of the greatest, most authentic bands of all time. The music of the Beatles is just KISS on the wrong notes. "

I wasn't having it. I love KISS. And if you don't like that, you can suck my Nazi cock.

5. "Public Image"—Public Image Ltd. (PiL)
Genuine charisma is very, very rare. It is the ability to persuade without the use of logic. It is a thing that makes you interested in hearing what comes out of someone's mouth. You either have it or you don't. Elvis had it and Bono doesn't. As for Madonna? Madonna is ordinary but, worse, does not have the grace to be ashamed of the fact. It is better to be an anonymous star than a famous nonentity.

John Lydon was one of those characters who was a star almost by nature. He had vision, intelligence, wit. It was as if a typhoon of energy had been released. And he didn't care what you thought of him. Strength of will is an important component of charisma. When people attack them, those with charisma look as if they don't have a care in the world. When things go wrong, you act as though nothing had happened. That's charisma.

The Sex Pistols weren't a band. They were a meteoric force that changed everything. Then came PiL, and Lydon did it again. I adore this song. It has such bite, surprise, attack. It was so bold and brave of him to come back like this after the Pistols. I love the righteous indignation of this song. It reminds me to only sanction music with a moral purpose.

**6. "Further Than We've Gone"—
 Captain Beefheart**
I hate love songs. I don't believe that people would ever fall in love if they hadn't been told

66 The Sex Pistols weren't a band. They were a meteoric force that changed everything. 99

20

about it. It's like abroad. No one would want to go there if they hadn't been told it existed.

And yet . . .

"Further than we've gone. The stars sing a song."

There is only one short verse repeated twice and the rest a music so beautiful it excavates the skies. It is an ocean. The deepest space in us. And in a voice as deep as the ocean, his voice conveys a lifetime in a sentence. Words that come from the heart enter the heart. It helps if you have got a cathedral stuck in your throat.

I always like the albums that you are not supposed to like. *Bluejeans and Moonbeams*, the most commercial, is my favorite Beefheart album. I know you are supposed to like *Trout Mask Replica*, but I'm afraid I don't want to listen to that shit. Neither do you. You see, people pretend to like these albums. It's like jazz. No one really likes jazz. They like being seen going into and leaving Ronnie Scotts. Once in there, they are asleep like everyone else. Don't be cool. It's very boring.

7. "Death Disco"—Public Image Ltd. (PiL)

To become a warrior, you have to give up the things you love most. To become a warrior, you have to give up the things you love to hide behind. The samurai code of honor, Bushido ("the way of the warrior"), is based on Zen and Confucian wisdom; it has seven principles: courage, honesty, courtesy, honor, compassion, loyalty, and complete sincerity.

Here Lydon the great Irish poet loses his chains and is wearing his crown. The song is about watching his mother die. It is ▶

so unflinching, unsentimental. We can't really look on death anymore than we can look at the sun and yet somehow he manages it. After silence, that which comes nearest to expressing the inexpressible is music. To dance and sing while the bells of death do ring! Compare the beauty of this song with the phony posturing of the Clash pretending to be bank robbers.

The song always reminds me of breaking into Lydon's house. He lived at 45 Gunter Grove, a few streets away from me. One day I found the door of Mr. Rotten's house had been left ajar. As I crept around among the tattered furniture and Red Stripe beer cans, my heart thumping louder than the Jah Wobbles bass beat, I scanned the room for something to steal, a sacred relic. Suddenly, I heard a noise upstairs. I panicked and ran, ripping a poster off the wall as I fled. It was a Public Image bill for this, my favorite song— "Death Disco."

8. "Under the Ivy"—Kate Bush
A great song should ache. And this song does. It has an aching creative heart. It's scope spans my life. It reminds me of playing at High Hall among the ivy and the paddocks. Golden nights on a sunset lawn making me feel so glad to be born.

All the quality of that life, and all the life like it that never came, have remained with me in all their splendor ever since—each memory chasing the next, merging with the next in an endless dreamy chase for lost sensation.

"I sit here in the thunder. The green on the gray."

> " A great song should ache. "

This song sings quietly the graveyard howl. We enclose our wilderness within a wall of words, lured from the first to the last by phantoms. At the end we survive only to be aware of all that we have lost. It is an emptiness beyond emptiness.

9. "The Happening"—Pixies

Well I should hate this song. I don't believe in UFOs, even if they exist. Flying saucers! What about flying cups? I also despise people who believe in them. They are so stupid. Given that reports of visitations mirror contemporary culture—five hundred years ago lights in the sky were regarded as dragons, and only when mechanized travel was developed did people start to see airships. How many things that served us yesterday as articles of faith, today are fables?

I don't care. This song is just so intoxicating. It makes me want to dance. Sober. And no sober man dances, unless he happens to be mad. I dance like a drunk killing cockroaches. It reminds me of Rachel 2 and Amsterdam and fucking whores together. It was my favorite time of year— November, that delicious month of sharp, pale mornings. The sun was shinning and I had resolved never to hit my girlfriend again. We walked arm in arm through the little canals in our hats and furs and we were happy. To be without some of the things you want is an essential part of happiness. But I had it all. I like women who are decadent, delectable, and, most important, deductible.

Rachel 2 and the Pixies are odd and ▶

> **❝** I like women who are decadent, delectable, and, most important, deductible. **❞**

The Twelve Disciples *(continued)*

I like that. The art of life is to be thought odd. Everything will then be permitted to you. Shall we marry, my darling?

10. "Idiot Wind"—Bob Dylan

Nick Cave introduced me to Bob Dylan. Name drops keep falling on my head. "There are many ways into Dylan," he told me. "Hatred and bitterness" is your way.

He was right.

"One day you'll be in the ditch, flies buzzing around your eyes, blood on your saddle. . . ."

The song is about futility to me. The senselessly negative feeling that hounds all reflective men: "Vanity of vanities, all is vanity . . . all is vanity and a striving after wind."

". . . It's a wonder we can even feed ourselves."

I adore these sentiments. They just seem so true. We are miserable, deformed animals whose bodies decay, who will die, who will pass into dust and oblivion, disappear forever not only in this world but in all the possible dimensions of the universe, whose lives serve no conceivable purpose, who may as well not have been born. We are crippled and unhappy and life is futile. We can hope for nothing. But then any dog in the street could tell you that.

Some see the song as a personal attack and that works for me too. Energy makes me write and it's often an energy fuelled by hate and disgust, jealousy and revenge, sadness and despair. I can be tender. But there is a lot of psychotic hatred coming out of me as well.

It always excites me to write about violence toward the things that I love.

I don't know what you think of Bob now. Is Dylan a tour de force or a forced to tour? Once upon a time, rock music was sung by the young to disgust the old. Now, it seems, it is sung by the old to embarrass the young. What on earth, my darlings, has happened to defiance?

The song reminds me of wandering around the phantom city of Essaouira with its medieval air. Nick and I had gone over there to try and get off heroin. We failed. Nobody told us that they had opium tea there.

11. "Double Talkin' Jive"—Guns N' Roses

The test of someone's humanity, Fitzgerald once said, is in their ability to appreciate the beauty and the horror of a rose. He meant Axl. Axl Rose is one of the greatest front men who has ever lived. He shares the stage with Elvis Presley, John Lydon, and Marc Bolan. The artist tries to make himself whole through his work. He makes it for something he lacks. Beethoven was deaf, Byron was lame, Keats consumptive, Homer blind. Rose is mad. It is a fair exchange. New roses for neuroses.

The band mirror me as a writer. I always saw *Dandy* as a rock 'n' roll book without music. What I loved about GN'R is that they wore their influences on their sleeves. You knew exactly where they had come from and where they were going. They nicked from different places but they were always open about that: British punk—the Pistols, the Damned, etc. Slash himself ▶

> **“ It always excites me to write about violence toward the things that I love. ”**

Read on

**The Twelve Disciples** (*continued*)

nicked his entire look from the cover of
Marc Bolan's *The Slider*. Bolan himself
was a great plagiarist. "Jeepster" is a
Howling Wolf song called "You'll Be
Mine." "Bang a Gong (Get It On)" is
"Little Queenie" by Chuck Berry. And
then, of course, along come Oasis with
"Cigarettes and Alcohol," which is "Bang a
Gong," etc., etc. That they stole matters not,
because they added to it. It is originality of
treatment, not of subject. They were
inventing within tradition.

All artists are rapists, pillagers, and
vultures. It's all just the transfer of bones
from one graveyard to another. For some
reason, theft is okay in music and art (look at
Damien Hirst—Francis Bacon in 3D!) but
not in writing, which I never understand.
Plagiarism is what the world's about. If you
didn't start seeing things and stealing because
you were so inspired by them, you'd be
stupid.

My book is about transgression.
Plagiarism is the ultimate transgression,
which is a case for doing more of it. Yes,
I am a literary pirate. So what? It is time to
hoist the black flag, put on my makeup, and
begin slitting throats.

Dandy in the Underworld is a dandy
book. Therefore it must be true to dandyism.
And authenticity is such a difficult pose
to keep up. You see, there is nothing
necessarily "false" about inauthenticity,
just as there is nothing particularly "real"
about authenticity.

Oh, and I love this song. Axl isn't even
singing on it. It's an Izzy song. That's how
good this band is. They have everything you

66 If you didn't
start seeing things
and stealing
because you
were so inspired
by them, you'd
be stupid. 99

26

need. Sex. Style. Subversion. Are you going to suck my Nazi cock or what?

12. "Decades"—Joy Division

This is one of the most beautiful songs ever recorded. It makes me giddy with desire and yearning. I want to swim into it like a river and drown. To melt into that holy chasm. To float away and stop hurting. It has an eerie, alluring, enticing aura. It is strange. Man is the only animal who can willingly embrace the inky abyss, even while understanding that it means oblivion.

The song has a dreadful sadness. An air of doomed magnificence. The Byronic weariness of life and the romantic passion for death are obvious. It is the same abyss that attracts both the romantic and the decadent, the same delight in destruction, self-destruction, that intoxicates them. But for the decadent, everything is an abyss.

"We knocked on the doors of hell's darker chamber."

Ian Curtis was a troubadour of trouble; a crooner of catastrophe. He knew that sometimes you can attain spirit only by practice of violence. That the road to hell has always been clogged with romantics. Perhaps by opening our hearts we open up our passage through the flames?

I guess we should be no more puzzled by the darkness into which we are going than by the darkness from which we came. Does it matter? One day we'll forget everything that's ever happened to us, and all the things we've seen will be lost like tears in the rain. ▶

The Twelve Disciples (continued)

The song reminds me of smoking crack with Rachel 1. And the song reminds me of the Seneca line:

> What need is there to weep over parts of life? The whole of it calls for tears.

..........................

The function of music is to release us from the tyranny of conscious thought. The most moving moments of our lives find us without words. What can be explained with words is only the waves, the foam on the surface, but music has its place underneath the waves, in the silent depth of the unspeakable.

A man gets up to speak and says nothing. Nobody listens and then everybody disagrees. Nothing solves the meaningless absurdity of life. But we can clothe the abyss and make it wearable. ∽

" The function of music is to release us from the tyranny of conscious thought. "